27685

WILEY SERIES ON HUMAN COMMUNICATION

Techniques of Photojournalism

Techniques of Photojournalism

Milton Feinberg

Director, Photographic Services
Advertising Services International, Inc.
(Subsidiary of AITS)

Wiley-Interscience,

A Division of John Wiley & Sons
New York · London · Sydney · Toronto

Library of Congress Catalogue Card Number: 73-96959

SBN 471 25692 7

Printed in the United States of America

To My Loves
(in the order I met them)
Barbara, Joan, and Polly

Preface

Having taught photography to many students, aged seventeen to seventy and of varying degrees of achievement, I have discovered that a serious deficiency shared by them all is one that lies in the basics of the medium. In view of what my students have taught me, in overcoming this deficiency, I offer my solution to the question, What must one learn to make his mark in photography?

The books that I have read on photojournalism and available-light photography are inadequate. Nothing is presented to motivate the photographer to perform the basic exercises that are needed to learn the necessary techniques. Instead, there is an overabundance of information about special lenses and equipment. There are Pulitzer Prize-winning news photographs and pictures of presidents, queens, and other dignitaries whom the beginning photographer reading the book can never hope to catch in his camera. He reads about the *what*, but not about the *how*.

The *how-to* books do not demonstrate the need to learn certain basics. The fundamentals of photography are presented too quickly, include too much too soon, and are not specifically correlated with the many problems that a photojournalist faces—the legwork, the telephone calls, the preparations, the digging out of essential information, the improvisations, and the actual work that goes into a simple assignment, such as obtaining an informal portrait.

No book presents a follow-through of assignments, which involves such other personnel as public relations men, writers, and graphic artists who share the responsibility for the finished product. No book demonstrates the methods of transferring the knowledge gained in one assignment to another assignment nor instructs how to obtain, locally, firsthand technical and other information that might be needed in carrying out assignments.

This book begins with the subject with which photographers begin—the photography of people. There follows a development of assignments leading up to the challenge of preparing a photo story for a national magazine. A photo story of national interest is a hectic task and involves working with about 40 other photographers representing local, national, and wire service groups, in addition to television men, reporters, and others. It is an assignment that requires the skill to photograph through elbows and between heads.

The discussion then shifts to some of the other assignments with which the beginner or "stringer" supplements his income: annual reports, brochures, house organs, and professional journals. By text and analysis of a variety of frames taken from actual assignments for these publications, a meaningful relationship is provided for all the elements that go into the education of a photojournalist. The minimum amount of knowledge that the photographer needs to respond adequately to a specific challenge is discussed at length.

This method of presenting photography will provide the neophyte in photojournalism, or the hobbyist in photography, with the necessary knowledge to help him become a photographer of better-than-average ability. The method will improve the professional's technique.

In writing this book I have had the help of many individuals who have given me their time and knowledge. It would be difficult to thank all of them for their efforts. I can single out a few to whom I owe my gratitude.

My daughter Joan helped me to write Chapter 1, and my daughter Polly posed for pictures and offered comments. Leo Gaffney, Director of Public Relations in St. Elizabeth's Hospital in Boston, helped in Chapter 9, and Greg Vitiello of New York made suggestions in Chapter 17, when he was with Shell Progress. Medical Economics, Inc., gave permission to use copyrighted material in Chapters 8 and 10; the New England Mutual Life Insurance Company allowed me to include photographs made for them, in Chapters 7 and 8. I also thank Sanford Sistare, formerly Director of Press and Public Relations for the Boston Symphony Orchestra; Jerry Miller for his help when he was photo editor of the RCA Victor Record Division; Kenneth Tong, Eastern Regional Editor for John Wiley and Sons, for his advice in preparing the manuscript; Herbert Goodman and Irving Rubin of Boris and Milton Studios for their cooperation and permission to use many photographs throughout the book; the New England Telephone and Telegraph Company for permission to use the photographs in Chapter 16, and the Beth Israel Hospital, Brookline, Mass., for permission to use the photographs in Chapter 15; and Joe Lesley of New York for his helpful comments in reviewing the manuscript. Many thanks to Mr. Leon Daniel, Managing Editor of PIX, Inc., New York, New York, without whose cooperation and assignments, this book would not have been possible.

My greatest indebtedness is to my wife for her encouragement to complete the task.

To these people and to the countless others who have directly and indirectly contributed to this book, I extend my gratitude.

<div style="text-align: right">Milton Feinberg</div>

Boston
August 1969

Contents

Techniques of Photojournalism

Introduction

Whether photographs are taken as an avocation or a vocation, whether they are snapshots or moonshots, the basic requirements for taking any picture—past, present, or future—have been, are, and will be the same. These universal basics are (1) light (its direction and intensity), (2) exposure (shutter speed and aperture), (3) sharpness (focusing and camera or subject movement) and (4) seeing (the relationship of all the elements in the photograph).

Although the science of photography is in a constant flux, these basics are the key to fine, eye-catching, communicating photographs. They are inherent in every picture.

The techniques, materials, and equipment will be refined, but the picture still will consist of what the photographer sees or does not see at the moment he releases the shutter. What he records or fails to record is everlasting.

The advertising of most camera manufacturer's leads us to believe that if we buy a camera all we have to do is load the film, push a button and—that's all. After you have read this book, you will realize that it is not that simple. You want to participate. You want to control your camera and not let it control you.

Hindsight will reveal that there is a great deal of trial-and-error learning involved in getting to know your equipment. The exercises presented here will show you how to eliminate wasted effort and to minimize the effort required.

A camera owner cannot feel that he has made a reasonable attempt to master his camera until he has learned the necessary basics of the medium in which he intends to work.

The informal portrait is emphasized because *your future as a photojournalist will depend on your knowledge of this subject.* More than 90% of the photographs taken include people; it is elementary that knowledge in this area should be stressed.

Public relations personnel are generally not trained in the photographic techniques of portraying their client or story in publications. This book will enable them to see the different ways their client or story can be presented and will explain what they should expect to pay for the different services.

There are three basic methods of portrait photography: flash, studio, and existing light. Most public relations men will hire a flash photographer—this is the most economical, but it is the least adequate. Those with more thought and a bigger budget

send their client to a studio, for the formal portrait. This provides the highest quality, but lacks in realism.

There is also the informal portrait. Not many professional photographers or photojournalists know the minimum requirements in lighting to deliver this type of portrait. The individual groomed in portrait lighting is usually not aware of the techniques of photojournalism. So, when approached for a portrait or other photograph, it is natural for him to employ the studio lighting techniques and not suggest the informal approach.

The era of the flash photographer is passing, even in the daily newspapers. The new breed of photographer will have to operate by available-light techniques: they will have to be photojournalists. They will have to photograph people by available light, and they will have to understand the medium.

The individuals responsible for annual reports, brochures, house organs, or publicity releases—wherever photographs will accompany text—are all demanding the realism of the techniques of informal portraiture. It is of prime importance that this knowledge be stressed.

The public, in personal use of photography, is beginning to demand something more realistic. The baby in her pretty new dress, seated on a table, with a white background—is out. Parents now want their children photographed in a natural setting. This approach demands the techniques of the photojournalist. The demand for something different in function photography will be supplied by photojournalistic techniques. The medium is light and shadow. These techniques are emphasized in the text.

You must read and understand the instruction book that accompanies your camera, meter, or other accessory you purchase. If you progress at a reasonable rate of learning and keep your ambitions within your capabilities, you will not be disappointed by comparing your early pictures with Pulitzer Prize winners, made by those photographers who have mastered the medium. Once you have mastered the basics you will be able to substitute confidence and knowledge for prayer.

If 70% of the 6 to 7 billion snapshots made today are spoiled by movement (camera or subject), it follows that once you know the shutter speeds that you can control with different focal length lenses, you have improved 70%.

If you can absorb the information in the instruction

manuals that accompany your equipment, and can follow the directions on the instruction sheet that is in every box of film, and can retain just 25% of the information in the manual written for your camera, you'll be successful.

This book does not contain data on the variety of films available or any formula listing of developers, or filter-factor data, which can lead to doubt as which should be used. The one film advocated is that used by 90 to 99% of all professional photojournalists. Why look for trouble?

After you master the basics, you should read, scan, study, and experiment on your own. But, master the basics of one camera and one film before you travel on.

The purpose of this book is to map the shortest and most efficient route to effective, creative professional photographs with what is available in terms of light, exposure, composition, and your own knowledge.

Unless otherwise credited, the author takes the credit or blame for all photographs appearing in this book.

Chapter 1

History of Photojournalism

The thinking and seeing processes must be so close that the photojournalist seems to think with his eyes. That is, he must think visually. He is usually associated with an organization the complexity of which determines his role. At *Life* or *Look*, he would have to contend with picture editors, art directors, layout men, graphic technicians, caption writers, as well as with the editorial policy of the publication as a whole. At a small-town newspaper, he might be all of these people in one.

Either way, the photojournalist must be technically competent, as well as socially aware.

From woodcuts to engravings, from wet plates to film, from 3-sec exposures to stroboscopic exposures of less than 1/1,000,000 sec, from the daguerrotype to computer-transmitted photographs—what is left? See what tomorrow brings.

Roots of Photojournalism

The beginning of the photojournalistic approach took place in eighteenth-century London. William Hogarth (1697-1764) introduced blunt honesty and courage into English painting at a time when prettiness and pomp were the fashion. He sacrificed much in the way of art to comment upon the morals of the English social structure in his series of pictures. He stirred up much argument because he refused to imitate the old masters and painted the scenes as he saw them.

Jumping the Channel, Francisco Jose' deGoya y Lucientes (1746-1828) of Spain lived at a time of corrupt society and cruel warfare. His works show brutality, cruelly portraying the Spanish life and times in which he lived. Both had in common a documentation of and commentary on the people and events which added considerably to the history of mankind.

Discoveries Important to Photojournalism

George Eastman, in 1884, helped free the photographers from clumsy, breakable, glass plates by introducing roll film, somewhat as we know it today, to the market. Prior to this, the photographer had to send the entire camera back to Eastman's plant in Roches-

ter, New York, where the film was processed. Fresh film was then inserted, and the camera was returned to the photographer.

The discovery of the halftone screen, which breaks up the solid tones of a photograph into a pattern of dots, permitted the first halftone reproduction to appear in *The New York Daily Graphic* in 1880. Before this discovery woodcuts were used. As with any other "first," the woodcuts continued to find use until the halftone process was perfected. It is analogous to the use of color in our periodicals and newspapers today. It was more than 20 years before the woodcut was completely eliminated.

A technician in Germany, Oskar Barnack, began work on the Leica prior to World War I, but it was not until 1924 that it was introduced.

The advent of flash powders for supplementary lighting did not advance photojournalistic techniques—it set them back. Today, to have pictures accepted for publication, they must be made by available light. And that is exactly how Erich Salomon and Alfred Eisenstaedt made their pictures four decades ago, for two German magazines, *Die Dame* and *Illustrierte*.

Photography as Historical Documentation

In 1855 Roger Fenton, founder of the Royal Photographic Society, entered the realm of foreign correspondence during the Crimean War. His equipment consisted of 700 glass plates, which were quite cumbersome for the terrain surrounding the Crimean Sea. Exposures could be no shorter than 3 seconds, a somewhat awkward condition if under fire from enemy guns. He also had to contend with censorship. His pictures could not contain any bodies. The public at large was not considered callous enough to accept the harshness and horror of war in its true sense.

1860 was the year of Lincoln's election and the year of Matthew Brady. Brady's picture, the portrait of Lincoln, helped dispel the impression that many people held of Lincoln as little more than an uncouth and ignorant, backwoods politician. Brady's pictures of the Civil War also pushed the field of photography further in its efforts to record history.

One hundred years later, before this nation and the world, the power of photography, in an advanced state, was illustrated by the Kennedy and Nixon debates on television. John Fitzgerald Kennedy, tanned, youthful, vigorous, faced a somewhat harassed and battered Richard Nixon. The results of the election, many people believe, showed the immense power of the photographic image.

Photography as a Social Statement

Two men used the compelling qualities of photography to communicate to the public the necessity of doing something about an evil situation. The misery and vice of the New York slums came alive under the lenses of Jacob Riis in the 1890's. The second was Lewis Hine who in the 1900's took pictures that exposed the horrors of child labor in sweatshops and the wretchedness of the coal miners. Both men provided the public with an opportunity to witness a despicable situation, with a greater reality than words.

There can be little doubt that these pictures helped to achieve the necessary reforms.

In 1932 the year of the Great Depression, Roy Stryker, an instructor in economics from Columbia University, headed a newly created photography unit of the Federal Security Administration. With a hand-picked staff of men and women, a detailed photographic study was made to report on the effects of the Depression in various parts of the country. A quarter of a million pictures are now in the Library of Congress from the cameras of Dorothea Lange, Gordon Parks, and Arthur Rothstein who were among the many talented photographers working under Stryker.

The genesis of the picture magazine came in 1936 when *Life* magazine used photographs as they had never been used before. *Look* quickly followed suit and then many others. The Sunday newspapers, under the impetus of these two magazines, began to use more and more photographs in their supplements. There just were not enough photographers to fill the need and so the "stringer" or free-lancer came into being. From the two large picture agencies, PIX and Black Star, emerged many other imitators.

Chapter 2

Informal Portraiture

Let us assume that you have visited several agencies with your portfolio* and have sold one managing editor the idea that you can be trusted with an assignment. Don't get the idea that your assignment will take you to Viet Nam, the White House, or even the mayor's office—it won't. You'll probably get a simple assignment, nothing more than a sophisticated identification picture, a photograph of an individual to accompany an article that someone has already written.

First Contact

The first contact is usually by telephone, asking if you are available for an assignment on a certain day. The basic facts, such as who the subject is, where he can be located, the coverage requested, and when the film should be sent to the agency, are given. There is usually a promise of a comfirming letter to follow. Which letter might look like this.

Dear Mr._____:

I am glad to have an assignment for you from M.E. The job will pay $x.00 of which you will receive your regular share plus expenses.

M.E. would like you to get in touch with Dr. W. D. of Gloucester, Mass. (address and telephone number) and if possible, would like to have the photographs in their hands no later than_____.

They would like to have a good selection of pictures, preferably one or one and a half rolls on each situation. The photographs should be taken from different angles and from different sides with good expressions.

Best regards,
Signature

A memo from the magazine with their "List of Requirements for All Photos" will probably accompany the letter. This memo should be your bible.

All photos must meet the following requirements.

1. Well lit—no head-on lighting.
2. Low grain.
3. Animation (not posed in appearance). No desk shots.

*How this portfolio is built and what it should contain will be amplified in each chapter.

4. At least one contact sheet for each situation, taken from various angles.
5. As long as we receive the pictures required, we encourage photographers to shoot situations the way they see them, since we are not always aware of the physical setup.
6. Model releases and caption information completed.

We feel our requirements on photographs are not very difficult for a good photographer to follow. In case any unforeseen problem arises, please call (person in charge) at (telephone) collect.

Lighting

Item 1, Well lit—no head-on lighting, means that you must be able to recognize head-on lighting, if only to avoid using it. It also means that you must be able to recognize and use other types of lighting; know something about direction of light, such as how the light is falling on the subject; and be aware of how light and shadow depict the features. Because you will be operating by the available light technique, you must know how to control it.

Available light may be defined simply as the illumination present in a situation where you are taking photographs. Other terms used interchangeably are "existing light" and "natural light." Basically, all three terms imply that you are operating your camera without using artificial sources of illumination such as flash or floodlights.

Light Direction

It is obvious that you have to have knowledge of light direction. As you acquire knowledge of light direction your photographs will show a marked improvement. Lack of knowledge can cause the results described below.

The camera is loaded and it's a bright sunny day. You know that you should get good pictures. You examine your prints when they come back from the finisher and are disappointed because they didn't come out the way you expected. There are black sockets where the eyes should be, and the shadow cast by the nose obliterates the mouth. Should you blame the

camera or the film? You could, but you would be increasing your knowledge of light direction if you pay particular attention to the shadow cast by the nose of your subject when frontal lighting is used.

Frontal Lighting

Frontal lighting is that type of light direction in which the main source of illumination is behind the camera operator and the light falls directly on the subject. The shadows will then fall immediately behind the subject. Light from the frontal direction flattens out details. Since photo editors and art directors do not want flat, monotonous photographs, it is best to avoid frontal lighting whenever possible.

Remember the black sockets for eyes in the snapshots? This result is not confined only to sunshine shots. You can get the same problem from light direction when working with stage lighting or other overhead fixtures. The bright sun can be compared with a spotlight or a photoflood, as far as photographic lighting is concerned. Your eventual achievement in photography will be directly related to your mastery in handling light.

The Nose Shadow

The nose shadow that obliterated the mouth of the subject in the snapshots can help us understand a lot about frontal lighting.

If you look at the features of a face that are illuminated by a front light, you will be able to formulate some good rules of thumb.

You should investigate the various positions of the nose shadow in relation to the over-all result when you are forced to use frontal lighting. Outdoors, with a bright, unclouded sun as the source of illumination, or indoors, with a spotlight or photoflood, the investigation will provide the same result.

First, try with the sun high overhead, or place the floodlight in a comparable position. Since you want to study the face, try to fill the entire viewfinder with your subject's head and shoulder, starting a little bit above the head and down to the middle of the chest (see Figure 2-1).

Note carefully the length and position of the shadow cast by the nose. When the nose shadow crosses the lips, what happens to the rendition of the eyes and lower part of the face? The eyes are the black sockets mentioned previously, and all detail is lost in the lower part of the face. The face casts a long shadow over the chest.

You can deduce easily that if the nose shadow crosses the lips the resulting picture will be poor.

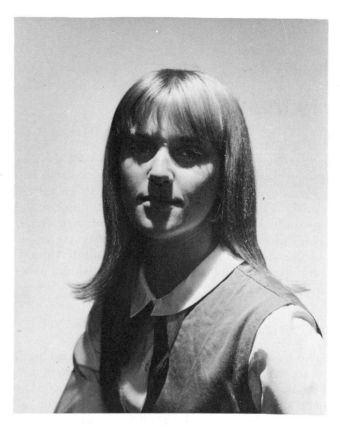

Figure 2-1

Don't bother to trip the shutter. What can you do if frontal lighting is the only light available to you? How about raising the subject's head until the shadow cast by the nose just touches the upper lip?

In Figure 2-3, note that the shadow cast by the nose just touches the upper lip. Comparing this photograph with Figure 2-2, you can see that it shows more detail in the eye region and in the lower part of the face.

Can we still improve on this? Let the subject raise her head a bit higher or, in the studio, move the main light until the shadow cast by the nose is midway between the tip of the nose and the upper lip (see Figure 2-4). The eyes definitely contain more detail, and the modeling in the chin area has improved.

If you have the subject raise her head until the nose shadow disappears, you will have a result similar to Figure 2-5. This is comparable to the illumination that a flash would give, if the flash gun were attached to the camera. True, there is more light in the eyes, but you have destroyed the modeling. The face is flattened into a two-dimensional figure. This is the effect that brings about a special restriction in a list of requirements from magazines or agencies.

You can conclude that if a frontal light is used for a portrait, your best results will be obtained if the

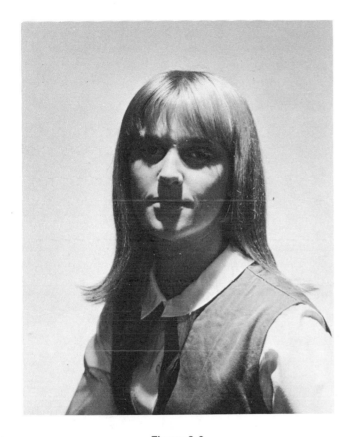

Figure 2-2

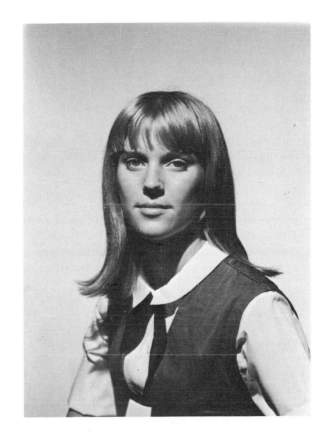

Figure 2-4

Figure 2-3

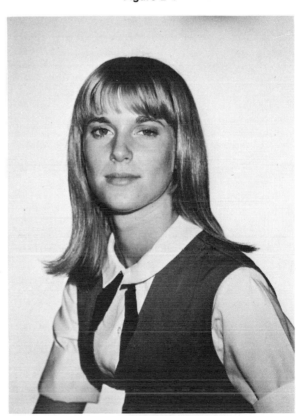

Figure 2-5

shadow cast by the nose is no lower than halfway between the tip of the nose and the upper lip. This is your minimum requirement for frontal lighting (see Figure 2-6).

What would happen if the nose shadow were not directly centered as in the illustrations? Try it and see. Figure 2-7 is a candid portrait taken on stage at Boston Symphony Hall. The nose shadow is half way between the nose and upper lip. Available frontal light was used to the best advantage under the circumstances.

In a candid situation like this, you have very little time for control. When you see the finished print, and the nose shadow is halfway between the tip of the nose and the upper lip, you have the best possible picture attainable, in terms of frontal lighting.

45° Lighting

Now that you are able to recognize frontal lighting, particularly the "head-on" variety, what can you substitute for it? One thing is 45° lighting. A guide for using this type of lighting is an inverted triangle. The key for recognizing the 45° light will still be the nose shadow. The shadow of the nose falls at a 45° angle,

Figure 2-7

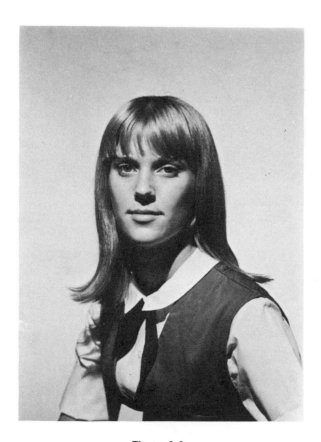

Figure 2-6

with the inverted triangle on the cheek opposite the main direction of the light source.

If you are using artificial sources, the size of the triangle is controlled by the height of your main light and its distance from your subject. Figure 2-8 illustrates the unbalanced 45° light created by an artificial source. Figure 2-9 is a direct sunlight shot at 45°. In both cases the identifying triangle is of the same intensity in highlight as the side of the face that is turned to the directional source.

These photographs are not suited for reproduction because they lack balance in the shadow areas. How do you achieve this balance? In the studio (or at home) it can be accomplished by an additional source of light—a balancing one. This light is placed near the camera position and a bit higher than your subject's eyes. Be very careful that you don't give equal play to both lights. Don't overbalance.

A close examination of Figure 2-10a reveals that there is no catchlight in either eye. This catchlight, which gives life to the eyes, is achieved by adding a balancing light. In Figure 2-10b you have added the

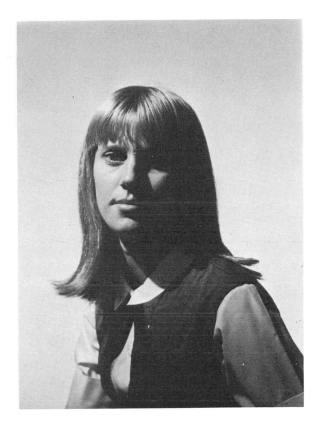

Figure 2-8

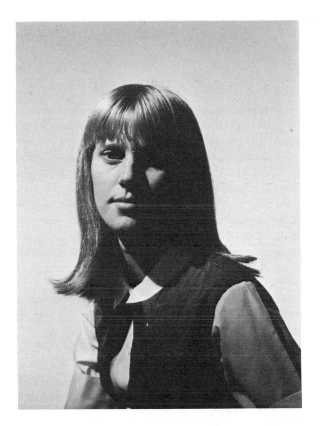

Figure 2-10a

Figure 2-9

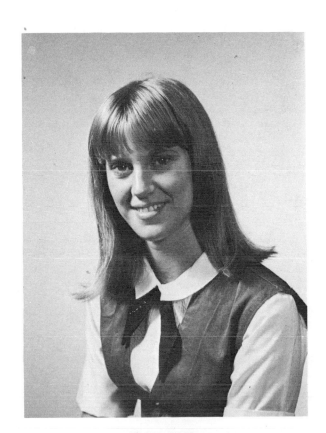

Figure 2-10b

balance light, resulting in increased detail in the shadow side of the face and eyes. You have also worked to get a more pleasant expression in your subject.

Outdoors you would need a reflecting device (a white blotter or newspaper held by an assistant) to achieve a balance. But unless you are working with professional models, or people accustomed to having their pictures taken, the presence of an additional individual to hold the reflecting device may tend to make your subject more self-conscious.

In Figure 2-11 observe the inverted triangle of highlight on the shadow side of the face. Here, available light has been used to its best advantage. The direction is from the rear so you have the additional value of backlighting.

The highlights on the hands help maintain the center of interest in the picture, but it is the patterns of light and shadow on the face that give you the best clue to the basic type of lighting used.

This picture was made in the tuning room of Boston Symphony Hall, while the bassoon player was shaving reeds. He is engrossed in his work and is oblivious to the camera. This adds honesty to the photograph. The bassoon and his arm frame his face well, and there are no disturbing elements in the background to divert the viewer.

Split Lighting

There is another type of lighting with which you should become familiar—split light. Half of the face is in highlight and the other half in shadow. This is achieved with artificial means by positioning your main light so that none of the highlight spills onto the shadow side. The height of the source of artificial illumination should be about level with your subject's head. It is necessary to have it this low to avoid the shadows cast into the eye cavities in both the highlight and shadow side of the face. It is almost impossible to use split light outdoors without getting these shadows, because you can't lower your source of light—the sun. Figure 2-12 is not suited for reproduction

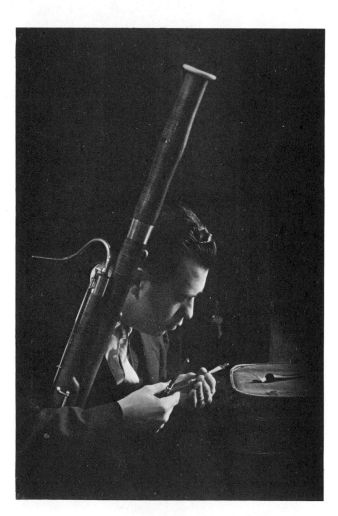

Figure 2-11

Figure 2-12

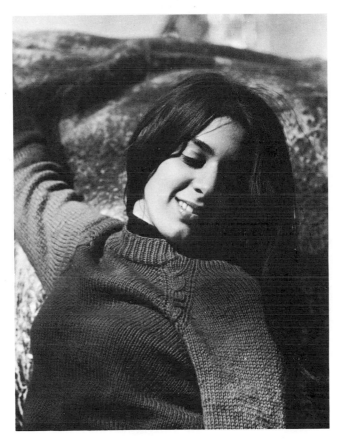

Figure 2-13

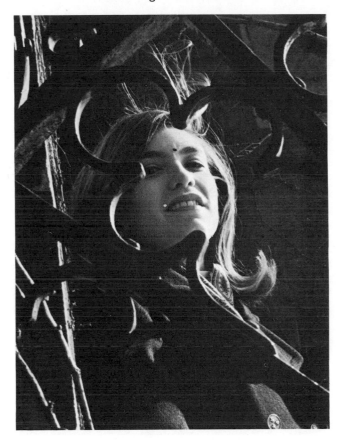

Figure 2-14

since it requires a balancing light similar to that used for 45° light. While Figure 2-13 is also unbalanced, it is more easily accepted by the public since the setting is outdoors.

It has already been mentioned that the presence of a third person holding a reflecting device may tend to make your subject more self-conscious. You should, therefore, try to employ natural methods of getting light into the shadow areas. Figures 2-14 and 2-15 show how effective split lighting can be achieved naturally. A slight turn of the head lets you take advantage of the wall upon which the young lady is leaning. The wall acts as a natural reflecting device, giving more detail in the shadow area.

Split light should not be used when you are photographing a face posed, full-front (see Figure 2-16). Its proper use demands that the head be turned at least three-quarter view (see Figure 2-17). The most effective use of this light is when the highlight side is the "short side" of the face (see Figure 2-17). When you make the highlight side the broad side, you'll find that the directional source is frontal and you lose the dramatic impact of the backlight.

You may also find that a combination of natural and artificial light sources is needed. For instance, Figure 2-18a shows a photograph taken with natural light from a window. Note the unbalanced shadow areas. Figure 2-18b shows the same subject in the same position with an additional source of light—an overhead fluorescent. Another technique that could have worked here would have been to move the subject further away from the window.

Obtaining Additional Information

I have used studio reproductions of three basic lighting arrangements that you will encounter in available light situations. You will be well on the way to getting an understanding of light direction if you can reproduce them artificially. It is hoped that you are now able to recognize frontal, 45°, and split lighting.

Good courses in portrait lighting are frequently offered by photographers who have portrait studios. There also may be courses in portrait lighting given by high schools or adult centers in your area. Camera clubs can be good sources for instruction. You might

Figure 2-15

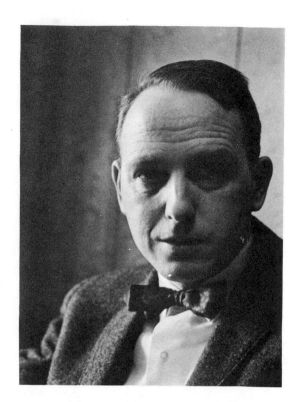

Figure 2-16

ask the personnel in your camera shop if they know of anyone that might give you the basic instructions.

Eastman Kodak Company offers a publication that lists the colleges, universities, and technical institutions throughout the country that offer instruction in photography. It can be obtained, free of charge, by writing to Eastman Kodak Company, Department 454, Rochester, N.Y. 14650 and asking for "AT-17," *A Survey of Photographic Instruction.*

DO	DON'T
. . . recognize head-on lighting.	. . . use head-on lighting.
. . . create artificially the 45° and split light.	
. . . get instruction in portrait lighting.	
. . . check light direction.	

Figure 2-17

Figure 2-18a

Figure 2-18b

Chapter 3

Changing Light

Photography is nothing more than photographing light.
EDWARD STEICHEN

Up to this point we have discussed the basic directions of light and you have a few ideas as to what you should look for concerning the distribution of light and shadow on your subject.

At first, the novice photographer is usually concerned only with the question, "Is there enough light to enable me to get a picture?" Many times the beginner doesn't even ask that question. If he does, he has unconsciously discovered that there must be sufficient *intensity.* Intensity will be discussed in detail in Chapter 4. Most beginners are also usually aware that they should keep the sun over their shoulder. This is their introduction to *direction,* which was discussed in Chapter 2.

If you are to be a knowledgeable photographer, you must be aware that light has variable qualities and characteristics that will affect your pictures. Even the term "daylight" is too general a term to employ.

Figure 3-1 is a portrait taken in bright sunlight. Notice that the "contrast" (ratio of light to dark) is very high; there is very little detail in the shadow areas—if any. From studying the previous chapter, you can say that the choice of frontal light was a poor one. The nose shadow has crossed the lip. If the subject had been asked to raise her head until the shadow was correct, there would be another difficulty. Her head would have to be raised so high that she would be looking into the sun. Even if a model could accomplish this task, she would have trouble getting a pleasant expression. One solution to this problem is illustrated by Figure 3-2. The subject has been turned 180° for a different light direction—backlight.

In bright sunlight, backlight poses a problem in exposure. Those of you with automated cameras—beware! You will get nothing more than silhouettes of your subjects if the sunlight activates the measuring cells of your camera.

Basically, the exposure problem is solved by increasing your aperture about 2.5 stops or by decreasing your shutter speed by an equivalent amount. The highlighted areas will, as a result, be overexposed.

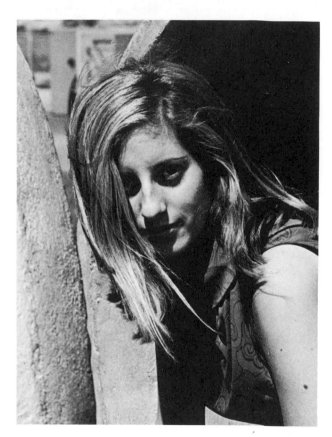

Figure 3-1

This, however, can be corrected by custom printing which will be discussed in a later chapter.

Direct sunlight photographs and photographs taken with spotlights share one characteristic—a very high contrast between light and shaded areas, with few middle ones. In halftone reproductions of this type of photograph, the dark areas tend to be completely black, unless a very fine screen is used in shooting the halftone. A good way to see the difference a fine screen makes is to compare a halftone in a photography magazine with one in a newspaper. This will probably be the difference between a 133-line screen and a 60-line screen.

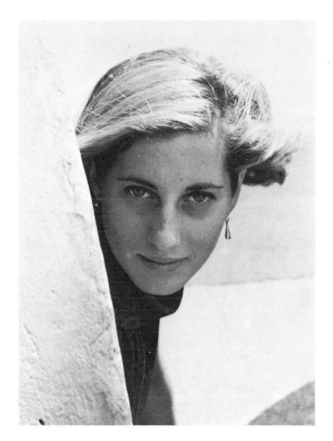

Figure 3-2

Figure 3-3

Overcast Skies

Overcast skies provide an ideal quality of light for taking informal portraits. It is ideal in that it permits photographs with the right contrast for good half-tone reproduction—that is, from dark to light with many shades of grey in between, no matter what printing process is used. Light from an overcast sky is comfortable for models, regardless of the direction. The light from a cloudy or overcast sky is similar in quality to that cast by a diffused photoflood or fluorescent tube.

In Figure 3-3, the subject was photographed when the sky was clear. Note again the dark cavities for eyes. The small triangle of highlight on the shadow side tells you that an acceptable form of lighting pattern was used. Unfortunately the ratio of highlight to shadow is very great and the photograph lacks detail in the shadow areas.

In Figure 3-4, the sun has been partially obscured by a passing cloud. The eye areas are delineated much better; the triangle of light on the shadow side indicates that the 45° pattern was used correctly. The lighting is definitely better balanced than in Figure 3-

Figure 3-4

3, and, consequently, the photograph is more suitable for reproduction.

Vagaries of Light in One Spot

In Figure 3-5 we see four consecutive frames of one girl photographed in one spot. Yet, each of these informal portraits depicts four different lighting arrangements. These arrangements were created solely by points of view and the manipulation of the subject.

When a passing cloud partially obscures the sun, you can get a photograph that is pleasingly balanced, as in Figure 3-5a. With the sun still partially obscured, a quick change in your point of view results in Figure 3-5b. There is a distinctive highlight edging the right side of the subject's face. In portraiture this is sometimes called the "sweetheart" line. This three quarter view with the camera slightly lower than the subject's face usually gives the best rendition of the subject.

Both Figures 3-5c and 3-5d were taken in full sun-

Figure 3-5a

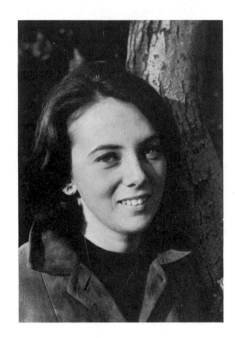

Figure 3-5c

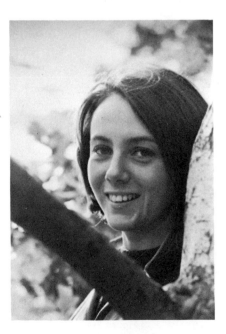

Figure 3-5b

Figure 3-5d

light. The contrast of light to dark is great. Figure 3-5 c shows 45° lighting—easily identified by the inverted highlight triangle on the shadow side. For Figure 3-5 d a slight turn of the subject's head resulted in the "split" light. Note that in Figures 3-5c and d, the demarcation lines are sharp whereas in Figures 3-5a and b the tone changes are subtle.

Those of you who are discerning, have probably noticed that Figure 3-5b has reproduced the best. The separation of the figure from the background is the reason for this. In all the other illustrations the hair lines merge with the background. Backgrounds and tonalities will be elaborated on in later chapters.

Practice will help you use these changes in light to your advantage.

While you are getting familiar with your camera, take it along with you when you are with your favorite subject and practice the basic types of lighting.

A Pattern to Avoid

When you "see" a picture, you should first notice the direction of light. In Figure 3-6 you have a poor representation of your subject. The branches of the tree are creating an unrhythmic pattern of light on the girl's face. You have a distorted representation.

Figure 3-6

When you see this, you should not take the picture. Since the source of light cannot be moved, you are forced to rearrange the subject. The best you can do, under the physical limitations, is to resort to a form of backlighting (see Figure 3-7).

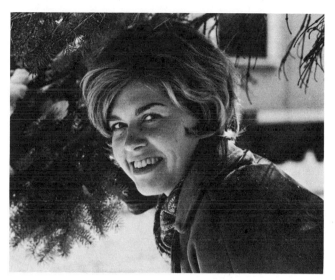

Figure 3-7

While the light that falls upon your subject is flat, a closer look will show that there is a good deal of reflection from the snow on the ground, resulting in higher tones in the lower part of the face. This direction, from below, is not a flattering direction and should be avoided, if possible. Your best bet would be to change the location and start over again.

The Importance of Lighting Knowledge

A photojournalist encounters many working conditions where the light is of several varieties. The photojournalist, or anyone with a camera, must know the difference between illumination and lighting. He must be able to handle light regardless of the source, the direction, the intensity, or the quality. As with any subject, the more you study the effects of your use of light, the more proficient you will become.

Fluorescent Light

Frequently, you will be called upon to photograph an individual where the source of illumination is from overhead fluorescent tubes. This direction would normally give us black holes for eyes but the light radiated by fluorescent tubes is of a diffused quality—similar to the light cast on a cloudy or over-

cast day—and there are pitfalls with which you should be familiar.

The intensity of light is going to be stronger in that part of your photograph which is closer to the ceiling. In Figure 3-8, the forehead is definitely lighter in tone than the lower part of the face. This can be corrected in making the final print by "dodging" or holding back the amount of light that reaches the enlarging paper from the lower part of the face (see Figure 3-14). In Figure 3-9, the subject has cocked his head to one side and there is an approach to the split pattern of lighting, with the side that is turned to the source of light being definitely in a higher key.

A Few Practical Tips

There are two items inherent in available-light photography that can cause you trouble. The first problem is that of the reflection of light in the lenses of your subject's eyeglasses, if he wears them. In Figure 3-10, the subject's glasses are reflecting all the light so that detail in the eyes is hidden.

For those of you who have studied physics, you know that the angle of incidence equals the angle of reflection, so the solution is simple: just change the angle. Have your subject turn his head while you are watching the reflection from his eyeglasses. When the reflection is gone, begin to trip your shutter.

In Figure 3-11, the subject has not only turned his head, but the photographer has also changed his viewpoint.

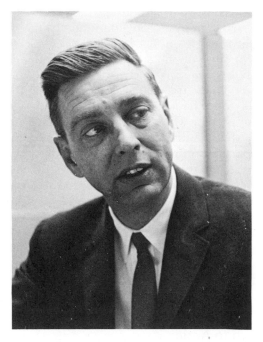

Figure 3-9

Getting Rid of Unwanted Reflections

Unwanted reflections can be a harassment to you. They occur not only from eyeglasses but from any reflective surface. If you notice an unwanted reflection on the subject or item that you are photograph-

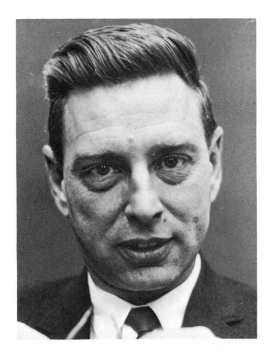

Figure 3-8

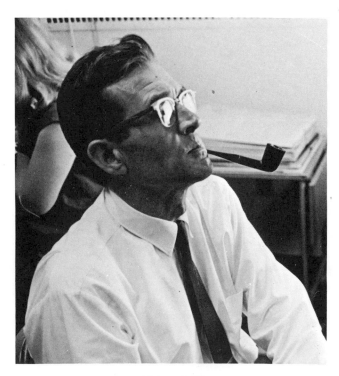

Figure 3-10

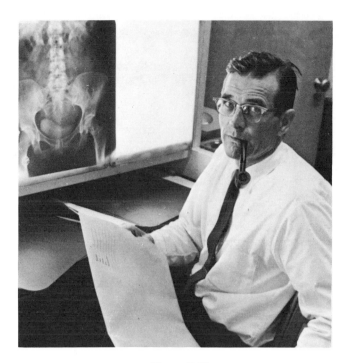

Figure 3-11

Figure 3-12

ing, you can eliminate it in one of three ways: (1) by changing the position of your subject; (2) by changing the angle of the light; or (3) by changing the position of the camera.

In Figure 3-12 you can't change the position of the light because it is the sun. You don't want the trouble of changing the position of the sign, so you change your position (Figure 3-13). The trick is to see the reflection before you press the shutter.

Closely allied to the eyeglass problem is that of the circles under the eyes. The best subjects for available-light portraiture are babies and young people whose complexions are flawless. Unfortunately, even with the ideal subject you are going to get circles under the eyes. If a public relations man selects the final picture for publication, you won't have as much difficulty as you would have if your subject were to choose the final pose. Here, vanity and the limitations of your film come into play. You have circles under your eyes, perhaps temporary or permanent blemishes, yet you don't like to see them in your own photographs. You are not aware of these defects in yourself, because you don't see them as static representations staring at you. Look at another person's face. Stare at the area under his eyes. You'll see the circles, but a person is normally mobile and so is your gaze. You don't continually look at this area in life, as you can in photographs.

Your eyes can distinguish the detail in the shadow areas even if your subject is lit by bright sunlight.

Figure 3-13

Photographic film is not that sensitive, however. The degree of darkness that exists in the shadows will be exaggerated. In Figure 3-14, you have nearly a straight print. The only trick here was to hold back the lower part of the face and to "burn in" the forehead during printing. This was done to compensate for the part of the subject's face that received a greater intensity of light (Figure 3-8). In Figure 3-15, the circles under the eyes have been lightened and the blemishes on his left cheek and near his left nostril have been removed. This was accomplished by the aid of a reducer—potassium ferricyanide. The process is a simple one, but have a professional show you how to do it.

Since 35mm negatives can't be retouched due to the small images, the use of a reducer or bleach is one way of correcting or "retouching." This method is not recommended for prints in quantity because of the time consumed. If you have to have prints in quantity, you should make an 8 × 10 print and perform the corrections on it. Then copy this print and from the new negative make the rest of your prints.

Another method is to make an 8 × 10 print without the retouching. Then copy this print on 4 × 5 or larger size film. Send this negative to a retoucher with your corrections notated on the original print—naturally after it has been copied—and make your new prints from this retouched negative.

Figure 3-15

More Than One Source of Light

Up to this point, you have studied light as though it were coming from only one source. In practice, light is usually striking your subject from more than one direction. This gives you a variety of sources. You should use this to advantage by keeping *one directional source dominant*. The most common error that the novice makes, if he has two artificial light sources available, is to give equal play to both. One of the sources should be used as a "balancing" or "accent" light.

The light present when shooting indoors, especially if there are many windows admitting light, can give your photographs impact if you are using the light direction principles knowledgeably.

From an examination of the two pictures of Richard Cardinal Cushing of Boston (Figures 3-16 and 3-17) it is quite obvious which photograph has the greater impact. You can't change the direction of the source of light (window); also, it is impractical in the circumstances of the sitting to request that the subject move. So you move.

In Figures 3-18 and 3-19 there is an extension of the same principle of light direction as it applies to a full figure. The purpose behind the illustration is to demonstrate the new attire of the nun. Sisters of the cloth are not prone to pose for photographs, even for a house organ, so the nurse was asked to engage our subject in conversation. When she did, the camera

Figure 3-14

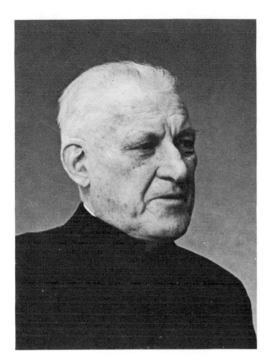

Figure 3-16

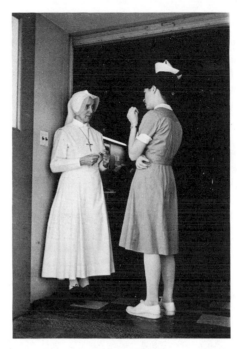

Figure 3-18

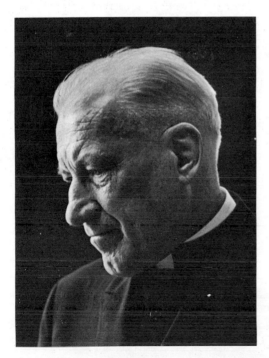

Figure 3-17

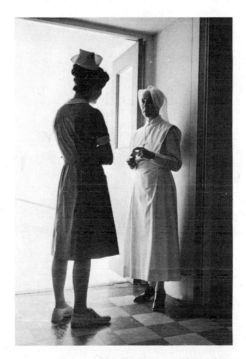

Figure 3-19

went to work. A comparison of the two photographs will demonstrate the impact of light hitting your subject from a rear source. The candid approach and the natural light source combine to give a believable and realistic interpretation.

A comparison of the photographs taken with the back or side light direction with those taken with the frontal source demonstrates why frontal lighting, particularly the head-on type, should be avoided, if possible.

Let's Be Practical

Most of the time you will be able to position your subject so that you can take advantage of your knowledge of light direction and get the best possible informal portrait of your subject. There are going to be times, however, when you can't ask your subject to move. If the light is frontal, or flat, make the pictures anyway. You know that they aren't going to be the best. You may even know that they are going to be uninteresting. You know it and you know that any other photographer, under similar circumstances, couldn't get better ones.

You should not compare your early attempts in informal portraiture with Figures 3-20 and 3-21. At present, you should be concerned only with the employment of light.

The light source is from one window—bright sunlight. You can't move this source of light, but you can move your subjects. You pose them so that the sunlight casts a 45° light on the lovely miss (Figure 3-20). You direct the man to tilt his head until the inverted triangular highlight is eliminated. This creates a split light for him.

When a passing cloud softens the light coming in through the window, you get a quality of light which enhances the intimate mood of the subjects (Figure 3-21).

DO	DON'T
. . . make photographs on overcast days.	. . . make all your photographs on bright, sunny days.
. . . change your point of view and the subject's position during shooting.	. . . confuse illumination with lighting.
. . . make pictures under differing light conditions.	
. . . keep one light source dominant.	

Figure 3-20

Figure 3-21

Chapter 4

Exposure: Variables We Control

Can you get on with your basic urge to take some pictures? You can recognize the three fundamental patterns of light. What more do you need to know? This brings us to the second point in the List of Requirements—low grain. Grain is caused by the innumerable particles of metallic silver that are left on the base of your film after processing. When you make an exposure, the light starts a chemical process in the silver bromide crystals embedded in the sensitized emulsion on the film base. The developer used splits off the bromine from the exposed silver bromide particles—the bromine being absorbed by the developer. This action reduces the original silver bromide to metallic silver in direct proportion to the amount of exposure it has received. Another chemical, "hypo," removes the unexposed silver from the film base. Now your negative is "fixed"—it is unalterable by any further action of light.

There is a direct ratio between the graininess of your negative and its sensitivity to light. Films on the market today vary greatly in their sensitivity to light. There are several ways to measure this sensitivity, but it is only necessary for you to be acquainted with two basic means—the arithmetical and the logarithmical. The arithmetical is the American Standards Association (ASA) method of calculating the emulsion speed of a film. This means that an emulsion speed of 400 ASA is twice as fast as one rated at 200 ASA. The logarithmical means of measuring emulsion speeds is the basis for the *Deutsche Industrie-Normen* (DIN) method, the British Standards Institution (BSI), and the Scheiner system. In these systems an increase of 3° means doubling the speed, that is, a 27° film is twice as fast as one of 24°.

The higher the speed rating of the film the greater the sensitivity, but also, the greater the tendency of the film for grain, because larger crystals of silver bromide are used in its manufacture. Graininess will be most evident in the medium grey tones of your print. It is obvious that the greater the degree of enlargement the more apparent will be the appearance of the grain.

Other factors that tend to produce grain besides the speed of the film are overexposure, overdevelopment, and the use of developers that are not specifically designed for fine grain development. In general, the more energetic a developer and the longer you

allow it to act, the greater will be the appearance of grain.

Photo editors differ widely in the amount of graininess that they accept. Chapter 5 expands upon this. A print, when examined very closely, may appear to have objectionable grain, but when the same print is viewed from a normal viewing distance, it may be quite acceptable.

My recommendation is that you use a fast ASA rating Eastman Kodak Tri-X. The reason for this choice will become evident as you read on.

Variables Pertaining to Exposure

There are two variables in exposure which you can control: the shutter speed and the size of the aperture. The shutter speed determines the length of time during which light will pass through the lens to the film. The aperture[1] is an opening that can be varied in size manually to control the variable iris diaphragm. (Diaphragm opening, f/stop, and aperture are used interchangeably.)

The light-transmitting power of a lens is measured in terms of f/numbers. The maximum f/number of a given lens is calculated by dividing the lens's focal length by its maximum diameter. All measurements are expressed in millimeters. Standard f/stops are 1.4, 2, 2.8, 4, 5.6, 8, 11, 16, 22, 32, 45, and 64. These f/numbers are accurate (theoretically) when the lens is focused at infinity. When you are taking a close-up, the barrel of your lens (or bellows of a view camera) is extended. When this occurs, the intensity of the light reaching your film is diminished. Thus, if you are focused at the closest point possible, you will find that you are underexposing the film by approximately one f/stop when compared with the focus of your camera at infinity. With a photograph the same size as the object, you would need 4 times the exposure.

The focal length of the lens is engraved on the lens mount and is the distance from a certain point in the lens to the film, when the lens has been focused on infinity. The normal focal length of a lens should equal the diagonal of the camera's negative. This cre-

[1]For a more detailed discussion of aperture effects, see Ralph M. Evans, *Eye, Film, and Camera in Color Photography*, John Wiley & Sons, Inc., 1960, pp. 97–100.

ates a size and depth relationship in the photograph which approximates what your eyes see (see Chapter 5).

Use the fastest shutter speed possible, commensurate with the depth of field[2] (area of sharpness) that you need in your photograph. The faster the shutter speed the more you minimize any camera or subject movement. The sharpest parts of your picture will be at the distance for which your lens is focused. The clarity will fall off gradually, both behind and in front of this focused distance. The zone in which everything is acceptably sharp is the "depth of field."

The depth of field for each lens is dependent upon the focal length of the lens, the f/stop used, and the distance for which the lens is focused. The smaller the aperture, the greater the depth of field. Very small stops such as f/16 or f/22 often cause a decrease of sharpness with high-speed lenses. At this point, the lens starts acting like a pinhole camera and the quality of the image gets worse. The maximum definition obtainable with f/2 lenses usually lies about f/5.6.

Determining the Best Exposure

There are six factors involved in determining exposures.

1. Intensity (and quality) of light reflected by the subject.
2. The speed (ASA) of the film in the camera.
3. The lens aperture.
4. Shutter speed.
5. Filter factors (if used).
6. Choice of film developer.

To measure the intensity of the light reflected you should have a good exposure meter and should be able to use it intelligently and with confidence. There are more than 100 different meters on the market. Most meters are designed so that they can be converted from the direct reading type (where the sensitive reading cell is pointed at the subject) to the incident type (where the sensitive cell is pointed towards the camera and is held at the subject's position). The incident reading measures the light falling on the subject. The switch from direct to incident reading is accomplished with a snap-on or sliding device, that can be attached to the sensitive reading cell. (You would be wise to purchase a meter that contains a viewing lens which permits you to see the area being read.)

[2]See Willard D. Morgan, *Leica Manual*, 14th ed., Morgan & Morgan, Inc., 1965, pp. 57–64; Evans, pp. 75–77, 97–100, and 308–314.

By taking a reading and moving the calibrated dials to the positions indicated by the reading, a quick and varied relationship between f/stop and shutter speed is revealed. But light meter systems are merely guides to correct exposure and they have a weakness. They do not operate very efficiently at low- or high-level areas. To compensate for this weakness and to coordinate *your* meter, with *your* camera and *your* mode of operation, you should test it. These tests will give you an understanding of your meter under all levels of illumination. It will give you the confidence to employ your meter and obtain the maximum results from it.

Testing Your Meter

Since meters are adjusted at the factory where they are manufactured, they are adjusted for average readings. Your problem is to coordinate this average adjustment with your individual manner of operating equipment and two other factors. The first factor is the actual shutter speed of your camera. The true shutter speed may vary from that indicated on the dial: normal wear and tear on the springs which control shutter speed can be one cause. The second factor is choice of developer used.

Place your subject in the vicinity of a window, so that half of the subject's face is in bright light and the other half in shadow (Figure 4-1). Set the meter to the film speed (ASA rating) recommended by the manufacturer. Take a direct reading by pointing the sensitive cell at your subject. Be close enough to your subject so that you can read a combination of the highlight side and the shadow side, that is, about 3

Figure 4-1

feet away. Follow the directions in your meter instruction book for taking a reading. The scale on the meter will show you the combinations of lens aperture and shutter speed you may select. (Sometimes a reading will fall between two readings; see Figure 4-5.) Record the direct reading on a sheet of paper. Now take an incident reading. It should read the same, but it might not. Record the incident reading on the same sheet of paper. After adjusting your camera to the combination of shutter speed and aperture you are going to use, note this also. Give the piece of paper, with the notations on it, to your subject and make an exposure (Figure 4-1).

Take the paper back and draw a line through the combination you have just used. On this same sheet of paper, write down another combination: increase the exposure one full stop, keeping the shutter speed constant and opening the lens the necessary amount. Write this down, give it back to your subject and make another exposure using this new combination (Figure 4-2).

Take the sheet of paper back and draw a line through this notation. This time you are going to decrease the exposure by one full stop under the original reading. Record this on the same sheet of paper, and make another exposure. (Figure 4-3).

You have just bracketed your exposures. For those of you who are really interested, you can bracket by half stops as far as you want to go in both directions.

You may be surprised to note that all the previous illustrations reproduced exactly the same, even though Figure 4-2 received twice the amount of light that Figure 4-1 received.[3]

Figure 4-2

ter speed. With this system, incident readings are not a major consideration.

Once the needle and target are lined up, note the aperture setting and write it down before making your exposure. Then, reset the ASA dial and repeat the procedure with as many variations as you want. After you have the processed film evaluated, you'll know the proper adjustment to make to obtain the optimum results with the specific film and camera tested.

There are some problems involved in getting accurate readings with these built-in systems. You must be

The Built-in Meter

The amount of work you must do when using a camera with a built-in meter or behind-the-lens meter is the same—if not more—than you must do if the camera doesn't have the light meter system built in. You also pay more for the built-in convenience than you would for a hand-held meter of a better grade.

When using a camera with a built-in meter, a setting for the ASA of the film used must be made. Then you set the shutter speed. Through the viewfinder of the camera you'll see a needle and a target. By turning the aperture ring, you line up the two. When this is done, theoretically, you'll have the correct aperture for the selected shutter speed. If they do not line up, you'll have to select a lower (or higher) shut-

[3]This is a matter of preparing a photograph for reproduction and will be discussed in detail in Chapter 19. At present, we are only interested in coordinating our equipment.

Figure 4-3

careful when shooting in backlit situations, in contrasty scenics, and into dark areas surrounded by brightness. You should also consider the possibility of error in reading due to leakage of light through the eyepiece. This can measurably affect results.

Although metering devices are accurate to within a full or half stop, it is desirable to take advantage of this variation and use an additional step in higher shutter speed or to stop the aperture down, thus increasing depth of field.

An advantage of this system is the ability to get the correct exposure quickly if the light intensity is shifting rapidly. For example, a person moving quickly from a sunlit area into a shaded area and then into the sunlight again. With the built-in meter system, you can make the necessary aperture adjustments without taking your eye away from the viewfinder.

Referring back to Figures 4-1, 4-2, and 4-3, note that these have reproduced nearly alike. The prints from which the engravings were made were very similar in their range of tones. The fact that similar results can be obtained from negatives receiving a variety of exposures is *latitude*.

If a contact strip is made of all three negatives, with the printing procedure calculated to obtain the best print from the negative that was exposed according to the meter reading, the strip would appear as in Figure 4-4. The first frame is good. The second frame is too light (remember that you increased the exposure for this one). The third frame is too dark: you decreased the amount of light registering on the film for this one.

Low-Level Testing

After you have performed the tests near the window, move your subject into the middle of the room or to an area where you have to switch to the low-level light measuring device on your meter and repeat the procedures as previously suggested. At this point another question arises. What is the slowest shutter speed you can control effectively?

An Alternative Method of Meter Testing Combined with Determining Your Slowest Effective Shutter Speed

If you have difficulty finding a subject that will sit still while you perform your tests, you can do it at your leisure with a calendar that has a picture on it. The picture is necessary to obtain a variety of tones with which you can evaluate your results. If you just

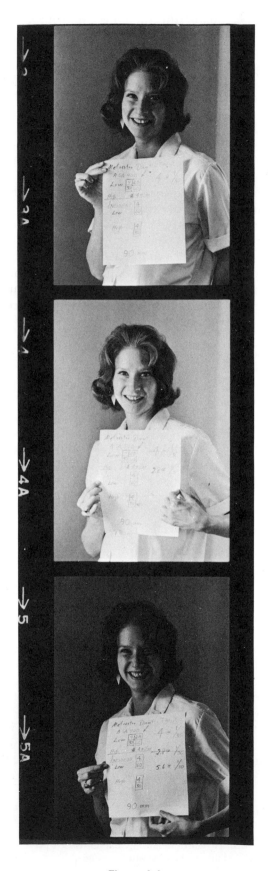

Figure 4-4

have the dates, you will have the two extremes of tonality—black and white.

Tack the calendar to a wall, with the level of illumination controlled so that you must use the low-level range on your meter, and take your readings as before.

This time you have a wide spread in meter readings. There is a difference of two stops, depending upon which method is used in taking the reading (incident or direct) and what area is read. You are not only testing your meter, you are also going to test your effectiveness at taking pictures with a 90 mm lens (a lens you must own to make portraits—formal or informal) at a variety of shutter speeds. See Figure 4-5.

You want to know *the slowest shutter speed you can control with differing focal length lenses.*

Meter Testing with Tungsten Light Source—Low Level

If you read the area with the large dates on the calendar, you will obtain a setting of 1/60 sec, with an

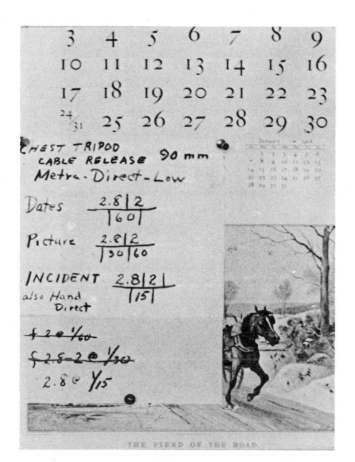

Figure 4-5

aperture halfway between *f*/2 and *f*/2.8. Write it down. Should you read the picture, your settings would be just about *f*/2.8 at 1/30 sec. This is approximately a half stop less than your first reading. You expect this because there is less white in this area to reflect the light falling on the calendar. An incident reading tells you that your settings should be halfway between *f*/2 and *f*/2.8 at 1/15 sec.

With all the information recorded on a sheet of paper (see Figure 4-6)—the lens used, the meter, all the readings, and how you are using the camera, that is, no tripod or chest tripod—you begin your exposures. Be certain that the sheet of paper is attached to the calendar. This is more effective than making notes on a separate sheet of paper or trying to remember what you did.

Keep the shutter speed constant at 1/60 sec, and decrease the aperture by half stops; see Figure 4-7a. You have bracketed your meter reading of the dates by half stops.

Determining Your Slowest Effective Shutter Speed

Begin[4] with a shutter speed of 1/60 sec. See Figure 4-7a. Keeping the lens opening constant, decrease the shutter speed to 1/30 sec, and make this exposure (see Figure 4-7b). Now cut the shutter speed to 1/15 sec, still keeping the lens opening constant (Figure 4-7c). You have just bracketed the meter reading of the picture area and have tested yourself at shutter speeds ranging from 1/60 sec to 1/15 sec with the 90mm lens.

You can go to slower speeds if you want to, but the limits are obvious from these tests when the camera is *hand held.*

Using a Chest Tripod with the 90mm Lens

With all the data recorded on the sheet which you tack to the calendar, begin testing your effectiveness at slow shutter speeds, this time using the table-top tripod as a chest tripod.

You could begin with 1/60 sec but this is satisfactory without the chest tripod. Instead, start with 1/30 sec (see Figure 4-8a). Then you expose at 1/15 sec (Figure 4-8b); and finally at ⅛ sec (Figure 4-8c). This series has bracketed the incident meter reading and tested your ability with the 90mm lens at shutter speeds of 1/30 sec to 1/8 sec, utilizing the chest tripod in reducing camera movement.

[4]You should first make one exposure with the camera on a tripod. This negative will be your yardstick against which all others will be evaluated.

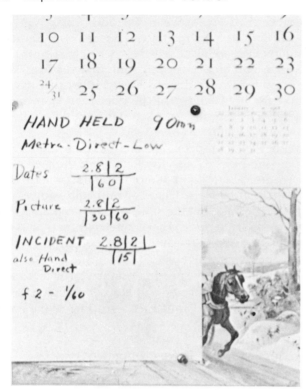

Figure 4-6

Figure 4-7a

Figure 4-7b

Processing the Film

Another variable that must be standardized to permit you to obtain maximum results is film processing. If you don't have the facilities to develop your own film, you should take advantage of a *custom* laboratory in your area.[5] If you do have the facilities to process your own film, you should follow the manufacturer's recommendations. He has tested more combinations of a specific film as to chemical combinations, time of development, temperatures of development, and dilutions than you can. You are also given a choice (it's on the instruction sheet that accompanies the chemicals) within their recommendations. You should select the one-shot developing method to standardize your individual style of development.

If you do not expose many rolls of film and you process your own film via the replenishment method, your results will vary depending on the age of the developer and whether or not you remember if you have replenished it. You have many variables to consider, so standardize as much as possible.

Figure 4-7c

[5]If you can't locate a custom laboratory in your immediate area, write to the Professional Photographers of America, 1090 Executive Way, Oak Leaf Commons, Des Plaines, Illinois 60018.

Figure 4-8a

Figure 4-8b

Figure 4-8c

Conclusions from Your Tests

Once you have had the processed film returned to you with or without prints, you will be able to correlate the information. If you don't know which is the best negative, have a professional or the personnel at the custom laboratory evaluate the negatives for you. They will be happy to assist you. If you belong to a camera club, ask the advice of a member whose opinion you value. As a last resort, try the sales personnel at camera shops; you can start at the store from which you purchased your equipment.

Figure 4-9 is a repetition for your convenience of the first tests we discussed. Your conclusions from examining the negatives should be that your "perfect"[6] exposure is a half stop less than indicated when reading direct, a combination of highlight and shadow, at a distance of 3 feet—keeping in mind that the source of light was daylight. If you are an "incident" reading photographer, you could conclude that you should use $1\frac{1}{2}$ stops less, if the meter is on low-level range. File this information in your head or paste it on the inside cover of your meter case.

The addition of the chest tripod permits you to employ, definitely, one slower stop in shutter speed and, in a pinch, maybe two. You also learn that the slowest shutter speed that you are capable of handling without the chest tripod, using the 90mm lens, is 1/30 sec.

All of these tests are made while you are standing. If you are really interested in what you can do under a variety of circumstances, you could test yourself while seated; with your back braced against a wall; with your back wedged between the corners of a wall; kneeling on one knee; kneeling on both knees; lying down on your stomach; or any of the other positions that you will assume at one time or another while working assignments.

An important consideration to remember is that these tests are made without the pressures present when actually working an assignment. Experience will give you the true answers about your maximum effectiveness.

Testing Your Optimum Efficiency with Other Lenses

Test yourself with your entire complement of lenses so that you will know the slowest shutter speed

[6]The "perfect" negative is one in which the shadow areas will reveal detail when printed and the highlights will not be blocked because of overdevelopment. The perfect or correct exposure is open for discussion when it comes to exposing color. Some art directors prefer differing degrees of color saturation, so it is wise to bracket your exposures by half stops.

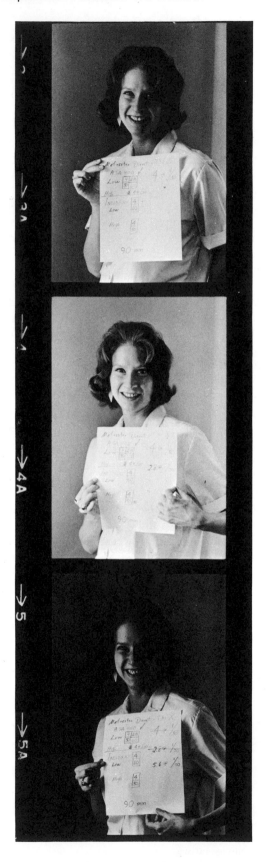

Figure 4-9

you can control with each lens. As you get to the slowest shutter speed you think you can control, try this several times. Draw your own conclusions from your tests as to the slowest shutter speed you can employ and get a picture suitable for reproduction by evaluating the enlargements of your negatives.

An enlargement of a section of the negative which you took hand held at 1/15 sec, compared with a similar exposure—but employing the chest tripod—gives you a valuable answer as to your capabilities with and without the chest tripod (Figure 4-10).

High-Level Testing

Take your camera to the beach on a bright, sunny day in the summer, or to the ski slopes in the winter. Following the same procedures as outlined in the previous tests, go through the entire process. Although most of your problems in photojournalistic assignments will be centered around low-level intensities, to know your equipment you should make the high-intensity light level tests.

Subject Movement

There are very few occasions when you will be strained in having your shutter speed set at $\frac{1}{4}$ sec. With an $f/2$ lens and the 35 mm lens, chest tripod, and cable release, the equivalent exposure of $f/4$ to $f/5.6$ at $\frac{1}{4}$ sec is between $f/2$ and $f/2.8$ at 1/15 sec. At these settings you know that you are quite capable of getting a picture that will be suitable for newspaper reproduction if using a chest tripod (see Figure 4-11).

Now all you have to worry about is subject movement.[7] The shutter speed that will stop varying speeds of movement of the subject varies with camera-to-subject distance. A good rule of thumb is to use the fastest shutter speed possible commensurate with depth of field needed in the particular circumstances in which you are operating. Of course, there may be times when you intentionally want "blurring" or movement to convey an idea, but this is another matter.

In Figure 4-12 you can readily observe that 1/15 sec is not sufficiently fast to stop action. Be patient. There will be a moment or two when the action of the subjects has dwindled to a near halt. If you are ready, you will seize this moment to operate your camera (Figure 4-13).

[7]An exposure table for moving objects, including directions of motion, is given in the *Leica Manual*, 14th ed., p. 141. There is a discussion of motion of subjects under varying circumstances on pp. 139–145.

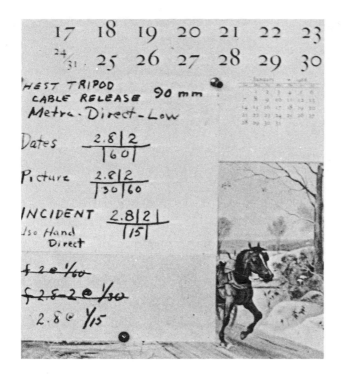

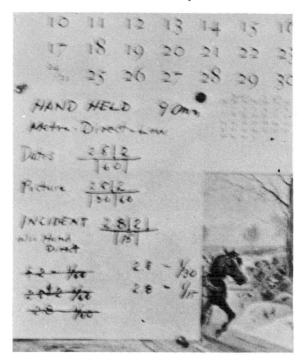

Figure 4-10

There will be times when you desire to get subject movement into your picture. Many photography publications have run articles on the intelligent use of subject movement. What shutter speed will record subject—or camera—movement?

Experience is your best answer; the rate of movement of your subject is a dominating factor. To get this experience, you should shoot a few pictures of various subjects moving at different rates of speed and at different angles. You might start with someone walking toward, across, and at a 45° angle to you. Start with 1/100 sec, then try 1/50 sec, and 1/10 sec. Then add to your experience by having your subject run.

Be certain that what you want to show in the photograph will be enhanced by having movement in it. An examination of the railing in Figure 4-14 proves that there is no camera movement, just subject wiggle. The camera was on a table-top tripod on the floor (exposure: 1/8 sec).

At the beginning of this chapter, the "grainiest" film was recommended for a "low grain" requirement. You now know why this "grainy" film was recommended: you need the high ASA rating because most of your available-light assignments will be at low-intensity light levels.

What about choosing a slower rated film which is finer grained? Now just double the development time or use a stronger (more concentrated) developer. If

you do, you will create grain, contrast, and sometimes chemical fog. Your results will be inferior with this finer grain film than the results obtained by using a grainier film, handled properly.

Beware of the braggart who states that he rates his

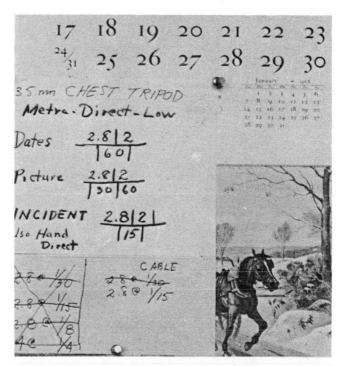

Figure 4-11

Figure 4-12

film at an ASA of 1600 or more.[8] You are after consistent results. And who tests his own product continually more than the manufacturer?

Just how good are the results for reproduction when you use the grainiest film (higher ASA rating) with the 35mm film, as compared with a larger film, which will give you better quality? Chapter 5 will amplify this question.

Basic Equipment for First Assignment

You have tested your equipment which consists of a camera body, a 35 mm wide-angle lens, and a 90mm lens. You have also employed an exposure meter, a

[8]See Evans, pp. 204–207 for a discussion of exposure and exposure calculation in a variety of ways, and a clarification of some mistaken ideas about latitudes of film. Also see *Leica Manual*, 14th ed., pp. 189–215.

large tripod, a table-top tripod (which you have converted into a chest tripod), and a cable release. *This is the minimum equipment you should own and know how to use if you hope to accomplish anything in the field of photojournalism.* If your avocation is photography, it is the minimum equipment you should aim for. Most cameras are sold with the 50 mm (normal) lens attached. The professional considers this lens a medium telephoto.

Why is a 90mm lens a must? Remember that your first assignment is going to be one of informal portraiture. Portraiture is best accomplished with lenses in the 85mm to 135mm range. A more pleasing perspective of your subject's features can be obtained with the longer focal lengths (see Chapter 5).

When you first approach a photo agency with your portfolio for possible employment, you will be asked to list the equipment you own. Do you fit into the following category?

Figure 4-13

Figure 4-14

" . . . each photographer is required to own one of the following types of cameras:

1. A 35mm camera with an *f*/2 lens or better.
2. A 2¼ × 2¼ camera with an *f*/3.5 lens or better.
3. A 4 × 5 camera with an *f*/4.5 lens or better.

Other required equipment consists of wide-angle or telephoto lenses for these cameras, tripods, exposure meters, light stands, film holders, filters, and lighting devices."[9]

Other than news photographers servicing the local dailies, I have yet to see an agency photographer working with fewer than two cameras around his neck, usually he has three. Today the demand for color is increasing so one camera is loaded with color and the other with black-and-white film. The third, when carried, is loaded with black-and-white film, if this is the basic coverage desired, but it has a different focal length lens.

If you are requested to answer the question about equipment you own, be prepared to offer the following.[10]

1. Two 35 mm bodies (three or four would be better).
2. 35 mm and 90 mm lenses of *f*/2 apertures (21mm and 135mm makes you more desirable).

[9]Arthur Rothstein, *Photojournalism* 2nd ed. (New York: American Photographic Book Publishing Company, Inc., 1965), pp. 174–175.

[10]If you live in a remote area, a 4 × 5 camera with flash may suffice, but if there is any competition in your locale, it is advisable to have the minimum equipment suggested.

3. A good exposure meter (maybe two).
4. An electronic flash unit.
5. Tripods.
6. One 2¼ square camera.
7. An enlarger capable of taking both negative sizes.

Although darkroom knowledge is not absolutely necessary, it will give a photographer a distinct advantage over those who don't know film processing and printing techniques.

The "fish-eye" lenses, sequence cameras, extremely long telephoto lenses, and other items of specialized equipment can be rented or are usually supplied by the pictorial magazines. Needless to say, whenever the specialized equipment is needed, the assignment goes to one of the staff photographers.

The depth of field required in the interior of a paper manufacturer's pressroom (Figure 4-15) demands a small aperture. With the camera (2¼ square) mounted on a tripod an exposure of 1 sec is triggered by a cable release. A sturdy tripod and the cable release eliminates any chance of camera movement.

When a large amount of detail is needed in an immense area, the larger format (larger than 35mm) is used. Familiarity and ownership of at least one 2¼ square camera will give you an edge over those photographers who do not have this.

DO	DON'T
. . . learn factors that control grain.	. . . push the ASA speed of your film.
. . . use fastest shutter speed possible.	. . . change from one film to another.
. . . stay with one film and one developer until you've mastered them.	. . . blame your equipment if you don't use it properly.
. . . get a good exposure meter.	
. . . test your meter with your equipment.	
. . . test your ability at slow shutter speeds with lenses of varying focal length.	

Figure 4-15

Chapter 5

Basic Equipment

In the previous chapter, you were told what your minimum equipment should be. Two 35 mm camera bodies were suggested. There is more than one reason for this suggestion. On some assignments, you might be requested to shoot some pictures in color and some in black and white. It would be quite inconvenient to change rolls of film every time action occurred that you wanted in color. There are also fast-moving assignments when you don't have time to change from one lens to another, say from a wide angle to a long focus. There is also the problem of what to do if one body needs repair. A neck strap may break, dropping the camera to the ground, or a tripod may be knocked over. It is reassuring to have another body along.

The 35 mm is not just more convenient than the other types. You can work with it under almost any conditions, from wading in the surf, to riding in subways. You can also work a 35 mm quite inconspicuously, when necessary. The controls are concentrated within a very small area and can be manipulated rapidly. This is extremely important when photographing a scene with shifting movements or when you are hopping about.

Another advantage of the 35 mm camera is its format, that of a compact rectangle. You may have trouble getting accustomed to "seeing" in a square composition.

Two Types of 35 mm Cameras

The 35 mm camera is basically divided into two types;[1] the rangefinder and the single-lens reflex, hereafter referred to as the SLR. Each has its own advantages and disadvantages. The rangefinder is much faster and more accurate in focusing. The SLR is better for composition and parallax, which is especially important in close-up work. In dim light situations the focusing can be more of a problem with the SLR than with the rangefinder.

There are several focusing systems in the SLR market. Even the men who use them can't agree which is the best system (split-image, multi-prism, or

[1]Any of the monthly photography magazines contain photographs of the variety of cameras, both 35 mm and 2¼ square, and so forth. Their virtues are extolled in the advertising. This author omits these pictures and refers you to your local camera shop or magazine.

focusing grid). Your personal ability and desire should be the determining factor if you decide to purchase this type of camera.

The Automated Camera

There is also the automated camera that does everything but push the button. Even this accessory is available. (Did you ever hear of time-lapse photography?)

The beginner in photography can get very satisfying pictures with this style of camera, without knowing the principles involved, or the corrections that the camera makes automatically for a given condition. You can get good pictures provided the light is coming over your shoulder so that no stray light will hit the delicate cells that operate the mechanisms. If this occurs, there will be no pictures.

Since the camera has been doing all the thinking for the operator, what would happen if there should be a malfunction or automation breakdown? If you decide to buy an automated camera, make sure that manual operation is built into the camera, and learn how to use it.

Buying a Camera

How do you select the camera for you, from more than 200 different brands and models? Buy the best you can afford.[2] At your camera shop try out some of the types that you are considering, and see if you are comfortable with the feel and operation. Perhaps you can take it out on a 5- or 10-day trial basis. The shop owner may let you borrow a used model of the type you are considering, but don't buy a used model. I have yet to find anyone trading in his camera unless he was unhappy with it. If you do buy a used camera or lens, be prepared to spend some money on repairing it. It will break down.

Minimum Lens Equipment

You are going to need at least two lenses for even a single body. In order to get a decent-sized image of

[2]Don't be misled into thinking that the purchase of a very expensive camera will improve your pictures. It will, but only as far as your individual ability to operate it is concerned.

the head, you'll need a focal length of 85 mm to 105 mm for the miniature camera.

The telephoto lens has the great advantage of being able to give you the dramatic impact close-up. It can give you selective focusing (see Figure 7-8) because of its extremely shallow depth of field. It can give you the collapsed perspective effect and also the depth of field that you want—if you know how to use it.

Modern 35 mm lens systems are designed for high speed and high resolution photography. Without getting into the study of optics, keep in mind that most optical aberrations are found in the bargain price lenses. A quality lens is costly to produce. Stay with the quality manufacturer in your purchase.

Your Workhorse in Portraits

The format required by photo editors (see Chapter 8) is long shot, medium, and close-up. If you get as close as possible with a 35 mm lens, Figure 5-1, notice how much of the subject is included. It isn't much of a close-up, even though the lens is 3 ft. 4 in. from the subject. This is really pushing the lens into the subject's face and certainly won't relax him. You'll almost be sitting on his lap. (If it were the subject illustrated, it might be a pleasant experience—but not photographically.) So for close-ups, rule out the 35 mm lens.

You have been advised not to purchase the normal lens—50 mm—with your camera body, but what size image would this focal length lens give you if you had one?

In Figure 5-2 you have the area covered by the 50 mm when you are 3 ft. 4 in. from the subject. Figure

Figure 5-2

5-3 shows the area of negative exposed if the 90 mm lens is used from the same distance.

You agree that a lens 3 ft. 4 in. from the subject's face is an imposition if he is aware that the picture is being taken. If you were 6 ft. from the subject and using the 90 mm lens you would get about the same film area as if you were using the normal 50 mm lens (Figure 5-4).

You can get the same results with a 90 mm lens as with a 50 mm lens but with greater advantages. This is true of the 85 mm to 105 mm range. This range of lenses is manufactured with apertures of $f/2$. You don't have to shove the barrel of the lens into the subject's face to get a close-up. You can work at a comfortable distance from him.

Figure 5-1

Figure 5-3

Figure 5-4

Figure 5-5

The 90 mm will not only do the work of the 50 mm but if your subject were engrossed in an activity, you could get a close-up with impact (Figure 5-7).

135 mm Lens

The other lens that is always mentioned for portraiture is the 135 mm. To get the same image size as illustrated in Figure 5-2, you would be about 8 ft. from the subject. This would again be an advantage in being able to work at a distance from the subject, but there are disadvantages as well. The 135 mm is manufactured at a maximum aperture of $f/2.8$. This one full stop less than $f/2$. In low-level light situations, this can mean a crucial difference. Camera movement is magnified nearly twice when the 135 mm lens is used instead of the 90 mm, and 3 times when compared to the 50 mm.

The Other Half: the 35 mm Wide-Angle Lens

Keeping your format in mind, the wide-angle lens is a necessity today. First, it is necessary in areas with limited space, where you will be working with your back against a wall, such as Figure 5-5, which was taken from an actual assignment. Second, the wide-angle lens has a wider flexibility in general news and photo essays. This lens is magnificent when you are shooting "from the hip," without critical focusing. With proper handling, you will not distort the image, although you can create an unusual, foreshortened, perspective effect if you desire.

You have seen that the 90 mm lens can do what the 50 mm lens can do and do it better. The 35 mm lens can do what the 50 mm lens cannot do. In low-level situations the camera movement is .7 that of the 50 mm lens.

In Figure 5-6 to keep your subject in focus and to get as much of the harp as possible in focus, you must use a small aperture. Your light meter indicates that at $f/16$, you need an exposure of $\frac{1}{2}$ sec. Your previous tests with the wide-angle lens (35 mm) abetted by the chest tripod, have given you confidence to take pictures at $\frac{1}{8}$ sec (Figure 4-8c). Referring to your meter, you see that with the given light conditions, $\frac{1}{8}$ sec calls for an aperture of $f/8$. This is within your ability.

Focus on the subject and note his distance (about 12 ft.) from the camera. Place this distance within the $f/8$ mark on the depth of field scale. Note the distance opposite $f/8$ at the other end of the scale. It is about 5 ft. Your camera is focused at 7 ft. Everything between 5 ft. and 12 ft. will be acceptably in focus. Make your picture.

If you can catch your subject in action, you are part way toward achieving a good picture (Figure 5-7). He will not be conscious of the camera, as his eye will be on the music or the conductor. The 90 mm permits you to get a close-up with impact, without smothering the subject.

In low-level light situations, the 50 mm ultrafast lenses won't be of much help because of their extremely shallow depth of field. Many photographers have these lenses—on their shelves. Most profession-

Figure 5-6

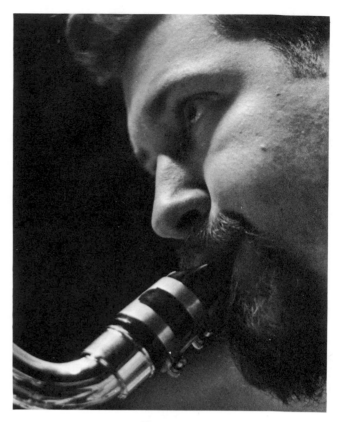

Figure 5-7

als use the normal 50 mm lens for medium telephoto use.

The usefulness of the wide-angle lens is aptly illustrated by Figure 5-8. The large depth of field, at maximum aperture, keeps both pianist Arthur Rubinstein and conductor Erich Leinsdorf in focus. These two artists, along with the other 104 members of the Boston Symphony Orchestra were recording Brahm's First Piano Concerto. Because of the noise inherent in the reflex camera, this type is ruled out. There are about 8 to 12 microphones around, and who would appreciate camera clicks in stereo or monaural?

How long you stay at this spot and how many exposures you make is your judgement. The recording artists, the producers, and the other technicians responsible for the recording are on edge. Don't push. Be inconspicuous. Shoot only during testing, rehearsal, or loud crescendo passages—then disappear.

Figure 5-9 appeared as a full-page advertisement in a national magazine. Compare the cropping by the art department with the original submission of the full negative. Since you are sent a "tear" sheet and information as to when the advertisement will appear, you add both to your portfolio.

If you could take only two lenses with you on an assignment, you should take the 35 mm (wide-angle) and the 90 mm. Always be ahead of your schedule, for reconnaissance if nothing else. Having tried out several spots through the viewfinder, the physical limitations of the building determined that this is the spot to make the picture you want, a long shot setting the scene. This picture (Figure 5-10) is valuable to the sound engineers; it shows the placement of the microphones. The 35 mm with its great depth of field keeps the picture sharp. The camera was mounted on a table tripod that, in turn, was placed on the edge of the balcony. The shutter was tripped via a cable release. Exposure: meter plus experience taught variation.

In Figure 5-11 in order to bring the soloist closer to you (getting a larger image), a telephoto has to be used. This shot was made from the balcony, using the 90 mm. From the action displayed by Leontyne Price of the Metropolitan Opera, it is evident that the music was at a crescendo or at least a fortissimo. You would not have dared to trip the shutter of your Leica unless the music had reached this pitch, lest the microphones pick up the click. An injudicious click might necessitate a retake. It is not only the cost involved in this, but this might have been just the take that was perfect.

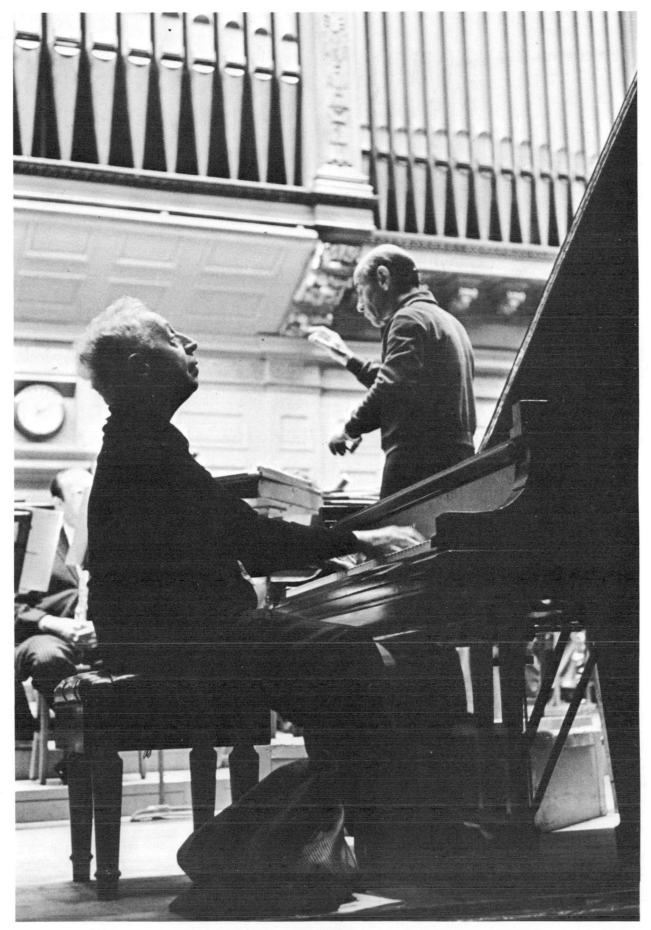

Figure 5-8

Artur Rubinstein's first stereo recording of Brahms' Concerto No. 1 in this splendid collaboration with the Boston Symphony under Leinsdorf is now available.

RCA VICTOR
The most trusted name in sound

Figure 5-9

For Figure 5-11 the camera was on a larger tripod, placed in position during one of the coffee breaks. This emphasizes the need for a second camera body.

When you are forced to shoot at slow shutter speeds, with the aperture wide open, the versatile wide-angle (35 mm) lens permits a sharper photograph than the 50 mm normal lens by minimizing camera shake. This is true whether the scene is illuminated by the headlights of a patrol car (Figure 5-12) or by a dim streetlight (Figure 5-13).

The 2¼ Square Camera

There are two basic types in the 2¼-square camera format: the SLR and the twin-lens reflex (hereafter referred to as the TLR).

There is only one advantage that the larger size camera has over the 35 mm. It has a larger negative area which means better quality.

The SLR in this size works just as well as in the 35 mm. There is no parallax problem, since the same lens is used for viewing and shooting. In the SLR type of camera the image is reflected by a mirror (in front of your film) upward through a prism where it is seen for focusing and composition. There is one problem. Although the image seen on the ground glass is right side up, it is reversed right for left by the mirror. In some models this error has been corrected.

There is another annoyance. Unless your camera has the instant return mirror, the image disappears from your view at the instant of exposure.

Twin Lens Reflex

The TLR has two separate lenses, one for viewing and focusing, the other for taking the picture. The upper lens is wide open at all times and is the focusing lens. The lower takes the picture and contains the shutter and diaphragm. Because the two lenses are some distance apart, there is a good chance of creating a parallax error in close-ups.

These cameras come with lenses of $f/2.8$ or less. They are bulkier and give you only 12 exposures per roll. The best known of these TLR cameras is the Rolleiflex. It does not have interchangeable lenses. A Swedish import, the Hasselblad, a SLR, is also very popular. This camera has separate backs, easily detached from the taking mechanisms. With the use of two backs, you can interchange your film, from black and white to color. It does have interchangeable lenses. This and the Bronica, a Japanese import, are very similar. Of the TLR's, only the Mamiyaflex has interchangeable lenses.

If you are going to work in an area where you need a quiet shutter, don't use the SLR camera. When working at recording sessions where microphones abound, SLR's are impossible. I would hesitate to use them in an operating room as well.

Rapidly fading from the scene is the 4 × 5 press camera. Since the daily newspapers have accepted available-light techniques and flash is dwindling, this camera is being retired. It is still being used for publicity pictures, where the public relations man has a limited budget and just requires a picture or two.

35 mm Compared with Larger Negative Areas

All the photographs in this book were made with a 35 mm camera unless otherwise noted. How do they stand up when they are reproduced? There are many factors involved in the reproduction of a photograph.

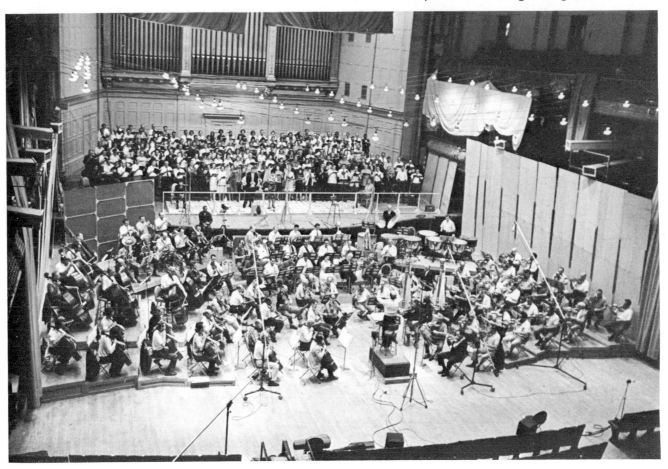

Figure 5-10

[3] Key considerations are the method of reproduction (letterpress, offset, or gravure), the type of printing paper used, and the number of lines per inch of the halftone screen. Our main concern is the quality of the original print.

If a print can be reproduced well in a newspaper, it can be assumed that it will reproduce better in any other medium. Metropolitan daily newspapers use a halftone screen of about 65 lines per inch. This is a coarse-screen halftone, to go along with the coarseness of pulp paper. Book publishers (text) generally use a screen of 133 lines. The finer the screen that is used, the greater emphasis that can be placed on detail. The print for newspaper reproduction should be contrastier than for the finer line reproducing methods.

[3]For those of you who care to know more about methods of reproducing photographs, and how an art director may want an illustration improved before he will accept it, read *Encyclopedia of Photography*, Vol. 16 (New York: Greystone Press, 1963), pp. 2993–3005.

Since you are interested in quality, you must know the answer to this question: Will the 35 mm negative give you all the quality needed, even for newspaper reproduction? Look at Figure 5-14 in which the photograph is reproduced on different line screens, and formulate your own answer.

Since the paper used in this book is better than the pulp used in a newspaper, the difference is made up by using a coarser screen in Figure 5-14a. This was used with a halftone screen of 35 lines per inch. Figure 5-14b is 65 lines per inch and Figure 5-14c is 133 lines per inch. The reproductions are the actual size of a single-column cut that would be used in a newspaper. Evidently, the answer to the question is *yes*.

Will the reproduction stand up if the head desired must be enlarged extensively? The answer is *yes* when the head size fills the negative area (Figure 5-14d).

Figure 5-15 is a contact print; Figure 5-16 is the same frame enlarged. In Figure 5-17 there are greater enlargements made to fill the space occupied by a single-column cut in a newspaper. Different line

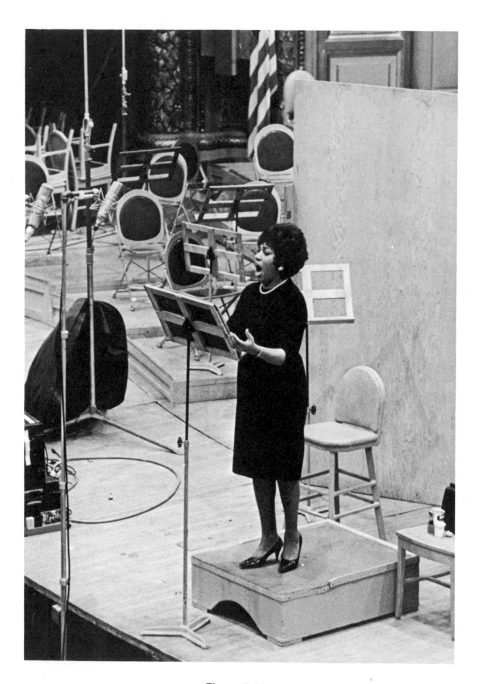

Figure 5-11

Figure 5-12

Figure 5-13

Figure 5-14d

Figure 5-14a

Figure 5-14b

Figure 5-14c

screens are used in their reproduction for you to observe and form your own conclusions.

The illustrations in Figure 5-17*a*, *b*, and *c* show the difference in quality of reproduction if 35-line, 65-line, or 133-line screens are used for printing.

This proves that the 35 mm negative will qualify for newspaper reproduction even if the original head size is fairly small (Figure 5-15). One factor is that the amount of grain caused by the degree of enlargement is not objectionable.

35 mm or 4 × 5

Assume that, by chance, you happened to be present at a scene that was being photographed for public relations coverage. The other cameraman was using a 4 × 5 format and flash equipment. The liaison man arranged the pose. The camera operator was able to make only two exposures with the flash technique[4] when the main subject said, "That's enough."

[4]Flash technique is covered in Chapter 14.

Figure 5-15

Figure 5-16

Figure 5-17*a*

Figure 5-17*b*

Figure 5-17*c*

In Figure 5-18 you see the full negative reproduced in 65-line screen. While the cameraman was making his 2 negatives, you easily made 6 exposures and could have made a dozen. Your exposures are reproduced in Figure 5-19.

Now let us enlarge the 4 × 5 negatives to the size that they would customarily occupy in a newspaper: a two-column cut. Do the same with frame 12 in Figure 5-19 and compare the results.

Figure 5-20 is the 4 × 5 negative enlarged to 5 × 7

and reproduced with a 65-line screen. Compare this with Figure 5-21 which was enlarged also to a 5 × 7 print using a 65-line screen and determine the differences and result. The photographs are made to a double-column size as the newspapers would use them.[5]

The exposures of the 35 mm strip, using Tri-X film, rated at an ASA of 400, were made at f/2, 1/30

[5]The slight difference in angle was due to my wish not to interfere with my colleague. The picture was his responsibility.

Figure 5-18

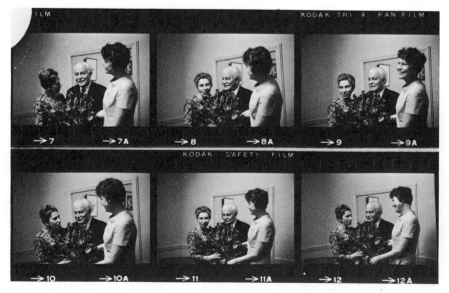

Figure 5-19

sec. Development was in Microdol X, diluted 1 : 3, just as the manufacturer recommends.

One Other Advantage of the 35 mm and Available Light

People are conditioned to thinking that only when a flash goes off is an exposure being made. They will usually "hold still" for two flashes. When you use available-light techniques, however, the subject has no idea as to the number of exposures being made, and you can shoot about 20 in the same time that it takes to make 2 flash shots. Each flash shot involves pulling the slide, taking the picture, replacing the slide, pulling out the plate (film holder), reinserting

it, pulling the slide again, and getting the subject's attention back after the first flash.

The advantage of the 4 × 5 flash is that the film can be processed quite rapidly (in a developer that takes 3 to 5 minutes), and printed wet. This makes for fast service

Comparison of 35 mm with 2¼ × 2¾ Format

You know that the quality of a print will be better from a larger negative. Just how many people can you squeeze into a 35 mm negative and have the quality acceptable for newspaper standards?

On a recent assignment, the 2¼ × 2¾ and the 35 mm were used for the same picture. Using the same Film (Tri-X) and the same exposure, both rolls were developed in the same tank simultaneously. From an examination of the results you can draw your own conclusions. Figure 5-22 is the contact print of the larger format; Figure 5-23 is the contact print of the 35 mm negative.

Both negatives were enlarged to 8 × 10—the standard size to submit for publication. Figures 5-24 and 5-25 show a section of each, reproduced with the same line screen. Can you tell which figure was made from the larger format negative?[6] The big question: Is the 35 mm quality acceptable?

Just what are the limits in the number of people that could be included in a 35 mm format? This depends upon a variety of factors. A picture that contained more than 2000 people was used as a record cover jacket (see Figure 11-20).

[6]Figure 5-25 was made with the 35 mm lens.

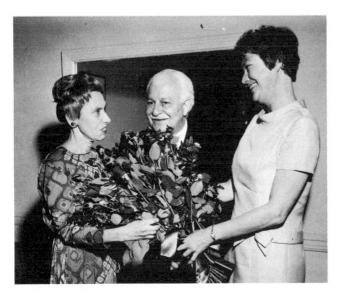

Figure 5-20

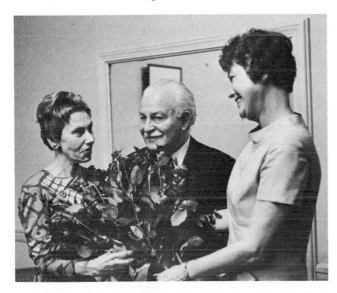

Figure 5-21

Figure 5-22

Figure 5-23

work?) The equipment we have suggested is basic; you will need these items time and time again.

Some time spent with such things as handling the equipment, manipulating the controls, changing lenses, proper setting and reading of your exposure meter, and filter factors, will save you valuable time when you are on assignment. No camera takes good pictures, it is up to the person who aims it. Good photographs demand practice and good taste. (When everything else fails, try reading the instructions.)

Accessories

If you should let your gaze wander in the direction of the display window of the well-stocked camera shop, you may be quite envious of all the accessories that are vying for your hard-earned money. If you should inquire of the salesman as to the purpose of any particular accessory, he'll need no further urging to extoll the virtues of the gadget. "This particular item will solve all your troubles in photography." Just what accessories do you really need assuming you have at least one camera body and two lenses.

A very good exposure meter should be your first purchase. A table-top tripod your next. Perhaps a sunshade, to protect your lens and to cut off the stray rays that might enter your lens, could be your next item. A UV filter that can be screwed into the lens barrel, will protect your lens. If you are going to do much color work, I suggest a Skylight filter that will warm up your transparency if you take pictures in the shade. If you are going to operate under fluorescent light indoors, you'll need Magenta color-compensating filters of magnitudes 10 and 20. The addition of a cable release will now complete your equipment to handle just about any circumstance you may encounter. How about a gadget bag to carry all your equipment?

As your experience expands, you'll find that there are certain accessories that you need. First, try to borrow the item from another professional or from a friend. If you can't borrow it, rent it. If you find that you can accomplish the job better with this item, and will use it frequently, buy it.

If you believe that you are going to need a flash gun, purchase an electronic one that will give you different levels of output. (See Chapter 14.) From a photojournalistic point of view, you'll need it only on rare occasions.

The type of picture in which you plan to specialize will determine the other accessories you may need. (Microphotography? underwater photography? copy

Renting Equipment

Chapter 4 lists the equipment that you should own. It is not necessary for you to have the "fish-eye" 180° lens nor the 400 or 280 mm telephotos. Occasionally you might decide, after discussing a forthcoming assignment, that one of these lenses would be most desirable for the coverage. The 400 mm and larger telephotos have maximum apertures of $f/5$. If this lens is going to be used outdoors and the level of illumination is high, there is no problem with exposure. Should the assignment be indoors, you have a problem. You aren't concerned about camera movement, for these lenses must be mounted on tripods. You are concerned with subject movement because of the slow shutter speeds necessitated because of the small aperture of the lens and the low level of illumination.

The TV Tape

The Boston Symphony Orchestra conducted an exchange of two of their personnel with two musicians of the Japanese Philharmonic. The educational TV channel in Boston planned to tape one of the POPS concerts, which would have the Japanese exchange musicians perform solos. Now you have the light! How will you take advantage of the situation?

The 400 mm lens will give you a close-up of Arthur Fiedler, the conductor. You intend to shoot color and hope that his recording company will purchase one for use as a cover. You rent the lens. The charge is $10.00 for the lens and adaptors, for 24 hours.

You arrive early and discuss with the TV operator, whose position you have selected to work from, the best way you can operate without disturbing or hindering his job. A previous discussion with the electricians gave you the Kelvin temperature of the light, so you know what kind of color film to use. It is color film balanced for 3200°K. You also bring along your

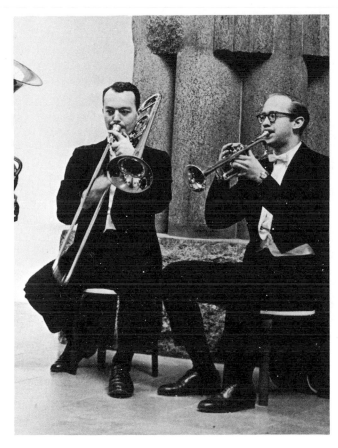

Figure 5-24

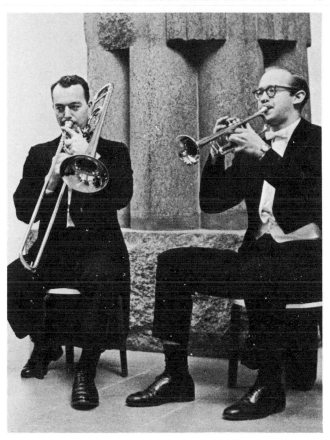

Figure 5-25

regular complement of lenses and bodies, and load one of these bodies with black and white film.[7]

The concert begins and you start taking pictures. You are about 50 ft. from the conductor and using the aperture wide open, your depth of field (acceptable area of sharpness) is about 12 in. (Your average is good when you get the negatives back. You have only to discard 50% of your transparencies. You do have enough to submit to the art editor of the company for which Mr. Fiedler records).

What About Black and White?

In the auditorium the level of intensity is high enough for you to use the black and white film, ASA

[7]You should carry 3 bodies at all times. For example, one is the all black model, loaded with black and white film; the other 2 are the regular models, but with different neck straps. The camera with a leather neck strap is loaded with high-speed daylight (when working in light of fluorescent emanation). The other camera has a snake chain, associated with "B" film (tungsten type), because the chain is silver Bright. In switching lenses back and forth, it is easy to forget which camera is loaded with which type of film. This is one answer to the problem, when working an assignment that presents the above difficulties.

400, at an aperture of $f/5.6$, 1/125 sec. With this setting, you have no difficulty in getting all the stage in focus when using the 35 mm lens. See Figure 5-26. You then attach this body to the rented 400 mm lens which is already mounted on a tripod. Figure 5-27 shows the area covered.[8]

With the longer telephoto lenses, 280 mm and up, there appears to be a new element introduced in the many variables pertaining to a photograph. The element introduced is referred to as "compression" or collapsed perspective. If you look at Figure 5-28, it doesn't seem possible that there is a distance of at least 15 ft. from the lower figure to the top violinist. Visually, they appear to be in the same plane, as though they were stacked one on top of the other, just as the children are in Figure 5-29.

In Figure 5-28 the photograph was made with the 400 mm and gives about the same perspective as the adjoining photograph which was made with the 50 mm lens. Here the children are truly stacked one on

[8]In Figure 18-9a,b,c,d, and e you can see the negative area that is covered by the 21, 35, 50, 90, and 135 mm lenses from the same subject-to-camera distance. These lenses should eventually be a part of your permanent equipment, as well as 3 camera bodies.

Figure 5-26

Figure 5-28

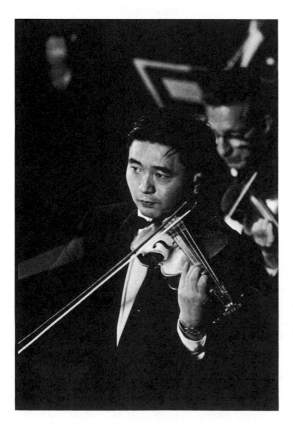

Figure 5-27

Figure 5-29

top of the other, yet the effect is similar to that of Figure 5-28.

Getting Practice for a Good Habit

Good, great, and offbeat pictures just happen and although Figure 5-30 does not fall into the category of "great," it demonstrates that a photojournalist should constantly be on the alert for "the" picture.

Following his performance, the violinist was presented with a bouquet of flowers. He bowed to the audience and on the way to his exit, he paused momentarily, took a flower out of the bouquet, and handed it to Mr. Fiedler. Later, the public relations man of the Boston Symphony, who was present at the concert, asked if the photographer had *seen* this incident. He replied as though he had been insulted, "See it? I photographed it."

If you are not prepared to catch the unusual, which always occurs without notice and is only a few seconds in duration, that particular moment will be forever lost photographically,

Every assignment should be covered by "saturation"[9] shooting. Your camera should be glued to your eye, your subject constantly observed and kept in focus until he is off the stage, or out of your view.

What do you do during the "breaks"? You look for pictures and sometimes if you look hard enough you'll find one. (See Figure 5-31.) It's not often that you have the 400 mm lens with you so, when you do, make pictures—for yourself.

It is not always necessary to fill the frame of your

[9]Saturation shooting is covered in Chapter 8.

negative with the image of your viewer. If you want to suggest that your subject is a philosophical, thoughtful individual, you can suggest this by using a somber light. In Figure 5-32, the intertwining branches hint at the variety of ways a thoughtful mind can travel. The dark cloud and the soft light are in keeping with the comment you want to make. Instead of using the 90 mm lens for portraits, use the wide-angle (35 mm) to keep all of the area in the picture sharp. The degree of detail in the subject can be controlled through the exposure and in the finished print.

Don't think that the 35 mm camera is the camera for all assignments. The quality it delivers will never equal the quality of the larger usable negative areas. For maximum quality, as demanded by photographs to be used in mechanical and/or engineering reproduction, the 35 mm, the $2\frac{1}{4}$ square, and the 4 × 5, will never equal the quality of the contact 8 × 10. In Figure 5-33 you aren't after artistry—but detail. (Photo courtesy of Fay Foto Service, Inc., Boston.)

DO	DON'T
. . . learn to handle automated cameras manually.	. . . depend exclusively on automation.
. . . get proper equipment: the 85 mm to 105 mm lenses are a must for portraiture.	. . . buy anything you won't use consistently.
. . . study instructions accompanying equipment.	. . . buy used equipment unless you intend to have it checked.
	. . . overload yourself with gadgets.

Figure 5-30

Figure 5-31

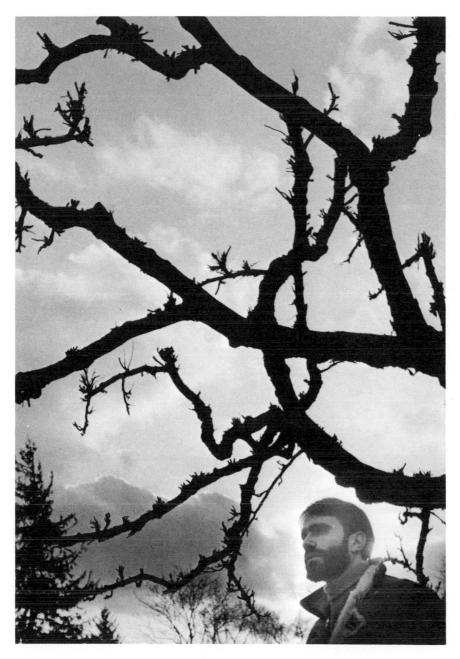

Figure 5-32

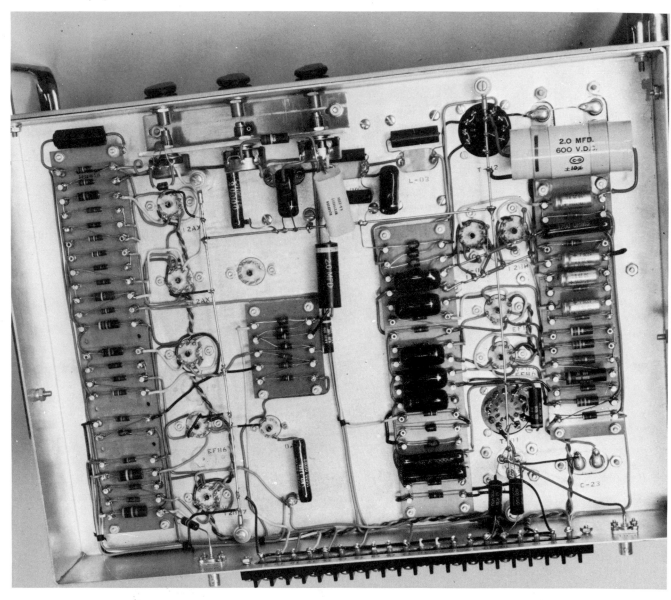

Figure 5-33

Chapter 6

Informal Portraiture: Unposed Posing

"Hold still!"

You can't say this any more. Not if you are going to fulfill the third point in the List of Requirements. Your editor is requesting animation, and you certainly won't get animation by asking your subject to "hold still."

Your camera is loaded, you have the confidence of your technical ability, you have been introduced to your subject, and he has confidence in you. He proves this by asking you, "What do you want me to do?"

You want a realistic, honest picture, so you say, "Just stay where you are and continue doing what you normally would be doing if I weren't here." He stays where he is and, for want of something better to do, looks at you while you begin to take pictures. You make one exposure and then you realize that without being told, *he is holding still*. This will never do.

You have noticed that there are several papers on his desk, a book or two, and other paraphernalia. To get animation, you ask him to leaf through the journal that you noticed and you start talking to him. Even if you tell him that what you are doing is merely a device to get him moving, that is a start. Try it—I promise that it will work. He will not be holding still. What you say as an opener and how you continue will depend upon a variety of factors—some you can't do anything about and some you can.

Relaxing Your Subject

It will help if you are an extrovert, a person who is active and expressive. An ability to converse, to engage in repartee, and to take the initiative, is essential. Draw your subject into a conversation, and you'll discover that he is no longer holding still. Some part of him is moving. He is either gesturing with his hands, adjusting his posture, or what is most important to your objective, his face is assuming a variety of expressions. This is just what you want, for you don't know just what emotion the editor wants for *his* picture. All you know is that you are getting a variety of animated pictures.

No matter how you slice it, the ability to converse is definitely correlated with your education—formal or informal. A liberal arts background will give you an enormous fund of knowledge that you can fall back upon, no matter what field of endeavor your subject is expert in. You will be able to ask a fairly intelligent question, just to get your subject talking.

If you have hit your subject at a sour moment, when he begrudges the time to you, be a diplomat. Agree with him in everything he says—while you are taking pictures. Now if you want a more fiery expression, stop being a diplomat and argue with him, but be certain that you don't change your tactics until the end of the sitting. The entire object of your psychology is to have your subject forget that he is having his expressions recorded. It is not an easy task but the onus of this falls upon you. Practice helps.

Seeing a Person

Photographing people is an art. It is an art in getting the best from the light and shadow available to you. This ability to employ light and shadow effectively is what gives impact to your photograph. The credibility of the photograph stems from the experience of the viewer but is not independent of your portrayal. What is a person's experience in "seeing" other people? He rarely sees them still, unless asleep. Therefore, animation should be a part of the picture.

The viewer's eyes are experienced in seeing people with a variety of light sources falling upon them. Usually there is one strong directional source (the sun, a lamp or other fixture) plus balancing (fill or reflecting) sources to lighten the shadows. The use of direct flash destroys this quality. Studio portraits can keep this quality of credibility, if the camera operator knows light.

We are also experienced in seeing the dress of other people. The view that we have of others in tuxedos or cocktail gowns or of little girls in pretty party dresses is infrequent. Thus, when we depict people in these garments, we depict the exception and not the rule. The exception destroys the credibility of the naturalness. A man in his working clothes or shirt sleeves is believable; a woman in sweater and skirt or in a daytime dress is believable; a child in a jersey or in playclothes is also more believable than one in a party dress.

We rarely see a person tense, certainly not in this era of tranquilizers. Most of the time our experience in viewing another person is in seeing him busy, engaged in an activity or just being himself. But in front

of a camera people do become tense, so the photographer must relax them.

Informal Portrait vs. Candid

Informal conveys the impression of being relaxed. Webster defines "candid" as (a) not prejudiced; unbiased; impartial; (b) honest, outspoken. This would be ideal reportage in either the written or the pictorial medium. The true candid depends upon circumstances and time. You need time to stalk your subject, and the subject has to be engrossed in an activity pertinent to the way in which the editor wants to present him. If your subject is really engrossed in a project, he is not necessarily relaxed—a surgeon performing a delicate operation is rarely depicted as relaxed.

No Desk Shots

Nine out of ten times your subject is seated at a desk when you enter his office. The other time he'll greet you at the door and then sit down at his desk. But there is a second part of Point No. 3 which reads "no desk shots."

Here is where you bring in your native visual ability for observation. While you are in the room you note the walls that are clear of any ornamentation. You also note the walls that hold plaques, paintings, and mementos. You notice the furnishings, those which would help your picture and those which would clutter it. You place all the information in your computer (head), push the button, and get the answer.

Now that you know where to put your subject, don't move him immediately. He is secure behind the desk so make a few exposures there, but very few. This beginning will remove a little fear that your subject has and will aid in getting him relaxed.

Along with noticing the arrangement in the room, you notice a few characteristics about your subject. Before you take the camera out, you notice that he cocks his head to the left; when he is thinking, before he answers the question you asked him, you notice that he purses his lips. You also notice what he does with his hands.

What Do I Do With My Hands?

If you observe a person for a few moments before operating the camera, you will find that he will give you the answer to the perennial question, "What shall I do with my hands?" Should he bring a hand to his face, bring this to his attention by telling him to "freeze." Then remark that he has assumed a very nice pose. Now make your adjustments: if his hand is covering his mouth, ask him to lower his hand. If his hand is indenting his features, ask him to just touch his fingers to his skin.

He will not feel self-conscious if you bring to his attention that he assumed this pose unconsciously and that it is characteristic of him. He would have felt self-conscious if you had attempted to pose him in this fashion without the foregoing comment. This is exactly what you have done, but under the specified circumstances, he accepts it. This is a fine line to draw but all you have to do is try it. It works.

Backgrounds

The subject of background study is the crux of a successful photograph. Every neophyte in photography is instructed not to pose people where lamps or trees will be growing out of their heads. This is the first lesson in composition that the novice receives. This lesson is not easily learned or retained. In Figure 6-1 you see the very common error of not seeing the tree growing out of the subject's head until the prints are viewed. This error is corrected as visual perception increases.

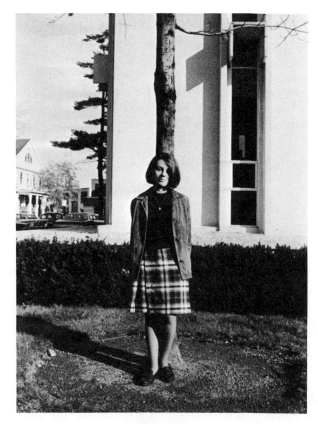

Figure 6-1

A distracting element at a distance behind the subject is not easily perceived. In Figure 6-2 the subject has moved forward. The tree is now in the background at a distance. Unfortunately for the photographer and the subject as well, the tree is still growing out of her head. It is more difficult to see the distraction when it is not close to the subject. Nevertheless, it is still there and the film will record it. The photographer must "see" every element in the scene that he will record before he pushes the button.

The greatest weakness of all beginners in photography is their failure to notice the background. A telephone pole, a tree, or any vertical (or horizontal) appendage, even though it may be 1000 ft. behind the subject, will be recorded when you trip the shutter. It will be just as disturbing to your picture as if it were 10 ft. behind your subject. When you have your subject properly framed in your viewfinder, take a second or two to look at the background, still through the viewfinder. Make certain that there will be no disturbing element in the background before you trip the shutter. To get the best possible picture of the young lady in this physical location, you must "see." You ask her to move to the spot you see and then compose (arrange the elements in the picture in a pleasing manner) your picture (see Figure 6-3).

Your subject now stands out because there are no disturbing elements in the background. She is framed

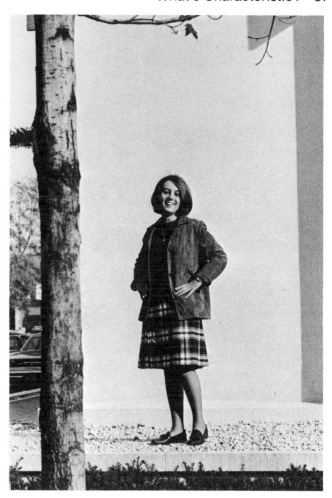

Figure 6-3

by the tree at the left; the shadow at the right balances it. The branch at the top of the picture balances the dark shrubbery at the bottom. Place a sheet of paper at the left edge of the tree trunk. It's now a better picture.

What's Characteristic?

The man in Figure 6-4 is a doctor whose specialty is anesthesiology: he administers the anaesthetic and also makes important observations while the patient is under sedation. What is the natural or characteristic situation for him to be in? What is believable and characteristic? That depends upon who you are.

How does the patient see her anesthetist? She doesn't see him: she is probably under some sedation before he enters the operating room.

How do his colleagues see him? In a variety of situations. How does his family see him? In a variety of situations also, but rarely in the dress of gown, cap, and mask. How shall you depict him?

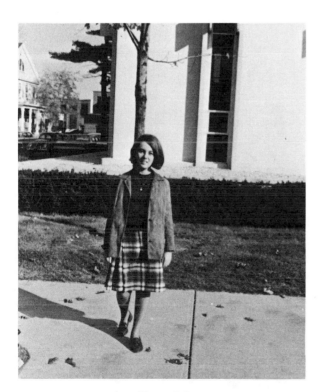

Figure 6-2

Figure 6-4

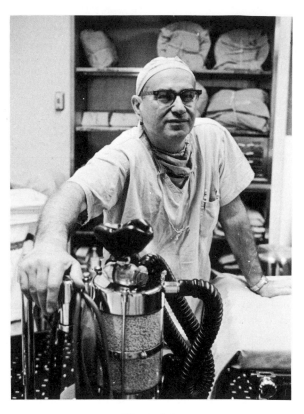

Figure 6-5

There are a few other questions before you can answer that one. In what type of publication is this picture going to be used? Who is the viewing audience? If you don't know the answers to the above, ask your liaison man. If you are working in a hospital— you have one; you'll need one to move freely about the areas in which you are working. Your liaison man will be someone from the public relations office. Be frank and discuss the situation with him. You should insist that your subject be photographed in two situations. The public relations department will then have on file their subject photographed both ways. Photograph the anesthesiologist in an area that the public will associate with him and in the clothes he normally wears while in this area (Figure 6-5). Then photograph him in his daytime clothes at a location where he wants to be. It is usually at a desk; but take heart, you have the first situation as well.

How about photographing him in action? Figure 6-6 is an action shot but the subject is wearing a mask.

Even though your orders are no desk shots, your subject will usually suggest that you start there (Figure 6-7). Do it, but *be sure* to get the others.

Each picture must tell a story. The viewer of the picture must associate what he sees with his experience. In Figure 6-8 you have your subject as he is. Who is he? How do you associate him? What business

is he in? We have no clues. The background tells us nothing. After studying Figures 6-9 through 6-15, see if you can tell the purpose of the photographs.

Figure 6-9 is a family scene. This photograph tells us a little bit about Mr. X. You could guess that this is

Figure 6-6

Figure 6-7

Figure 6-9

a picture of his family. What about the arrangement of the group? Did it happen or was it posed? It was definitely posed. The posing of even-numbered groups is not easy. It is easier to achieve a better balance with an odd number.

Are the expressions of all four people good? Was the photographer lucky? Was it the camera he used? Or was it his talent? It came about because the photographer was talented and lucky. He was talented because he didn't depend upon luck, but by taking at least 24 frames, he was able to get that lucky frame in which all subjects have a pleasant expression. (More

about the saturation method of shooting in Chapter 8.)

Here we have our subject (Figure 6-10) visiting—whom? His mother? His mother-in-law? No, he wouldn't be shaking hands with his mother-in-law. He has just been introduced to someone by his mother. Right? Wrong! Does the background give any clue? No? Yes?

Figure 6-8

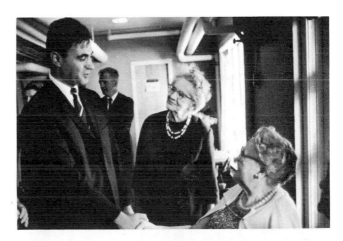

Figure 6-10

How about the next photograph (Figure 6-11)? Here he is shopping with—no, it isn't his wife (See figure 6-9). Even though the background says that he is in a supermarket, you can't be certain that he is shopping. Is he the manager asking a customer about

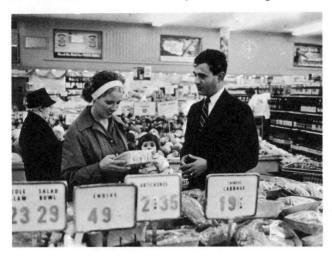

Figure 6-11

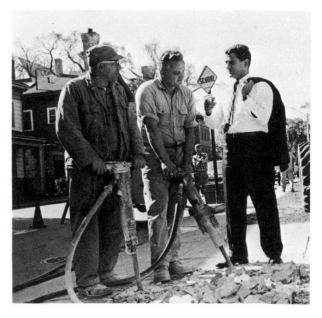

Figure 6-13

the product she is contemplating? You can't be certain yet!

What does the background tell us about our Mr. X now (see Figure 6-12)? Is he a teacher? Is he picking up his child? Is he daydreaming? Mr. X did go to this school. Just a word about the lighting in this one. It is an unbalanced backlight: the source is the sun. There is not much, if any, detail in Mr. X's face. Does this make it a poorer photograph than Figure 6-8 of Mr. X? Yes, if the purpose were to have a good portrait of him. Please hold off on your answer to this until the sequence is finished.

Figure 6-13 convinces you that the subject is an engineer. Would you believe a foreman? A union representative? The setting wants you to believe that he is associated with these men, but how?

Do you need another hint? If you add Figure 6-14 to the others, you'll understand all the previous pho-

tographs. If you had this photograph by itself, you would not have to guess who Mr. X is. You know that he is in politics. All the preceding pictures, except Figure 6-14, were employed in a political brochure to present an image to the voters. Does Figure 6-9 say that he is a family man? Incidentally, does this interpretation do the job better than having the family sitting on the sofa in the living room (see Figure 6-29)?

We know now that it isn't his mother-in-law he's shaking hands with in Figure 6-10. These are elders in the town, a group with which Mr. X is sincerely involved. And the shopping center (Figure 6-11)? Being a family man, he too is vitally interested in the rising cost of living. All in all, the pictures are intended to convey that our Mr. X is interested in all phases of the community—as a responsible public servant should be.

Now back to the silhouetted figure of our subject in Figure 6-12. When you are doing a photo essay, it is not necessary to have your subject recognizable in every detail in every picture. It could be his profile, as we have used; it could even be his back.

What about Point No. 3—no desk shots? In Figure 6-15, our subject was at the table which could be a desk, but the subject is standing and doing something.

The backgrounds are employed as symbols; they are chosen to tell us something about our subject. You should work extremely hard studying the background and foreground in relation to the picture about to be made, before tripping the shutter.

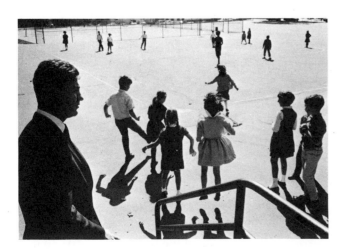

Figure 6-12

Figure 6-14

Groups

Add one more person to a picture and you have a group. If ever a camera operator can demonstrate that he knows anything at all about composition, it will be in the manner that he poses his groups. In Figure 6-16 is the all too prevalent presentation of a group. These six girls and one man could be the bowling team, the debating club, or any group whose picture is to accompany a release. An appropriate designation for this arrangement comes from the police department: the lineup.

Why is this arrangement poor? The individuals are easy to identify from left to right. But this posing wastes space. Because the individuals are spread out horizontally, occupying more space for the given number, the faces are necessarily smaller. It takes just a little thought to improve the presentation. And one bench, or two chairs, or your camera case (Figure 6-17). If there is nothing around, angle the subjects, have some kneel—improvise. Do anything to get the heads out of a straight line. This applies to the vertical as well as the horizontal line. If there is a man in the picture (as in Figure 6-16) have him put his hands in his pockets—anywhere—but not where they are in the illustration.

In Figure 6-18 you have eight girls. At least they are not in the lineup pose. If the three girls who are standing each took a half step to her right so that their bodies were between the heads of the seated girls, you would have improved the presentation.

Figure 6-15

Figure 6-16

Figure 6-19 is just one idea of improving the "impaneled jury" pose.

And now a word about obtaining expressions. Please don't tell your subjects, especially a group, to "relax." They want to, but you have to make them relax. How you accomplish this essential element—getting a pleasant or happy expression in a group—depends a great deal upon whether or not you are an extrovert. This is a matter of personality. Tell them a joke or fall back upon the standard cliches: "All together now, say sex."

Groups Allied with "Desk or Table Photographs"

Every organization has a committee of one sort or another; if it's not a committee, then it's a "board," or it's the trustees. Whatever it is called, it falls into the category of a group, photographically speaking. The group is usually seated around a table. And in Figure 6-20 you have fallen into the trap of having every individual's head in the same horizontal line. Again, you are wasting negative area as you did in Figure 6-16. Because you have the subjects spread out, you

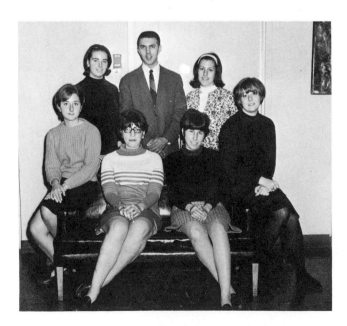

Figure 6-17

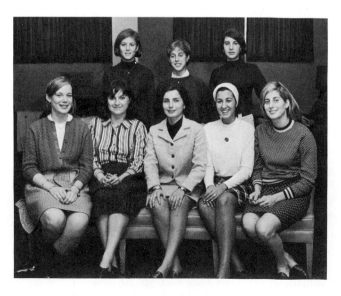

Figure 6-18

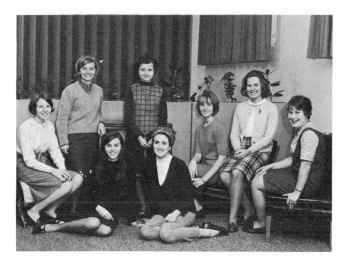

Figure 6-19

Figure 6-21

have to increase the distance of the camera from the subjects. As a result the head images are smaller than in Figure 6-21. If you refer to Point No. 3 in your bible, you see that you still have the group posed in appearance. To satisfy the editor you must get the group "not posed in appearance."

Suggest a definite action in which your subjects will become engaged. Ask the two gentlemen who are seated to talk about the weather, if nothing else comes to mind. The objective is to get their gaze away from the camera (Figure 6-22). Figure 6-22 would have been improved if there had been a fifth member. You could have used him to tighten the composition (see Figure 6-24). If you are saddled with the even-numbered group, do the best you can, and the next time, do even better.

An Odd-Numbered Group

When you walk in on a committee meeting to find your subjects seated in the horizontal pattern that you desire to avoid, don't be disheartened. Make a few exposures the way you find them. This is the honest representation and might be just the composition needed if a horizontal format is desired. When the members of the committee finally notice you, they will have had their fears of the camera alleviated by your unobtrusive operation. The psychology employed is the same you used in making your first photographs of the single subject. Remember the long shots to break the ice? Figure 6-23 comes across as more credible than Figure 6-21 because the former illustration is how the viewer expects a committee in

Figure 6-20

Figure 6-22

Figure 6-23

operation to really look. They have papers in front of them and are obviously unaware of the camera. But for publication purposes this composition poses a problem. There is a lot of wasted space. A suggestion to the two individuals on the extreme left and right (Figure 6-23) that they stand between the seated men and continue giving their attention to the business at hand results in Figure 6-24—a tighter composition, more suitable for reproduction from an editorial point of view. Because the utmost use is made of the negative area, the quality of the print will be better.

The 60-Second Picture

There will be times when you will have just 60 seconds in which to make a picture. The bigger the membership of a board or a group of trustees, the less time will be allotted to you. These men find it difficult to find time to meet in the first place, so you will have to be fast. You should arrive at the location and test several points of view *prior* to the time of the meeting. Of course, before the members file in, the

light intensity is measured and technical matters are decided upon: shutter speed and aperture. In this way, you can employ the few seconds given to you, in taking the picture.

To help you achieve the greatest area of sharpness in a picture of this type, find a means of getting elevation. In Figure 6-25 a ladder was placed in position 15 minutes before the scheduled appearance of the board. From a position on top of the ladder, the camera was focused on the single figure at the head of the table. This distance is noted on the engraved lens mount. Focus on the nearest chair and note the distance. The furthest distance is then aligned with one of the aperture marks on the depth of field scale, and the near distance is viewed to see if it falls within the corresponding aperture mark on the other side of the focus mark. If it doesn't, you will have to select an aperture that will have both distances in focus. This might necessitate the selection of a slower shutter speed. Before the group enters, pull the chairs away from the table at varying distances, so that all the members' faces will be visible.

If you have time, "shoot it as you see it." Not all your viewpoints necessarily have to be made from either eye-level or ladder-level. Place the camera on the table and pretend you are loading film while your subjects are engaged. In this case you made the "shoot it as you see it" picture (Figure 6-26) before taking the bread-and-butter views. Naturally you need the lens equipment for this point of view: a 21 mm wide angle.

A Last Word about Groups

While building your experience to become a photojournalist, you will get a few calls from relatives or friends who want a family group. It may be your luck that the group to be photographed is an even-num-

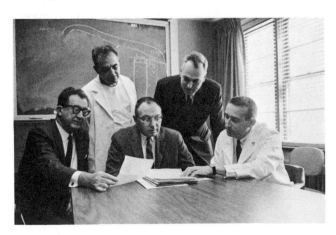

Figure 6-24

Figure 6-25

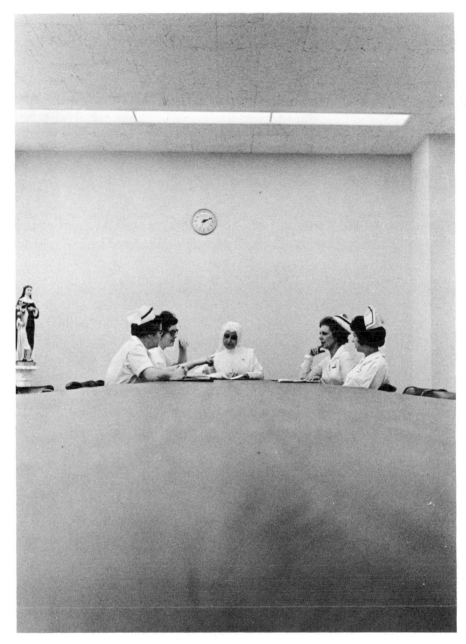

Figure 6-26

bered one. On location you look around for back-grounds and find an unobtrusive bay, medium in tone. This is your background; there is nothing distracting. You begin your posing (composition of the group) by getting the piano bench on which you seat the two young ladies. Father is easy to place: you put him directly behind and *between* his two daughters. They are now in the triangular compositional form. Mother is seated with junior beside her. So far so good. Brother is asked to stand between mother and sister. You ask both girls to cross their right ankles over their left, and mother her left ankle over her

right. The arrangement is now complete (see Figure 6-27). You take the picture, but something is wrong. There is an empty space to the left.

You have an answer. Looking around the room, you see a table with a vase of flowers on it. You place it in the empty space and think how clever you are to add something from the house to balance your composition (Figure 6-28).

There are other ways to balance the composition of this group. You could shift junior from his perch beside his mother and place him beside his sisters (see Figure 6-30). This will achieve the balance that you

Figure 6-27

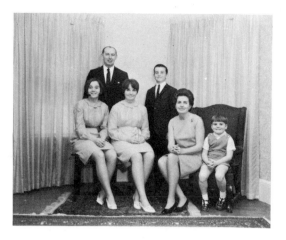

Figure 6-29

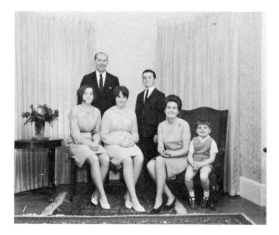

Figure 6-28

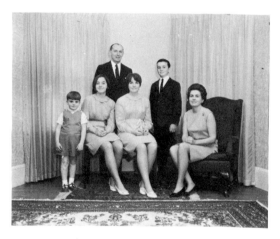

Figure 6-30

are looking for. By having the two people at the extremities of a grouping smaller or lower than the rest of the group, you get a composition that falls into the triangular classification. This is pleasing because all the elements within the frame of your photograph are balanced. Now, employ the saturation method, at least 6 exposures (Figure 6-31). You made at least 6 exposures with the vase, didn't you? From your contact sheets, you eliminate those in which a member of the family has his eyes closed, or is grimacing, and enlarge the rest for presentation.

Minimum Requirement for Composition

The visual ability for observation can be inherent or learned. The minimum requirement you must possess in this area is the ability to coordinate what-

ever is going to appear in the background and foreground of your negatives. You must be able to select points of view which will eliminate distracting elements. Intelligent elimination is just as important as what is included.

DO	DON'T
. . . spend time observing your subject before taking pictures.	. . . ever say "hold it."
	. . . ever say "relax."
	. . . ever say "smile."
. . . get a conversation going.	. . . make all your pictures with the subjects looking at the camera.
. . . note foregrounds and backgrounds.	
. . . eliminate clutter from your pictures.	

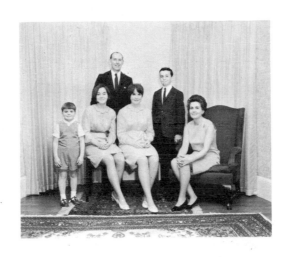

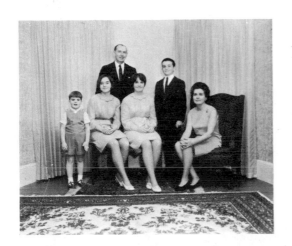

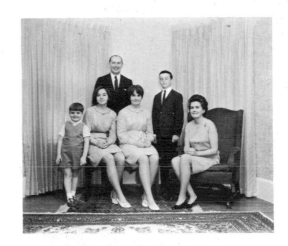

Figure 6-31

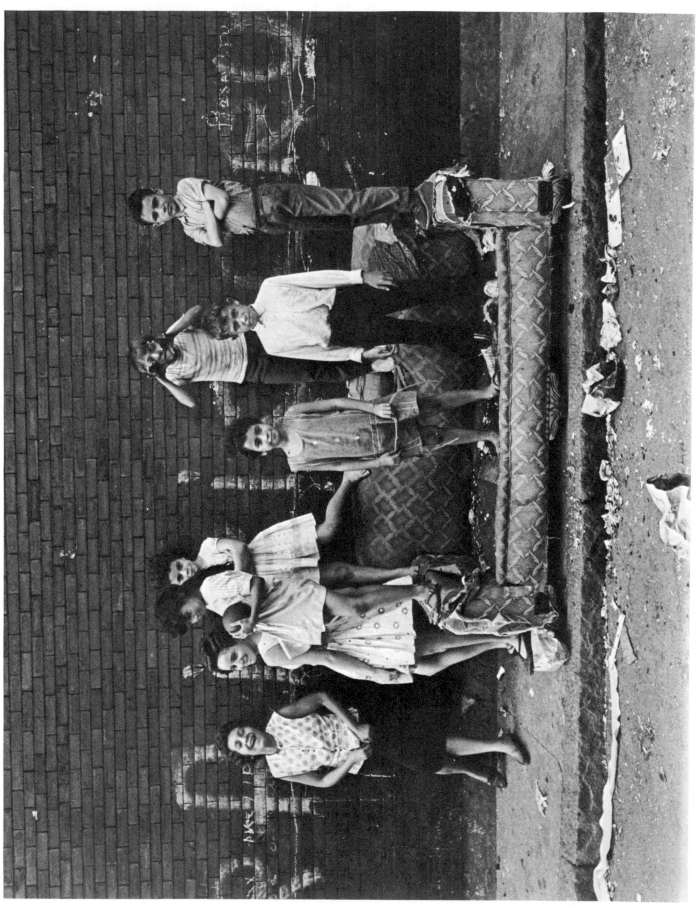

Figure 6-32 Sometimes your groups will arrange themselves on a sofa.

Figure 6-33

Now that you know the rule about placing the shorter people in a group at the ends, you can break the rule—but knowingly. The two older girls in Figure 6-33 seem to be the way of keeping this arrangement best. The ruins of the wall provide a frame which abets breaking the generalization. The sexes of the subjects play a part in the decision as well: the boys are kept together and are "framed" by the girls.

Chapter 7

Composition: Shoot It As You See It

And now, Point No. 5 in our bible: "As long as we receive the pictures required, we encourage photographers to shoot situations the way they see them . . ." There are two elements that the photographer must consider in the above statement. First in importance, is to make certain that the agents get what they asked for. Once this is done, you can let your creativity shoot it as you see it.

If you want a second call from your agency, you'll give them what they asked for. What have they asked for? "A well-lit, animated picture with a variety of expressions." What this means has been discussed in detail in the previous chapters. The new ingredient is seeing. What is "seeing"?

Figure 7-2

Figure 7-1

You should, first, "see" the light direction. This element has already been discussed. Now, look at Figure 7-1. You should see the disturbing figures in the background near the subject's head. You should see them in sufficient time to make the picture without the distracting elements. You should see the deportment of the children. Are they passive? Are they active? Seeing this before you take a picture would be ideal. Is it asking too much that you see this before you cease taking pictures?

Is the picture improved by paying attention to background detail in Figure 7-2? If you can't give direction to the elements you want eliminated (the distractions near the head), you must wait. In case the action is over before the composition takes the form that you would like, you should expose several frames

to insure some pictures, keeping in mind the rest of Point No. 5: "because of the physical setup the photographer might not be able to get what they (and you) want."

Giving Direction

Who is featured in Figure 7-3? It should be the man second from the right. Is he featured? How would you correct it if you aren't satisfied?

The man at his right shoulder fights with your main subject for interest. He is higher. If you eliminate him from this position, you strengthen the indi-

Figure 7-3

70

vidual you want featured (see Figure 7-4). Now your subject is the dominating figure in the group.

Figure 7-4

Attention to background and foreground for distracting elements and the intelligent elimination of these distractions would be the minimum requirement in composition before you begin compiling a portfolio.

Framing

If there is one element that can raise the ordinary snapshot into the realm of art, it is framing. The concept of framing is inseparable from the criteria used in evaluating a photograph. The ability to frame a picture is synonymous with "seeing." You must see the frame before you can use it. The frame can be very obvious or it can be subtle. It can apply to an aesthetic subject or to one that is mundane. The frame holds the viewer's eye where the photographer wants it held: on the significant. The frame helps isolate the point of interest and it does this by the intelligent elimination of distracting elements.

Frames are everywhere: portholes, trees, shrubbery, shadows, fences, parts of the anatomy, and parts of machinery. All you have to do is "see" them. You use the frame with a purpose; you must establish a meaningful relationship between the frame and the subject material that is framed. The frame is effective in direct relationship to the photographer's ability to "see." This "seeing" is more than a visual aptitude; to be truly creative it must contain the photographer's empathy.

The assignment: a picture of the man in Figure 7-5 working. He is an actuarian for a life insurance company. This medium shot (Figure 7-5) was used in the company's brochure; and this picture includes the setting.

Figure 7-5

The major tools of this man's job are a pencil and computing machine. How do you know this? Either through your own education or from asking questions. Can you see any more pictures? Any pictures or ideas that have not been suggested to you by the art director?

"Seeing" means work. You have to work at looking. Take a closer look at one of this man's tools: the pencil in his hand. This time you switch from the wide-angle lens to the 90 mm to get a close-up (Figure 7-6).

Figure 7-6

Your format is still operating: long, medium, and close-up shots.

Does this tell a story when used in association with the other picture? It does. Can you tell it better? You can. How? By framing that gives impact to a picture that photo editors want. Figure 7-7 contains two frames. The first is obvious: the actuarian's left hand. The second is selective focusing. The thumb and forefinger holding the pencil are sharply defined, while the foreground is out of focus. Selective focusing is another way of concentrating the viewer's attention upon what you want to be significant in the picture. Sometimes you "see" it as in Figure 7-8 — *selective focusing* and sometimes as in Figure 7-9. It depends on the background, foreground, and how you decide to make *your* visual comment.

Once you put the viewfinder to your eye, you are going to extend your vision. You are going to "see" what you have never taken the time to see. You are already seeing more than you have before. You now see light direction, light quality, and intensity. Hopefully, you are seeing the background in more detail than before.

You begin with framing. This needs an extension. The frame that you select can be in the vertical or horizontal format. The format you choose will have a definite effect on the viewer's response. Because every individual is unique in his experiences and because the response is based upon the individual's experiences, it is easy to conclude that there is going to be a divergence in the responses. There will be different meanings and perhaps different values assigned to a specific photograph by different individuals. Yet, these differences are valid: they are valid for each individual.

Shape of Picture Space

Along with the differences there are similarities. In our society we all nap and sleep in a horizontal posi-

Figure 7-7

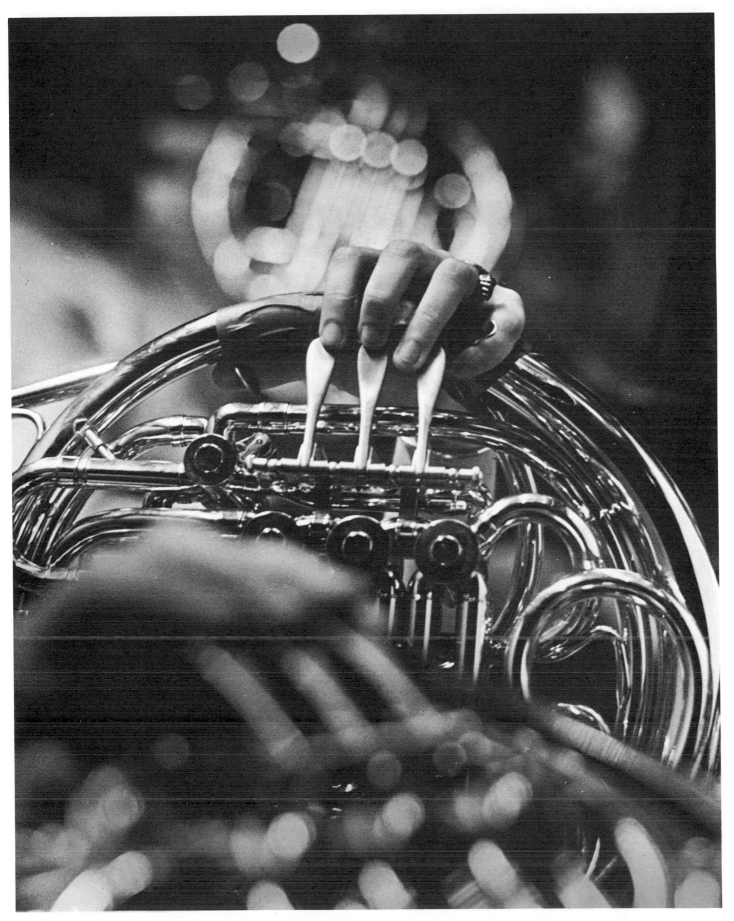

Figure 7-8 Selective Focusing.

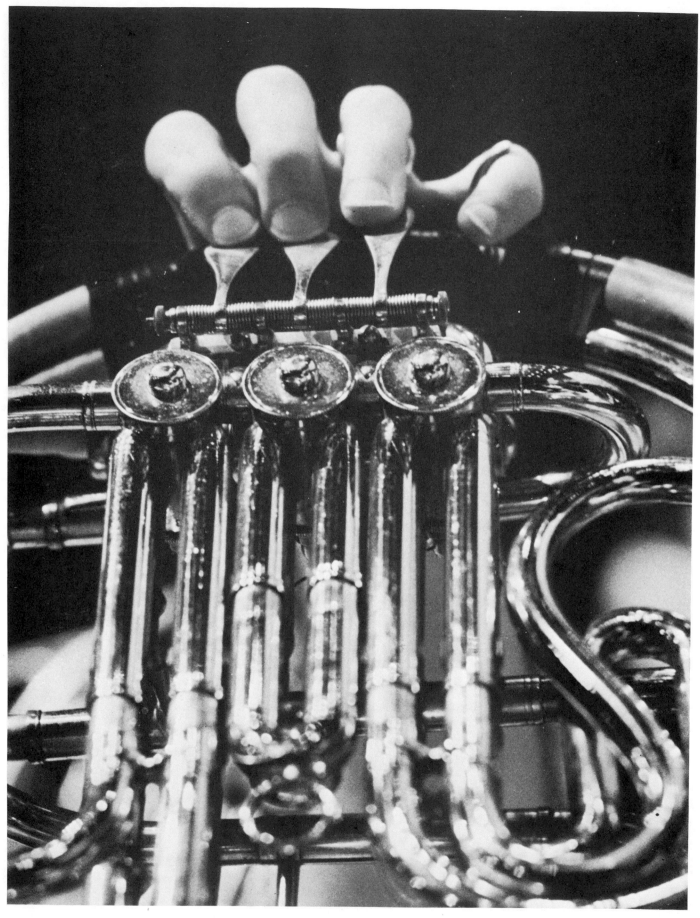

Figure 7-9

tion. But there are those who can do this sitting up and even standing: they are the exceptions. You should not be surprised to discover that photographers, as well as artists, employ the horizontal format when they want to convey the idea of a restful, peaceful, or quiet scene.

Before continuing with an examination of the emotional states that the lines within our format will induce in the viewer, you must learn that all the compositional elements in your picture will be in relation to the margins and shape of your picture space.

If you are asked to think of vertical objects, among the list would be trees, poles, monuments, and buildings. In general, vertical lines within a format tend to induce the emotional idea of strength: an inspiring or elevating feeling.

Lines that are diagonal within your margin space tend to create the feeling of action: there is stress and strain present. Curving lines, like a river, induce the idea of fluidity, grace, and femininity.

It is the intelligent employment of these lines within the shape of your picture space that makes or breaks the composition of your photograph.

A Few Additional Tips

Horizon lines play an important part in creating a mood for the viewer. If the horizon is in the middle, he tends to view this with less interest than if it were in the upper or lower third of the picture. An extremely low or high horizon line will create a strong illusion of picture depth.

If motion is depicted in a picture—and looking can be motion—it should be intelligently related to the picture space. If a man is running toward a place, give the runner some space to run into.

You should look at your photographs upside down. It becomes easier to see and evaluate the abstract quality of an object when this is done. Upside down, the various objects in the picture are dematerialized and the unbalanced portions of the picture are more readily noticed.

The above comments are not intended to be taken as rules of composition, but rather as aids to help you, as photographers, see just a little deeper. A lack of imagination and personality can never be replaced by any arbitrary set of rules of composition. Like the camera and its accessories, rules of composition will not perform by themselves.

Point of View

It is just as important to select a point of view 1 or 2 ft. away from you, as it is to choose a radical one.

When you see a picture that might vanish in an instant, grab it. Figure 7-10 is the grab. If you have time and if you can "see" a better composition, grab that. The violinist, in relation to the chairs and music stand (Figure 7-11), makes for a better arrangement. You didn't touch a thing. You just selected a better point of view.

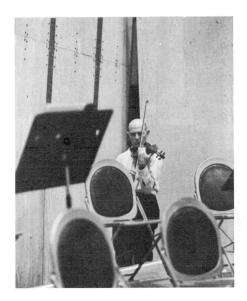

Figure 7-10

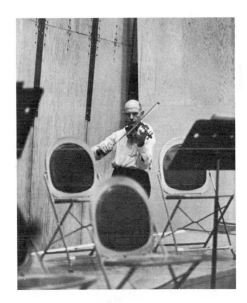

Figure 7-11

There will be times when you can get an unusual point of view. Figure 7-12 required a long climb of 4 stories. It was worth it: this picture was used as the cover for a percussion text. The 90 mm lens was used on all 3 photographs.

Figure 7-12

Are You Creative?

All definitions of creativity include the production of something new (to the individual or to the culture) as a factor. It will be safe to assume that you are creative. It is the degree of creativity that will be under discussion.

The desire to create stems from within the individual. It is a need that he has. He has to break away from the commonplace and the conformity of society. This breaking away can be for good or for bad. When it is for the good, it tends to be creative.

Creativity is definitely related to Point No. 5: "Shoot it as you see it." If you can take the familiar or the commonplace and make it appear in a new light, you are being creative. If you have made the familiar different from the average, you are more creative than the average.

Another Ingredient

Imagination is the stuff that dreams are made of. And it is this ingredient that will let you rise higher in creativity—all other factors being equal. A visual image conjured up by the mind is the first step in one's creativity.

You enter a home for the purpose of photographing a child. While you intend to make staple pictures ($\frac{3}{4}$ views and close-ups of the child), your eye searches

the area for backgrounds and settings which might give you an unusual picture. A large window catches your eye. *In your mind* you create a picture: the small child contrasted with the big window. Before placing the child on the settee, you want to choose your angle for the best available composition and to take advantage of the best source of light direction.

Through the viewfinder of your camera you examine a head-on angle—from an eye-level position and again from a kneeling position. You reject this point of view because of the direction of the light: you would be shooting directly into the source of illumination, a direction you don't want for the picture in your mind. You begin ascending the stairway, examining the setting as you go. You visualize the completed picture: the child seated on the settee, her diminutive figure dwarfed by the large, unique window in this austere setting.

From the lenses you have brought, you select the 35 mm: this will let you include the portions of tapestry, window, wall, and balustrade you want. Once you are in position, you request the mother to place her child upon the seat and to give her a large picture-book. You have attended to the technical matters (aperture and shutter settings) before giving these directions to the mother.

As soon as the mother is out of your viewfinder, you begin operating the camera via the saturation method. You are lucky and are able to get off 3 shots before the child drops the book and toddles after the security of her mother. You have created this picture (Figure 7-13) in terms of light direction, subject matter, and composition.

In Figure 7-14 the photographer "saw" a good picture. It already existed—he didn't create it in terms of light direction or subject matter. He created it only in terms of composition. But—he has the technical background to draw upon so that he can take advantage of a situation and record (or in this case "abstract") a view that universally says "baby."

Extending Your Vision

You accept the statement that you are creative—at least to a degree. The problem is to raise the temperature. How do you expand your basic talent? Because photography is an art, like any other art, the performance will increase as you practice. It is as simple as that. Take pictures, study them, and have them evaluated. Take more and more pictures. (Suggestions about where you can get evaluations were discussed in Chapter 2.)

To broaden your experience look at subject matter you don't like. Don't abandon your personal tastes

Figure 7-13

and standards, nor meekly accept the verdict of judges, critics, or teachers, but give them a fair chance.

Study the work of others. The illustrations of the most creative men in photography are published in the fashion magazines. If you see a photograph that particularly impresses you, make this your starting point. See the light direction that was employed. Look for the quality of light—soft or harsh. Try to visualize what the result would be if the camera angle (point of view) were changed. Plan how you will take a similar portrait of your subject. You may decide to do it differently. Great. Go ahead. But first, you must have mastered the technical aspects of your art.

Figure 7-15 is a recently published picture of a violinist. You decide that you want to take a picture of a violinist. Where would you begin practicing? You could begin at home (Figure 7-16) in a setting where a group gets together for a bit of fun. (Lens: 21 mm Super Angulon; shutter speed: 1/25 sec; aperture:

Figure 7-14

Figure 7-15

f/4.) Slip on your telephoto lens and start to make pictures of the violinist.

After you have made a few frames such as Figure 7-17 you remember that backlighting is more dramatic. You shift your position because you can't change the direction of the light source and you don't want to disturb your subject. This and the following pictures (Figures 7-18 and 7-19) were made with the 135 mm lens. When you see the results you aren't surprised that the back-lit source is more effective.

Now, are you ready to make the picture for the national magazine? No. Go to a civic group and start the procedure over again. If the civic group is too difficult to get into, try the local school orchestras. If you try, you'll find an orchestra that will let you work by the available-light techniques.

You'll not only learn how to photograph a violinist, but you'll pick up some of the badly needed experience in how to conduct yourself when you are photographing a musician in an orchestra. For example, don't obscure the conductor from a musician's view (Figure 7-20). Add to this vital knowledge the lessons you learned about getting permission to photograph during a rehearsal, and you might be ready for an assignment from a news magazine.

It might have occurred to you that some of the pictures produced in obtaining the technique and know-how of photographing the concert-master are supe-

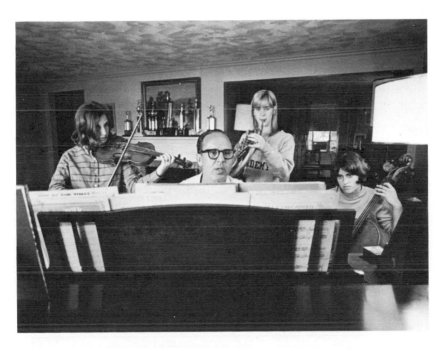

Figure 7-16 Begin practicing at home.

Figure 7-17

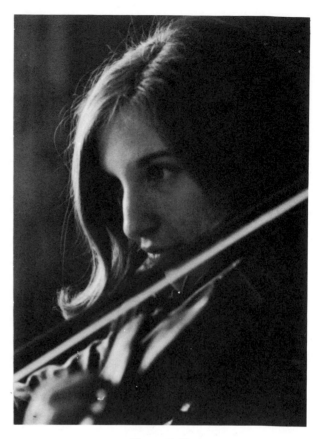

Figure 7-18

rior to the one that appeared in the magazine. Let me remind you that the same man made all the photographs. The editors of the magazine knew that the photographer could produce the photograph they needed, before he was given the assignment. Why, you might ask, does the picture published lack the artistry of the others? A fair question. You may remember Point No. 5: The physical background and other conditions[1] do not always permit the photographer to exercise his talent.

Additional Practice

Practice! After you have had several sessions with the local civic group, you become a photo editor yourself. You select about a dozen of the best shots of your shooting, and enlarge these to 5 × 7 (8 × 10 would be more impressive). Your selection for submission should contain, at a minimum, three views of the long shot: one from the left, one from the right, and one from—in this case—the stage. A medium grouping should also be submitted. One should show the

strings, another the brass, the percussion, and/or woodwinds—all as sections. Include three or four close-ups showing the faces of the players, as well as the hands, single instruments, or "abstractions," if you have captured them. Be certain to get the identifications of the individuals who are identifiable.

With this material and perhaps a news release written by the public relations department of the sponsoring organization, you head for the newspaper of your choice. It might be published (Figure 7-21), but even if it isn't, you will get constructive criticism and make an important contact.

While you are working with the local groups, building your experience, you will be exercising more than just your technical ability. There are going to be moments when you must refrain from taking pictures of what you are mainly after and have to do with what is within camera range. Your eye will be trained to look for pictures. Pictures are there, all you have to do is "see" them.

It won't be just the violin section that you'll see; you'll see other instrumentalists as well (Figure 7-22). And intermission time? Do you take a break with the other players? Extending your vision is work: so work!

[1]Men and women whose photographs are needed for publication have very busy schedules. The time they have available is very brief. It is not easy to get the artistic or interpretive picture the editor and you want if you are given 5 to 7 minutes to take the pictures.

You'll see amusing pictures. The violinist who left his glasses on his instrument (Figure 7-23) said that people are very careful of eyeglasses, and this is how he protects his violin. And you'll see geometric forms (Figure 7-25): this will give you exercises in composition. And then one day you'll work with *the* symphony orchestra. And you'll be ready.

Abstractionism

Don't let the big word frighten you. All it means is taking the essence out of the overall scene. A small part of the scene should let the viewer's mind conjure up the entire scene. Your ability to "see" will determine your ability to abstract. Figure 7-9 is an example of abstracting an essence pertaining to an actuarian. There are several schools of thought in the area of abstraction. One school portrays nothing but patterns. Another employs darkroom manipulation to achieve a variety of effects. If you lean towards these schools, fine. I prefer the school that abstracts according to the definition of abstract; here is the essence, now let your mind see the whole. In the area of abstraction, your ability to compose will be put to the test. See if you can tell what Figure 7-24 shows; try it on edge and upside down. Now do the same with Figure 7-25. Figure 7-24 was taken with the 35 mm lens and is a scaffolding. Figure 7-25 is that part of

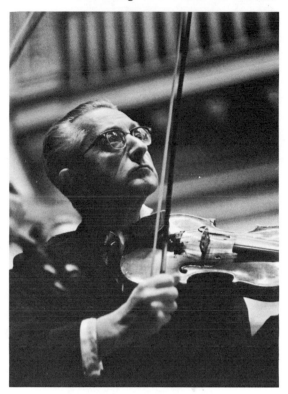

Figure 7-20

the cello near the "f" shaped sound holes; a 90 mm lens was used for this close-up.

Figure 7-25 may change appearance if you look at it for a few moments. If it doesn't, turn the page a quarter or half turn and look at it again. It didn't provide the optical illusion when the photographer was making the picture. He was interested only in the curves and the play of light on the instrument. Figure 7-26 is the full negative. You may see other compositions that are more appealing to you than the one illustrated in Figure 7-25.

Belong to no "school" of photography. Don't be a slavish imitator. Build up your own confidence by mastering the basics so that you can make your own comment.

Choosing Your Area to Practice

How do you choose an area to practice mastering camera technique? There are many areas available to all. If it's sports, pick the sport you are interested in. Baseball? Start with the Little League, then high school or park department games. If you have it, you may make the major leagues. Hockey? There's the Pee Wee League in arenas, the open ice games on frozen ponds. Track? High school and college meets. Opportunities abound, but you must have an *interest*

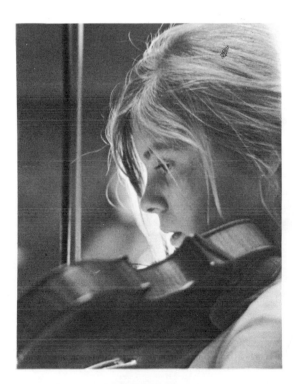

Figure 7-19

New Group Plans Concert

Under the baton of Harry Ellis Dickson, right, the Brookline Civic Symphony Orchestra, sponsored by the Brotherhood of Temple Ohabei Shalom, is rehearsing for season's opening concert to be held Wednesday evening at Roberts Auditorium, Brookline High School. This will be first community-wide performance for the 75-member non-sectarian orchestra of highly trained amateur musicians. Program will feature violin virtuoso Joseph Silverstein, Boston Symphony concertmaster, playing Mendelsohn's Violin Concerto in E Flat Minor. The orchestra is comprised of students, housewives, professional and business men dedicated to bringing good music to Brookline residents and neighboring communities.

Viola section and violins blend together in skilled performance by, left to right, front, Dr. Louis Wasser Samuel Rice and Priscilla Holmes; rear, Gerald Hartzberg and Jacob M. Gordon. Left, bassoonist John Miller, who has performed with Baltimore Symphony Orchestra.

Working on a difficult section are, front row, cellists Mrs. Bernice Cahn and Robert Dobson, rear, cellists Felma Pratt and Beverly Geyer, bass violinist Robert Martos, and flutist Jack Goody.

BOSTON SUNDAY GLOBE, JANUARY 7, 1962

Figure 7-21

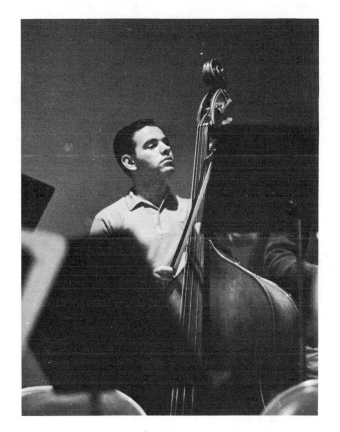

Figure 7-22

Figure 7-23

Figure 7-24

Figure 7-25

Figure 7-26

in the area you choose, and you are the best qualified in knowing where it is. Interest will lead to attentiveness. Attentiveness will lead to that extra bit of looking which, with practice, changes to *seeing*.

Take pictures and study the results. Do this as often as you can. In time—and it won't be a short one, no matter what the manufacturers of equipment advertise—you'll master your equipment, you'll have that extra vision, and you'll have all that is needed to evaluate a constantly changing kaleidoscope and capture its essence.

Practice: when it comes time for you to put your reputation and future on the line, be as qualified as possible.

Another Form of Seeing

"Seeing" is not confined to just taking the picture that is there. Since photography is a visual means of

communication, let's use it to illustrate another ingredient of "seeing." There is a picture in the strip of enlarged frames in Figure 7-27. Can you "see" it?

When Sviatoslav Richter, the eminent Russian pianist, made his first visit to the United States, he was important news. His concert in New York was featured by coverage in *Life* magazine. Let us assume that he went to your home town, and you were seeking the opportunity to make pictures of him. Your earlier contacts at Symphony Hall (see Chapter 11) might permit you to enter the room where guest artists relax before their performances. If you don't have this permission, you could buy a ticket to the concert and enter the room after the concert. Usually, the artist greets his "fans" and signs autographs. If you are early, you can station yourself in a corner and using available light be quite unobtrusive (Figure 7-28). The use of flash equipment will bring attention to you immediately and will result in your being expelled from the room.

All that is required to produce the photograph in Figure 7-29 is knowledge of printing[2] or the ability to tell a custom laboratory what you want done. Only the photographer knows what points he wants emphasized and what the total effect should be. Unless you are familiar with photographic printing techniques, you are only a 50% photographer.

[2]The head is enlarged to the desired degree and placed in position on the printing paper. While the head is being exposed on photographic paper, you hold back (dodge) the light from the enlarger so that very little exposure is made on the sheet of printing paper where you visualize the spotlight. You can use your finger or a piece of cardboard cut to simulate the spotlight effect you "see" in your mind. Once the proper exposure for the face is made, you remove the negative from the enlarger and with the "dodger" covering the area where the face is, you bathe the entire sheet of photographic paper with pure, white light, continually moving the "dodging device." Result: a picture that has been sold several times.

Timing

In taking pictures, you must be able to select the exact moment when all the elements in your photograph have a harmonious relationship with each other. Action means movement and the faster the movement of the components of your picture, the less time you have for "seeing" their arrangement.

You have all heard your subjects ask, "what shall I do with my hands?" when you were going to take their picture. You must know where to position the hands for the best results when you have the subject's cooperation before attempting to capture these elements in motion.

For example, when photographing a conductor of an orchestra, the moving elements to consider are his hands and head. Even an experienced photographer will find it difficult to get the moving elements where he wants them with his first exposure. In making the informal portrait, you learned that it takes more than

Figure 7-28

Figure 7-27

one or two exposures to get the definitive photograph of a person. Add motion and you add more difficulty. The only answer to this is saturation shooting (see Chapter 8). This does not mean that you are exposing a lot of film indiscriminately, hoping that one exposure will be satisfactory. Each frame is carefully timed. Saturation shooting is the method used by professional photojournalists to insure getting what Cartier Bresson calls "the decisive moment." The knowledgeable photographer is anticipating the decisive moment and he starts tripping the shutter a fraction of a second in advance of this moment.

Luck or Ability?

But a great many things can happen to the moving elements you are trying to record during the fraction of time after you depress the shutter release. As the maestro's hands weave about building the tapestry of music, they are constantly under your observation through the viewfinder. You anticipate the moment that the hands will be close to his face and squeeze the shutter release, capturing just what you want. Or have you? Were you able to retain in your eye just what you recorded on the film? You can't, for the eye is unable to retain an image for any length of time. Are you aware that the baton was bisecting the con-

ductor's face (Figure 7-30)? Or are you busily engaged in the saturation method and unconsciously working the lever that transports the film and "cocks" the shutter so that you are ready to capture the moment when the hands are placed close to the face and the baton doesn't cut across his face as in Figure 7-31?

Would 6 exposures be sufficient coverage if you *knew* that you had the above picture? Hardly. The composition of the hands and face may be exactly what the editor wants—but he may desire a different facial expression. It is advised that you submit at least 50 frames to show that you tried to get a variety of expressions as well as the composition needed.

When you *know* that you have covered what the editor wants, do you call it a day? No. Now you go ahead with the "shoot it as you see it" phrase of Point No. 5 in the list of requirements. You go after a picture that would satisfy the requirements for a vertical layout. Editors and clients are known to change their minds even if they aren't women.

Don't believe for a moment that the photographs in Figure 7-32 were made at the first attempt. The conductor's right hand, in several frames, obscured his face; in other frames it was his left hand. But, the professional doesn't show his "misses." (Practice in your chosen field. Today's professional did—before he became a professional.)

In Figure 7-34 Arthur Fiedler, the Boston POPS

Figure 7-29

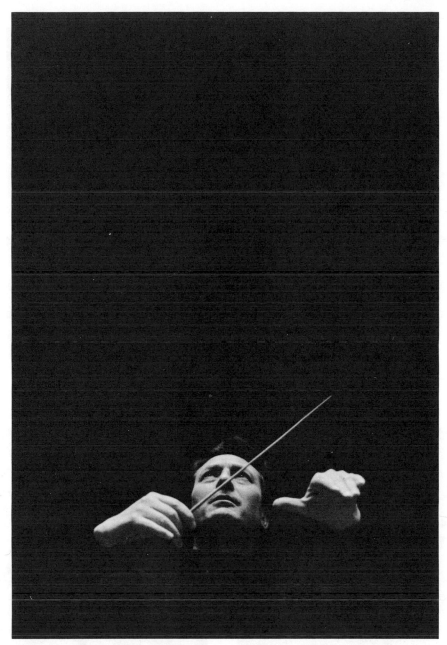

Figure 7-30

renowned conductor, is certainly not asking for a quiet passage. His left hand, clenched into a fist accompanies his facial expression, just as his orchestra accompanies him. A line connecting his hands and face will give you a diagonal: this denotes action. The movement of his right hand adds to the action.

In Figure 7-35 Erich Leinsdorf, conductor of the Boston Symphony Orchestra is requesting the orchestra to play pianissimo. The softening of the music is depicted by his face as well as by his hands. It is a good idea to get at least one picture of a conductor with his hands close to his face so that the editors can't crop them out. The hands of a conductor are an integral part of your comment about him.

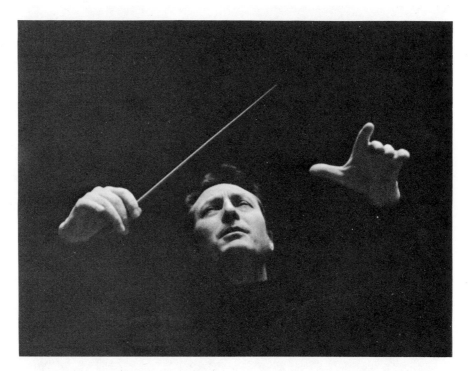

Figure 7-31

Figure 7-32

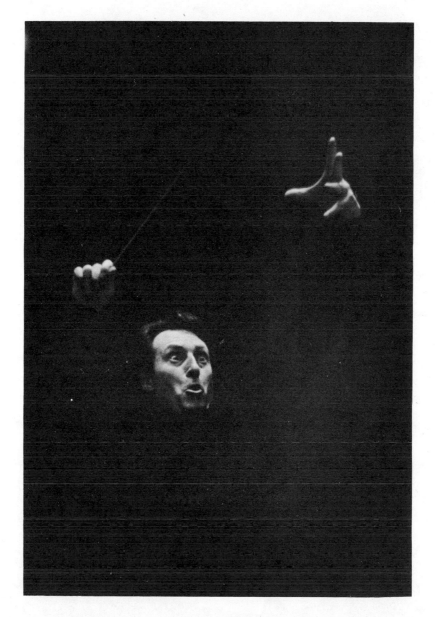

Figure 7-33

The high emotional content displayed in the face of Carlo Maria Giulini (Figure 7-33) is also mirrored by his left hand. If you drew lines connecting his ring finger to his nose to his right thumb, you would have a triangle. This geometric form is a basic harmonious arrangement.

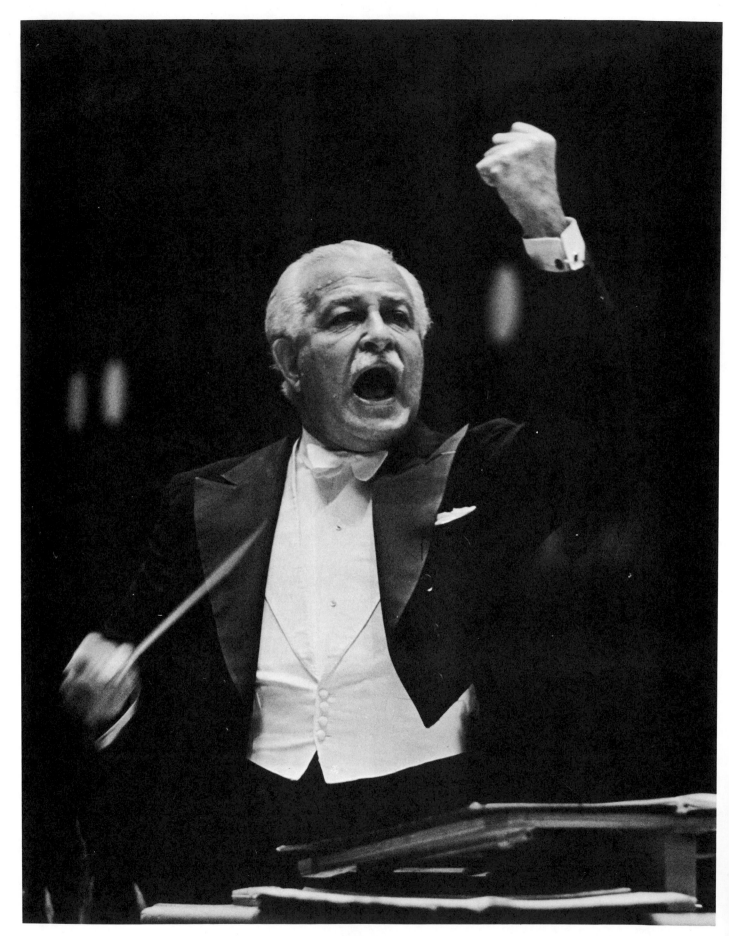

Figure 7-34

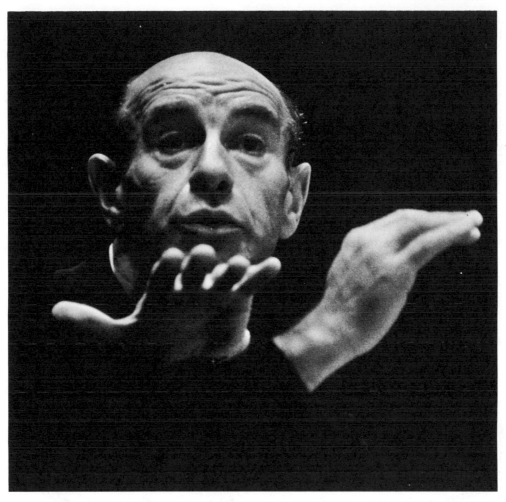

Figure 7-35

Transfer of Knowledge

By this time you already have the knowledge to transfer some of your skills into "commercial photography." But you need one more bit of knowledge in your photographic lore.

Even a simple object such as the one illustrated in Figure 7-36 requires the application of presenting objects so that the viewer can immediately draw true conclusions from your representation of it. What can the viewer of Figure 7-36 deduce from the object as presented? Does he know how large it is? If the viewer can draw from his experience, which he must do, has he had the necessary experience to draw the correct conclusion?

For isolated objects, such as the one shown in Figure 7-36, you must remove all doubt as to the size and assume that the viewer does not have the experience to draw the true conclusions. Therefore, you must include something in the photograph which will remove all doubt.[3]

[3]See Evans, pp. 255–285. The author amplifies the principles by which a photographer can modify, control, arrange, distort, converge, and make us see what is there, honestly or dishonestly.

Figure 7-36

The object shown in Figure 7-36 looks like a "jack" with which children play the game of jacks. But closer scrutiny of the object reveals that it is sharply pointed. It's not a jack. How can you remove all doubt from the viewer's mind as to its size? Simply by including in the photograph something that all viewers will be able to recognize easily. By introducing something of familiar size, you provide the necessary clue for comparison. Figure 7-37 contains a trap. The hand might not be in the same plane as the object. If the hand is in front of the plane of the object, the size of the hand would give the impression that the object is smaller than it really is. If the hand were behind the plane of the object, the object would appear larger than it is.

Figure 7-38 is better, but the thumb and forefinger conceal the tip of the object. Figure 7-39 leaves no doubt as to the relationship (size) of the object, but the angle at which you have photographed the setup is disturbing. One of the prongs is hidden and the hand, now part of the background, interferes with a clear view of the four-pronged object.

Try a variety of ways to present it, to show the object honestly (Figure 7-40). Since this "commercial" photography was sprung on you, you use whatever comes to your mind.

Slipping off your ring, you place it beside the caltrop.[4] Unfortunately, your point of view is too high. In Figure 7-41 you are looking down on the object. For this object, and what the editor had in mind, the

[4]Caltrop (kal'trop), n., an iron instrument with four spikes, placed in ditches, etc. to hinder the advance of troops; a name for various plants with prickly fruit.

Figure 7-37

Figure 7-39

Figure 7-38

Figure 7-40

camera should be in just about the same horizontal plane as the object. The illumination was "available" and from the side. You can tell this from the highlights and shadows. (Figure 7-40 was selected for publication in a house organ).

Figure 7-41

The Other End of the Scale

In Figure 7-42 the magnitude of a paper manufacturing plant is not as evident when the man in frame 30 is eliminated, as in frame 31. Nor is the plant as interesting. As the photographer, you must make certain that there is something or someone in the picture, whose size or dimensions are easily determined. And it will be through this object that the viewer will be able to draw correct conclusions about the diminutiveness of a small object or the magnitude of a large one.

DO	DON'T
. . . learn to frame your pictures.	. . . imitate.
. . . get what the editors ask for.	. . . set your goals too high.
. . . study the work of others.	. . . be stingy with your exposures.

. . . honestly evaluate your pictures.
. . . practice.
. . . shoot in the format desired.
. . . include a familiar object if scale will add to the impact.
. . . learn the rudiments of photographic printing.

Figure 7-42

Chapter 8

Exposing: Saturation Method

How many exposures should you make of your subject to satisfy the editor? You have a definitive answer for this question. Point No. 4 in the list of requirements requests at least one contact sheet per situation, taken from various angles. While a contact sheet of 2¼-square film gives 12 frames, a contact sheet of 35 mm film yields 36 frames. The following format has proved very acceptable to photo editors and art directors.

The Long Shot. A minimum of 6 frames encompassing a view from a distance of 12 ft. employing the 35 mm wide-angle lens. This will show the subject in relation to his environment.

The Medium Shot. At least 6 frames should be exposed embracing a view from a distance of 12 ft. employing a 50 mm (normal focal length) lens. If you didn't buy this lens, just move in closer with the wide-angle. This medium shot will show more detail in your subject and will still include some of his surroundings.

The Close-Up. Six frames should also be your minimum coverage with the 90 mm lens, at distances from 6 to 10 ft. existing between subject and camera. With these views you emphasize the features of your subject.

Even if your instructions are to get just close-ups, you would be wise to include a minimum of 6 long shots and 6 medium shots. The long shot serves three purposes: (1) It's easier on your subject if you first begin taking pictures at a distance of 12 ft. than if you begin at a distance of 6 ft. It will help to relax him; (2) It sets the scene, letting the editor see the area you had to work in; (3) In case the editor decides to run several pictures, he will have a variety from which to make an interesting selection.

In an earlier chapter the art of relaxing your subject was discussed. You should remember that a photographic session is an artificial situation. If you consider that most people are very self-conscious and ill at ease in the critical eye of the camera, it won't help matters if you poke a lens 40 in. from their faces at the beginning of your photography.

Moving in Closer

After you have clicked off 6 frames or more, move in—just a bit. By this time, when the subject is im-

pressed by the fact that you are not using flash, and he isn't constantly bombarded by sudden bursts of blinding light, he'll be over his initial fright. You are constantly keeping him engaged in conversation. Remember?

You should change lenses; if you have started your long shots with the wide-angle lens, switch to your other camera, which has the 90 mm lens. Now you can make your medium shots without moving any closer to your subject (see Figure 8-1). You rapidly click off another half dozen frames—*or more.* And then you move in for your close-ups, still talking.

What Do You Talk About?

You should have started your conversation when you took your camera out of the carrying case. The ensuing conversation can go in many directions. Your subject might be interested in photography and he'll question you about your equipment. He might ask you to help him with a problem he is having in photography. Thus you can talk about a topic in which you are well versed.

Another approach is to ask intelligent questions concerning your subject. Many times you are aware of the reason his picture is desired. Questions about this can get the subject talking. While conversing you should be observing your subject for characteristic poses.

A Few Technical Matters

You have taken meter readings to get the intensity of the light under which you will be operating. You have determined the correct combination of aperture and shutter speed that will give you the best possible negative. You have done all this before you started taking your pictures—haven't you?

Since your subject seated himself at his desk, you leave him there because he is relaxed. You take his picture, but in the back of your mind is the admonition, "no desk shots." Slipping on your 90 mm lens you eliminate the desk and make your close-ups.

The lighting (available) in frame 1, Figure 8-1 and frame 8, Figure 8-2 is "split." Half of the face is in highlight and the other half is in shadow. The light

Figure 8-1

Figure 8-2

from a lamp lightens the shadow side of his features.

The wall is of a good tonality for this sequence: it is just a bit lighter than his suit. This difference provides separation of the subject from the background; yet, it is dark enough to subdue his apparel, resulting in more emphasis upon his features.

When the highest light comes from the direction of the short side of the face, there is a slimming effect to the features, the bridge of the nose being noticeably narrowed.

During the time that you are taking pictures you keep the subject in conversation. This keeps him animated and prevents him from becoming self-conscious.

Are you confident that your meter has given you a correct indication of the low-level light circumstances you have encountered? Have you performed the necessary tests with your equipment and can you trust it? (See Chapter 4).

What makes you so certain that you can get a picture, free of camera shake with your 90 mm lens at 1/60 sec? Because you have performed the necessary tests and have some experience on your side.

How do you know that you can get a picture free of objectionable camera movement at 1/15 sec with your 35 mm lens? Because you've done it. Buy why don't you take advantage of the additional depth of field that this slow shutter speed will give you when you stop your lens down to give you the equivalent exposure of $f/2$ at 1/60 sec? Because of the possibilities of subject movement.

The Reason for the Saturation Method

You have already taken 18 exposures of your subject. This is more than you have ever taken of one person and you haven't even changed your point of view. You have at least 18 more to take. Why so many?

The human face is capable of assuming more than 72 expressions. If you add to this only 3 basic light directions, you now have 216 possibilities. If a change in dress is used, you can double again—432 frames. And you haven't counted the possibilities of different settings.

What about the preference of the editor who is going to select the particular photograph for the article? What are his tastes? He needs a variety. Editorial space can change. There is the possibility that the picture might appear in two different periodicals—each with a different viewing audience. (The approach for *Playboy* would be different than for *Boys Life*.)

Your subject can't remain tense and camera shy every moment that the camera is pointed at him. There are going to be fleeting changes of expression. By having your camera operating in sequence—as fast as you can change the film and depress the shutter—you'll catch a revealing portrait of the subject.

You'll get the serious, the smiling, the quizzical; in fact, you'll get a gamut of revealing expressions. You'll also capture eye-blinks, subject movement, and unflattering poses as well. But you will give your editor a selection.

Changing the Situation

To add variety to the selection and to record another characteristic of your subject you should change the background. The background should be one which the viewer would find believable for the subject, and it should tell something about the subject. If you have been observant upon meeting your subject, you may have noticed that he did not have his coat on. He put it on before you started taking pictures. After you have made a sequence with his coat on, you remark that you noticed he didn't have it on when you met him. Would he mind taking it off while you photograph another sequence?

In this new situation (Figure 8-3), just repeat the format that you have previously followed: long shots, medium shots, and close-ups. Again, you don't have to pose your subject. He will assume a situation that is comfortable for himself. If he asks you what you want him to do, just tell him, "Whatever you would do naturally."

When the dress or location of your subject is changed, the procedure of long, medium and close-up is followed. Try as you might, you can't conveniently place the framed degree hanging on the wall where you want it (frames 15–17), when using the 35 mm lens. Does the background tell us something about the subject in Figure 8-3? The long shots do, but not the close-ups (Figure 8-4).

When the opportunity presents itself to change the location as well as the dress, you do it. Once again the subject takes a pose that is comfortable. Keep the conversation going. Repeat the procedure of several frames per situation.

The lighting (available) for the frames in Figure 8-5 is basically flat: not the best for this subject but the highlight on the edge of the face gives a necessary separation from the background. Here, as in frames 21 to 26 (of Figure 8-6) the light walls subdue the white shirt.

Figure 8-3

Figure 8-4

Figure 8-5

Figure 8-6

Evolve a rule of thumb concerning backgrounds in portraiture: *keep the background close to the tone of the garment worn*; a bit lighter if the suit is dark, a shade darker if it is light. You want separation of subject from background.

A simple request that the subject change his position and place his stethoscope around his neck gives you another situation. You give the editor a wider choice. Frames 21 and 22 of Figure 8-6 tell more about the subject than frames 18 to 20 of Figure 8-3. Frame 25 of Figure 8-6 was chosen for publication.

Once you are in the habit of using the format of long, medium, and close-up shots, use it whenever you think the situation demands it. Every situation will benefit by this type of coverage. When you are in an industrial plant and you are on your own, this approach is mandatory. In Figure 8-7, the long shot and close-up were included in an annual report.

Minor Changes and Problems

Unless your subject is a frequent target for the camera, he will be a bit flustered by the many exposures you are making. The average citizen, if he is to have his picture taken for the local press, assumes that the cameraman will come in, flash a bulb or two, and leave. He will not expect the coverage that you are giving him. There will be a time when you have to reload the film in your camera, and your subject will invariably assume that the session is over. He will attempt to dismiss you with a remark, "Have you taken enough?"

Explain to him that you are expected to turn in at least three rolls of film but you'll stop at two. When you explain your problem to the subject, he will usually cooperate. You should be in control of the situation. Men, particularly busy men, want direct, concrete, and concise direction. It is a good gambit to tell them that the more you take, the better the chances will be of having a good likeness published.

When your sixth sense tells you that your subject has had enough, quit. He'll ask how he can see the pictures that you have taken. Tell him the truth: all your film goes directly to the agency that has hired you and he should contact them. The first that your subject will see of what you have taken is what appears in the publication you are working for. Before you leave be sure to have your subject sign the releases that your agency has sent you.

Processing

It will be to your advantage if you process your own film as discussed in Chapter 4. You can see your results quickly and will know from an examination of the negatives if everything is in working order. However, when you work for an agency, it is not necessary for you to process your film. You can send the exposed, undeveloped film directly to them. Do this only when your schedule is tight and you don't have the time for processing.

Getting Experience for Your First Assignment

Your friends or members of your family will be the first subjects that you will work with. Approach them with the idea that their picture is needed for a specific purpose. Assuming that you start photographing a man about 35 to 55 years of age, you should operate in the format suggested. Pay attention to the list of requirements. Practice the format as outlined earlier in this chapter. Have your film custom-developed (as suggested in Chapter 4) and have a contact sheet made of every exposure you take. It would be preferable if you processed your own film and made your own contact sheet. (Figure 8-8 is a contact sheet, showing half the minimum requirement for adequate submission to an agency.)

Examine and criticize each frame. Select about 6 of what you think are the best and have them enlarged to 5 × 7. Study these enlargements for technical quality, lighting, composition, and finally, expression. Show them to your subject and discuss the enlargements with him. You may decide to reshoot your subject, concentrating on anything that you may have had trouble with in the original session.

You should practice this format with others in the same age group until you are satisfied that you can handle this type of assignment with confidence. If possible, when you have reached this decision, take your negatives and contacts to a professional photographer for evaluation. You might also take them to the photo editor of your local newspaper for the evaluation.

Changing Your Model

After you feel that you have the ability to photograph a man, then practice with a woman. You should practice with a woman in the 40 to 50-year age bracket, because this is usually the age level of people that you will be called upon to photograph for publication.

Getting Animation into Your Posed Informal Portraits

One of the best areas for a high school or college student to practice this very important phase of pho-

...After medicare—what?

"The events of the past six months," says Dr. Walter E. O'Donnell of Gloucester, Mass., *"have finally jolted many physicians out of their apathy. Now they're having second thoughts about where American medicine goes from here."*

per cent wrong. It's easy—and human—to look for a scapegoat when the going gets rough and frustrations run high. The A.M.A. is a particularly appealing target because it's given to bizarre public spasms of self-righteousness accompanied by pronouncements that consign to perdition all those who oppose. A retrospective analysis of its past record of "too little, too late and usually against" on matters of public health and social welfare doesn't invite unlimited confidence.

The real culprits are those physicians, like me, who have regarded the perennial contest of Big Government vs. Big Medicine as a spectator sport. You and I—the absentee delegates, the silent voices at past A.M.A. meetings—must take a big share of the blame. Too long have we sat idly by while the hot-eyed "rights" and "lefts" have gone at each other.

Where are the medical moderates? Where are those physicians who aren't doctrinaire liberals or conservatives, who don't see all issues as black or

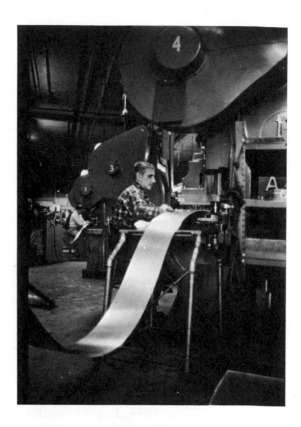

Figure 8-7 Even in industrial photography, the format of long shot, medium shot and closeup should be followed.

Figure 8-8　This is one of two contact sheets submitted to the agency.

tojournalism is right on campus. Every year institutions of learning publish yearbooks. The faculty is made up of both sexes in the age group you want.

Each yearbook has a professional studio that assumes the responsibility for the formal portraits. This studio would welcome the opportunity to take advantage of your attendance at campus to make photographs that would supplement the candids that must be supplied to the photography editor.

But, you must have the knowledge of handling the camera and the basic equipment, and you should have absorbed some of the prerequisites in the early chapters. You will be working under the available-light conditions that you will encounter in future photojournalistic assignments: daylight (with subject sometimes close to a window and sometimes in the center of a room); office light (fluorescent or tungsten); and night pictures.

The professional studio that has the contract for the "formal" portraits could advise and give you constructive criticism in items pertaining to the quality of the prints or negatives you submit, as well as your approach to the particular instructor you are photographing.

The series of frames in Figure 8-9 suggests one approach you might use. The subject is an instructor of budding teachers who will teach elementary mathematics. You ask a few questions and ask her to explain to you how the "cuisenaire" rods are used in teaching mathematics to children in the kindergarten and elementary grades. This is just a diversionary tactic to make your subject less self-conscious. You know it and your subject might know it—but what matter, if it helps your subject to relax and get animated?

Use the 90 mm lens so that you won't be poking the lens into her face. She begins giving you an explanation of the differing colors and sizes of the rods. While she is telling you how the concepts are conveyed to the student by means of the rods, you take pictures. You should continue to take pictures until you feel that you have at least one that will be usable in the yearbook. And don't forget the format! In addition to gaining knowledge about photography, you'll pick up some knowledge about cuisenaire rods.

The best time to request some of the instructor's time is just after a class. There is usually a 10-minute break before she has another class, and with the aid of the editor of the yearbook or the representative, you'll have about 5 minutes to make the pictures. It won't be necessary for you to shoot a full roll of film, but give the instructor a break and take about a dozen exposures. You'll be getting practice not only in shooting via the saturation method, but experience in taking pictures in short time periods.

Comments on the Lighting and Suggestions

The room is well-lighted—windows on both sides. But since the sun is entering from one side of the room, the natural fall-off in intensity gives you a well-balanced "split" type of lighting.

If you notice (which you should) that the lighting happens to be evenly balanced, you could pull down the shades at one side of the room to create a contrast.

If the instructor is cooperative and has no class following, you might suggest that she write on the blackboard and explain the "rods" to you. As she does this, you take pictures.

Practicing the "Grab" Shot

There is an axiom known to photojournalists and photo editors that great pictures just happen. A corollary to this statement is that your more pictorial or interesting pictures will fall into the "grab"[1] category. This is the true, unposed picture that you *see*. With a camera in your hand you will begin to sharpen your perception. The grab shot, photographically speaking, captures the fleeting passage of a moment of time; usually a moment that is never to be repeated. You will not only look—but with practice you will begin to see. Most people look, but don't see.

As you walk throughout the buildings on campus, you come upon individuals who are unaware that you are going to take their picture for the yearbook. Frame 12 of Figure 8-10 is a grab shot. How much more animated is this particular shot than the rest of the frames in which the subject has regained her self-consciousness about being photographed?

While ambling through the buildings you see another picture—a member of the faculty in his office. With the 21 mm lens you don't have to focus, you just shoot (Figure 8-11). It would be difficult to take a meter reading since you are shooting into the light. Your best bet would be to estimate the aperture from your experience and then bracket your exposures.

A faculty member who is conversing with one of her students is captured as a shadow (Figure 8-12). This shadow is easily identified by the students with whom this instructor has had contact. And so it goes throughout the entire gamut of activities on your particular campus. There are various athletic activities, drama groups, musical organizations, and other situations and opportunities for you to shoot. All of this is practice in seeing. Figure 8-13 is one reward for practicing. Your results will show how well

[1]Figures 7-8, 7-9, 7-14, and 7-29 are of the "grab" category.

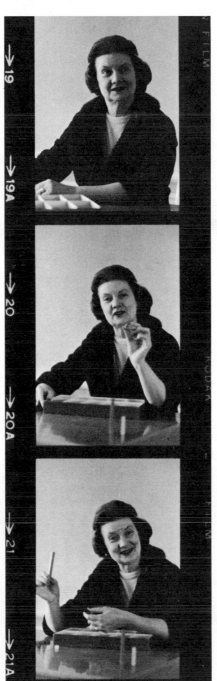
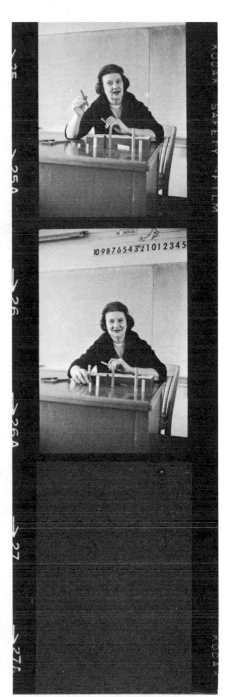

Figure 8-9

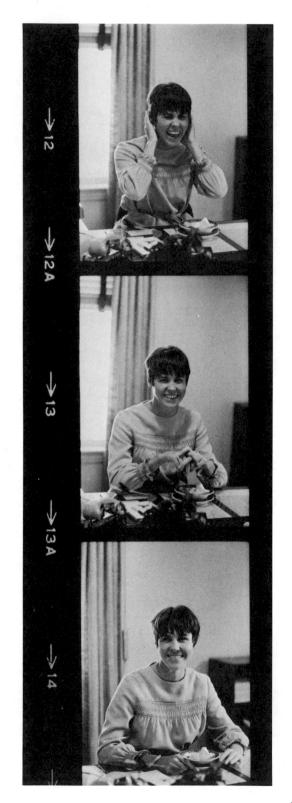
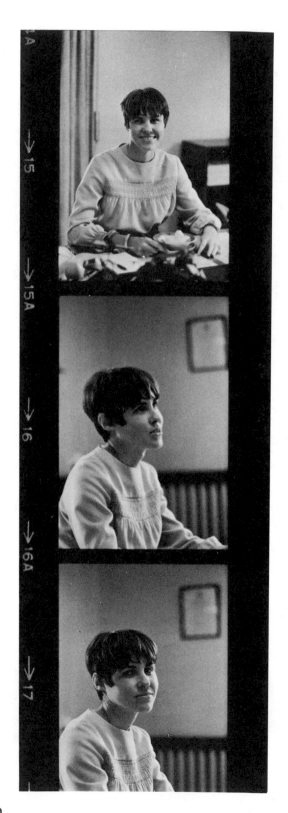

Figure 8-10

Figure 8-11

you've mastered the four basics inherent in every photograph.

Some Thoughts on Vanity

There is a great difference in taking an informal portrait of an individual when the assignment is not for the individual but for a publication. Vanity does not play a part in the selection for publication. The editor is after a particular expression and/or animation. He won't be unhappy if there are circles under the eyes. But the subject might want the entire sitting discarded because of vanity (see Chapter 3).

When working for a publication it is very rare that the subject will see the proofs, or a picture until it appears in the publication. Since available-light portraits with the 35 mm camera are not flattering in this age group, it might be best if at the beginning of your practice sessions, you don't let your subject see all the results. Not every picture that the professional makes is good: he does take some bad ones. But the professional does not show the subject the bad ones.

Your practice sessions can take place in the kitchen, in the den, in the living room, or wherever your imagination takes you. The procedure is the same. Have a brief conversation with the subject after you have introduced yourself and begin shooting with the long or medium shot. Keep your subject as relaxed as possible. If your subject wants to tidy up the area, discourage her. If she insists, let her, but take pictures of her doing it. You want realism.

Practicing with Children

And then there are children to photograph, not so much for publication, but because of the problems

and experience they will give you. While children are less self-conscious in front of a camera, they are not as easy to direct as adults.

There is a bit of psychology involved in the photography of children. If you walk in with a gadget bag and are wearing a shirt, tie, and business suit, you might give the child the idea that you are a doctor. And they don't like doctors.

Wear sport clothes. When you enter the house, ignore the child unless the child is of a gregarious nature. Try sitting on the floor and make a fuss about the "goodies" in your camera bag. The child's natural curiosity will bring him to you. Make your first exposures at a distance and, when you have evaluated your rapport, move in.

Your direction of the child has to be subtle. Find the least distracting background and have his mother bring out a favorite toy. Then you operate in the format. If the mother (who is the editor in this case) lets you know that she wants close-ups, concentrate on them. Give her what she wants, but also keep Point No. 5 in the back of your mind—shoot it as you see it. You may be lucky and the subject will stay put long enough to give you time to get a variety of ex-

Figure 8-12

Figure 8-13 Don't lose the tree because of the forest!

pressions. With sufficient practice, you might start getting remunerated for some of your work.

Advice to a Doting Father with a Camera

It is not necessary that you have an expensive camera and assorted lenses to make good pictures of your children at home. The average residence—even an apartment—has windows. Sufficient light will fall upon your subject to enable you to record some precious moments of your child's activities with a minimum of effort. You have the added advantage that the child is secure in your presence. This security is an advantage you have over the professional. Begin your picture-taking close to the window. (See Figure 8-14.) Leave the child alone and just record what happens. Observe the background. Keep it as simple as possible. There may be an activity going on outside which will engross the child's attention. Of her own volition, the child will sit down, particularly if you have had the foresight to provide a toy or plaything for her.

Don't attempt to create a situation which is foreign to the child's experience. Avoid the use of flash. It may condition the child to be camera shy. If your first results are disappointing, find out why. Don't be discouraged, but try again. Use the saturation method. Most amateurs expose one or two shots, whereas a whole roll may be the only means of photographing a situation that may never be repeated. Isn't it better to shoot the whole roll of film rather than wait a month before you pick the camera up and forget what type of film you have in it?

If the baby tires of the situation outside and decides to sit down, let her (see Figure 8-15). You can enlist the aid of your wife or an older child who can take direction from you. Keep this assistant close to you, for the child's attention will go to this area. Notice where the child is looking in Figure 8-16. It is in the direction of your assistant's hand (in this case your assistant was the child's mother). If you have patience, you will eventually obtain an available-light picture of your child as in Figure 8-17.

The pixyish expression you caught on the young miss in Figure 8-18 was neither accidental nor a matter of luck. You had positioned her so that the highlight would be on the short side of her face. You gave her a bouquet of flowers to occupy her hands. You made one exposure (frame 14, Figure 8-19) and then came up with a comment that evoked a priceless expression. By employing the saturation method you were able to record this expression on film. Knowing

Figure 8-14

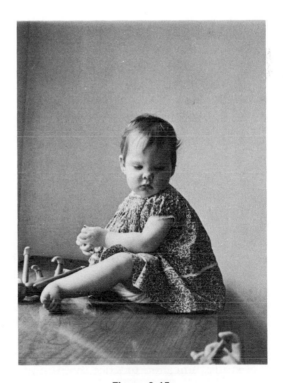

Figure 8-15

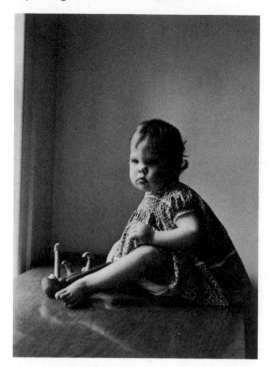

Figure 8-16

that you have *the* shot you want, you move in for close-ups (frame 16).

You can't get your subjects to give you the expression you want by telling them to look happy or wistful, or any other useless command. You must obtain it naturally. You help evoke it, with conversation and personality. This is just as true whether you are working with a nuclear physicist or a child.

Don't forget the format! Move in a bit closer, when you think that you have recorded the long shot, and concentrate on the expressions. You will be rewarded with a picture that you will be proud to show.

If you have the local photo finisher do your processing, keep it to the normal 15¢ print. These will be your proofs. From this selection, send the negative and the proof to a custom photo finisher (see Chapter 4) and have him make the final prints for you.

It may take several rolls of film before you have coordinated your equipment and gained sufficient experience. This is a small price to pay for the ability to get pictures of your own family and build a "documentary" story of your family's activities.

Start with black-and-white film until you know the results. By using window light, you are using what is considered the most beautiful of all light, natural daylight. Your results will be in direct proportion to the amount of study, time, and practice that you put into your work. After you have achieved a modicum of

success with black-and-white film, then try your hand with color film.

Practice with a Group

This would be an optional but very valuable assignment for you to practice. In Figure 6-5 we had a simple arrangement of a family group. Did the photographer follow the same format? Here are the elements discussed separately: man, woman, and child, all together. How would you handle it?

"Why am I taking this picture?" is the question that you should ask yourself before you press the shutter release. To determine the value of any photograph, this question should be the first one asked. The primary reason that Figure 8-20 was taken was to illustrate that the subject (the man) is a family man. It was one of a series for a brochure.

If ever there is a reason for saturation shooting, you have it when there is more than one individual in the photograph. By this time you should know how difficult it is to get a definitive portrait of one person. Now, your problem is compounded.

Since you know the purpose of the picture you can dispense with the long shot. The children are secure because they are with their parents.

Analyze frames 8 through 13 in detail. The back

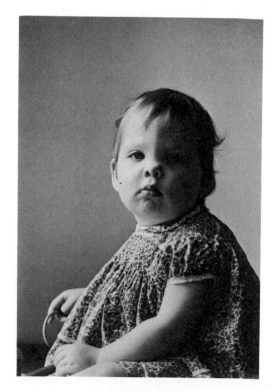

Figure 8-17

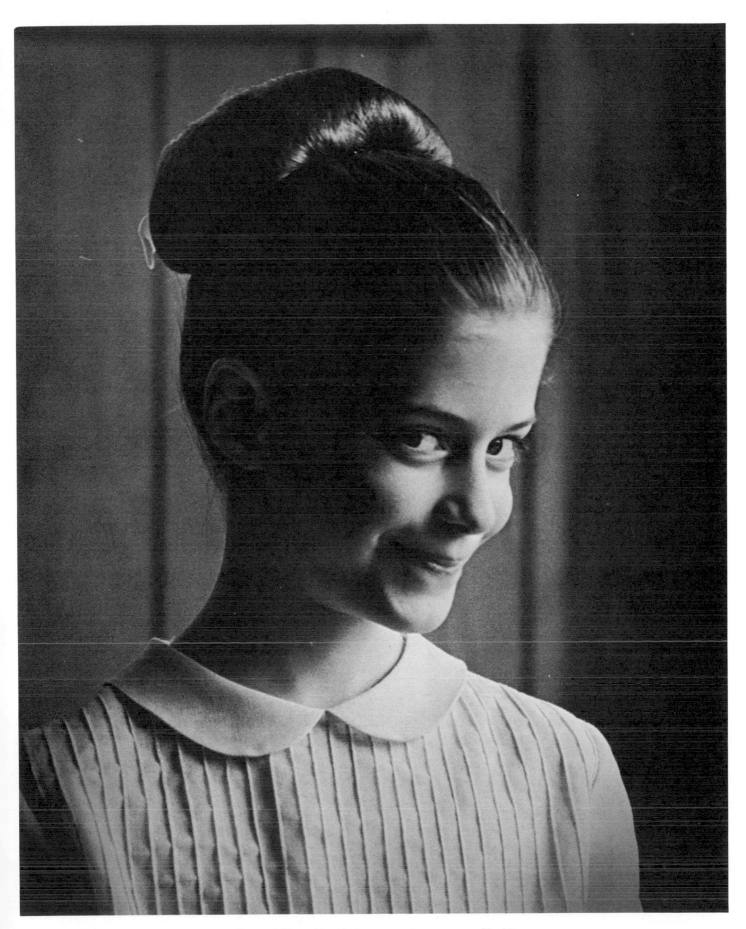

Figure 8-18 Is this priceless expression a matter of luck?

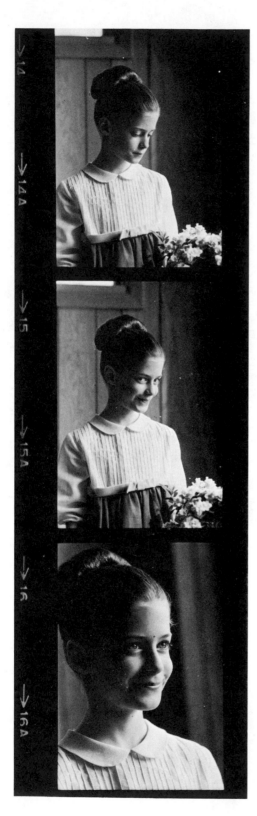

Figure 8-19

ground is rather busy, but it was the best available under the circumstances. The youngest child is satisfactory in all but frame 8. The mother could be used in all but frame 13. Father is acceptable in all. Junior, perched on Dad's shoulders, could be used in all but frame 9. So you eliminate frames 8, 9, and 13. The sun has filtered through the branches to put a spot on Dad's head in 12. This brings us to consider frames 10 and 11. Which is the best of our main subject—the father? I would pick 11.

After you have made what you think is the best sequence, do you stop? Not if your subjects are cooperative and you have more film. You try two other settings and arrangements of your subjects before calling it quits on the "family" photograph for the brochure.

In Figure 8-21 the sun through the branches has fallen upon the mother's face in an unrhyming pattern (frames 24-25) which is disturbing. You should abandon this area. A third setting was tried (frames 28-30). You shot the sequence as you saw it, now have the film processed, edited, and proofed.

Saturation on Assignment in Industry

When working in premises that have large areas, where supplemental lighting would be too costly or impractical for the photographic budget, the available-light approach gains in effectiveness through its characteristic of reproducing natural conditions. The saturation technique is indispensable in providing the layout man with ample material with which he can work. The miniature camera with its 35 mm lens can give sufficient detail in foreground and background. The following strips were part of those submitted to show the "glamour" of a life insurance company. Figure 8-22 is a grab shot (frame 1). The second frame shows the close-up of a man (although the control panel was what caught the photographer's eye). The third frame shows another point of view.

The next two strips fall into the "unposed posed" situation. The man on the left was instructed to treat the other man as though he were new on the job. While he does this, you shoot a variety of frames, shifting your position as you feel and see it (see Figure 8-23). Finally, you call the session to a halt (Figure 8-24, frame 32) and the men return to their normal duties.

Don't take your eye off your subject until he is out of your sight. The photography session was over, the personnel dispersed to their various duties but you "saw" one more shot. You made it. Frame 33 falls into this category.

Figure 8-20

Figure 8-21

114

Figure 8-22

Figure 8-23

Figure 8-24

This is
PETER DeGEORGE

The Methods and Procedures Department is responsible for the continuing analysis and refinement of Home Office data processing systems (manual and electronic), the investigation and installation of new systems, and for the allocation and use of office space and equipment from typewriters to Univac. The newly named Assistant Director of this department's data processing function is a 33-year-old Babson graduate and veteran of both Navy and Air Force. Pete DeGeorge came to New England Life from Sperry Rand, developers of Univac, bringing with him valuable experience as a programmer for electronic equipment. In Medfield, where he lives with his wife and daughter, Pete takes an active part in community life and is developing an interest in town government.

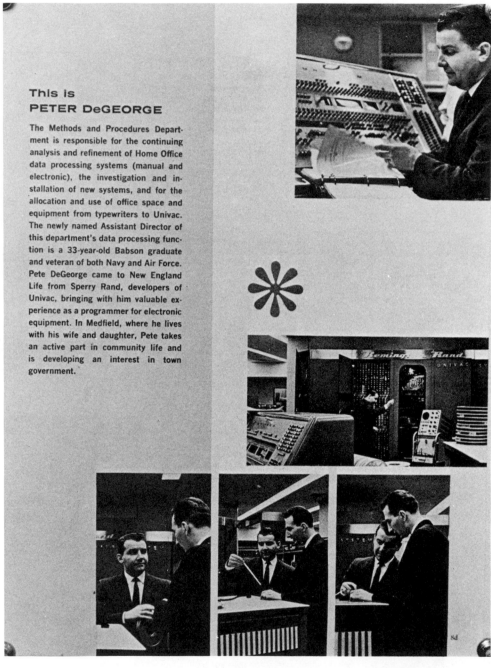

Figure 8-25

You have exposed at least one roll of 36-exposure film in this room. The final selection (see Figure 8-25) consisted of one grab shot (frame 2, Figure 8-22); two consecutive shots (frames 28 and 29, Figure 8-23); and your "good habit" shot (frame 33, Figure 8-24). How they were finally cropped and used by the layout man in designing this page of the brochure is illustrated in Figure 8-25.

You should obtain at least three copies of your published material. Send one to your agent, file the second, and add the third to your portfolio. When visiting other possible users of your work, you should bring along the contact sheets, so that the individual to whom you are selling your work will see your approach.

DO	DON'T
. . . take care of the mechanics before operating.	. . . begin photographing close to the subject.
. . . take at least 6 frames before changing point of view.	. . . force situations.
. . . heed the format.	. . . show all your pictures to the subject.
. . . practice with different sexes and age groups.	

Chapter 9

Publicity

There is no job for you in a photo agency unless you have experience. No on-the-job training programs are available. Your experience must be acquired all by yourself. The easiest way to break the ice is via newspapers that have no staff photographers. These are usually weeklies in your neighborhood. They always need pictures. It is up to you to find out what kind and how many.

The categories are familiar. First, there is the simple identification photo of a person, a place, or a group. Then, after you have made the grade, comes the photo essay. But that takes some doing, as you will see.

At the outset, the basic (or primitive) picture is the one to seek. It is easily found in the public relations department of a factory or institution that operates without an in-plant photographer. The routine need there is for photos of company events—products and, of course, portraits.

Flash equipment is generally enough for such assignments—for the simple reason that the more time-taking technique of the photojournalistic style is, as yet, too little understood by management and boards of directors to enable them to allot the proper budget. To them, a picture is, as yet, only a picture. The quality that the photojournalistic technique delivers (and the necessity for it) is catching up with irritating slowness.

Therefore, be ready to accommodate the low-budget jobs. Even the public relations directors are only beginning to learn the differences in flash, studio, and natural light techniques. But be ready, too, to demonstrate the superior ability of your approach to get the message across, since you, also, have a product to sell.

While flash is the last means to employ in photojournalism, it is, nevertheless, a technique in which you must be proficient. It is the quickest, cheapest, and even at times the most adequate medium. (Chapter 14 explains the basic technique of flash photography.)

Using the flash, the photographer has the subject pointed out to him, finds a plain background, focuses the camera, determines the exposure, and then makes two fast pictures. Back at the lab, where the film is processed, the better of the two is printed, sometimes wet, and the glossy is ready for reproduction. The total cost to the public relations man is $10 to $15 for the taking and the first print, plus $1 to $1.50 each for reprints.

The photographer does not need much talent for this type of publicity picture. But then not much money is being budgeted. The time spent on the job is brief, and the purchaser is getting what he paid for.

Flash Portrait

In Figure 9-1 we have a ¾ pose of a man. He has been photographed via the flash medium. The lighting is monotonously flat; there exists a minimum of modeling. There is an ungainly shadow on the wall; his left ear is of the same intensity in highlight as his nose. This gives the illusion of bringing his ear into the same plane as the nose and other highlighted areas, destroying a desirable illusion in portraits—the third-dimensional quality. It looks cheap when compared to the formal portrait.

The advantages: this service is the least expensive and the fastest. The photographer doesn't have to worry about light intensity; he carries it with him.

Figure 9-1

Studio Portrait

If the public relations man (or whoever is responsible for getting a picture of an individual in a newspaper or magazine) knows in advance that he is going to need a photograph of Mr. John Doe, he should consider the advantages of a portrait sitting.

The portrait photographer, through his manipulation of lights, can create a far more impressive presentation of Mr. Doe to the viewing public. The average individual does not have his photograph in publications very often. When he has the opportunity, he should present his best face.

Figure 9-2 is the portrait-for-publication photograph. The background is light in tone, to give separation from the background. If the background were closer in tone to the man's jacket, there might be a tendency for the ink to run over the dark masses, giving a blotchy rendition in the reproduction.

There are many advantages to this type of sitting. First, a variety[1] of proofs are made so that the subject can present one of his better faces to the public. By means of intelligent retouching, the objectionable

[1]This is a variation of saturation shooting.

blemishes and dark circles under the eyes, for example, can be brought into balance. In summation: a quality presentation of the individual is made. As expected, the cost is increased to about $25 to $35 for the sitting and 6 glossies. For best results, the sitting should take place at least two weeks prior to the time that the releases and pictures are to be mailed to the various publications. It would be advantageous to have at least two different pictures finished to send to competing newspapers, or to give the editor some choice. If you request, the glossy may be returned to you for further use.

The Photojournalist's Technique

In an ever-increasing wave, the available-light-saturation technique is rolling over the flash approach. It is also superseding the portrait approach, mostly in the area of men. Women still have a bit more vanity. It is the most realistic presentation you can give. The viewer knows that what he sees is an unretouched, honest presentation of the subject (Figure 9-3). There is a feeling of intimacy. The viewer can more easily place himself in the setting of a home or office than with just a blank wall. If you add animation to the picture, the credibility is enhanced.

Figure 9-2

Figure 9-3

For any national magazine, be it news, pictorial, or company, this approach is the only one that should be employed.

A photographer with portrait experience (gleaned from working in a studio that catered to quality portraiture), who has mastered the techniques of available-light photography, would be the ideal man to fulfill this particular type of assignment.

Before evaluating the compensation for this coverage, look at the knowledge and time that go into a conscientiously executed assignment of this nature. The photographer knows enough about Point No. 1 to recognize the situation of frontal lighting (Figure 9-4). The shadow that the man's body casts against the wall is quite similar to that of the shadow cast on the wall in Figure 9-1 when the flash gun was used.

He also knows what he has to do to get better lighting on the subject: he changes his point of view and requests that the subject change his position.

When the subject asks the photographer what he should do, the photographer replies, "Answer the telephone," even though it isn't ringing (Figure 9-5). The photographer knows enough about backgrounds and can "see" that when the subject goes to answer the telephone his figure will be free of the furnishings that tell us that this subject is interested in the sea. It is a busy background as well as foreground. Do you think that the photographer makes good use of the physical surroundings?

To get varied situations, the photographer makes a series of medium shots. In Figure 9-6 he demonstrates that he knows how to substitute split lighting for head-on lighting, and in Figure 9-7 the 45° light direction is used. The bearskin rug, nailed to the wall, is just as distracting to the photographer when he begins making the pictures as they are to you. Would you have asked the subject to remove this trophy nailed to the wall for the sake of a few pictures?

In Figures 9-8 and 9-9, you can evaluate for yourself the merit of having the main directional light source coming in on the short side of the face, as opposed to having it depict your subject by falling on the broad side of the face. A photographer with portrait background would know that a very sensitive part of a person's face—the nose—can be narrowed and made to look smaller when the main light plays on the short side of the face (Figure 9-8).

As you look over the 60 to 72 frames that depict your subject in a variety of situations; when you know that your client did not have to go to a studio; and that the entire office sitting took only 25 minutes, do you think that $35 to $50 for the sitting and 3 fin-

Figure 9-4

Figure 9-5

Figure 9-6

Figure 9-8

Figure 9-7

Figure 9-9

121

ished prints suitable for reproduction is fair? And that $1.50 to $2 for additional reprints is reasonable?

Ten-Dollar Thinking

A photographer can be harassed about adequate compensation for his work. Most public relations departments still have penny-pinching photographic budgets. Management has yet to realize that whatever is paid for photographs is still only a small fraction of the total budget appropriated for a presentation. It is the picture that stops the reader; not the text or the caption. If the picture stops the reader, he will read the caption, then the text. If it does not, the message will not be communicated.

A $10 compensation seems to be the top figure that public relations departments feel is adequate for a single illustration. It may be fair payment when all the photographer has to do is appear at a designated place at a certain time and make two flash exposures of one or two people who are waiting for him.

The photojournalist must open the eyes and pockets of the public relations man when the point of view desired is not specified.

If the powers-that-be take you by the hand and bring you to a spot and say, "Take a picture of the college chapel from here, keeping the lamp post at the left and the historical marker on the right," then maybe $10 is fair for your time, processing, and other knowledge (Figure 9-10). But in truth you would be asked, "How much would you charge to get us a picture of the college chapel?" Be very careful before you answer that one!

Arriving at a Fair Quote

Just what is involved in "getting a picture of the chapel?" You must spend time in traveling from your studio, showing your portfolio to the man in charge, discussing the coverage desired, and returning to the studio. If you are smart, you might ask whether you can get a view of the chapel. If you are brilliant, you'll know that in order to submit a fair variety of views of the chapel you'll have to walk around it for the full circumference. You'll want to view it close, and you'll want to view it from afar. You'll know that you must study the chapel from every angle and make many exposures. The clue to this is the fact that the powers-that-be can't take you by the hand and tell you what they want. They don't know. You will have to submit many views (Figures 9-11 and 9-12). There are about 2 hours of walking and viewing ahead of you.

As is to be expected, there are many pictorial views of the chapel to capture (Figures 9-13) and some that aren't poetic (Figure 9-14). You photograph the latter view, since you don't know what kind of picture is wanted.

While you are composing some of the views that have caught your eye, you are disappointed that you have an overcast sky. You wish for cumulus clouds. If there were cumulus clouds, you would put a K-2 filter or orange filter over your lens to emphasize them. But there isn't a break in the overcast, so you have to do the best you can (Figure 9-15). Should you return at a time when the meteorological conditions are favorable? This is a possibility to consider. But if you have made the trip, could you tell management that you would have to include this additional expense, or would you absorb it?

Figure 9-10

Figure 9-11

Figure 9-12

Figure 9-14

While you are walking around the campus in a circle, you are using your "seeing eye." Other pictorial possibilities are caught by your retina and you, in turn, make a permanent image of them (Figures 9-16 and 9-17). As different points of view and subject matter present themselves to you, you trip the shutter. If the campus is big and if your imagination is in keeping, your estimate of 2 hours can be far short of the time you spend on the campus.

Now, pack up and go back to where you do your processing, editing, and contact printing. Are you going to figure this time in or absorb it? You have spent 3 to 6 hours on this assignment and have used 5 rolls of film; there have been travel, telephone calls, and other overhead expenses. Would $75 be fair, if it included one print of the chapel? Would each additional original selection at $10.00 be reasonable?

Or how about $50 for the coverage, plus expenses? And the expenses would include cost of film, mileage, telephone calls, and postage. This payment would include one original print of the client's selection. Any additional originals would be billed at $5 to $10.

By keeping your "seeing eye" open for all possibilities, you can increase your sales. Such was your fate

Figure 9-13

Figure 9-15

Figure 9-16

when you made the extra exposures of the outdoor class (Figure 9-17).

Feature Stories

In the beginning you speculate. You must be willing to give your time and to absorb your costs against the gamble of having your photo published. Once you have established a contact with a public relations man, you can determine whether he has been contemplating any article within his organization. If you are knowledgeable, you approach him with the idea of a photo essay involving his employer. He might have written an article about a section of his company, that could use photographs. He can summarize the high spots. As he relates it to you, you could interject the picture that his words conjure up in your mind; or you could read his text and suggest pictures to him as they flash across your mind.

Aspects other than Photographic

A feature story takes far more planning than a simple news release. First, you have to decide where the story will be placed. This means that you should know the pictorial policies of the publication. You can determine these policies by studying the photo essays they publish. In every camera store there is a publication for sale that lists the payment and photographs desired by periodicals in the United States.

You and the public relations man will agree that

the local Sunday newspaper would be your goal. In this case the payment would come from the public relations budget.

Automatically, the viewing audience is determined as being universal. The story would appear in the magazine or rotogravure section. The public relations department head probably has several contacts with the local newspapers. You can get acquainted with the photo editor of a newspaper by discussing with him your projected photo coverage before you begin work. Or you can wait until you have completed the work and then introduce yourself to him. In either case, you are starting to be recognized.

The section of the paper that publishes your photos will determine the manner in which the prints should be made. The rotogravure section, which is usually reproduced with fine line screen, will give a quality reproduction, yielding more detail than the pulp part of the paper can accomplish.

And there are deadlines. Different sections of Sunday editions have different deadlines. You should at least be familiar with the one that pertains to you. You will have to know the time schedule of the people and the events that you want to photograph. Special permission may be needed to gain access to areas that you want as locations. There may be research and telephone calls required before shooting schedules can be coordinated.

Although a single picture normally will suffice to illustrate the real or contrived news item, the feature story is another matter. A rapid survey in any Sunday

Figure 9-17

supplement will show that at least four photographs are needed. For every one published, the editor would like to have several from which to choose. Different editors have different yardsticks, so you should keep in mind the format previously suggested when shooting.

No matter what the yardstick, they all want an appealing photograph. There are four elements that you should strive to capture in your pictures: they should be imaginative, eye-catching, have good composition, and be quality prints from quality negatives.

Your Presentation

After performing the necessary tasks in photography, you will be faced with the decision about presenting your work. Many public relations men (art directors and even some photo editors) are not at ease with the postage-stamp size of a 35 mm contact sheet. It is a good idea to enlarge several of your negatives to 8 × 10 and include these enlargements (there is nothing better than a visual presentation) along with the contact sheets in your first presentation. You should bring along an extra magnifier for viewing the contact sheets. Eastman Kodak manufactures a 10× viewer. Agfa offers the Agfa Lupe, an 8× viewer. Test both, compare prices, and you will purchase the Agfa.

For handling and filing, it is best not to cut your film into strips of less than 5 frames. On the standard 8 × 10 photographic paper, 5 strips of 6 frames each can easily be printed. It is a good idea to make at least two contact sheets: one for the public relations file and the other for your own file. The frames are numbered, and you can number the contact sheets. The duplicate set will facilitate ordering over the telephone and will help to prevent errors in printing.

Other Publications of the Public Relations Department

The public relations departments of large organizations are responsible for many publications: annual reports, brochures of all types, and special communications, all of which call for the photojournalistic approach. These are discussed in detail in later chapters. What was said about the presentation of the simple identification photograph of an individual holds true for the feature story and all the other publications that emanate from the public relations office. The most realistic, believable, and effective photograph will be delivered via the searching and seeing eye of the photographer employing the available-light technique.

Let me emphasize the magic word "experience."

Before you approach any photo agency you must have several feature stories in your portfolio. If you have a backlog of 6 features—self-assigned or speculative—you have a valid reason for visiting a photo editor, say, once a month. In this way he will become acquainted with you, and if your work is good—it doesn't need to be great—you will stand a good chance of getting that first assignment: the simple identification photograph of an individual.

Before visiting an advertising agency, you should have some published material to show the art director. How does a novice in photojournalism have his material published?

Getting Published

It is the responsibility of every public relations and publicity man to have his organization favorably reflected in the press. Therefore, anyone willing to work, to gamble on his ability and power of persuasion, is bound to encounter an opportunity—the break!

The following account is the play-by-play report of an opportunity that produces experience, the kind of experience that teaches better than any book.

As part of your pavement pounding, you visit the Public Relations Director of St. Elizabeth's Hospital in Boston. You are cordially received, invited to tell your story, and to show your wares. One piece of published material so impresses the Public Relations Director, Leo Gaffney, that his own thought processes are stimulated. Having been a newspaper editor for many years, Mr. Gaffney—hereinafter called PR—comes up with an idea. The idea of an ex-newsman will probably "hit print"—if properly executed. That part is up to you. The voice of experience—the teacher—explains. In the public print at that very moment is the story of a high school boy badly injured while playing hockey. Hospitalized at St. Elizabeth's, the boy is suffering from a clot on the brain which, unless relieved, will have dire consequences.

An operation known as cranioplasty must be performed. A piece of the top of the head would be taken out, the brain exposed, the clot removed, a metal plate inserted to close the skull, and the skin rolled back into place.

PR proposes that you photograph the operation as the highlight of a dramatic story in pictures telling of a boy who would surmount a most grievous injury in order to "play hockey again next season," as one Sunday newspaper subsequently headlines it.

PR does not hope for a science feature emblazoned on the shiny pages of a national magazine or a medi-

cal journal. A cranioplasty is not "news" any more. But, as applied to a local boy who just has to get back on the ice again, the story is a "natural" for its human interest appeal in some local Sunday rotogravure section. However, it does not happen simply. The details are many, and you are anxious to do the story.

What are the details? The first move is yours. To express confidence in yourself, you offer to gamble on the outcome. You will accept no fee unless and until the feature story is published. PR grins; it is his turn to gamble. With no precedent at the hospital for photographing such an operation, he must get permission from the top, get the surgeon on his side, and arrange for you, the photographer, to be in the operating room.

Since the operation is scheduled for the first thing on Monday morning, PR arranges for your shooting schedule to begin on Sunday when parts of the hospital will be comparatively quiet. Because your Hockey Boy (as he is becoming known) is not quite 16, he is classified in the "child" category, which puts him in Pediatrics.

Meanwhile PR has accomplished all the "leg work." The boy's father, overcoming an understandable reluctance to face publicity, has been appealed to, for the sake of other parents in a similar situation. He readily assents. There will be no "invasion of privacy."

With consent of the parent, the hospital cooperates to the fullest. The boy is ambulatory and, in view of his injury, is reasonable. As the shooting progresses, he even begins to enjoy it, which is encouraging.

Putting You to Work

After preliminary small talk in the boy's room, you realize that you must put into practice the exercises performed in learning the informal identification portrait, because in making your picture scenario you will need all of the techniques.

Since you want a picture that will identify the subject, you don't bother with the long shot, but you do make the medium shot. When the boy asks you, "What do you want me to do?" you know how to answer. You pick up the hockey magazine he has brought with him and ask him to thumb through it. All the while you are taking pictures. The saturation method, remember? You then slip off the 35 mm lens and replace it with the 90 mm. You take a few of the close-ups when your instinct tells you that the first sequence, which included the hockey magazine (Figure 9-18), revealed more. Therefore, you stop taking pictures. You have been operating the camera less than one minute and you are ready to leave. All of the previous planning and talk, about four hours

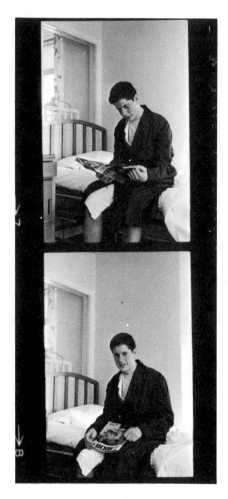

Figure 9-18

of it, is to culminate in just 60 seconds and 7 frames. You feel let down. But you have not reckoned with an experienced newsman. His thoughts transcend just the boy: he is thinking of his responsibility. He wants a representative of the hospital in the picture, and you get a lesson in the three "B's" of publicity: beauty (the female mystique), babies, and beasts (animals). If you can't get all three "B's" in a picture, get as many as you can.

A Lesson in the Three "B's"

Your teacher (the PR man) suggests that you and your subject walk to the playroom. There you find a younger patient and an attractive student nurse. In keeping with the story, there is a manual hockey game for all to play with. Your colleague knows the score. You replace the 90 mm with the 35 mm lens and proceed to take pictures. A sequence of 5 frames follows (what happened to the sixth?) with your boy playing with the younger lad and the nurse looking on (Figure 9-19). You even change your point of view in this sequence. You are really progressing. And

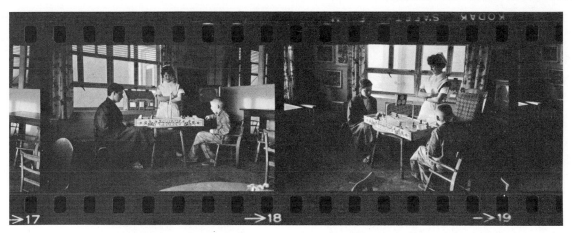

Figure 9-19

then you make 5 more frames (you still can't count) of the hockey player with the nurse as his opponent (Figure 9-20).

Another suggestion from your teacher: place the boy and the nurse closer together, in case the editor of the newspaper would like the two subjects together. He might have space for only a single-column cut (you are really picking up information and experience). The shooting for the Sunday afternoon is finished with this sequence. You put your equipment away and adjourn to PR's office to discuss the next day's shooting.

On the way back, you ask if you can go into the operating room to take meter readings. No operations are scheduled for that day.

You are told that the operation is scheduled for 8 A.M. and that you should be there no later than 7:30 A.M. What you will photograph will depend on what takes place. You are told that you will have to be in a sterile cap, mask, and gown, and must wear nonconductive shoes. All items will be supplied by the hospital.

Before you go to bed that night, you check your two camera bodies, load one with black-and-white film and the other with Type B Hi-Speed color. You decide that just two lenses will suffice: the 35 mm and the 90 mm.

The Second Phase of Shooting

You arrive a bit ahead of time the next morning and meet your contact. You both take the elevator to the fourth floor where the operating rooms are located. Now the question that you asked yesterday about what you would photograph begins to be answered. There is a group of student nurses waiting for their assignments. You see them as you leave the elevator (Figure 9-21). You notice a green blackboard on which the day's operations are written. Heading the list is the one that you are going to photograph. Of course, you take a picture of the board (Fig. 9-22). As you head for the doctors' room, where you are to don the sterilized garments, you are surprised to see your subject in the corridor getting a haircut — a real

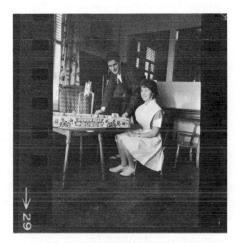

Figure 9-20

Figure 9-21

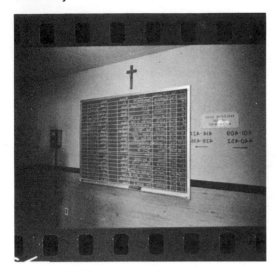

Figure 9-22

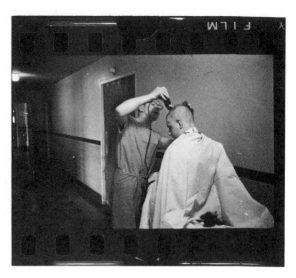

Figure 9-24

close one. You quickly get one of your cameras going. After a few exposures (Figure 9-23), you realize that you aren't including the boy's face, so you shift your point of view slightly and mutter a silent prayer that he will turn his head. You don't want to ask the doctor or the patient to turn for fear you may destroy the naturalness of the situation. You wait and are rewarded (Figure 9-24).

Properly attired for the operating room, you ask the scrub nurse just where you should stay. Then the patient, still awake, is wheeled in. Preparations continue: the anesthetic is injected (Figure 9-25), and then the patient is placed on the operating table (Figure 9-26) where his close haircut is made even closer.

A vagrant and outrageously irrelevant thought crosses your mind as you are making these pictures.

Somehow you are reminded of the many weddings you photographed: the bride getting ready to leave the house, the groom scrupulously dapper, and the various attendants hovering about to make certain every detail is correct.

You are quickly brought out of this reverie by the presence of the operating surgeon and his orders to his assistants about where he wants his patient positioned (Figure 9-27). As the operation proceeds, you are too interested in what is going on, and in adjusting your camera dials, to get squeamish. But when you take your eye away from the viewfinder to change lenses and wipe the fog from your eyeglasses, and take a look at the paraphernalia on and in your subject's head (Figure 9-28), a tremulous feeling begins in your abdomen. You quickly turn away, change lenses on the cameras, bring the viewfinder back to

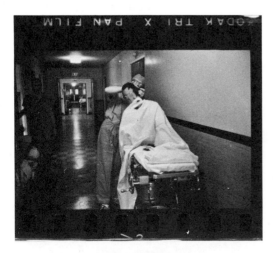

Figure 9-23

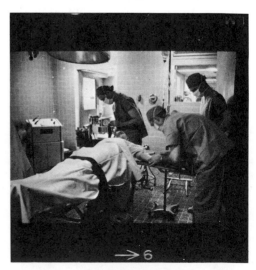

Figure 9-25

Figure 9-26

Figure 9-28

your eye, and observe the action. As long as you see the scene through the viewfinder of the camera, there is no more tremor in your stomach.

When you feel that you have sufficient frames on the action taking place, you change cameras and record a few frames in color. Once the excitement passes, you look around and warily and carefully decide to change your point of view.

The operation continues, but you feel that you have enough pictorial material. Using the 90 mm lens you begin to concentrate on the individuals: the nurse and the anesthesiologist have the best light falling on them (Figure 9-29). You were aware of the light direction and the light intensity before the operation began (Sunday's reconnaissance), but what you could not know before hand was the way it would illuminate the various individuals participating in the operation. As you take the pictures of the nurse, you

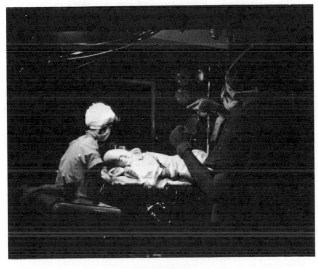

Figure 9-27

Figure 9-29

notice that she is threading a needle. The metal plate
has been screwed into the boy's skull and his scalp is
being sutured. The surgeon leaves and, a few mo-
ments later, so do you.

You return to the doctors' room to change into
your street clothes, but as you enter you see a scene
that you think should be photographed: the sur-
geons, finished with their responsibilities of the
morning, are drinking coffee and talking (Figure
9-30).

You need a cup yourself, but first you must photo-
graph the scene. The format is still working. With the
35 mm lens you make a few frames including the
coffee urn. Then you use the 90 mm lens on those in
conversation. The latter pictures are taken between
sips of coffee. You are inconspicuous to the observer,
since you concealed the camera between your thigh
and the arm of the sofa. You leave the camera there
until you notice that all the people in the room are
ignoring you. Then you take truly candid pictures
(Figure 9-31).

Figure 9-30

Figure 9-31

Many of the pictures that you have taken on this self-assignment did not occur to you when you were discussing the job with PR. You are going to discover that on future assignments a principle will hold true: many pictures, of which you have no conceived idea, will present themselves. Incidents and scenes will appear for a tantalizing moment. Even though what you see may not appear to have any connection with the story you are working on, you should always be ready to shoot. By taking these pictures, you can build a stockpile for yourself. PR can also build a file of hospital personnel, which he can call on at any time.

It is best to have two cameras, both loaded with the same film: one with the wide-angle lens, the other with the 90 mm lens. By constantly taking meter readings whenever you shift to a different location, and by having both cameras adjusted to the correct shutter speed and aperture, you will be ready for those "lucky" pictures that just pop up. With these preparations, all you have to do is focus and shoot.

If you have a superwide-angle lens on the camera and your other settings have been made, you won't even have to focus.

Keep Shooting

Is the coverage complete? That depends on you. On the way out, with your equipment packed, you discover that your prime subject is now in the recovery room. You unpack a camera and start making this sequence (Figure 9-32). You finish when the attending personnel discover you (Figure 9-33).

Now can you go home? Occasionally you will be asked by individuals outside the assignment to take their pictures. It is good public relations for you to comply.

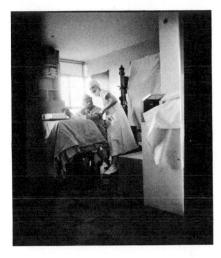

Figure 9-33

You return to PR to relate what was photographed. He (but not as much as you) is anxious to see the results. You tell him that he will get his copies of the contact sheets in a day or two. He will get in touch with you for the next phase as soon as he knows when the Hockey Boy is going to be discharged. If you have spent any time in a hospital, you know how vague doctors are about the date of discharge. Just be prepared to drop whatever you are doing if you want the discharge sequences.

Dropping Everything

At best, you can be wondering what you are going to do for the rest of the day. At worst, you will have just begun to develop some film when the telephone rings and PR informs you that your subject is being discharged in 45 minutes. When you arrive at the hospital, you are directed to a waiting room where the young lad and his father have been waiting for you. You take meter readings and, with the 35 mm lens on your camera, you are ready. Then the eternal question: "What do you want us to do?" By this time you are experienced sufficiently to answer, "Just check out."

Father and son assemble their gear and walk out of the waiting room (Figure 9-34). It is easy for you to get this on film, since you have prefocused your camera on the chair which is slightly behind the door. You have time for 3 frames as they walk out. This doesn't seem sufficient for someone versed in saturation shooting, and you are not happy with the direction of the available light.

You request the father and son to enter the room for another sequence. You think that, as far as a

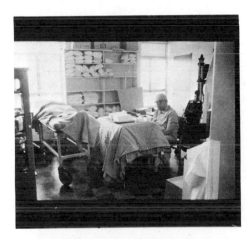

Figure 9-32

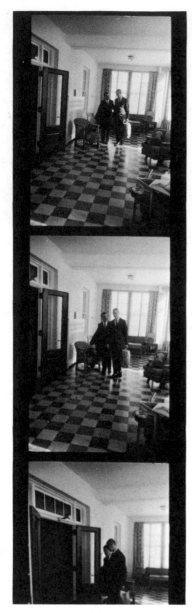

Figure 9-34

The lighting in this sequence is the best you've had. It is side lighting from the point of view that you are using.

There is a delay here until the records are squared away. Your mind recaps the pictures you've taken and you aren't happy. Not enough time! You think of the pictures you made in the elevator and, although the subjects were impressed by your operation (taking pictures in a moving elevator with no flash), you are thinking of the background and foreground of the shots, which are nothing. These pictures could have been taken against a wall. You think back to the importance of background and foreground (stressed in Chapter 6) in helping the viewer to get the story you are trying to tell. You are brought back to activity when your subjects leave the cashier's window and head for the exit. You ask them to stop a moment while you run ahead to obtain a position where you can photograph them as they leave the hospital.

Outside, you take new readings on your meter and make the necessary adjustments pertaining to your aperture, shutter speed, and focus. For the latter, you focus on the door. You note the distance. You figure that you won't take any pictures when they are 10 ft.

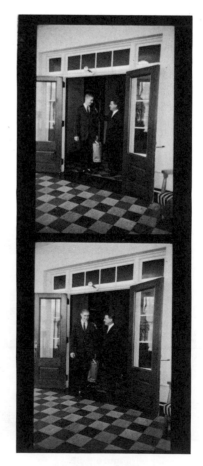

Figure 9-35

viewer is concerned, they could be walking out of a corridor into a hall. This sequence is certainly well lighted, but now you have frontal lighting (Figure 9-35). By this time, you have considered all possibilities in the waiting room and have decided that this location isn't the spot, and you do have some film exposed for protection if nothing better presents itself.

In the meantime your subjects are taking you at your word and are proceeding to check out. They get into the elevator. You accompany them. You naturally get a few frames—this would be the closeups (Figure 9-36)—and then the father walks to the cashier's window to pay the bill. You don't know whether this sequence is active enough, but you take it—just as it presents itself (Figure 9-37).


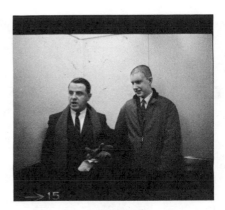

Figure 9-36

from you. Since the exposure will be $f/5.6$ at 1/250 sec, you set the 10 ft. mark on your lens dial opposite the $f/5.6$ mark, on the depth of field indicator engraved on your lens. You note with satisfaction that the corresponding $f/5.6$ mark indicates that the farthest distance in focus will be close to infinity. When father and son exit, you will be able to shoot frame after frame without focusing, and your subjects will be in focus. They appear. You have time to get 3 frames. You would like to have more but you haven't the nerve (as yet) to ask them to go through this action again. Once they're out of the hospital, you can't ask them to go in again.

Your inexperience is most obvious in the "exiting" sequences. Your zone-focusing adjustments are fine for the sequence in Figure 9-38. But you should have moved up closer to get larger images for the initial frames. As your subjects walk forward, you should be moving backward at approximately the same pace.[2]

[2]Compare this sequence with Figure 18-7 in Chapter 18.

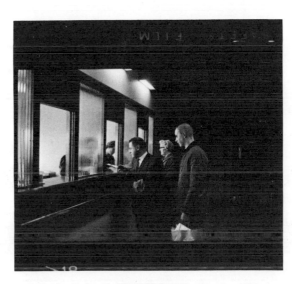

Figure 9-37

The fast shutter speed you are using—1/250 sec—should minimize any movement of the camera.

There is one more phase of this photo essay to shoot and you return to PR's office to discuss it.

The Concluding Picture

It was decided in the beginning that your concluding shot would show the boy, in triumph, whizzing down the ice as good as new. This is fine in theory, but there are difficulties. Although the boy's progress has been good, it has not been that good. Weeks pass. Anxious to finish the story, you telephone PR. He finds out that the boy will not be able to play hockey until next year.

You are stymied again. You simply must have a better, more dramatic finish than father and son walking away from the hospital. How about dressing the boy in his hockey suit and posing him near the bench? This is too tame. After more thought and more telephone calls, you decide to wade in somehow and get whatever you can.

With PR's help, you invade the boy's home. Again you are cordially received by the boy's father who, you find out, is an art director. His aesthetic sense is

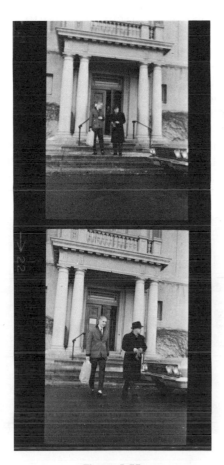

Figure 9-38

apparent everywhere in his home. Your luck is picking up again. And the lad's hair is growing out fine.

The pleasantries over, you get down to business. Since there is no hurry, no pressure, you can take time to look around and find the best place to situate your subject. He proudly shows you an autographed hockey stick from the Boston Bruins. This is your beginning.

He sits down at a table and shows you the stick.

You pay attention to the light direction and get a nice split light on his face. You take pictures. The situation seems static to you (Figure 9-39), so after you have made 5 frames you suggest a change. How about having him look out the window? You want the picture to convey the idea that he wants to get outside. You want him to have a wistful expression on his face, but just how to prevail on him to do this is another matter (see Figure 9-40). Your subject is very cooperative and follows every suggestion you make.

There is one difficulty: you don't have enough experience to know what to suggest (you don't realize this, but it is true). You ask him to pick up his trophy and look at it. You'd like to add, "Look at it wistfully," but you don't. You're lost, but you can't admit it.

His father asks you if you'd like to see the headguard that his son is going to wear when he resumes his hockey playing. You seize the opportunity for getting out of a spot and say, "Great!" You are now inspired. When you are asked, "What would you like us to do?" you quickly reply, "Explain the construction of the helmet to your son."

Since the boy assumes a natural position and has a good 45° light falling on him, you start making your pictures. First, you use the vertical format, and then you shift to the horizontal. Your eyes "see" that the boy's head falls in the area of the window (Figure 9-41). You realize that this isn't good. You request a

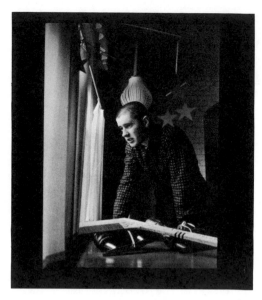

Figure 9-40

change in his position and, when you change your point of view, you notice that the father's head falls directly in the window area (Figure 9-42).

Should you suggest another shift in position? You can't, since you have already been suggesting change after change. You don't want them to know what you now know—you don't know enough!

Rationalization is a wonderful defense. Your mind provides you with this: the boy is the important figure. The father is merely a prop. The picture is more effective this way. You are not as poor a photojournalist as you were beginning to think. In fact, because of this rationalization, you are a pretty good photojournalist. You make just 2 frames in this position, having forgotten how many you should be making (6, remember?). You return home. There is still the processing to handle.

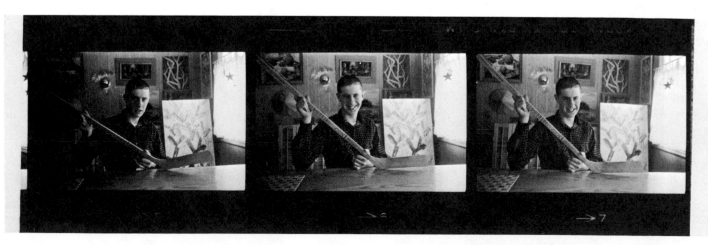

Figure 9-39

Figure 9-41

More Ashes on Your Head

When you view the contact sheets of this sequence, you are really chastened. The sequence (Figure 9-39) is static. You wish the boy's skates were in the picture. They could have been, you know. All you had to do was to ask. The frames of him looking out the window? Why didn't you "see" his head in relation to the lamp in the background (Figure 9-40)? Back to Chapter 6 again. And for the final few frames? You had better go back to Chapter 2.

The color transparencies of the operation are eagerly scanned. There is a greenish cast in all of them! A call to Eastman Kodak brings a technical representative. You are informed that a Daylight Type film

Figure 9-42

should have been used because of the color temperature of the operating light, and not Type B which is balanced for tungsten. Why didn't you read the instructions that accompanied the film? You are also informed that whenever the source of light emanates from fluorescent tubes, a color film balanced for daylight should be used. Later in your career, you learn to add a Magenta CC20 filter to improve the color of your transparencies, if the source of light is from cool white fluorescent tubes.

Your Presentation

You sit down with all the contact sheets to decide on a presentation. Because of the lack of impact in the final sequence, you decide to bring just three 8 × 10 enlargements for viewing: two are medium shots of the boy displaying his autographed hockey stick (one serious, one smiling), and one of his father with the headguard.[3]

Back to the opening coverage. You'll bring the contact sheet of this. Since frames that identify the boy in his hospital room have large images of him, you won't enlarge any of these: you'll let PR pick out a few. You make 2 8 × 10's: one of your subject playing with the younger boy while the nurse is looking on and one with the subject and the nurse (Figure 9-43).

You really go to town on the operating room coverage: 17 8 × 10's. You include in these the close-ups in the operating room and those pictures of individuals taking a break (Figure 9-44). Your thinking on the latter enlargements is to impress PR with the idea of having pictures on file of the various doctors connected with the hospital. Even if nothing comes of the basic story, you may be able to persuade PR to have every staff physician photographed. Doctors are difficult men to pin down for pictures, and you hope to sell the idea of getting them photographed before a news release is ready for the press. To complete your display, you submit enlargements (8 × 10) of the frames shown in Figure 9-45.

With these enlargements and the contact sheets, you call on PR. First, you show him the enlargements and then the contact sheets. A viewer (8×) is presented to him to aid in studying the contacts. He is happy with the presentation. You feel better. He tells you that he will submit his story and all the material you have brought to an editor.

[3]Even in your thinking of the presentation, you display your immaturity. You should start with the beginning of your story and follow through. You have promise though, you submitted a serious and smiling pose for variety.

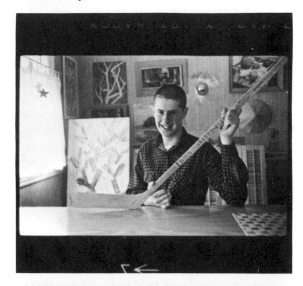

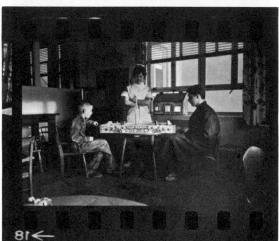

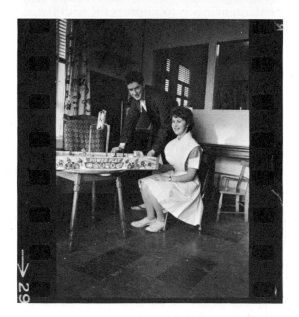

Figure 9-43

The Outcome

Six weeks later in the rotogravure section of a huge Sunday newspaper is your first published story (Figure 9-46). No byline, no operating room pictures, but you have published material with which you can build a portfolio. On Monday you call PR, and you are both happy. You are even happier to learn that you will get paid for your efforts.

Epilogue

This is the last contact you will have with PR for three years. One day he calls you. The hospital is going to publish a dedicatory issue. PR has tried other photographers who use the flash technique. But this doesn't work out well in a hospital. He did try one photographer who uses the available-light technique, but PR wasn't happy with the results. PR finally remembers you. And now you are to have another chance. Fortified by three years of experience and a good bit of published work, you confidently discuss the coverage and your reimbursement. No speculation this time: $150 plus expenses for a 5-hour shooting period. One set of contacts and a choice of 10 original prints. Additional originals will be $5 each. You get this assignment, at the completion of which you get another, and then another.

How Do You Break into the Big Time?

After you have mastered the basics of your medium, it will be speculation, speculation, and more speculation. The only way you can convince an agency that you are capable is by submitting photo essays.[4] While you are in your training period, you must use "self-assignments." The subjects of these essays must, of necessity, be conjured up by your own imagination. If you can't think of a theme, you have a rough road ahead of you.

Don't try to do it all alone. Good help is always just around the corner. The contribution of PR in his teaching capacity has been shown. Even Van Cliburn,

[4]If you have a theme, shoot it. Study the contacts. Now act as if you are the photo editor. Enlarge those that you feel will best tell the story you are trying to tell. Attempt your own layouts. If the results are disappointing, get help, as suggested in Chapter 2, and reshoot the story. Learn your weaknesses and work to correct them. If your results are good, test them. Bring them to the photo editor of your local paper and see if he will print them. Even if he does not, he might have some valuable suggestions.

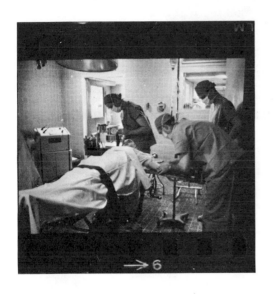

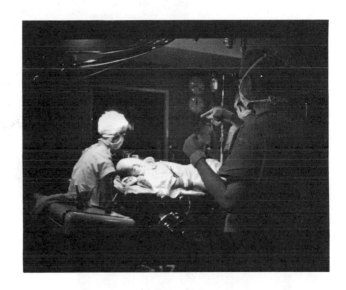

Figure 9-44

Figure 9-45

the famous pianist, practices every day "until he falls off the bench."

DO	DON'T
. . . learn what a job entails before quoting a price.	. . . ignore the help you can get from others.
. . . give yourself sev-	. . . forget your "viewing audience."

eral self-assigned photo essays.

. . . speculate in the beginning.

. . . learn the "behind-the-scenes" work.

. . . learn to suggest credible action.

. . . submit quality prints.

. . . underprice your services.

He'll Play Hockey Again Next Season

A hockey game, a collision on the ice, and a boy goes to a hospital in critical condition.

The story of William N. Brule, Belmont Junior High School student, began at the Skating Club of Boston, Soldiers Field rd., Brighton, last October.

Things looked bad for Bill, then 14. He was taken to St. Elizabeth's Hospital in Brighton where a skull fracture was found. His condition improved for a few days, then deteriorated. He began to see double, indicating a possible blood clot.

Special x-rays of the blood vessels pinpointed a clot. Only one thing to do: operate.

His skull was opened and the clot which had formed between the covering of the brain and the skull was removed by Dr. Joseph F. Dorsey.

Within 48 hours the boy was calling for a steak. A few days later he went home to 59 Channing rd., Belmont—but with a hole in his head.

On the morning of his 15th birthday—Feb. 8—he went back to the operating table at St. Elizabeth's. This time a vitallium plate was inserted to protect the brain.

The happy ending will come next hockey season when Bill—wearing a helmet given by the Boston Bruins' Charlie Burns, who suffered a similar injury, and carrying a stick autographed by all the Bruins—will take to the ice again.

On the eve of his 15th birthday William Brule of Belmont, left, plays a game of table hockey with another young patient in St. Elizabeth's Hospital before second operation. Priscilla Vincent, student nurse, looks on.

A week after the operation Bill leaves St. Elizabeth's for home with his father, Norman Brule, art teacher in the Lexington schools.

PAGE 4

When the next season rolls around Bill, as good as new, will be playing hockey with this stick autographed by all the Boston Bruins.

BOSTON SUNDAY GLOBE, MAY 5, 1963

Figure 9-46

139

Chapter 10

Assignment: Four Specified Pictures

After you have successfully completed several assignments of the informal portrait type, your agency feels you can handle a more challenging coverage. A letter comes to you through the mails which reads as follows.

July 29, 6—

Dear M.:

I am glad to have another assignment for you from *M.E.* I am enclosing a memo that will describe the pictures they would like you to take.

The job is considered a one-day job, and we will get $X of which you will get your regular share and expenses. All the people shown have to sign a release and the releases must be sent together with the negatives.

M.E. would like you to get in touch with Dr. R.A.N. at the L. Clinic (address and telephone number) and, if possible, would like to have the pictures taken between now and August 6. If, however, Dr. N. can only make it later, it is all right too, but please inform us.

They would like to have a good selection of pictures, preferably at least 1 or 1½ rolls on each situation. The photographs should be taken from different angles and from different sides with good expressions.

Looking forward to another fine execution of assignment by you.

With best regards,
L.D.
P. Incorporated

This letter is not a surprise, for you had been contacted previously by telephone to see if you were available for this assignment. During the conversation you were informed that instructions would be included with the letter.

P. enclosed a carbon of the memorandum that the agency had received from *M.E.*

We'll illustrate this article with photographs as follows:

1. A photograph of Dr. R.A.N. with an armful of medical journals boarding or preparing to board the bus on which he commutes to and from the L. Clinic.

2. A photograph of Dr. N. and his colleagues in the nine-man gastroenterology department making G.I. Grand Rounds at the N.E.B.H. where the L. Clinic sends most of its internal medicine patients. (After telephone conversation with Dr. N. we agreed that if the above is not possible, we'll photograph the group walking down a hospital corridor, implying that they are going to a meeting or to rounds.)

3. A photograph of Dr. N. working on the plan or a model of the new equipment that he's designing for diagnosis of esophageal impairments. (If this photograph is *not* made in Dr. N.'s office at the L. Clinic, ask the photographer to take a shot in that office illustrating its smallness: perhaps the doctor can be dictating a letter to a referring physician.) (After talking to Dr. N., it is suggested that Dr. N. be in his office with catalogues, etc. strewn about the desk and office, and Dr. N. poring over one as he is standing up which would indicate some kind of equipment.)

4. Dr. N. escorting one of his sons, who frequently accompanies him to the office on Saturdays, on a visit to some Boston attraction—skyscraper, the zoo, the railroad station, or the like.

Along with this were the usual releases and the List of Requirements mentioned in Chapter 2.

Getting to Work

Now you go to work. Armed with the telephone number, you dial it. If you are lucky, you are connected the second time you call. The trouble is that doctors at clinics are busy people, and trying to locate them, pin them down, and talk to them for a while on nonmedical matters, is not easy.

Your first telephone call to Dr. N. results in being told to call him back at 4:30. When you call back at that hour, you are informed that the doctor left early and that you should call again tomorrow. You diligently call at 10:00 A.M. and are instructed to call back at 3:00 P.M. This time the operator informs you that the doctor is busy and you are to call back at 4:30. This time you are successful. After identifying yourself as the photographer from M.E. (they have told

him to expect a call from a photographer), you request permission to visit with him to discuss the assignment. A date and time are set.

Beginning the Assignment

You set out with your equipment. Even though it is just for a discussion, it always pays to have your equipment with you for the unexpected. Upon arriving, you are rapidly ushered into his small office and your conversation begins. It is a rainy day and the discussion naturally centers around the weather. With the amenities over, you take out the memorandum and discuss what you think will be the most difficult picture to arrange, as far as timing is concerned. The doctor concurs with you that the fourth—the sequence with one of his sons—will require the most planning.

Since it is now late in the afternoon, you assume that he will be heading home and point 1—boarding the bus—comes to mind. He tells you that due to a very busy schedule, he has hired a car for the next two weeks and will not be using the bus.

Masking your disappointment, the two of you become involved in item 2. Here you are informed that "grand rounds" don't exist. You'll set up a group walking through or down a hospital corridor. Disappointed again. By this time you are wondering about ever getting a picture taken and how you'll explain it to your agency.

A bit of hope as you come to item 3. You ask Dr. N. if he can get out the plans or the experimental model of the new equipment that he's designing. He takes out a catalogue, some rubber tubing, and a few other small items, and places them on his desk.

Again you mask your disappointment, for you had envisioned yourself taking dramatic photographs of laboratory equipment, test tubes, and bubbling beakers. In your mind you have photographed your subject as framed behind a myriad of glass tubing. His head is just discernible through a gap in the smoke emanating from one of the bubbling beakers. You were going to show these editors *pictures*! But now what to do?

Take Pictures

Take pictures. First from one side. After a few exposures you notice that the light falling on the doctor is very flat (Figure 10-1) and Point No. 1 comes to mind—avoid frontal lighting. You change your position 180° (Figure 10-2). His office is so small that even with the 35 mm wide-angle lens on your camera, you

Figure 10-1

Figure 10-2

have to step outside the office. This gives you back-lighting from the window, overhead lighting from the lamp on the ceiling, and some light from his desk lamp (Figure 10-2).

As soon as your subject gets busy, so do you. It doesn't take long to realize that the lighting is flat (frames 4A to 6A). You quickly shift to a position that gives more dramatic backlighting (frames 7A to 9A). Note the appearance of flare on the subject's back: particularly frames 9A and 15A. If the head fell in this area your photographs might be spoiled.

Some Welcome Visitors

An interruption occurs when another doctor enters wanting to talk to your subject. When the visitor sees that your subject is occupied, he says that he can come back later. Do you let him go? You are very polite and say that you will wait. The patient they want to discuss certainly comes before your assignment. When they have finished, you suggest to your subject that he explain his development to the other physician. They cooperate and you take pictures still employing back-lighting (see Figure 10-3).

A doctor's office is a busy place, and in walks a third physician. A brief conversation follows. Dr. N. explains the situation and you begin the entire shooting again (see Figures 10-4 and 10-5).

A nurse approaches and wants to speak with Dr. N. You tell her to go right ahead, which she does. You retreat to the corridor and use her entrance for a new series of pictures (see Figure 10-6).

The entire sequence, including the interruptions, takes about 10 minutes. The nurse leaves along with the other doctor. This session, which covered item 3, is over.

When another person enters, you keep on shooting. Because you were operating with the camera vertical, your first frame with the new person's entrance was made vertically, but you quickly shifted to a horizontal format. This is to give the art director more space for his idea of cropping.

Having made sufficient frames from one point of view, you have no choice but to return to the less interesting frontal, flat light to get additional coverage (Figure 10-5, frames 18A to 20A). Feeling that you have enough of this situation, you move back for a long-shot sequence. A nurse appears to ask the doctor a question and you back off even further to include her (Figure 10-6, frames 26A to 27A).

All pictures were made with the 35 mm wide-angle to get a large depth of field and to minimize camera

Figure 10-3

Figure 10-4

movement at the slow shutter speeds necessary, *f*/2 at 1/30 sec.

Always include one frame to show the situation, if you think that the points of view for taking pictures are limited. Figure 10-7 clearly shows how cramped the room is, limiting the points of view.

You have seen all the sequences made. If you were the editor, which would you have selected to illustrate the third requirement—not posed in appearance? Figure 10-8 is the picture selected (frame 10A, Figure 10-3) and the way it appeared in *M.E.*

Grand Rounds

Just as you are set to shoot the simulated grand rounds, the doctor is called to the house phone. What do you do? Of course, take pictures (Figure 10-9, frame 2A). When he has finished the call, he and two other doctors who have been pressed into service are asked to do exactly as they would do if they had just

finished with a patient in the examining room behind them. Having made 4 medium shots, you decide that you want more of the hospital corridor in your pictures to give a better feeling of "hospital," you back off.

You are happy when two nurses walk by (Figure 10-10, frame 10A), paying no attention to you. You feel that they have given your picture just the right touch of realism that you think the editors are looking for.

Which of this sequence was chosen? Frame 5A, Figure 10-9 was selected (see Figure 10-11).

You aren't completely satisfied with the previous coverage, because the idea of "Grand Rounds" brings forth—in your mind—the idea of movement. What you have just shot is fairly static. You want more animation in the sequence. You want the subjects to be walking.

In frames 12A and 13A, Figure 10-12, your subject is convincing the nurse that we need her. You focus on the corner (frame 14A), and then place this point

Figure 10-5

Figure 10-6

Figure 10-7

at the far end of your depth of field scale. Now you can take advantage of having more of the foreground in focus as they turn the corner and walk towards you. You are dismayed when you notice that one doctor has been partially hidden by another (frames 15A and 16A). You advise all the participants that the previous sequence was spoiled because of this, and they agree to give it one more try (Figure 10-13, frames 19A to 21A).

Advantages of the Wide-Angle Lens

After processing and examining the film, you are gratified to see that you have what you want. Now the question is, is it what the editor wants? You had a few misgivings because you were working at slow shutter speeds and wide aperture ($f/2.0$ at 1/15 and 1/30 sec). To compound your misgivings the subjects were moving. By employing the 35 mm wide-angle lens and the table tripod converted to a chest tripod, you minimized camera movement. By having the subjects walking directly toward the camera, you minimized subject movement.

An examination of the negatives through an 8×

viewer convinces you that these negatives will give you prints that are suitable for reproduction. One picture is selected from the nine shown. Your choice? Frame 17A, Figure 10-13, was the editor's choice (see Figure 10-14).

Picking up the Assignment

Two days later you make your afternoon call and are told that Dr. N. has some visitors for the weekend and will not be bringing his son into Boston this weekend. What now?

Checking back to the instructions that you received in the letter, you write to P. telling him what you have and what the problems are. At least, this time you don't have a rush deadline to meet, so the week's delay until Dr. N. brings his son into Boston doesn't matter too much. You left Dr. N. with the understanding that you will be getting in touch with him about the middle of next week.

On Wednesday you make your telephone call. Dr. N. still has the hired car, so you both decide to simulate his taking the bus. He is very cooperative and arrangements are made for him to meet you at the bus station at 6:30 P.M.

gives his services gratis. Lahey's administrators aren't opposed to occasional free treatment on a one-time, first-aid basis; it makes for goodwill. But they maintain that such treatment shouldn't turn into medical moonlighting. And Dr. Norton makes sure that it doesn't.

He prefers to concentrate when he can on his subspecialty —something he was unable to do on his own. He had opened a private practice in Hingham after completing his post-graduate training in gastroenterology at Scripps Clinic in California. But he found that only

PURSUIT OF SPECIAL INTERESTS IS ENCOURAGED among Lahey Clinic doctors. Dr. Norton, for example, is studying disorders of swallowing. Here he considers a selection of testing equipment the clinic will buy to help with his research.

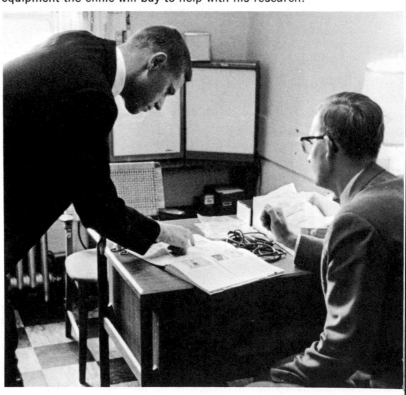

Figure 10-8

Figure 10-9

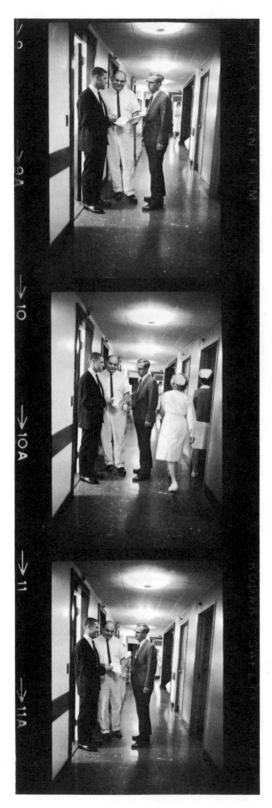

Figure 10-10

Don't Miss the Bus

You arrive at the bus station ahead of the appointed time, hoping to photograph, as one situation, Dr. N. arriving at the station. It doesn't work out this way. Dr. N. is asked where he waits for the bus if he arrives at the station early. He replies that he normally sits down on a bench. You recreate this situation (Figure 10-15). Then you go outside where the buses are boarded, to the spot where his bus usually stands, and you start to make pictures (Figure 10-16).

You simulate just what the doctor would have been doing for item 1 (boarding the bus) on the requested situations, if he had not hired a car. You make medium shots and close-ups, and ask the subject to turn the pages of the medical journals all the time you are taking pictures.

When you feel that you have had enough of this situation, you both walk to where he would board the bus and repeat the procedure.

Note the subject movement of a passerby in the background of frame 9, Figure 10-16. These frames were exposed at $f/2$ at 1/15 sec. The camera was on a tabletop tripod which was braced against a convenient column in the station. Additional situations were photographed, but the final selection was made from those discussed. Which one? Frame 5, Figure 10-16 was chosen (see Figure 10-17).

Is the assignment over? Hardly. You only have two situations. You'd like four, but you will settle for 3. This time the boarding entrance provides a clue as you see a sign over the door that reads "Hingham." You suggest to Dr. N. that "he get in line." He cooperates and while you are shooting, the Hingham bus comes in. You both go outside, and with his arms filled with the medical journals, he waits to board. You take a few shots. The bus driver has a schedule to meet, the doctor wants to get home, and so do you.

More Problems, or Someone is Camera Shy

On parting, Dr. N. informs you that his sons are under the weather and won't be coming into Boston. Now what? You call upon your ability to improvise and your imagination, and suggest that you drive to Hingham to shoot the pictures there. While discussing the pros and cons of this—his time schedule is a big factor—you both decide to shoot this sequence in the late afternoon.

Dr. N. tells you that the son whose turn it is to go into Boston is camera shy. You ask Dr. N. to invite his son to visit the harbor with him and not talk about

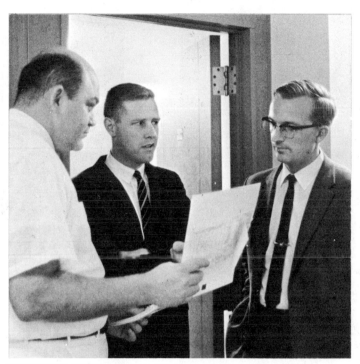

TEACHING DUTIES ARE A STIMULATING CHANGE of pace for doctors in clinics with fellowship training programs. Here Dr. Norton, center, discusses management of a patient with Dr. Saul Adams and Dr. Victor A. Lesniauskas, clinic fellows.

ions from two of the clinic's specialists, an abdominal surgeon and a gynecologist. A solo man on a similar case would have spent several days lining up the same consultants for his patient.

Big-clinic medicine, Dr. Norton finds, is more intensive medicine, too. The heavy proportion of seriously ill patients who present unusual medical problems, and the interesting conditions frequently available for clinical research, combine to make clinic work more challenging. "It adds up to a more satisfying kind of practice," says the 36-year-old M.D.

For a look at that practice, let's follow Dr. Norton through his typical day, starting at 6 A.M. when the alarm clock rings at his home in the seashore town

Figure 10-11

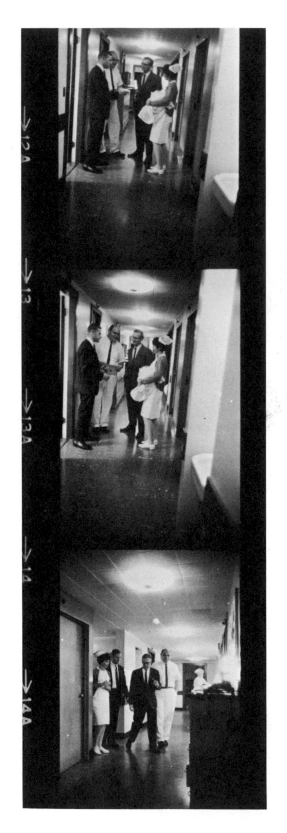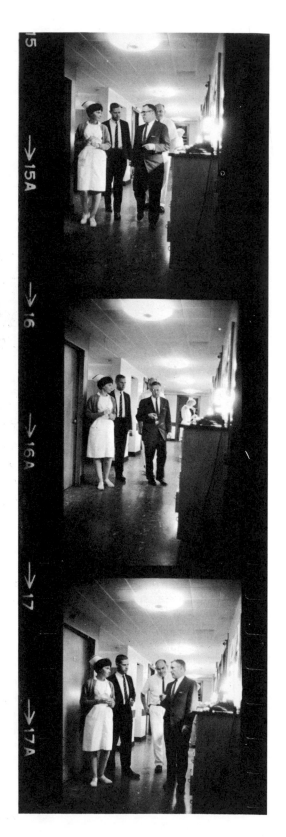

Figure 10-12

your presence—that you'll shoot this candidly. You get them leaving the house once, request a second sequence, get it (Figure 10-18), and then while Dr. N. explains to his wife that he'll just be going down to the harbor and will be back in 15 minutes—what are you doing? Taking pictures (Figure 10-19, frames 25 to 27).

This sequence could have been improved with a longer focal length lens—or if you had moved in closer, but you don't want to take the time to change lenses or camera or re-focus, lest the naturalness of the situation be lost.

One of these nine was chosen. Can you decide which one? Frame 27A, Figure 10-19: the last of the sequence—a true candid (see Figure 10-20).

You go to the harbor and take another half roll. You finally thank him and bid him goodbye.

Chores without the Camera

The next day you process, edit, and contact your film. Assemble all the authorization sheets which are signed, and mail these to your agency, with your expense sheet—telephone calls, film, processing, travel, and postage.

It is not necessary for you to process the film; you can send the exposed film, in its cassettes, directly to your agency. The agency will take care of all the processing. (I prefer to do my own processing. I want to know as quickly as possible whether or not I have a good job, and an examination of the negatives is the way to find out. This also provides you with a constant check of the equipment used.)

Two sets of contact sheets are made. One is included with the negatives and other material mailed to the agency, the second is filed in your notebook.

Two months later you receive "tear sheets" of the pictures published (sometimes you get the entire publication), and one month later comes the financial reimbursement. The regular share of the $X is 50% plus expenses. Every telephone call, the mileage, postage, and about $2 per roll of film processed and contacted, plus the cost of the film, are included.

The Breakdown

The time spent at the clinic getting the sequences of the doctor and his new diagnosing equipment and the grand rounds took about 1½ hours. Add 30 minutes for telephoning, and another 30 minutes for

Figure 10-13

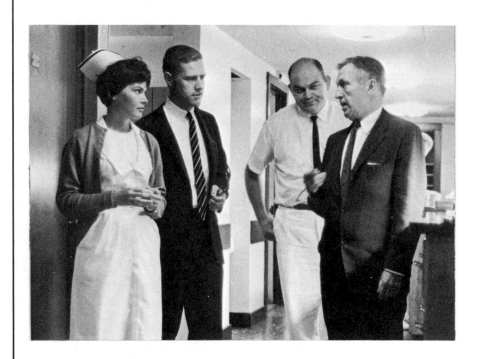

and residents and in the clinic's labs, Dr. Norton has yet another duty to perform before he can knock off for the day. He spends about an hour dictating letters to referring physicians, patients and their families. "But," he says, "at least I don't have to labor over insurance claim forms the way I did when I was a solo man."

Then, with the paper work out of the way, Dr. Norton can usually call it the end of a working day. But not always. Not long ago, as he was sitting down to dinner with 16 guests at home in Hingham, Mass., a resident phoned to report that a patient had started to bleed heavily. Dr. Norton drove the 20 miles to Boston, took care of the patient—and got home in time for the end of the party. "Fortunately," he notes, "that sort of thing happens only three or four times a year. Usually, when I'm off, I'm *off*."

When he is at work, Dr. Norton can concentrate on his subspecialty—something he wasn't able to do on his own. In 1961 he'd opened a private practice in Hingham, Mass., after com-

Medical Economics, November 29, 1965

Figure 10-14

Figure 10-15

travel to and from the clinic (the studio is in the area of the clinic), and you have 2½ hours spent on this part of the assignment. About one hour was spent doing the bus sequence, to which should be added 45 minutes for telephoning and travel.

Since the doctor lives about 25 miles from the studio, 2 hours of travel were needed for the father and son picture. He lives in a summer resort area and traffic is slow. The photography took about 45 minutes. Fifteen minutes of telephoning has to be included.

If you add just the time spent on location, you have 3 hours, 15 minutes. If you include travel, telephon-

ing, identification, and mailing, you have 4 additional hours. You are paid about $9 per hour.

Later, you receive $12.50 for another picture that was used in a subsequent issue of the magazine. Since the agency files the negatives, you have no additional work.

Transference of Old Knowledge and Gaining New

Because of the knowledge gained in recognizing light direction from the informal portrait, you are

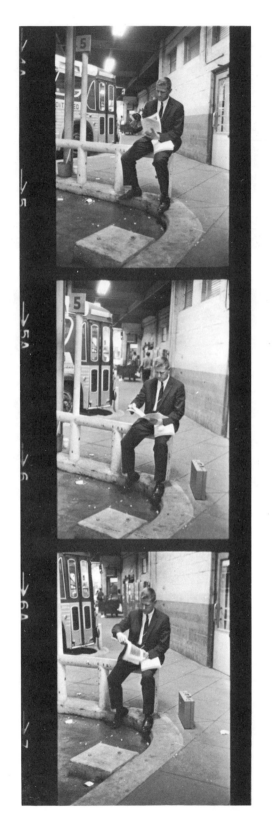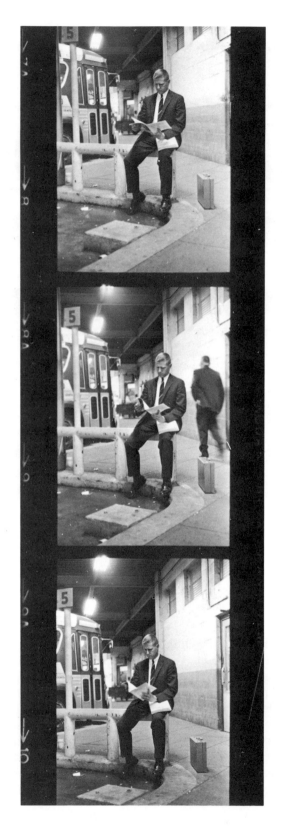

Figure 10-16

held together by the clinic administration and by a common setting.

At Lahey Clinic in the afternoons, Monday through Friday, Dr. Norton normally sees some 15 outpatients, including, generally, three new ones who require complete work-ups. And three days a week, he sees another 10 to 20 patients for special procedures—fluoroscopic X-ray work (the gastroenterology department takes care of its own), proctoscopy and occasional gastroscopy.

During his hours in the clinic Dr. Norton finds time to pursue his special concern with disorders in swallowing. He helped start the clinic's use of Bernstein tests for esophagitis, and, with the help of Lahey's thoracic surgeons, he's working on the design of new equipment for diagnosis of esophageal impairments. His research findings are published in the clinic bulletin, and they contribute as well to the lectures he gives as part of the clinic's fellowship training program.

After his work with patients

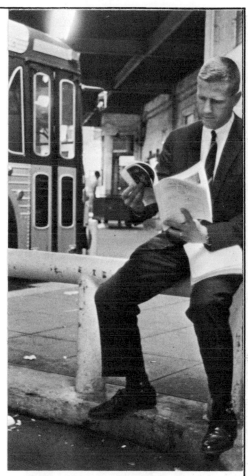

Economical use *of travel time marks Dr. Richard A. Norton's daily commuting from his home in Hingham, Mass., to his job at Lahey Clinic. While waiting for his bus and during the ride to Boston, he can catch up on reading journals.*

Medical Economics, November 29, 1965

Figure 10-17

Figure 10-18

able to transfer this knowledge to a scene (Figure 10-8). Since you had tested yourself as to your ability to hold a camera steady at 1/15 sec with the 35 mm lens (Chapter 4), you can confidently make pictures at the low-level illuminations in hospital corridors (Figure 10-14). You also know (from prior testing) that you can use the meter readings when set at low level, at $\frac{1}{2}$ stop less than the meter indicates, and get the best possible negative.

This assignment taught you the necessity of improvisation and perseverance; you also learned that you have to adapt your schedule to the subject's.

Contact Sheets

Figure 10-21 is the full contact sheet on item 3. You had an appointment for a discussion of the photography but, just in case, you brought your equipment along. You'll never know what opportunities will present themselves to you, so be prepared.

Figure 10-22 is the full contact sheet on the grand rounds. Figure 10-23 shows the sequence on item 1 as shot with one camera.

Figure 10-24 is the complete contact sheet on item 4 (visit to Boston). If you look closely you'll see that the one selected (frame 27A) was the last of the sequence of our subjects starting out for Boston. The shy subject thought picture taking was over and relaxed.

DO	DON'T
. . . reshoot a sequence if you think you can improve what you have.	. . . forget to identify the people you have photographed.
. . . plan and discuss all angles of an assignment with the principals.	. . . neglect candid shots. . . . neglect improvisations.
. . . keep your agency informed of progress or delays.	

Figure 10-19

Taking his son to the big city *is an important part of Dr. Norton's schedule on Saturdays. After farewells to his wife, Joanne, he takes young Tommy along while making rounds among hospitalized Lahey Clinic patients. (That's no medical bag; it's a satchel of toys to entertain Tommy while he waits in the hospital lounges.) Father and son will spend the rest of the day seeing Boston.*

Medical Economics, November 29, 1965

Figure 10-20

158

Figure 10-21 The full contact sheet on item 3.

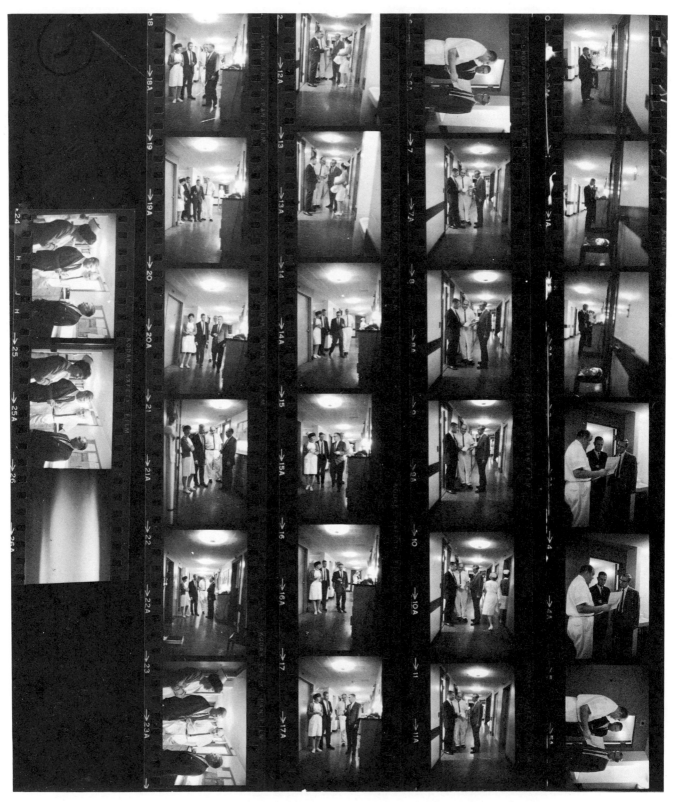

Figure 10-22 The full contact sheet on the grand rounds.

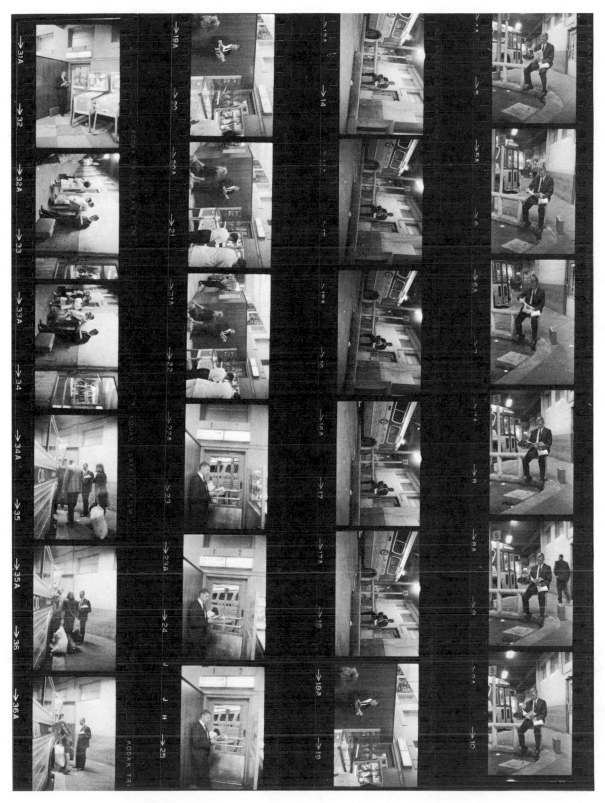

Figure 10-23 The sequence on item 1 as shot with one camera.

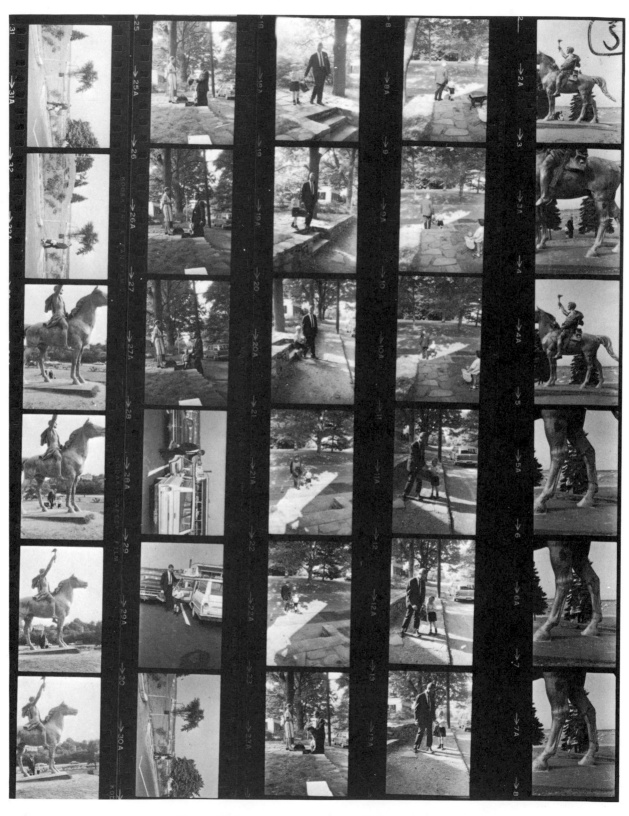

Figure 10-24 The complete contact sheet on item 4.

Chapter 11

Assignment for a National News Magazine: One Unspecified Picture

During your practice sessions and period of self-assignments, you introduced yourself to many sources that could give you a paying assignment. Completely unexpected, but very exciting, is a telephone call asking if you are available for an assignment. The magazine in which your work will appear has a national circulation.

The local bureau chief briefs you over the telephone as to the requirements. The story they want illustrated (just one picture) is about the Boston POPS and its world-renowned conductor, Arthur Fiedler. The interpretation is up to you.

Why You?

Since you had chosen the medium of music to develop your technique of photojournalism (see Chapter 7), you had the opportunity of presenting some of your self-assigned stories to the bureau chief. One of these self-assignments had brought you to work at Boston Symphony Hall with Mr. Fiedler and the Boston POPS orchestra. You were not an unknown to the bureau chief, nor to the management and personnel of the famed orchestra. The magazine has several other "stringers" on their list in the area, but due to the volume of work that you submitted pertaining to musicians and conductors, you had left a strong impression that you were a specialist in this field. This impression took about two years and five self-assigned photo essays (three of which were published) to build.

Planning the Assignment

At the conclusion of the telephone conversation with the bureau chief, you immediately call Symphony Hall and ask to be connected with the Press and Publicity Bureau. You need clearance to work in different areas of Symphony Hall. Since you had purchased many tickets for the POPS concerts over the years, you knew some of the sequences that you thought would best capture the essence of POPS. You arrange an appointment with the head of the public relations at Symphony Hall. Since this was your first big chance, you requested his permission to attend one concert prior to the assignment to better acquaint yourself with the points of view you would need to capture the mental images of the pictures you desired.

Mental Images

How can you capture just what POPS is, in just one picture? Your mind races through the elements that go into a concert. There are the throngs that come every night to a sold-out house. There are the backstage occurrences that the public does not see. There is the serving of wines, beer, ice cream, POPS punch, and other light refreshments. There are the soloists, the encores, and the concert-goers of all ages.

You decide to photograph the evening as an observer, from the beginning. You would enter the hall from where the musicians entered, take some pictures of Mr. Fiedler in the room he uses before and after the concert. You would then try to show the conductor, the orchestra, and the physical appearance of the concert in a long shot.

You need clearance to get backstage. You need clearance to be in the conductor's room before the concert, and also in the organ loft (the most difficult clearance to get). In fact, you need clearance for just about every picture you intend to take. The management of Symphony Hall believes that the ticket holder is entitled to an undisturbed concert, and they will not permit anyone to detract from the concert-goer's pleasure. Fortunately, the POPS atmosphere is one of joy, conversation, smoking, and indulging in beverages, so that you could get behind the organ pipes, if you didn't stay more than 5 minutes.

In the back of your mind were the pictures that you would take during the two intermissions. You would concentrate on the maestro and the orchestra for the first third of the concert. During the first intermission you would return to the conductor's room for backstage shots. The second third of the concert would be spent photographing the audience with the orchestra in the background. During the second intermission you would concentrate on getting close-up

shots of the tables, to see if you could convey the feeling of light classical music and the old Viennese flavor with champagne glasses and music. The last third of the evening, devoted to show tunes and lighter music, you would use in getting shots from the floor.

All of these thoughts are related to the public relations man and the necessary clearances are given, plus the admonition to keep in mind — management's concern for the ticket holder.

Figure 11-1

Invaluable Advance Information

Your reconnaissance of a concert the evening before you are to take the assigned pictures gives you very valuable information. One of the sequences you decided to make included the audience as well as the orchestra. You were able to take meter readings of the auditorium area while in the audience. In order to have this area register on film, you need an exposure of $f/4$ at $\frac{1}{4}$ sec. If you had waited to get readings of this area the evening of the assignment, your meter would not have given you a correct evaluation, because the dimly lit audience area would be behind the brightly illuminated stage. (If you are depending on a built-in meter for exposure and didn't have the foresight to get the reading without the stage lights on, you are in trouble.)

By running through your projected movements, you are able to meet those backstage individuals who could impair or prohibit your movements. By seeing them and telling them that you would be back on the following night, your groundwork is set for unimpeded movement. You are also able to get previews of your different points of view. There is no teacher like experience. This was proved to you as you performed the assignment. There is much more invaluable knowledge to obtain than you had obtained. What you didn't know will be discussed as you review the assignment pictorially.

It is a June night and the sun doesn't set until after the concert begins, so you are able to make a few pictures of the location as you drive to the concert. Figure 11-1 is one of 5 frames. Even though traffic is moderate, you have to spend time waiting for the moment when there is no traffic to clutter your picture (Figure 11-2).

You enter the room that Mr. Fiedler uses as his headquarters. There is action in this room. The maestro is busy discussing a clarinet passage with an instrumentalist. In the other corner of the room the POPS pianist, Leo Litwin, is rehearsing one of the soloists for the evening (Figure 11-3). You have time to make only 5 frames of the activity when Mr. Fied-

ler leaves the area to change into full dress. At this point, the opening downbeat is 10 minutes away and you decide that you had better get to your position behind the organ pipes.

Since you know that your shutter speed is going to be $\frac{1}{4}$ sec (at $f/4$), you know that if you want the shot free of subject movement (Mr. Fiedler is a very energetic conductor), you better trip the shutter just before he gives the downbeat. The camera with the tabletop tripod is placed on a ledge. You decide to make the first exposure in a horizontal format (see Figure 11-4). After making 2 exposures, you switch to the vertical format to include more of the hall (Figure 11-5). A cable release is used to trip the shutter and the 35 mm lens is used. You make 6 exposures using the wide-angle lens and vertical format before changing to the 90 mm lens. You don't use the 135 mm lens because its field of view would exclude the audience and orchestra members. To tell the story of POPS in one picture, you feel you

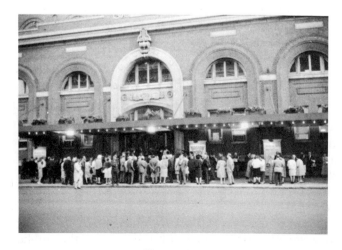

Figure 11-2

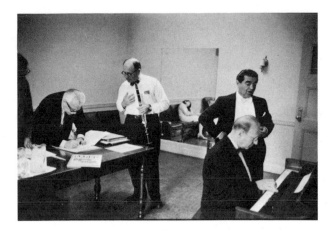

Figure 11-3

must include the conductor, some of the musicians, and part of the audience.

At this point you increase the shutter speed to 1/60 sec; your aperture remains at *f*/4. This is the correct exposure for the conductor and the musicians on stage. Of course, the earlier sequence over exposed Mr. Fiedler and the stage by 4 stops, but you knew that this could be corrected in the printing.[1] You get a better print for reproduction if there is sufficient detail in the shadow area. In order to obtain the necessary detail in the audience, for a good print for publication, you have to over expose the brightly lit stage area (Figure 11-4).

After making 7 frames with the 90 mm lens, you decide to leave your position behind the organ pipes and shoot from another point of view.

Now you are beginning to get more experience. The first third of the concert is just about over. You hadn't realized that in order to get several frames of

[1]See the discussion in this chapter on improving the picture.

Figure 11-4

Figure 11-5

the conductor, you would have to wait as long as you did until he is at the peak of a downbeat or motionless. There are many occasions when this situation exists, but his head is either down or turned away from the camera. You have to wait for the proper moment[2] before tripping the shutter.

Working Your Way Back

The next part of your shooting is going to be routine. You decided the day before to use the area of Row A, Seat 1, first balcony left, as one location to get your usual number of frames in long shots and close-ups. Then you would take up another point of view, still first balcony left, but this time from a midway position. Then you would shift to the center rear of the first balcony and just make wide-angle shots. You would then return to Row A, Seat 1, first balcony right, and repeat your procedure.

Switching back to the camera with the wide-angle lens, you decide upon the vertical format. Through the viewfinder you can see that you have the conductor, several musicians, and part of the audience—just the ingredients you want (Figure 11-6).

[2]The proper moment being when the conductor is not looking at his score, his hands are near his face, and his face is conveying excitement. You aren't going to wait until all of these elements are present before you trip the shutter. If you do, you might not expose one frame. You depend upon the saturation method of coverage to give you at least one frame that approximates the proper moment. (See Chapters 7 and 8.)

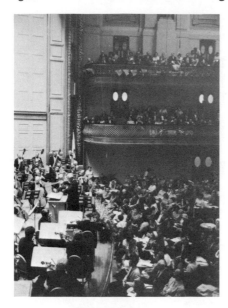

Figure 11-6

This time you feel that you can shoot at 1/60 sec, because there is a great deal of light spilling over onto the front tables. You discover, later, that it doesn't spill up into the balconies. By force of habit, you replace the 35 mm with the 90 mm and make a few frames, before you realize that one ingredient is missing—the audience (Figure 11-7).

Leaving this spot, you head for the midway position. As yet, you haven't made any pictures that included the entire orchestra. This next group of pictures features the orchestra, with just a bit of the audience showing. What is more, Mr. Fiedler has added an encore to his regular program. This is typical of POPS. It's a toe-tapper (Figure 11-8).

A look at the program tells you that there is only one more number left to play in the opening third of the concert, and you want to be in the wings when the conductor leaves the stage.

You go down the stairs and start cutting across the floor at the back of the auditorium. You have almost reached the exit door when you see a picture. It is the curve of the first balcony, framing the orchestra and the audience (Figure 11-9). This point of view is in direct contrast to the opening frame you made when the conductor gave his downbeat for the opening number of the concert (see Figure 11-4).

Figure 11-8

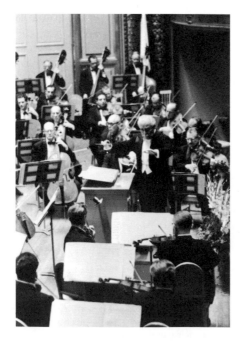

Figure 11-7

You focus on the stage to get the distance and you then focus on the near table to get its distance. Your object is to get an aperture opening that will keep both the near table and the orchestra in focus. You can't, for the required f/stop would be $f/8$, and your exposure would run to a full second. There would be too much subject movment. You select $f/4$ as the best combination of aperture and shutter speed. You, therefore, keep the foreground in focus and sacrifice the background. You set the distance of the near table on the $f/4$ indicator on your depth of field scale using the 35 mm wide-angle lens. You place the legs of the table-top tripod against the wall and, with a cable release, trip the shutter. You do this several times, and then hurry backstage. By the time you have finished this operation you are too late to make the picture of Mr. Fiedler leaving the stage, but you know that you have two more opportunities to get this particular shot.

In the conductor's room, you see the conductor

Figure 11-9

Figure 11-10

rehearsing a few passages with the piano soloist (Figure 11-10). This soloist is blind; you file this information in the back of your head, because of the human interest element. This is another aspect of a POPS program. There is always a soloist in the second half of the concert. Mr. Fiedler usually gives the young, talented musician an opportunity to break into the "big time" via an appearance with the Boston POPS.

When you hear the bells announcing the end of the first intermission, you decide to make a few frames of the soloist in performance. You have another surprise awaiting you. The vocalist is going to be the first soloist and not the pianist. You make your medium shots (Figure 11-11) and your close-ups. You don't want to use a lens that will single out the soloist, for the value of these photographs is to have the orchestra and Mr. Fiedler in the picture with him.

The pianist appears upon the arm of Mr. Fiedler, as he guides her to her seat. Once she is in position, you have to get to the other side of the hall if you want her face to appear.

You use the same approach with her, that of including Mr. Fiedler and a few members of the orchestra, as you did with the vocalist. You then go backstage to the wings to catch the conductor as he leaves the stage. You not only get him leaving the stage, but he is escorting the pianist as well (Figure 11-12).

The Last Third of the Concert

After you looked in on the conductor during the intermission, you are able to relax a bit. The warning bells ring, and you check your equipment before starting your coverage from the floor. Your idea is to get a table that has champagne glasses on it. It should be in line with Mr. Fiedler and the stage. It should be close enough so that you can take advantage of the light that spills over from the stage, enabling you to use a shutter speed of at least 1/15 sec. A great deal of your time is spent looking for the situation.

You find a table satisfactorily located. Now you wait until the conductor turns to cue the viola section, so

Figure 11-11

you can at least capture him in profile. Unfortunately for you, he gives all his time to the first violins and woodwind sections. Figure 11-13 is the closest he comes to presenting his profile. You are still waiting for him to give more attention to the violas, when the concert is over.

You pack your equipment and hurry back to your studio. Although your photography is finished for the evening, you haven't finished your responsibilities. It is 11:30 P.M. and the film has to be airmailed that evening, special delivery, to arrive at the magazine's photographic laboratory by 9 A.M., the next day.

Nonphotographic Duties

You have exposed a total of 3 rolls of film, and would like to identify the people that you have photographed. The film is to be mailed unprocessed and you neglected to number the cartridges. Luckily, you can think of only 2 or 3 people who have to be identified. Mr. Fiedler doesn't require any identification, but the singer and pianist do. You have their names, because they requested that you send them (for payment) any pictures which show them performing on stage. You include a note to the photo editor of the magazine, identifying the pianist and the baritone. (You make a promise to yourself to always mark

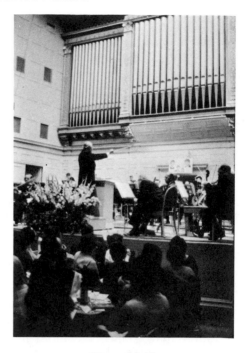

Figure 11-13

the casette after rewinding. Your experience is still growing.) Along with this note is your expense account. It includes parking, the cost of film, the charge for telephone calls, postage and mileage, plus your fee of $X for photographic services.

You wrap up your package and drive downtown to the main post office. You don't know what the postage will be, or the collection times. The notices on the street mailboxes tell you that the mail will not be collected from these boxes until 10 A.M. the next day.

At the post office you gain more experience. You are told that they will accept your package and that it will arrive in time. They also tell you that there is no way to buy the necessary postage. These windows close at 5:30 P.M.

If you are a stamp collector, you might go home and use your commemoratives. The postal clerk estimates 75c as ample postage. You return to the studio where there is a postage meter. You put $1 postage on the package and drive back to the main post office where you mail it.

You are home by 1:30 A.M. You left the house at 7 P.M. You have spent 6½ hours including yesterday's planning for a net profit of $50.

Is It Worth It?

There is no guarantee that the article will be printed. There is no guarantee that your picture will

Figure 11-12

be used even if the article is run. Even if this occurs, it is worth it, for you now have a reason for writing, telephoning, or seeing the photo editor of a national magazine and reinforcing your name with him. There are other assignments coming up in your area, from time to time, and you would like the opportunity of serving again.

The day the magazine appears on the newsstands you buy a copy. You find the article and your picture is used: a two-column cut, a by-line. It is quite a thrill. The feeling of your first by-line in a national magazine is unique.

Which picture was used? They chose the first shot that you made of the concert as a whole. This photograph contains the four items mentioned in the article: the conductor, the musicians, the audience, and the interior of the hall (Figure 11-14). From this picture it is easy to get an idea of how a POPS concert looks.

Cut out the page with the published photograph of the magazine and add it to your portfolio. Two or three weeks later, you receive the contact sheets and the negatives from the magazine. You have the privilege of selling any of the other pictures that you made during the coverage—if you can find a buyer.

Other possibilities of Sale

Two potential customers for you are the vocalist and the pianist. If you were thinking, you have their names and addresses. You should select a variety of frames and enlarge them. Stamp them with "PROOF" markers on the face of the print and include a brief note as to what your charge for "finished" photographs would be. Then wait.

Another potential purchaser could be the public relations department of POPS. With a few of your choice frames enlarged to 8 × 10 and the contact sheets, you make appointment with the man in charge. His choice, as well as those of your other buyers, is based upon their needs. From the public relations head comes a suggestion. He is interested in a picture similar to the one the magazine used, but would like to see more of the orchestra members included. His other interest is in a view similar to Figure 11-9.

Getting the Picture He Wants

In order to get what the public relations department wants, which is a greater angle in coverage than your 35 mm lens was able to give, you need a super-wide-angle. A visit to your camera shop elicits the in-

formation that there are 2 lenses available which will give you a wider angle of coverage. There is the 28 mm whose maximum lens opening is $f/5.6$ and the 21 mm which has a maximum lens opening of $f/3.4$.[3] You can either rent or purchase these lenses.

Before you decide which to do, you think of the many times when you could have used the greater angle of coverage. You will be able to use this lens far more frequently than the 400 mm which you rented. You purchase this lens, and the special viewfinder that accompanies it.

A constructive critique takes place with the pictures of the previous assignment. This editor wants the picture taken from a more central point of view. To accomplish this, you tell him the cooperation that is necessary. The evening for the shooting is decided upon and you are given the required clearances. You have to be behind the organ loft. Your camera will be in position before the doors are open to the public. You will be dressed in black and wear black gloves. This form of attire is necessary so that you will minimize the amount of attention that you will draw from the audience.

This assignment is easier than the first, for two reasons. First, you *know* the two pictures desired. Second, you have the results of your first coverage from this spot to evaluate.

You have checked with the music librarian to ascertain that all the musicians will be on stage because you don't want any empty seats in the photograph. There are not many musical compositions that call for the entire complement that makes up an orchestra to be on stage. You are not concerned about any empty

[3]The "fish-eye" lens was not on the market.

Figure 11-14

seats that the public occupies, for it is a rare occasion when a POPS concert is not "sold out."

The Photography

An assignment often contains an element that appears unexpectedly. In Chapter 5, it was noted that the viola soloist stopped to give Mr. Fiedler a flower from the bouquet. Now, you view the orchestra members appearing on stage without their coats. It is a warm night and it is the custom of the conductor to let the musicians play in their shirt sleeves. He wears a summer jacket, however. POPS is a unique institution in Boston, and this bit of informality goes right along with the atmosphere. Your only doubt is whether or not the public relations man wants the orchestra members represented without their jackets. The conductor raises his arms to begin the concert and you trigger the shutter via the cable release (Figure 11-15).

Each time you think you have the conductor in a desirable position, you trip the shutter. You must wait for the peaks of action or complete halts. You know that you need a shutter speed of $\frac{1}{4}$ sec for the audience to register sufficient detail. Your lens is open to $f/4$, but with the 21 mm lens and the distance you are from the nearest subject matter that you want in focus, everything will be sharp.

Are You a 50% Photographer in Ability?

You'll never achieve more than 50% of your potential as a photographer unless you are experienced in photographic printing. You must know both halves of photography, the first half being that of obtaining the negative and what it should contain (quality, sub-

ject matter, composition). The other half is the ability to transfer the negative to the finished product, which is the print, either for viewing or reproduction.

The medium in which you are working is divided into halves: getting the negative, and making the finished print. If you depend upon a local finisher, camera shop, or drugstore, this is what you would receive. You would not care to submit Figure 11-16 as a sample of your ability.

A custom laboratory will be able to give you a print that you would be proud to exhibit, provided that there is sufficient detail in the shadow areas which they can manipulate. Don't expect to pay drugstore prices, however. It is not the aim of this book to make you a qualified printer, for there are many fine books on the market which will help you achieve this end. I merely want to point out that to be a complete photographer you must be able to print adequately, or be able to give intelligent and reasonable instructions to an individual who is a competent printer. You should know what "dodging," "burning in," "holding back," "fogging," and "flashing" mean. These are all basic terms in print manipulation.

Minimum Knowledge of Print Making

If you refer to the compromise print of Figure 11-16, what could be done in getting a print suitable for reproduction? If a straight print is made from the negative, you get a result that you would expect. *The exposure for the negative was based on the intensity of illumination on the audience. Figure 11-17 is the resulting print if the printing paper is exposed for the density of the negative of the audience. The results are just what you expect. The orchestra, being over exposed, has denser deposits of silver and con-*

Figure 11-15

Figure 11-16

Figure 11-17 **Figure 11-18**

tains no detail. The areas shaded by the overhanging balconies are too dark to show detail.

If you make a straight print calculated to give you detail in the orchestra, you lose the audience (Figure 11-18). Evidently, you must perform some manipulation to get a print suitable for viewing or reproduction.

Send the negative to a custom laboratory and request that they make a print suitable for reproduction. They, in turn, will make a basic exposure on the printing paper for the center of the audience. During this time, the darker areas (near the overhanging balconies) are "held back" or "dodged." How much is held back is determined by experience.

The orchestra will then be "burned in" (given additional exposure), so that the final print will contain detail in all areas. Even with the current crop of density analyzers, it is rare that the first print will be useable. Many times, 3 or more prints will have to be made before the final product meets with the laboratory's standards or, for that matter, your own. This is why you should expect to pay more for custom finishing that involves time, labor, and know-how.

Additional Markets

Not only will the public relations department be interested in this particular coverage, but perhaps the recording company will be interested as well. If they use it for publicity you will receive $X. If they should decide to use it for a record jacket cover, you'll receive $X plus $Y. You have made another contact.

Figure 11-19 is the print, made with the 35 mm wide-angle, a reproduction of which appeared in a national news magazine. Figure 11-20 is the picture made with the 21 mm lens, which was used as a record jacket cover.

This is the way to improve continually. Study the results of each assignment and think how you could improve on what you have already done. Be merciless in your own critique, never be satisfied.

"Is the original assignment worth it?"

To paraphrase a current airline slogan, "You bet your career as a photojournalist that it is."

Now that you've purchased the 21 mm wide-angle lens, you wonder why it wasn't part of your equipment in the first place. You didn't have sufficient knowledge to use it and *in the early stages of your development you shouldn't give yourself challenges beyond your capability.* Learn how to use the 35 mm wide-angle first.

When your back is to the wall and you need more area in your negative, the 21 mm gives it to you as already demonstrated. The other use is its ability to keep all areas sharp at wide aperture. This is especially true when one of the elements in your photograph is close to the lens, as illustrated in Figure 11-21.

DO	DON'T
. . . get clearances before working in an area.	. . . miss a chance to reconnoiter an area before shooting.
. . . evolve a plan of coverage.	. . . neglect using varying focal length lenses on the same scene.
. . . employ both vertical and horizontal formats.	. . . be caught short by the unexpected.
. . . learn as much about photographic printing as possible.	. . . neglect other possibilities for sales.
. . . have several dollars in postage always available.	

Figure 11-19 Coverage obtained with 35 mm lens, f4 at ¼ sec.

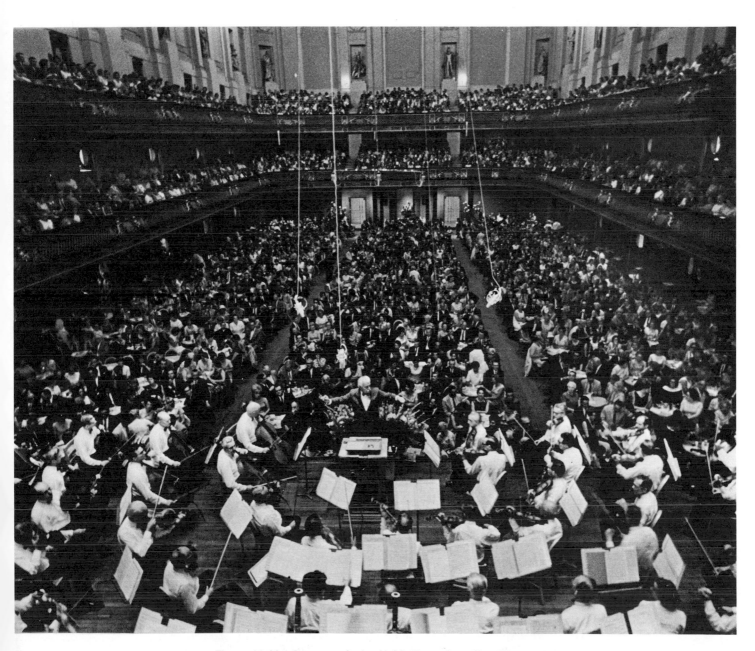

Figure 11-20 Coverage obtained with 21 mm lens, f4 at ¼ sec.

Figure 11-21 When your back is to the wall and you need more area in your negative, the 21 mm gives it to you as already demonstrated. The other use is its ability to keep all areas sharp at wide aperature. This is especially true when one of the elements in your photograph is close to the lens.

Chapter 12

Assignment for Foreign Press: VIP

Ah! The "glamour department," or so the uninitiated think of the celebrity. How does an assignment like this come about? You must have successfully carried out several photo essays, as previously mentioned, and you must have built up confidence in the photo editor's mind about your ability. You must have done this before he will ever think of you when he gets a cable such as the following.

D_____ P_____, INC

JUNE 1, 1961

AFTONBLADET INTERESTED REPORTAGE SWEDISH PRIN-
CESS CHRISTINA IN USA STOP ARRIVAL IN NEW YORK, THE
BALL AT THE WHITE HOUSE SATURDAY JUNE 5 AND HER
VISIT TO _____ COLLEGE

IMAGSERV

(Imagserv is the cable address of International Magazine Serivce, a photo department of Bonnier's magazines.)

Mr. D. contacts his "stringers" or free-lancers in Washington and New York, but you in Boston are not contacted yet. Another cable arrives in New York.

D_____ P_____ PHOT

June 4, 1961

AFTONBLADET WANTS COMPLETE _____ (COLLEGE)
COVERAGE JUNE 15 AND 16 PRINCESS CHRISTINA

IMAGSERV

On the same date he receives this cable, a letter goes out to you:

JUNE 4, 1961

Dear _____:

I tried to reach you today over the phone but understand you are on location. Since there is not a big rush, I can send you all the information by letter.

We have an assignment from the Swedish newspaper *Aftonbladet* for a complete coverage of Princess Christina's stay at _____ (college). She will probably arrive at _____ from New York on the evening of June 14 and is supposed to leave on the evening of June 16 via New York for Sweden.

Our client would like you to cover her stay as completely as possible including the commencement exercises for which she is coming and would like to get many negatives. We are going to get details in a few days telling us if the pictures can be developed, contacted, and captioned in Boston, or if they have to be rushed undeveloped with very skimpy captions, therefore, to Sweden.

Kindly let me know immediately if you are available for this job. Our client will probably pay us $200. It will be another meeting with the Princess for you, and I hope she will still remember you as the nice photographer who cooperated with her so fully. I will not be in the office on Monday, but would appreciate it if you would drop me a line over the weekend as to whether it is okay.

Best regards,

L_____ D_____
_____ INCORPORATED

Getting Needed Information

Immediately, as requested in the letter, you inform your agent that you are available for this job. After mailing a letter to let him know this, you reread his letter and some questions, unanswered in the letter, arise in your mind. "She will probably arrive at _____ from New York on the evening of June 14 . . ." The flight she will take is not given, nor is the time of arrival, nor the airline.

This is a new experience for you. All the prior assignments that you have been given contained times, dates, telephone numbers. The groundwork had been laid for you, but now you find yourself having to dig out information and do all the work previously done for you. Your nonphotographic abilities are being challenged. Your experience will keep growing.

Where can you get this information? You start thinking. If she is staying at _____ College, they will know her plans because they have a responsibility for housing her and her retinue. They will certainly be on hand for her arrival.

You telephone the college and ask to be connected with the Public Relations Department. It is June 7 and you have plenty of time, since your subject won't

be arriving for a week. The result of your call is frustrating. You are told, "We are not yet acquainted with the Princess's schedule and won't be until she arrives."

Further questioning elicits some information concerning her probable activities while on campus. This information is related in the letter you send to your agency (see letter below). You still have no information as to her arrival. Who else might have this information? The city editors of the local newspapers would certainly be informed. Two telephone calls to the local papers draw a blank. They don't even know that she is coming in.

You sit down at the typewriter and send to your agent a summation of all you have done.

June 9, 1961

Dear Mr. D_____:

Thank you for the assignment on Princess Christina. I have been in touch with Mrs. X at _____ College and the following information was passed on to me.

Speaking for _____ College: no cameras, press included, are permitted in the chapel. No pictures are permitted in any of the dormitories, unless the Princess agrees. No pictures during commencement or during baccalaureate.

We are permitted to take all the pix we can before and after commencement and baccalaureate.

Mrs. X is not yet acquainted with the Princess's schedule and won't bc until she arrives, but I was told the following: Tuesday (June 15) about noon, she is having lunch prior to baccalaureate with her former classmates, but unless the Princess says O.K. we cannot take pix. _____ College would stretch a point here about permitting cameras inside the dormitories if the request came from the Princess.

Tuesday evening she is having a private dinner. But this is off-limits unless the Princess agrees.

No pictures are permitted during the "robing" just before commencement on Wednesday morning.

Following commencement on Wednesday, she will have lunch with the president of the college, but no pix unless the Princess requests it. And then she leaves.

Mrs. X will assign a "guide" to me who will take down the identifications and captions as I photograph. For this I shall have to reimburse the young lady at $1.85 per hour.

It would help me greatly, if I knew where and when she was going to arrive at Cambridge.

Sincerely,

On the following day Mr. D. writes back to you:

June 10, 1961

Dear_____:

Thank you for your letter of June 9, copy of which I have sent to Sweden so that they know what the problems might be. The Princess has been photographed very frequently while in New York these days; in fact, she hardly could make a step without having photographers follow her. (This makes you feel awful since you wonder how you'd feel after being dogged all through your trip). I suggest that you telephone me some time on Monday (which is June 14, the day of her arrival—the pace is quickening—no more letters, phone calls now), so that I can give you instructions as to the processing or nonprocessing and where the shipment should be sent.

Best regards,

And on the next day you receive another letter by special delivery:

June 11, 1961

Dear_____:

I have just received a cable from Sweden that the pictures have to be air-freighted, undeveloped, on Wednesday for arrival in Sweden on Thursday morning. Will you please give me a call any time Monday or Tuesday morning so that you can reconfirm the arrangements.

We would like to send the films to New York by *air freight* not, I repeat, not air express, as per enclosed envelope. As soon as possible you will give this package to the Air Cargo Department of American Airlines or Eastern Airlines. You then have to phone Mr. C. immediately and give him the way-bill number. He will then pick up the envelope at the airport and re-address it to Sweden.

Since Princess Christina will also leave on the 16th for Sweden, the activities will surely end in the early afternoon, if not before. The arrival of the negatives in New York should not be later than 4:30 or 5 P.M. because the package will have to be taken from LaGuardia Airport to Kennedy Airport and put on the 7:30 plane on Wednesday, June 16.

Try to give some captions, with names, as the Swedes might otherwise have difficulty identifying the pictures. I do hope that the Princess will be cooperative since pictures of her have appeared every day now in all the daily papers here and hardly any restrictions must have existed.

I am thinking that it might be a good idea to develop some of the pictures—those you will take on the 15th or possibly the evening of the 14th—but it is not absolutely necessary.

Best regards,

This last letter did not get into your hands until Saturday, June 12, so what did you do on June 11? You telephoned Mrs. X at _____ College again to get arrival time. She still did not know except for "some time on Monday." In case she was holding back—you are a suspicious person—you telephone the newspapers again. Again nothing. Have a happy weekend!

Her Arrival

Monday, June 14. As soon as you arrive at your office, you are back on the telephone contacting the Public Relations Department at the college. This time you are told to call back in the late afternoon for that is when they expect to have the information. This time you get the information that has been eluding you all week. The ETA (estimated time of arrival) is 5:30 P.M. at Logan International Airport. Just in case the original informant wasn't aware of Daylight Saving Time, you are at the airport in time to catch the 4:30 P.M. arrival.

You head for the information counters to find out at which gate the planes due in from New York will arrive. The arrivals, due in on the half hour, come in at Gate 3 and the arrivals on the hour come in at Gate 8. These gates are at opposite ends of the airport.

At about 5:05 P.M., you notice the arrival of another cameraman. Each minute brings another, until there are about five of you: three from the local newspapers, and one each from the wire services, AP and UP. Shortly thereafter the Public Relations Director of the college arrives with three of the Princess's former classmates. She has brought along two photographers from her department. You stick close.

You check both cameras around your neck, check your meter reading, set your shutter speed and aperture setting, and chat with some of the other photographers.

During this waiting period your cameras are not inactive. You go after a few background shots (Figure 12-1). Your subjects are the Princess's former classmates awaiting the arrival of her plane. Occasionally one will look at you (frame 5A). If you can, tell her to look elsewhere—anywhere but at the camera.

The plane finally stops its taxiing and the passengers begin to disembark. Your eyes are glued to the door of the plane. You sight your quarry. As the princess sees her friends, she raises her hand in greeting. You get this shot (Figure 12-2). You feel it's a good one.

While the Princess is descending the stairway, you

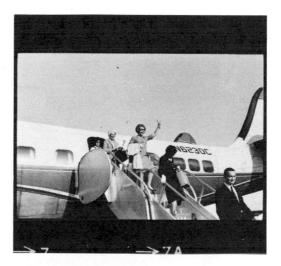

Figure 12-2

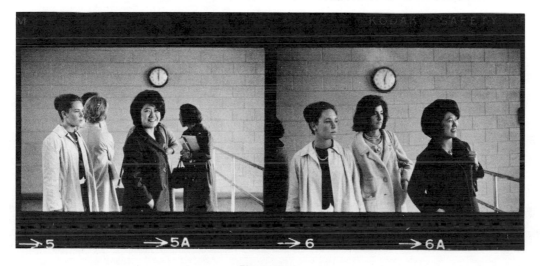

Figure 12-1

quickly turn one of your cameras back to the waiting retinue to record their reaction to her arrival (Figure 12-3). This could be compared with crowd-reaction shots in sporting events.

With one of your cameras—you are switching back and forth so fast, you don't have time to notice which[1] —you continue to record the reunion of the group (Figure 12-4).

Action Continues

The action shifts to the long corridor inside the airport building. You keep about 12 ft. in front of your subject, having already switched back to the camera with the wide-angle lens (35 mm); this has been prefocused at 12 ft. All settings have been previ-

[1]You have set your cameras for "zone-focusing" shooting and don't have to focus. There is plenty of illumination and with a small aperture your depth of field assures you of a sharp picture. For additional information on "zone-focusing," see Chapter 19.

ously determined. They are walking forward, and you are walking backward taking pictures whenever you can (Figure 12-5). You have improved a great deal since first using the zone method in Chapter 9.

The group stops and a brief discussion takes place. The person in charge of the Public Relations Department of the college approaches the subject. The group enters the room reserved for the 5 to 10 minute press interviews for VIP arrivals. The regulations are set forth: the photographers will be granted 2 minutes for taking pictures and the reporters will be given 3 minutes for their questions.

You take new readings and go back to work taking pictures, employing the saturation method. First, you make a general view (Figure 12-6). In frame 26A, Figure 12-6, the Princess is seated. To her left are the reporters; to her right, her classmates; and the flash of one of the local newspapersmen is visible.

After the 3 minutes for the interviewing have passed, a request is made by one of the photogra-

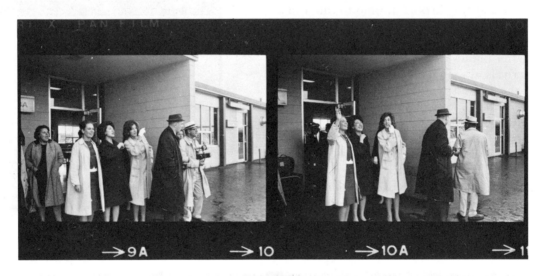

Figure 12-3

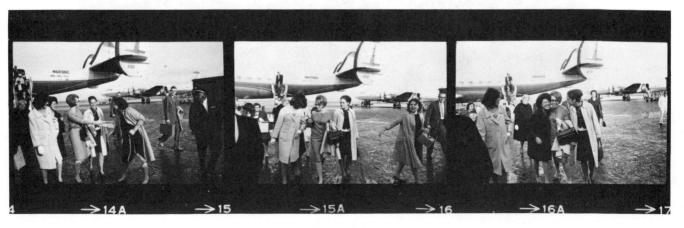

Figure 12-4

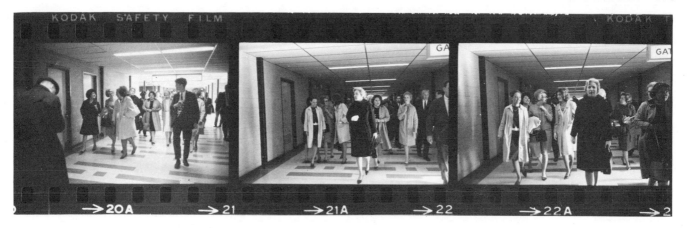

Figure 12-5

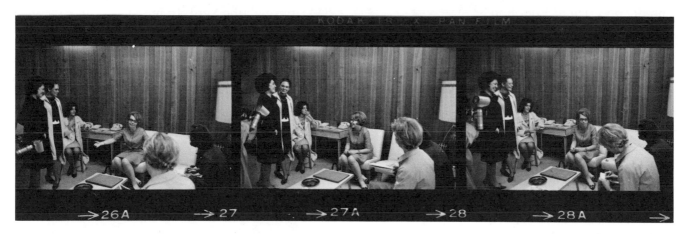

Figure 12-6

phers that the Princess and her friends be grouped together (see Figure 12-7). Three photographers are using flash. One of them remarks after he has taken about 4 exposures, "What the hell am I shooting so many for?" He was caught up in the saturation method that the members of the picture agencies and magazines employ. These photographers, and you as well, can easily shoot a roll of 36 exposures, and still want more.

This period comes to an end, and once more you are walking backwards down the long corridor, although the pace of shooting is slower (Figure 12-8). The official retinue enters two cars that are waiting and the Princess, with her welcoming committee, takes off.

Summary of Accomplishment and Planning Next Day's Work

You have exposed only 2 rolls of 36 exposures each. Your subject has been on the scene about 15 minutes. You have spent less than one second on shooting. This is calculated from your average exposure at 1/125 sec, and you have made only 70 exposures. You have put in over 6 hours of preparation with phone calls and the letters previously mentioned. You are late for dinner and will have to cancel the bridge game your wife had planned for the evening, and your job has just started.

Before your contact from the college leaves, you arrange to call her office to find out the availability of your subject for the next shooting session. This will be the baccalaureate exercises at the chapel: the time will be about noon.

The Selection

You are unaware of what will be chosen from the pictures you have submitted. Figures 12-9 and 12-10 are the two pictures that were published. Each figure shows the full frame and the way it was cropped.

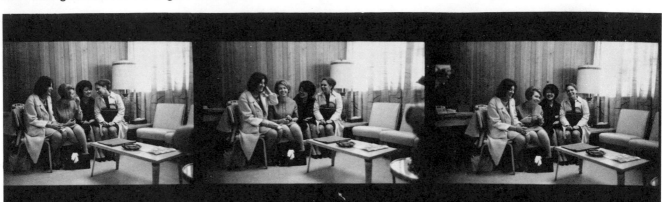

Figure 12-7

The Second Day of Shooting

You arrive at the public relations office at 10 A.M. You aren't the first photographer on the scene. In addition to the colleagues you worked with yesterday, there is a free-lancer who is speculating, and one other new face. This one is from Sweden, but he is stationed in New York. He represents a different press outlet from the one you are working for.

All of you are briefed as to the starting place — where the Princess spent the night. All of you gather your equipment and head for her residence. You are not too surprised to find additional cameramen present. To contend with the photographers present yesterday, you now add one more professional, representing a national weekly pictorial.

The Walk Through the Yard

From the starting place (Figure 12-11, frame 3A), along the streets bordering the Yard (frames 5A and

23A), through the Yard (frame 11A), where the seats have been set up for the commencement exercises, all the photographers are constantly bombarding the retinue. If it isn't you, it's two or three of your colleagues. Your exposures may be a bit uneven in this

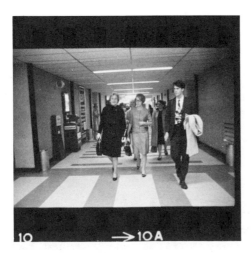

Figure 12-8

Figure 12-9

Figure 12-10

sequence as the subjects alternately walk in sunshine, and then into a shaded area, and then back into sunshine again. Finally, all photographers are requested to stop shooting. Most of them comply—you, especially, because you are stationed in this area and can afford no animosities.

You begin shooting again (permission having been granted) as they approach the chapel: frames 12A and 13A. Now you recall the instructions: *no* pictures permitted inside the chapel. Before you stop taking pictures you interpret the prohibition. You say to yourself, "I'm not actually in the chapel, and no prohibition was stated as to the foyer of the chapel." You aren't using flash, so you feel fairly safe about stretching the point. Figure 12-12 is one of a series that you steal. Compare this shot (Figure 12-12) with the shot in Figure 18-8.

The Reception

During the baccalaureate services, you and the other photographers chat, smoke, and relax. Following the services, the entourage makes its way to the trustees' reception. You don't approach your subject to request poses for a variety of reasons: protocol, ethics, and instructions.

The occurrences and physical setup is such that

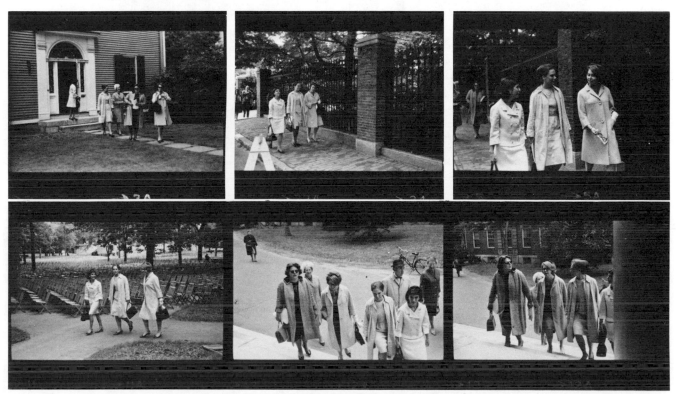

Figure 12-11

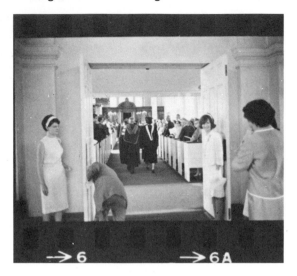

Figure 12-12

When you feel that you are sufficiently covered for the close-up and medium shots, you wait until the room contains more guests and you make a long shot. This time you use the camera with the 35 mm lens. You have examined the room to see if there is a balcony, but none exists.

You alternate your position from the medium views that contain the Princess, to the long shot showing the room as it gradually fills up (see Figure 12-14).

The time allotted for the photographers is about 10 minutes. After this time has elapsed, *all* photographers are requested to refrain from picture-taking. If you want to return again for future assignments, you comply.

Before leaving you ascertain the Princess's whereabouts for the next day's action.

you make your medium shots (using the 50 mm lens) first. See Figure 12-13. Throughout your shooting you are sending your assistant to get the identifications (name, hometown, and connection with the college or the Princess) of whomever you believe is included in the pictures you are taking.

Back at the Studio

Your watch tells you it is 3 P.M. You return to your studio and process the exposed film. While it is drying, assemble all your notes, especially the identifications. When the film is dry, cut it into strips of 6

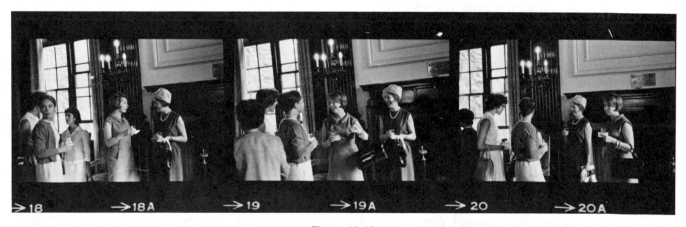

Figure 12-13

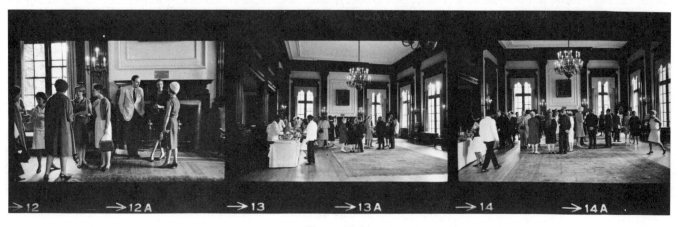

Figure 12-14

frames each and place them in numbered envelopes. Then make at least 2 contact sheets of each envelope: one to be included when you mail the negatives, according to instructions, and one for your own files.

Type out the identifications that your assistant supplied and match them with the corresponding contact sheet numbers and frame numbers. Before leaving for the night, replenish your stock of film, clean out your camera case and lenses, re-pack your camera case, and sigh. Including the processing and editing, you have spent 8 hours on this phase of the assignment.

The Selection

One picture was selected from your efforts of the day. We have shown the enlarged full frame (Figure 12-15) and the way it was published (Figure 12-16).

The Final Day of Photography

The day dawns beautifully, even though you are not up early enough to see it. It's a bright, sunny morning. Contrary to popular belief, this is not the best type of day for photography—the contrasts are too great.

Once on the grounds, you head for the area where you see other photographers congregating. Another press briefing follows. You are told that the Princess

Figure 12-15

will be available for photographs a few minutes before the graduation exercises are to start. Once the graduation services start, no further photography is permitted. After the services are over, the picture-taking may be resumed.

Since you have about 30 minutes before she appears, you spend this time trying to discover just where she will be sitting. You look around for vantage points from which you might be able to make pictures of her during the services—but unobserved.

One of the buildings on the campus offers a possibility. You ask the police officers stationed about if

Figure 12-16

you can get into the building and how you could exit from it. One of the officers tells you that you can enter from his door, but that you'll have to walk a quarter of a mile to get onto the grounds again. You check with another officer to make certain that he'll let you on the grounds, and then you return to the area where the press conference is to take place.

She finally appears and you make a series of exposures similar to Figure 12-17. It's hot in the sun so the public relations head takes over and selects a spot for the Princess and the president of the university to sit. After they are seated, you and the other photographers are given the go-ahead to shoot.

Your first series of frames is in this category (Figure 12-18). You aren't happy with the arrangement of the subjects but you have no control over arranging them to your satisfaction. Your results are

strictly a matter of luck. You can't shift too much because your colleagues are on both sides of you, tightly packed.

When you feel that you have sufficient coverage of this situation (at least 6 exposures), you change to the camera with the 90 mm lens and make close-ups (Figure 12-19).

As before, you have no control over directing your subject. You depend upon the saturation method to get something that the editors will be able to use. You are unhappy about the background situation in both the medium shots and the close-ups. The only action you can take is to radically shift your position to the end of the group of photographers. It's impossible to wedge in between them. You shift your position, and while it's an improvement, you are annoyed by the background: the tree trunks are most distracting

Figure 12-17

Figure 12-18

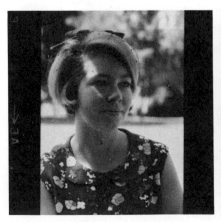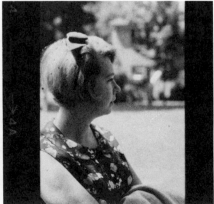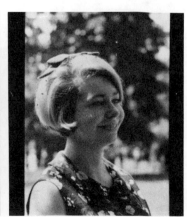

Figure 12-19

(Figure 12-20). At least the subjects are better arranged than those obtained from your first point of view.

You switch to the other camera body to make your close-ups. You feel better when the Princess turns her head (frame 6A), and has an expression which you think might be "it." Then and only then do you attempt to get a close-up of her companion (Figure 12-21).

This session is brought to a halt. The photographers disperse and your subject heads for her seat from which she will observe the graduation exercises. Keeping a respectable distance, you take pictures until the physical limitations prevent your further advance (see Figure 12-22).

Now your earlier reconnaissance begins to pay off. You enter the building you previously reconnoitered, and walk up 5 flights of stairs to a window that overlooks the scene. The procession has not started, so you check a few doors to see if you can get a better vantage point.

"Bending" the Restrictions

Although you have been repeatedly told "not to take pictures during the exercises," you feel that from the interior of the building you will not be seen, nor will you be disturbing any of the ceremonies that are taking place. This is your justification for bending the restrictions. You are comforted a bit when you notice

Figure 12-20

Figure 12-21

Figure 12-22

that the photographer from the national pictorial magazine is doing exactly what you are doing.

You decide from which window to operate. The ceremonies begin with the graduating class parading across the campus in their robes.

Operating within your conditioned format, you first make a wide-angle view, (Figure 12-23, frame 15A) showing the setting. As the line progresses, you shoot it again and again. You also remember the vertical format, this time using the 50 mm lens (frame 16A). Your instructions were to take many pictures, and that's just what you are doing.

Back to Your Subject

Once you have the setting of the scene recorded, you turn your cameras back to the Princess. You wish you had a 400 mm lens. From the same vantage point on the fifth floor, you make a few frames (frame 30A, Figure 12-24), and then you go down to the first floor. Staying away from the window, you make additional exposures (frames 11 and 14, Figure 12-24). Since your assistant is not with you, you take notes

Figure 12-24

describing the dress of the people and anything else which will aid you in getting identifications later.

You exit from the building, take the long walk around to the rear, and have about 15 minutes to relax before the exercises are over.

Commencement Is Over

Now that the commencement has ended, your subject is fair game for photographers. You hurry to the area where you last saw the Princess, and begin making pictures as soon as you locate her. After you make a sequence, you hesitate a moment wondering if you should go after the identifications of the people in the pictures or keep taking pictures. You feel that you have the minimum requirement of 6 exposures (see Figure 12-25), and you go after the names. While you are getting the pertinent information, you keep glancing at the Princess to keep her location in mind. She starts to leave the grounds. Looking around you see that only one other photographer is still on the scene. It is the same one who was in the building with you. All the others have left. The local men need only a shot or two, and they have a deadline to meet. The same is true of the television cameramen. You and

Figure 12-23

Figure 12-25

the other photographer follow the Princess's course. You follow until she enters the private residence where she will have lunch. You make one last shot of her entering (Figure 12-26) and have to call a halt. The luncheon is off limits.

Meeting Your Deadline

You look at your watch: it's 1:15 P.M. You have to get back to the studio, identify the rolls of film you will not process, and try to correlate the notes with the approximate frame numbers. You must assemble all the material, pack it well, and put in the correct envelopes. You think back to the letter of June 11 to be certain that you don't mess up the instructions. Double-check everything, and then check once more. If possible, you want to get your package aboard a plane that will land at Kennedy Airport rather than LaGuardia because it will be from Kennedy that the plane bearing your film will leave for Sweden. Finally, you drive off to Logan Airport.

It's 3 P.M. when you arrive there. You have plenty of time, so you relax a bit. At Eastern Airlines you are told that your package can be placed on the 4:30 P.M. flight. You are too late for the 3:30 P.M. plane, since

all packages have to be written up at least one hour before they can get on the plane. Without going into more detail, the important point to gather from this is that you must know the transportation details beforehand: the time necessary for transportation and transfers from point of origin, intermediate points, and all other duties that are your responsibility. The people you are working for expect you to know these things. In fact, most of them assume that you know them.

Figure 12-26

You are assured by the agent of the air-freight line that your package will be aboard in time to meet your obligations. Then you head back to your studio, more relaxed than you have been for a few days, with just one more chore to perform: phone your contact in New York with the "way-bill number."

A moment of panic comes over you as you realize that his phone number is not in the letter you received, but had been written on the envelope which you have just sent to New York. Did you copy it down? You did. Back at the studio you make the necessary call, fill out an expense sheet, and mail this to the agency that gave you the assignment.

The Selection

You have no knowledge as to how the coverage of the commencement came out until a month later. You receive 3 copies of the newspaper in which your pictures appeared. Your request that your agency mail you the negatives is granted, and you receive them in acetate envelopes, cut into strips of 4. A perusal of the negatives tells you which were considered for publication: there is a small punch mark on the numbered side of the negatives. Of your coverage of the commencement, the frames in Figure 12-27 were considered; two were selected for publication.

If you were the editor, what would be your choice, cropping, and space allotment?

Figure 12-28 shows how your coverage was used.

Epilogue

What qualities were demonstrated in the performance of this assignment—typical when a VIP is involved?

(a) Thorough knowledge of your equipment and its operation.
(b) The ability to follow instructions, interpret them, and improvise upon them.
(c) An almost intuitive knowledge of where to get answers.
(d) The ability to write a decent letter.
(e) An outgoing personality.
(f) Patience.
(g) The ability to be disappointed (in your plans), to go hungry, to be harried, to be spoken sharply to, and to work steadily, without regard for personal comforts until the assignment is completed.

DO	DON'T
. . . learn where to get information.	. . . neglect improvising.
. . . follow and interpret instructions.	. . . lose your patience.
. . . keep your agency informed.	. . . miss press briefings.
. . . plan tomorrow's shooting today.	. . . bend restrictions heedlessly.
. . . get identifications.	

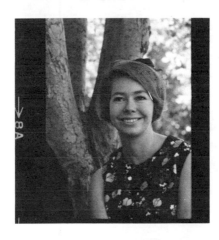

Figure 12-27

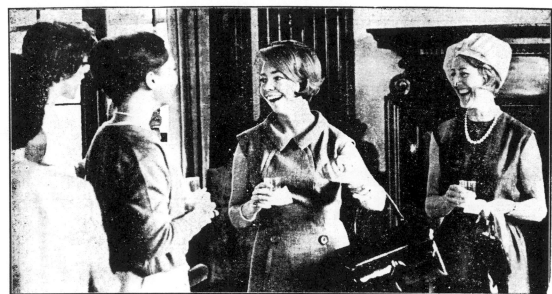

Nej ingen hade glömt Christina i Radcliffe. Det var bara glada leenden.

Alla glada - men pojkarna dansade dåligt

Christina hade jobbigt med att berätta om allt som hänt sedan sist.

Tänk er, den där roliga svenskan är tillbaka.

...och så förstår ni dansade vi hela natten.

Prinsessan Christina togs emot med idel öppna famnar när hon gjorde ett återbesök vid Radcliffes universitet. Hon fick bl a träffa universitetspresidenten Helene Gilbert.

De amerikanska unga männen dansar betydligt sämre än de svenska!

Prinsessan Christina kom till Stockholm i dag. Under tre veckor har hon gjort stor succé som svensk PR-sessa i Amerika.

Aftonbladet mötte vid Arlanda och frågade:
— Hur dansar de amerikanka pojkarna?
Prinsessan Christina:
— Dåligt?
Aftonbladet:
— Sämre än svenskarna.
Christina:
— Javisst!

Resan har varit mycket trött sam men trevlig. Trevligast? Ja, det har varit så mycket, så ... Det var trevligt att träffa Lyndon Johnson. Han sa dock inte mycket mer än "goddag" och "adjö".

Trött i dag

Prinsessan verkade trött när hon tillsammans med hovfröken Dagmar Nyblæus steg ur flygplanet. De möttes på plattan av chauffören Einar Linde.
I morgon åker Christina själv till Solliden på Öland. Med tillbaka från Amerika hade prinsessan en blomstergarnerad hatt, vilken fotograferna gärna sett att hon haft på huvudet. Nu bar hon den som en påse äpplen i handen.

Till Radcliffe

I dag återvände Sveriges bästa PR tillbaka från en tre veckor lång resa i Amerika.
Prinsessan Christinas, 21, amerikaresa har varit en total framgång för vår unga prinsessa — och för Sverige. Svenska PR-män jublar. Amerikanerna vet nu att Sverige existerar.
Resan har varit mycket jobbig. Ett intensivt program och pressande värme har dock inte nämnvärt minskat Christinas glada leenden, som amerikanerna blivit så förtjusta i.
— Är alla svenskar lika glada eller är det bara prinsessorna som ler? frågade sig amerikanare som tidigare vetat vad svensk synd är. Just inget mer.
Världens mest svårflörtade journalister — de amerikanska — har noggrant bevakat Christina under hela resan.
Den del av resan Christina kanske uppskattade mest var när hon fick göra ett återbesök vid Radcliffe universitet där hon studerade under läsåret 1963—64.
Man hade inte glömt bort den duktiga eleven från Sverige. Återseendet blev mycket glatt, på gränsen till tårar, uppges det.

Bilder: Pix

Figure 12-28

Chapter 13

Working with Others: VIP

After you have completed 5 or 6 informal portrait assignments and several assignments calling for more than one picture, don't be surprised if a telephone call reaches you about 6 P.M. inquiring if you can cover a very important person that same evening. The coverage has been requested by a foreign magazine that has contacted your agency in New York which turned to you.

You are unhappy at the timing, because you are just preparing to leave your home to cover an assignment at Symphony Hall. The person calling you is hesitant to tell you just who he wants photographed. He has mentioned that the function is taking place at the Boston Philharmonia Hall. You have never heard of this hall, but you suspect that it might be Boston Symphony Hall, your previously arranged assignment. A few more questions by you and some hesitant answers from him clear up the situation.

The foreign magazine wants Mrs. Jacqueline Kennedy covered. She is making her first social appearance since the assassination of her husband. She also happens to be the honorary chairwoman of the ball that you are covering for Boston Symphony. This function is the ball of the century. You have a few reservations about working for your agency because your first obligation is the Symphony Hall Press office who hired you. Since you are bringing along two assistants, you feel that you can give some of your time to the agency but that you won't be able to devote yourself exclusively to their coverage. Would the agency be satisfied with this arrangement?

The agency is not too happy about it. They ask you if you can help out a photographer whom they will fly in from New York and request that you do what you can about shooting a coverage for them. You offer more information to your agency: you tell them who the head man is for the press coordination and you give them the telephone number. They, in turn, give you the name of the man they will fly to Boston and again ask you to look out for him. You tell your agency that you doubt if their man will be permitted inside the hall. You have a great deal of background on the forthcoming ball.

The Background

This party has been in the planning for more than a year and you have followed it. This is the first time that the Boston Symphony would sponsor a party in its 85-year history. The fact that Mrs. Kennedy will be returning to gala society via this function is of worldwide interest.

The local press was allotted tickets, as were TV and several photographic agencies servicing the world. Each member of the press, as well as photographers and other technicians—and the guests as well—have their names on a printed list. You think that the "man from New York" might have trouble entering the hall, since he doesn't have a ticket and his name isn't on any list. After you hang up, you finish dressing: this evening your work clothes are formal—a tuxedo.

The Press Conference

Arriving at Symphony Hall, you present your ticket. You are given a name tag and instructions about where to report for a press briefing. You and a multitude of others—photographers, their assistants, TV personnel and their technicians, reporters (male and female), society editors, and coordinating members of the press staff at Symphony Hall—gather for the briefing, and you are gradually forced higher up the staircase. You have an interesting view, two cameras around your neck, one loaded with a fast pan film and the other with a high-speed Type-B color film. In one of your pockets are 3 spare rolls of pan film, in the other are your meter and a spare roll of color film. Attached to the camera body with the black-and-white film is your wide-angle (35 mm lens) and on the other camera is your 90 mm. Your camera case with another body is in the balcony—loaded with daylight film. In the case is your 135 mm lens and additional film. A tripod and flash (strobe) equipment are also stored in the balcony.

As the head of the press department begins to give his instructions, you note that he is wearing tails and you begin your photography (Figure 13-1). You can

Figure 13-1

count 32 press representatives on the floor, 6 more on the stairs with you, and others are still trying to edge in. How are you going to make pictures?

This is soon clarified. At the entrance where the dignitaries will enter, a section will be roped off. All photographers must stay within the bounds. There is a small balcony to the left of the entrance (Figure 13-2) which has room for an additional dozen. At the base of this balcony is space for another 6 or 7. We are to make all the pictures we can from the positions we take, without leaving the area bounded by the tapes.

Once the main subject is at her table, we will be permitted a few minutes at that table to make pictures there. Because there are so many of us, we shall work in shifts. At various times throughout the evening we shall be permitted to approach the table, but none of us can approach the area unless permission is granted. No pictures are to be made from the floor when the food serving starts. No photographer is to be on the floor when the dancing has started. Your

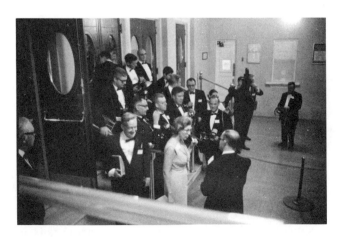

Figure 13-2

great anticipated coverage is dwindling. You must adhere to the house rules, for you are working for the house. As for the others? You shall see.

You have noticed that the waiters are dressed in very colorful costumes and want to record this. But if no pictures are to be permitted once serving has started, what can you do? You contact the man to whom you are responsible, you explain the situation and are given permission to photograph the first course being served. You hastily seek out your assistants to convey this exception for them. There is about 30 minutes of free time before the arrival of the first dignitary, and you have a few chores to perform.

Re-estimating the Assignment

You have noted that the light levels are extremely low at all areas of expected action. While you might be able to get usable negatives using existing light with the black-and-white film, it would be impossible to get anything usable for publication in color, using existing light. At $f/2$ and $\frac{1}{4}$ sec, the exposure required for color, any subject movement would register. And with the jostling of so many colleagues you have your doubts about being able to ignore camera movement.

These are the thoughts that go through your mind as you walk to your camera case to get your flash equipment and the body with daylight color in it. Daylight color film is balanced for strobe. Further coordination with your assistants would have to wait until the next breathing space. You are not concerned about their ability, for they have proved it many times.

You take your position on the balcony (Figure 13-3), take meter readings, select a shutter speed and corresponding aperture on the camera. You recheck the camera with color film to ascertain that the dial is set for "X" operation (for synchronization with strobe, see Chapter 14). You push a button in your battery pack to build up a charge. You check all your connections and are startled by a brilliance that encompasses the entire floor.

The TV section is testing its equipment and taking its readings. Fortunately, you have the foresight to take new meter readings. Now you wish you had the other camera body—the one with Type-B color film in it. But where would you hang it? You have one camera and tabletop tripod hanging from your neck; another camera on your left shoulder, and the strobe pack hanging from your right shoulder. Your glance travels over the assemblage of your colleagues to see how many cameras they are carrying. There is an abundance of those with two cameras, but none with

three. You feel better. Six months later you will be working with two other photographers, one of whom will be carrying three, and the other will have four camera bodies draped about him. You still have much to learn.

Arrival of the Dignitaries

While you are awaiting the arrival of the dignitaries, you wonder whether or not the 35 mm lens is the best one for you to use. When the TV lights are on you can safely shoot at $f/5.6$ to $f/4$ at 1/125 sec. Your normal lens (50 mm) would give you a larger image. But with the TV lights off, you need $f/2$ at 1/30 sec. And for the same distance, you will have a greater depth of field with the 35 mm lens. You decide to stay with the wide-angle mainly because the 50 mm is in your camera case upstairs.

The mayor of Boston arrives and you start taking pictures. He and his wife stop in the foyer and offer their visages to all sides so that photographers can get a few negatives. Bulbs flash everywhere, and you are glad that you stayed with the 35 mm wide-angle, for the TV lights are not on. Suddenly they are. It takes a few frames before you stop down, because you are caught up in the excitement. As yet, you are not sophisticated enough to be relaxed. The mayor and his wife continue on into the hall and matters settle down awaiting the arrival of the next couple.

The governor and his wife (Figure 13-4) arrive next. The decorum is excellent. Every man and woman remains in his place. Everybody gets his required quota of negatives, and this time you stop your lens down when the TV lights go on. You wish your other camera (with the 90 mm lens) was loaded with black and white instead of color. The couples are stopping long enough for the TV and newsreel cameras, which would permit you to make long and medium shots as well. Next time you will know better.

Note how clear the foyer is of any disturbing or renegade figure. Even the interviewer remains back and extends his microphone so that he will not interfere with his colleagues' viewpoints (see Figure 13-4).

The governor and his wife move into the hall, and all of you await the next arrival.

The Honorary Chairwoman

There is a murmuring outside that gradually swells. Many shouts of "There she is" are heard. You and your colleagues nervously check camera adjustments for the nth time. You (and I assume they as well) wish you could be outside making pictures, but

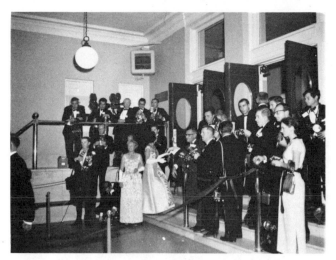

Figure 13-3

you dare not leave your position. You see occasional bright flashes of light and bemoan the fact that you can't be getting pictures from where you are. You wonder (and hope) that one of your assistants is outside and that a few of the flashes are of his making.

After what seems an interminable wait, Mrs. Kennedy finally appears. Flanked on both sides by her escorts, who in turn are surrounded by police, ushers, and other security personnel, a small nucleus completely surrounded by molecules of humanity presses forward into the foyer (see Figure 13-5).

Your colleagues on the lower steps (Figure 13-3) are in a bit of trouble. Their view is completely obliterated by the crowd. In order to obtain any pictures, they are forced to shoot "blind" (Figure 13-5). They have to extend their arms to their limit and point the camera in the general direction of their subject. It would help, you think, if the viewer were on the bottom of the reflex cameras.

Figure 13-4

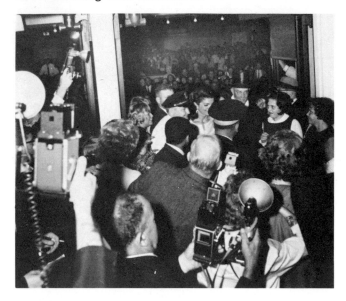

Figure 13-5

Throughout this ordeal, Mrs. Kennedy demonstrates a remarkable poise. It is as if she understands the problems of photographers, the problems of those assigned to her, and the excitement of those who mill, push, and crowd around her. Gradually, order is restored and the unofficial entrants in the foyer are backed out of the way. Without the slightest indication of even being ruffled, Mrs. Kennedy remains in the foyer, giving every photographer an opportunity to record her arrival (Figures 13-6 and 13-7).

There isn't the slightest change in expression when some of the photographers pinioned to a spot where they have no view of her yell, "Hey, Jackie, turn this way." You think that they should at least address her with, "Please, Mrs. Kennedy, turn this way."

She and her entourage enter the hall. By the time you can get off the balcony and press through the others who fill the foyer, the group has disappeared from your view. It is easy to locate where she is; you look for the largest throng and see the lightning storm of flashes.

You have learned two reasons why an assistant photographer should always accompany you on this type of assignment. The first is in the assigning of positions. One man would, if stationed as you are, have his points of view limited. Second, the unknown—who knows whether or not everything will work out as planned? No one expected the public to overrun the foyer.

As you battle your way to the table where your quarry is, you hope that your assistant has not been held up as you are. He can cover your subject and make the pictures you can't. Later in the evening you will again be thankful to have an assistant with you.

Finishing the First Shooting Session

When you finally reach a position where you can see your subject in the viewfinder, you are dismayed at the constantly changing light intensity caused by the TV technician. Finally, you just yell out, "Leave the TV lights on." And so, you are able to make a few medium shots of Symphony's gift to its honored guest with the available light (Figure 13-8).

Because it has taken you quite a while to reach the table and squeeze between and under the press of photographers, you don't have the best angle. Nevertheless, you record the presentation of a fan to Mrs. Kennedy. The musical director and the governor are also in the viewfinder. Their position is not the best for newspaper editors, plagued by space demands, but this is the best you can do under the circumstances (read Point No. 5 in the list of requirements).

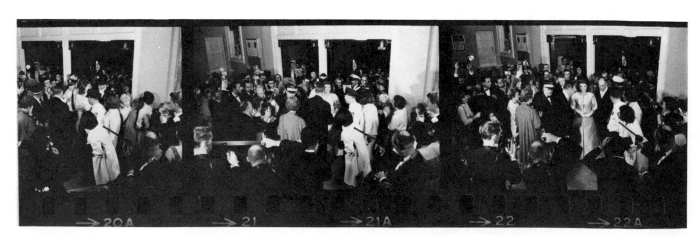

Figure 13-6

Figure 13-7

The constantly shifting direction of the TV lights gives less-than-great exposures and lighting balance (Figure 13-8).

Suddenly you remember one of the suggestions given you over the telephone by your agency. "We would like some close-ups of Mrs. Kennedy." Hastily, for you have no idea when the shooting privileges will stop, or the TV lights will be extinguished, you release the 35 mm lens from the body with the black-and-white film and replace it with the 135 mm lens. You place the *f*/5.6 aperture mark on its correct designation and quickly turn the dial to 1/125 sec for the shutter speed. This is the reading you obtained in the foyer. You do not have time, nor the physical freedom of movement, to get an accurate meter reading.

Putting the viewfinder to your eye you are stopped because you are much too close. You have to back off to get your subject in focus. As you do, you are dismayed to see the spot you just vacated immediately filled with another camera operator. You have to wait until you can catch a glimpse of Mrs. Kennedy, whenever it is presented unobscured to you (Figure 13-9). It is at this point that you fervently hope that the TV

lights remain on. There is a tremendous amount of activity surrounding the area, and you breathe a sigh of gratification every time you have more than 50% of her features clear for a picture. Are you aware that you have "split" lighting?

You are able to get 8 frames exposed before officialdom steps in and calls a halt to the proceedings. Three of the frames are illustrated (Figure 13-9). The TV lights are extinguished and all the photographers file out of the main hall. All of you are instructed to stay away from Mrs. Kennedy's table until further notice. Naturally, the questions fly fast as to when permission will be granted to take more pictures. You are told, "in about an hour."

Each press representative heads for his own particular headquarters for a rest. Wearily, for you have expended a great deal of physical as well as mental energy, you climb the stairs to the balcony where your camera case is deposited, to rewind your film and reload the cameras.

The spot you have selected for observation is across the hall from where your subject is seated and you have an unobstructed view of her.

Figure 13-8

Figure 13-9

After relaxing and taking care of your chores, you look around. There beside you is one of the local press with a 400 mm telephoto mounted on a sturdy tripod.

Operating from a Distance

At first, you are a bit envious of the lens, for the longest you have is a 135 mm. You just know that the other photographer's picture is going to be much better than any you can get, for you are about 100 ft. from the subject. After you watch for a while, you discover that he isn't making any pictures. He tells you that he just can't make an exposure with his maximum aperture of $f/5.6$. The light level is extremely low. When the house lights are on full, you know that an exposure of $f/4$ at $\frac{1}{4}$ sec is the minimum required to record the audience (see Chapter 11). But the scene you want to photograph is beneath an overhanging balcony and, therefore, shaded from the house lights.

There are some lighted candles on the table and perhaps this will compensate for the ineffectual house lights. It might even provide more illumination than those tables that have the benefit of the house lights. So you think. Anyhow, you are going to try. What else could you be doing for the next hour?

You remove the tabletop tripod that you have been using as a chest tripod and attach the camera to the larger tripod that you have brought. You also connect your cable release.

The combination of aperture and shutter speed that you select for your exposure is $f/4$ at $\frac{1}{4}$ sec. Then you think about bracketting your exposures (you're learning). Keeping the aperture constant, you make a few exposures at $\frac{1}{2}$ sec and some at $\frac{1}{8}$ sec. The final results demonstrate that you were within the film's latitude on all exposures. Your previous experience in Symphony Hall (Chapter 11) has stood you in good stead. The candles do throw more light on your subjects than on those at tables without candles. And noticeably so (Figure 13-10).

You can relax a bit, and you do. You look around to locate your assistants to inquire about their luck and are happy to learn that they have done well. Further inquiry about when the press will be able to take more pictures reveals that no picture-taking will be permitted until dinner is over.

Some More Background Information

Most of the guests have been dancing to the music that has been playing throughout the evening—but not the people at the table you are watching.

Now you remember a bit more information from

Figure 13-10

the first press briefing. Arthur Fiedler, the eminent conductor of the Boston POPS Orchestra, will lead the members of the Boston POPS in a series of 6 waltzes. This will be the first time that this orchestra has played for "public" dancing, and it will be during this performance that Mrs. Kennedy will resume her social life. You had better be ready.

What point of view shall you use? You can't be on the floor and on the balcony at the same time. What about the possibility of starting the pictures from the floor and then heading for the balcony? Or shall you start your pictures from the balcony and then head for the floor?

Decisions, Decisions, Decisions

Two factors help you to decide. You experienced one hectic situation at the table, in the early part of the evening; and you remember your instructions that no photographer will be permitted on the dance floor. You decide to make all your shots from the balcony and hope that your assistant will be able to supply coverage from the floor. Now a bit of luck. Your assistant finds you on the balcony and you instruct him to make what he can from the floor.

Suddenly, a fanfare is played by three trumpeteers. The big moment has arrived. You look down at the spot where Mrs. Kennedy is located and notice that a crowd is forming at both entrances that border the table. You don't need binoculars to see the vast display of camera equipment in that mob.

You push the button that activates your power pack and push the button for the maximum output. You focus on the candelabra because the light is so dim it is impossible to focus on anything else. You try to read the footage on your lens mount so that you can select the proper aperture. You know your guide number. Next time you'll bring a flashlight with you, but this time you have to light a match to see. Finally, you have everything set and you double check to make certain that the marker is on the correct setting for strobe synchronization.

A Letdown

Someone approaches the center of the floor with a microphone. The dim lights get even dimmer. A spotlight traps the solitary figure and introductions begin. First, you make his picture. Your flash fires and you realize that you had better change your exposure settings. A spotlight should be about the same as the TV lights, you think. Disconnecting your strobe, you reset your dials to $f/5.6$ at 1/125 sec. You make his picture, and as the probing spotlight encircles those introduced, you make as many exposures as you can of the people in the spotlight.

Whatever occurs, you must photograph it. After the film is developed, you discover that a more powerful spotlight was used than you calculated. You could have cut your exposure down 2 more stops and had a good negative. More experience gained.

Finally, the introductions are over. Mr. Fiedler gives the downbeat, there is a flurry of excitement about the table. You see the lightning storm of flashes again, but you are busy getting your settings for flash operation. This time you focus on Mrs. Kennedy's white gown, and light your matches to get the footage. You divide this into the guide number and obtain your aperture (see Chapter 14). On high power you make exposure after exposure (Figure 13-11). It is really dark on the floor, and you are grateful for the appearance of your assistant for now he can tell you when Mrs. Kennedy's face is visible. All too soon the dancing is over. You make a few general views, cover the entertainment, pack up, and go home.

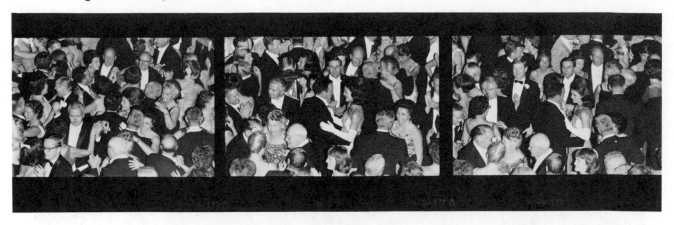

Figure 13-11

You drive home wearily (it's 2:30 A.M. and you started the day at 9 A.M.) wondering if you should have attempted to make some pictures of Mrs. Kennedy leaving. After you have submitted the contact sheets to your agency and have seen the other published material from this soiree, you note that no picture of her departure was published, and your editor did not comment upon the absence of this coverage. But, weeks have passed before you know this, and the thought of not attempting to cover her exit bothers you.

Processing and Nonphotographic Chores

The following day, back in your laboratory, you process the film. You are amazed that you have 6 rolls of 35 exposures, for such a short duration of shooting. True, you spent a lot of time on the assignment, but very little of it was actual photography. You cut the film into strips of 6 frames each and separate the parts that you feel can be sent to your agency.

You make your contact sheets, bring them to Symphony Hall, and show them to the man that hired you. This is your first allegiance. He gives you his permission to send them to your agency, and you return to your studio. You then telephone New York and inform your contact what has transpired and that you are sending along the contact sheets and the negatives. The color that your assistant was shooting is sent to the custom laboratory for processing. It will be a few days before these are returned to you.

Several weeks later you receive a tear sheet. This is the sheet that bears your pictures that were published in the foreign magazine. There are four of them, two of which are yours (Figure 13-12). For this "side" job you are sent a check for $250.

Figure 13-12

When you receive the color material, you edit it and make a selection which you forward to New York. Two of these pictures are selected and are sold by your agent, for which you are compensated.

Epilogue

As you reassess your performance of this assignment, you think back to the "List of Requirements." As far as the "no frontal lighting" item is concerned, you chuckle: because of the physical situation you had nothing to do about the lighting. But photo editors are aware of problems that photographers encounter during such a session. Your picture that received the largest space (Figure 13-12) was made with flash. The "animated in appearance—not posed" requirement—great, but you had nothing to do with this either. The "shoot it as you see it" phrase, you feel should have been modified to "shoot it as you *can* see it," and some of your colleagues had to shoot it *without* seeing it (see Figure 13-5).

Your agency sends you several additional checks of good size, over the course of a year, as a result of this coverage. Naturally, the tear sheets are carefully placed in your portfolio to impress other prospective clients. The photograph that brings you the greatest monetary return is—the *informal portrait*.

DO	DON'T
. . . check meter readings when shifting locations.	. . . neglect the help an assistant can give you.
. . . evaluate situations rapidly and act.	
. . . keep a small flashlight in your case.	
. . . carry at least 2 cameras with you.	
. . . have a flash unit available.	

Chapter 14

Flash in Photojournalism: Basics

Some of the reasons why flash should not be used in making your pictures have already been noted. A picture made with flash-on camera results in the perfect example of head-on lighting which is what the editors do *not* want. Yet there will be times in your career when the intensity of light is just too low for the available-light technique and the only way that you can get a picture will be with flash equipment.[1]

Flash destroys the realistic quality (see Chapter 19) of your picture, but to be a well-rounded photographer you must know how to use this sometimes very valuable accessory.

Types of Flash Equipment

Flash equipment can be conveniently grouped into two basic types: the flashbulb and the electronic tube. Whichever type of flash equipment you decide to buy, your camera must have built-in synchronization and you must know how to use it intelligently.

The flashbulb made its initial appearance in this country in 1930 using aluminum foil and pure oxygen in the bulb. In 1953 the foil was changed to zirconium, 1/1000 in. thick and wide. While there are more than 30 types and sizes available, all are constructed along the basic pattern shown in Figure 14-1.

They are made in different sizes to provide a choice of light intensity output. Most bulbs are made of clear glass, but some have a blue-tinted glass. The latter provide the correct color temperatures for daylight-balanced color films. You can use either type for black-and-white film.

Electronic Units

Although your introduction to flash photography will be via the expendable flashbulb, the professional photographer discarded this a long time ago for the "strobe." Strictly speaking, it is erroneous to refer to

these units as stroboscopic. The term "strobe" came about because one of the earliest uses of this light was in the study of high-speed motion. The stroboscopic light provides a continuous flash, while a speed light will glow only once for each exposure.

The flash tube is unlike the shape of the flashbulb. The tube, usually bent into a U-shape or other configuration, is filled with an inert gas, usually xenon. The flash is the result of discharging a large amount of electrical energy into the tube.

When you consider that for prices beginning at $25—and going up to $300—you can purchase a flash unit that would be the equivalent of carrying 60 to 200 flash bulbs with a single charge each, you have the reason professionals use electronic equipment. With recycling times varying from 1 to 8 seconds, you are ready to take another picture quicker than you can change a flashbulb. Compared to strobe units, flashbulbs are expensive to use. The cost of exposing a 36-exposure roll of 35 mm film by flash is about $4. If you take more than 200 flash pictures a year, the speed lamp will turn out to be economical.

Built-in Synchronization

Cameras manufactured today, whether expensive or inexpensive, have built-in shutter delay systems to synchronize the opening of the shutter with the peak of the flash—bulb or strobe. Cameras of the better class will have an "X" and "M" near the flash connection or on the dial settings. When using a flashbulb, the setting should be on "M." If using the electronic flash tube, the setting should be on "X." When you push the button setting off your flashbulb, it takes a

[1]In Chapter 13 there was one part of the coverage where the light level was so low that flash had to be used in covering part of the assignment. One photographer assigned to cover this affair did not have any flash equipment with him, but he was shooting along with the rest of us, aided (or hindered, if you will) by the TV lights. The picture that his magazine published was not one that he made, but was a wire service photo, made with the flash.

Figure 14-1

very short time, about 20 milliseconds from the igniting of the foil to the maximum output of the bulb. The electronic bulb builds to its peak in approximately 5 milliseconds (see Figure 14-2).

The letters "FP" preceding a designation of a bulb stand for *Focal Plane.* This class of flashbulb must be used with cameras equipped with focal plane shutters. These shutters consist of a light-tight curtain with rectangular slits in the curtain. The time of exposure is governed by the width of the slit travelling across the film and the tension of the spring controlling the speed of the curtain. This demands a longer peak in the flashbulb. This peak is accomplished by using 2 selective sizes of foil in the bulb (Figure 14-3).

Many Advantages of Electronic Flash over Flashbulb

In Chapter 4 we discussed some of the variables determining exposure. You were advised to stay with one type of film to make matters easy for you. A glance at the exposure information provided by a manufacturer for just one type of flashbulb should convince you of the necessity for standardization (see Figure 14-4).

When using the flashbulb, you must consider the size of the bulb, the shutter speed of the camera, the ASA of the film, the finish of the reflecting device (polished or diffuse), and the synch setting (X, F, M, or FP). Acquiring a fast-working arrangement with all these variables is not impossible but very tedious — and unnecessary if you use the strobe. With the flashbulb you have to memorize a different guide number for each change in shutter speed. With the electronic unit you don't because the speed of exposure is determined by the duration of its glow. This glow is so brief (1/800 to 1/1600 sec) that you are guaranteed

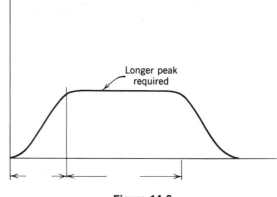

Figure 14-3

stopped action. Of course, you must consider extraneous light if you are using a shutter speed in the 1/50 sec range. As a photojournalist, you will be using the flash only when the light levels are very low, prohibiting a picture unless a flash is used. In this case you won't be annoyed with the problem.

Calculating Flash Exposures

Did you ask, "How do I calculate my exposure in the first place?"

To facilitate the calculation of correct exposure when using flash (bulb or electronic), you use a guide number. Divide the proper guide number by the distance (in feet) that the subject is from the flash. The number you get will be your aperture opening.

$$f/\text{opening} = \frac{\text{guide number}}{\text{distance of subject from flash}}$$

Your guide number is easily calculated by the following formula:

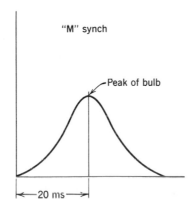

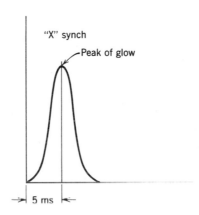

Figure 14-2

EXPOSURE INFORMATION FOR G-E M3B FLASHBULBS (17.5 MILLISECONDS TIME-TO-PEAK)
For Use with Black & White and Color Film

| | FILM | Simple Camera Distance | Shooting Distances in Feet @ 1/30th Second or Slower | | | | | Guide Numbers for Polished* Reflector | | | | | | | | |
			f/5.6	f/8	f/11	f/16	f/22	X, F, M or FP 1/30 or slower	M Sync. Only 1/50 1/60	1/100 1/125	1/200 1/250	1/400 1/500	35mm Focal Plane Only 1/125	1/250	1/500	1/1000
Daylight Type Color Film	Anscochrome 50	7-12 Ft.	25'	18'	13'	9'	6'	150	130	115	100	80	80	55	40	30
	Anscochrome 100	40'	30'	20'	15'	10'	220	185	175	150	110	110	80	55	40
	Anscochrome 200	55'	40'	30'	20'	15'	300	250	230	210	160	160	110	80	55
	Ektachrome-X	7-12 Ft.	30'	20'	15'	10'	7'	175	150	140	110	90	85	60	40	30
	High Speed Ektachrome	50'	35'	25'	18'	13'	280	230	210	180	150	140	95	65	45
	Kodachrome II	20'	15'	10'	7'	5'	110	95	90	75	60	55	40	30	20
	Kodachrome-X	7-12 Ft.	30'	20'	15'	10'	7'	175	150	140	110	90	85	60	40	30
	Kodacolor-X	6-12 Ft.	30'	20'	15'	10'	7'	175	150	140	110	90	85	60	40	30
	Polacolor	35'	25'	18'	13'	9'	200	165	145	130	105
Black & White Film	All Weather Pan	8-25 Ft.	40'	30'	20'	15'	10'	250	210	195	155	125	125	90	65	45
	Panatomic-X	25'	18'	13'	9'	6'	140	120	115	100	80	70	50	35	25
	Plus-X	40'	30'	20'	15'	10'	250	210	195	155	125	125	90	65	45
	Polapan 200	55'	40'	30'	20'	15'	300	250	230	210	160	160	110	80	55
	Polapan 400 Super Hypan Tri-X	80'	55'	40'	30'	20'	440	370	350	300	230	220	160	110	80
	Verichrome Pan Versapan	8-25 Ft.	40'	30'	20'	15'	10'	250	210	195	155	125	125	90	65	45

*For diffuse or Folding Fan Reflectors, open lens 1 f/stop or multiply Guide Number by .7.
For f-setting divide Guide Number by shooting distance in feet, lamp to subject.

MADE IN U.S.A.
CG 612-AF2

Figure 14-4

$$\text{Guide number} = \sqrt{.005 \cdot L \cdot t \cdot M \cdot S}$$

where L = total lumens
t = time of exposure
M = reflector factor
S = tungsten exposure index.

You can also find the guide number on the box in which the bulbs are packaged. In every box of film there is a paper describing the type of film you have purchased, along with many suggestions about how to obtain the best results. This paper is not packed with the film solely to keep the film from rattling in its box. Read it!

With every electronic flash unit there is packaged an instruction manual. Read this! You will find the recommended guide numbers for the different ASA ratings. You are cautioned that these values are intended only as guides. To be completely confident in your equipment you should test these guide numbers with the film you are going to use. The tests follow the same pattern you employed when you tested your exposure meter. (See Chapter 4).

Three Exposures Give You Confidence

Make one exposure at exactly the guide number recommended by the manufacturer. Make another using 1 stop larger aperture, and a third, 1 stop smaller aperture than the first. This is for black-and-white film. If testing with color film, your bracketing should be half-stop increments. Be certain that the information is recorded so that you can read it. After you have evaluated the results (one of the pictures should be better than the rest), you'll know the best guide number for you and your equipment.

Buying an Electronic Flash Unit

As with the purchase of a camera, you will be confronted with many different manufacturers' electronic units. There are just two basic units, but many prices. There are the newer, one-piece constructions in which the flash head and power pack are contained in one compact assembly. The other, still in majority use, is a two-piece construction power pack carried by a shoulder strap. The flash head is separate.

Before you purchase any unit you should ask yourself two questions. Why am I buying it? To what use do I intend to put it? No matter which unit you purchase, you should look for two characteristics. One would be the ability to operate the flash head off the camera, when desired. You should be certain that the flash head will be above the lens when the camera is held for a vertical format picture. The flash head should also be versatile enough to permit you to tilt it 45° (this is better than 90°) for a bounce effect.

In Figure 14-5, the flash head is mounted on the side of the camera so that when the picture is made, the black shadow that the subject casts against the wall is quite evident. It will always be there unless the subject is a good distance from the wall. If he is, the background will go black because it will be underexposed. You will have no separation of the subject from the background.

Figure 14-5

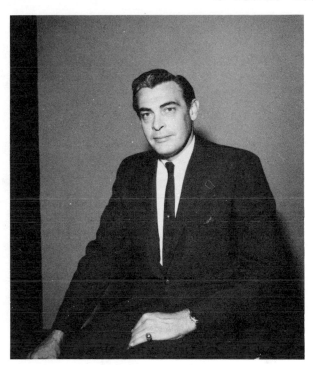

Figure 14-6

If you can disconnect the flash head from the body of the camera and hold it at arm's length over the camera, the outline of the shadow is cast beneath the subject (see Figure 14-6). If your flash is mounted on the camera with a shoe bracket, you'll have to buy an extension cord. Unless you have rigged up a device that will trip your shutter, you are going to be involved in a juggling act trying to trip the shutter while holding the camera with one hand.

If the flash head is mounted on one side of the camera and you turn the camera into the vertical position, the shadow will be very prominent. In Figure 14-7, the flash was mounted on the side of the camera, and the photographer took a kneeling position since the subject was seated. The camera was at the photographer's eye level.

When the direction of the light is from below the subject's face, the appearance is not natural. This type of light direction is employed for horror movies and to give sinister effects. It is to be avoided unless special effects are desired.

45° Bounce

To get away from the deleterious effects of flash, the positioning of the flash head at a 45° angle to your subject is recommended. Since a certain amount of light will be absorbed by the ceiling and walls, the lens should be opened 3 to 4 stop numbers. The adjustment depends on the height of the room and the reflectivity of the surrounding areas. At the same time that you are determining the guide number that will give you your best results in direct flash position, you should also determine the adjustment you will need when using the 45° position.

As can be seen in Figure 14-8 the big advantage of the bounce technique is the virtually shadowless lighting which results. This approximates the available-light approach.

DO	DON'T
. . . purchase a unit that permits a 45° flash head position.	. . . do anything until you've read the instruction book.
. . . determine your own guide number.	. . . use flash unless it is absolutely necessary.
. . . stay with one film until you have mastered it.	

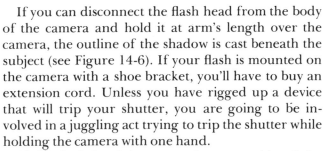

Figure 14-7

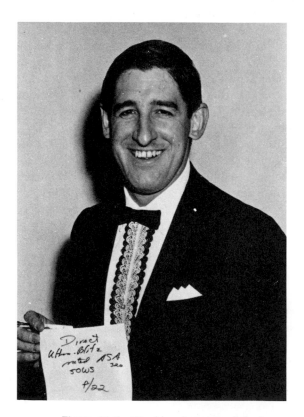

Figure 14-8 The big advantage of the bounce technique is the virtually shadowless lighting which results.

204

Chapter 15

Nurse Recruitment Brochure

Working the Camera Between Assignments

While you are building a reputation with your agency via the informal portrait assignments and even if you have successfully completed the second (Chapter 10) and third (Chapter 12) phases of your development, you won't be earning more than a bare subsistence unless you have other sources for your services. There are so few assignments in your territory, and so many men after them, that it is difficult to earn even a subsistence, assuming that you are the number one man for just one agency.

Where will this other work come from? Two of the best sources are advertising agencies and public relations departments of large institutions or manufacturing houses. These sources pay better than the free-lance assignments that you have had.

How do you get these assignments? In exactly the same manner that you obtained your first assignment from the agency in New York. You had tucked your portfolio under your arm, had worn out one pair of shoes, and had calluses on your knuckles.

Ideally, it might just happen that the day you call on an agency is exactly the time that this agency is thinking about a job for one of their clients which needs the approach in which you profess to be an expert: 35 mm available-light. There is an element of luck involved, but it is luck of your making. Your published material convinces the art director that you can handle the assignment. An agency won't give you even the responsibility of making an identification shot unless you have been recommended to them by another photographer whom they have employed for years, or unless you have convinced them through the published material in your portfolio that you can handle their photographic requirements.

You leave the office with the knowledge that they will call you when they are ready to go to work on the project.

Preliminary Discussions

A telephone call from the agency informs you that your approach and technique will be used to illustrate a brochure. Can you be at the office in the afternoon to discuss the assignment? You can, and you are there at the arranged time.

Just what are your approach and technique? Your approach is candid, recording what takes place, unposed. Your technique? It is available light with the 35 mm camera. You are not going to bring in any outside source of illumination: no flash, no floods. You will use just the light that is available. What are the advantages of this technique? Available-light illumination is realistic and gives the viewer a feeling that what he sees is authentic. It is believable.

Once in the PR office you are given a rundown of the job. You are to illustrate a recruiting brochure for graduate, registered nurses. The client is a local hospital. You read the copy that will accompany the photographs. Your pictures must convey the information in the copy. You are shown pencil sketches of some ideas and a copy of a photograph that illustrates their thinking. The items to be featured are discussed. Some of the photographs will be made with a professional model, and you are shown pictures of several models. You are asked which model you think will best convey the message that the agency hopes to get across. Which model do you think will project the "all-American-eager-attractive-youthful" image? He also asks you how long you think you will need the model. In estimating the charges for the client, the cost of the model—about $25 per hour—is important. Before you answer either question, you request the art director to review the situations in which the model will be used.

Pictures with Model

She will appear on the cover of the brochure. For this shot a close-up of her head with an "appealing" expression on her face is desired. You feel that you can do this in about 30 minutes.

A picture of her in the living quarters that the hospital provides is another featured illustration. The thinking of the agency and the hospital is that nurses will be greatly interested in where they are going to live. A large amount of thought and effort will be expended in readying the room. You estimate about 30 to 45 minutes will be required for this picture.

For the back cover they want a picture of the nurse, in uniform, entering the hospital. This is to be a medium shot of the nurse, but the background should show an impressive view of the hospital buildings. You estimate another 30 minutes.

The other photograph that encompasses the model is one of her with an "Emergency" sign as an integral part of the photograph. You estimate 15 minutes for making this picture.

You and the art director conclude that 2 hours will be sufficient time to engage the model. In the back of your mind, you file the information that this will occupy a half day of your time.

Other Pictures Needed

This brochure is to aid in recruiting trained nurses. It is a selling job. The appeal to the nurses must convince them that this is the best hospital in which to serve. What are the factors that will convince a nurse to select this hospital over others?

As outlined to you, these factors revolve around the living quarters, the in-service teaching programs, the research, the variety of nursing opportunities, salaries and benefits, and the fact that the location of the hospital offers them "life, excitement, friends, and fun."

The agency has been in conference with the public relations and personnel departments of the hospital discussing what would be used to illustrate these factors. Off-duty nurses, interns, and whoever the public relations department could gather, will be your models to illustrate the teaching and research phases. The salaries and benefits need no photography—just copy.

You discuss the idea of using the model for the "friends and fun" bit. The conclusion is negative. The agency has a small budget, and they don't want to use the model any more than is absolutely necessary. To illustrate this phase of the brochure they will draw upon your file of the Boston Symphony and Boston POPS. They have noticed these pictures in your portfolio. In exchange for the use of these pictures, you will be given a credit line rather than payment.

You estimate that you will need half a day for each of the projects wanted: in all you submit a figure of $300 maximum. You don't have the assignment yet, because the agency dosen't have it either. They have to total the charges and present them to the authorities at the hospital. The charges have to be approved by the hospital management. You may not be the only photographer called in to give an estimate pertaining to the photographic charges.

Interspersed throughout the conversation are references to Miss Jones who is in charge of personnel at the hospital. To solidify the assignment, you suggest that a discussion with her would be helpful in determining the photographic interpretation. You and the account executive representing the advertising agency make an appointment to see her.

The Hospital's Ideas on the Brochure

When you sit down with an individual who is inexperienced in brochure work, be prepared for a few shocks. A series of pictures are presented to you. You are asked your opinion as to their inclusion in the brochure. You mask the disbelief you feel. The focus is bad, there is definite camera shake in the majority of them, some were taken with flash, and some are in Kodacolor, from which a black-and-white print will have to be made before an engraving can be produced. You are careful before you make your comments, for she might have been the photographer. A few, very carefully couched questions elicit the information that she was not the photographer. You gently point out why these photographs should not be used. It is not she who is to be censured for suggesting the use of these pictorial atrocities, but management, who puts pressure on her to trim costs. Some day management will realize that photography is a small but very important part of the total budget for a project of this nature. The picture must stop the reader and interest her in the text. If the reader is not stopped, then the "message" will never be read.

As the conversation progresses, you discover that she is prepared to entrust you with the photography. You also discover that she stresses the "where you live" picture as the most important. She plans to decorate one of the vacant rooms in the nurses' residence for you to use with the model. Another morning ends as you and the account executive part.

Two days later he contacts you; you have the assignment. The maximum allotment for photography will be $300, and it is decided that the shooting will begin on the following Tuesday. The agency will hire the model and the account executive will pick you up.

A Picture not on the Agenda

The complete entourage—art director, account executive, model, and you—assemble at the personnel office. You all go to the nurses' residence. During the 10-minute walk, you are told about the time and effort that have gone into making the room attractive. Pictures were hung on the wall, new curtains were

hung at the window, and the best mirror in the residence was borrowed to hang over the dresser.

You are listening attentively when the residence looms ahead. As you approach the entrance, a thought crosses your mind. What about a picture of the nurse (model) entering the dormitory? The others aren't too enthusiastic about the idea, but since a bit of trouble about getting into the dormitory has arisen—no one answers the ring—there is no further objection to your occupying the time with a few shots. Instead of photographing the nurse entering the dormitory, have her leave it.

The model is very cooperative. You discover that she is just as anxious as you are about getting this brochure into a portfolio. She asks "What do you want me to do?" It is easier for you to demonstrate the action you desire than to describe it, so you go to the entrance and jauntily (you think) walk down the three steps.

You tell her that she is to think about her day being over and going out on the town. You find a position, take meter readings, set dials, and action (frame 2A, Figure 15-1).

You get one shot when the art director asks, "Are you giving us enough room?" He is referring to the area around the model. You think you are giving him enough room for his art work, or cropping, but to be obliging, you retreat a few steps and give him more room. You can always enlarge the negative should you be giving him too much room.

Following the format you are conditioned to, you make 6 exposures and seek another point of view. Here it isn't necessary, you decide, to follow through the entire format of 6 long shots and 6 close-ups as well. You get 2 shots here, before an inner sense tells you that this second situation (Figure 15-2) is not as good as the first. You stop shooting.

Someone arrives with a key and you enter the nurses' residence with those ahead of you announcing in loud tones, "Men on the floor."

A Discovery

You are to learn that frame 2A of Figure 15-1 will be selected for publication in the brochure. This is the first picture of the sequence. And you are also going to learn that many times the first picture of a sequence will be selected. Why? In this case the model was not "set." She is carefree. As yet, she has not decided just how to present herself: she hasn't started to model and you have an honest picture. The lack of self-consciousness in your subjects for the first picture will become ingrained in you as you proceed in your

Figure 15-1

Figure 15-2

career. You will learn to have all technical matters attended to, prior to giving direction to your subjects, be it the single subject in the informal portrait, or groups. You get the picture before the subjects think you are going to get it: while they are still relaxed. Your reflexes will be quicker.

You are now convinced that point No. 5 in the List of Requirements is a good one: "Shoot it as you see it." And you are going to continue to make pictures as you sense them, even if they aren't on the agenda. All you need is the opportunity.

The "Where You Live" Picture

Upon entering the room you take care of your own public relations by making complimentary remarks about the room. You don't go overboard, for it isn't that great a room. You look for that point of view which will produce a "stopper." Sitting on the floor, with your back braced against the wall, the 35 mm lens, Tri-X panchromatic film in your camera, you are ready to commence making photographs. You purposely selected the low angle (Figure 15-3). It is not a "worm's eye" view—the view you would obtain if the camera were on the floor. You adopt a view that is halfway between the floor and one you would have from a kneeling position, if the camera were at your eye level.

What does the model do? Is she oriented to the assignment as you are? Sometimes yes and sometimes no. Experience has taught you to direct by suggestion. In this situation you are careful not to give a

specific order. In one sentence you suggest a series of actions. You ask the model to "imagine that you have just come in from a day's shopping and are bone weary. Now, do whatever comes naturally to you." She responds by sitting on the bed after throwing her handbag, hat, and assorted magazines on the bed.

When the time comes to change the viewpoint, you decide to go with the idea of the unusual angle and take additional frames from an elevated point of view by standing on a table.

With the legs of the tabletop tripod braced on the ceiling, you commence operating again. Because of the position of the camera the images are inverted on the film (Figure 15-4). Your camera is upside down. You make a few frames from this vantage point and then request the model to change her position. She sits in the chair, kicks off her shoes, and sheds her jacket.

You have made a series of exposures from this position when someone asks, "Are you getting the mirror in?" This comment causes you to halt because you are not getting the mirror in your viewfinder.

You change your point of view once more and request the model to change her position. Several suggestions are forthcoming from several sources. "How about having her with her feet on the bed?" "What about her reclining on the bed?" One suggestion is finally accepted by all. During this time you are not making any sounds, you are just listening. After all, it's the art director, the account executive, and the representative of the hospital who are making the suggestions.

After you have made a sequence with the model reclining on the bed, propped up by one elbow (frame 30A, Figure 15-5), she finally comments that she is a bit cramped from the position she has been maintaining. You tell her to change position but to continue to turn the pages of the magazine. She raises herself on one hand (frame 31A, Figure 15-5) and begins to flip the pages. You continue shooting (always the saturation method) and after about a half dozen additional frames, the roll of film ends.

While it is best to shoot a scene long, medium, and close-up, you don't do it here. Your discussions with the others interested in the brochure have dictated the long shot only. The room is the important item for this phase.

Reinforcement for Your Discovery

While the first frame that you made of this entire phase was not selected, as was the case with the first frame of Figure 15-1, the *first* frame of the sequence

Figure 15-3

Figure 15-4

Figure 15-5

wherein the model propped herself up, was selected (Figure 15-6). The principle of getting the shot before the subject can get self-conscious is valid.

With the end of this phase, everyone returns to the office where you first met. While the model is changing into a nurse's uniform, it is decided to make one of the minor illustrations: the nurse and the "Emergency" sign. This picture is dispatched in less than 5 minutes and you are ready for another key illustration.

The Back Cover

The pencil sketch that the art director has shown you for this important picture was a ¾ figure of a nurse, head held high, and the plaque with the hospital's name slightly above the nurse's head. The background should show an imposing array of buildings in the hospital complex. The psychology behind the thinking for this picture is to have the reader of the brochure want to enter the organization. The conclusion being that she will identify with the nurse in the illustration who is striding into the hospital.

The model appears in full regalia with one minor note. She is wearing white sneakers. The problems that this discrepancy might cause are ignored since the picture called for does not include her feet.

The personnel director states that she is now going to return to her hospital chores; the art director will return to his drawing board. You, the model, and the account executive are left to finish the assignment.

Value of Reconnaissance Is Reinforced

In Chapter 11 you learned the value of performing a reconnaissance of the area where you are going to work. You can familiarize yourself with the physical area, meet guards, take advance meter readings, and try out various points of view.

You are happy that you performed a reconnaissance to locate the position of the plaque. With the model's time ticking off at $25 per hour, this would be no time to spend locating the plaque in the large complex. There is only one plaque you can use, and you head for it immediately.

Keeping in mind the sketch previously shown you, you select the 50 mm lens, focus on 12 ft., stop the diaphragm to $f/11$, and set the shutter speed at 1/250 sec. The camera is ready; now you instruct the model. You tell her to keep her head high and to purposefully strut up the stairs.

You make one shot (frame 12, Figure 15-7) before her stride takes her out of the position she must be in

Figure 15-7

Figure 15-6

to maintain a meaningful relationship with the plaque. You ask her to return to her original starting point and do it over again (frame 13, Figure 15-7). At this point the account executive asks, "Are you getting it three-quarters?"

You aren't, so you move in (Figure 15-8). You make 4 frames at this new distance (Figure 15-8) before you see that you aren't including enough of the buildings in the background.

The light direction isn't right to outline or to separate the model's face from part of the building in the background. The highlight that falls upon her right thigh (Figure 15-7, frame 12) is what you want on her face. No matter how you change your point of view, you can't get this highlight on her face. If you shift the angle at which the nurse approaches the plaque, you can't get the plaque in the dominant position called for in the sketch. This problem with light direc-

tion, combined with the background problems, causes you to call a halt to the photography and to have a discussion of the problem with the account executive. Due to the direction in which the sun is moving, you'll have to shoot the scene you want—the point of view that you started with (Figure 15-7) the following morning at 10:30. This would entail hiring the model again, and an additional fee. "Forget it," you are told, "do the best you can." You change your position 180° and begin again (Figure 15-9). You are unhappy.

The direction of light does not illuminate the plaque. But this is an important illustration so you must take pictures to show the art director that you tried every possibility.

There exists another element which is disturbing. The area you are working in is under construction, and this also limits your points of view. The art direc-

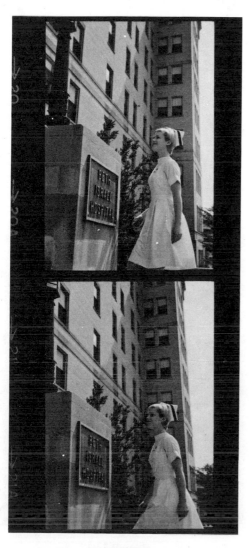

Figure 15-8

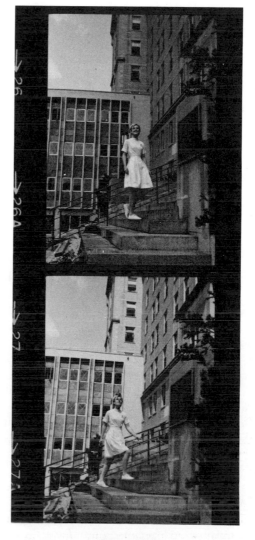

Figure 15-9

tor was on the scene earlier, but memories are short. You decide to make a long shot of the scene to refresh memories at a later date (Figure 15-10). You hope that the art director and others who will review the contact sheets are aware of point No. 5 in your List of Requirements: "Due to the physical setup, the photographer might not be able to give them what they want." This picture might help them remember it.

Your Experience Continues to Grow

In all, you make 19 exposures trying to capture what is wanted. You could have made just the first shot (frame 12, Figure 15-7) and moved on to the next situation, for this is the frame selected for publication on the back cover of the brochure. The selection of this picture poses a problem for the art department. The debris on the first step (bottom right of the frame) has to be retouched out. This is done by airbrush. Since the feet of the nurse are included in the final cropping, her sneakers will have to be retouched to look like shoes. If they are not, some sharp-eyed nurse will notice the discrepancy and the entire brochure could be worthless.

This experience teaches you to ask some very important questions before shooting other staged scenes. "Is this the way it would really be done?" "Is the dress authentic?" "Is the equipment (if included) the correct type?" "Is everybody that will appear in the picture attired correctly?" When you get affirmative answers to all questions, you can go ahead.

The Cover Illustration

Making a cover! It is a big thrill for any photographer when his picture makes the cover of a magazine. In addition to building ego, it will build a bank account. More money is paid for the cover than for an interior picture. The cover of a brochure is just another picture, or is it? It has its own special importance. It is featured. But more important, it is the cover. And like countless covers, it is an informal portrait!

When you are untried in the field, your first assignment will be that of the simple identification picture—the informal portrait. Yet when you are established, it will be the same type of photograph that will give you the ego-laden comment, "A picture of Mr. X that I took made the cover of a magazine."

In the introduction, I stated that "the informal portrait is emphasized because your future as a photo-

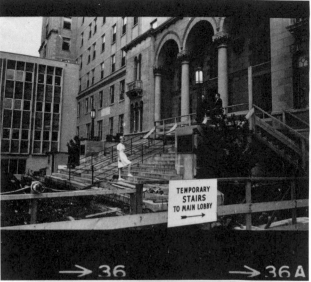

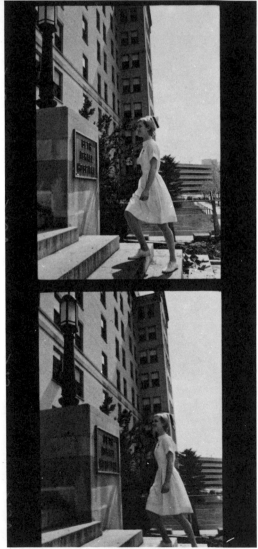

Figure 15-10

journalist will depend upon your knowledge of this subject." The apogee and perigee of your career will be a photograph that demands similar knowledge.

The importance of the cover picture may not be apparent to you at the beginning of your career, because every picture that you are making for publication has equal importance for you. And this is the manner of thinking you should possess every time you trigger the shutter release. If the picture has a purpose, it is *the* picture. It may be only a picture of momentary importance, but life is just an accumulation of moments. Each moment is just as important as the next, in its own time.

It's All Basic Knowledge

About 20 minutes are left of the budgeted 2-hour model's time when you try for the cover illustration. Hastily, an idle emergency room is commandeered. You scan the room to locate the best foreground and background. You decide on a very natural framing device: the operating room light. It will be a natural halo (Figure 15-11). As you are posing the model, you tell the account executive what you are doing and how you visualize the picture. He comments, "It's corny."

That is all you have to hear to decide you had better get a new composition. You ask the model to step to her right about 1 ft. You still want to use the operating room light as part of the picture.

You are after a serene expression. The serenity must be accompanied by compassion, determination,

Figure 15-12

eagerness, youth, and an all-American look. You don't know how to inspire this conglomeration of attributes with words (10 years later you still don't know what to say to get a model to have all the above qualifications on her face). You say, "Don't look at the camera, look to your left." She does and you get Figure 15-12.

Two frames are exposed when the account executive says, "Are you getting in close enough?" Evidently, before the art director left, he briefed the agency's representative to keep an eye on you. It is time to change the point of view. You seize the interruption to repose the model. The demure, universal look that you are attempting to capture (Figure 15-11) isn't it: your second attempt doesn't look good either (Figure 15-12). You feel that her shoulders are too square to the camera and that the background is rather busy.

You ask the model to turn her torso to her right and turn her head a bit to her left until you have a good 45° light direction on her face. You can tell that you have it by the inverted triangle of highlight on the shadow side of her face. You still want the operating room light in the picture and when you feel that you have the composition, you again begin the saturation method of shooting (Figure 15-13).

Since this illustration demands a close-up, you can dispense with the long and medium versions. Instead, you make additional close-ups. At the end of this sequence, you stop; it's also the end of the roll of film. You feel that you have the expression desired, the model's time is up, and it's time for lunch.

Figure 15-11

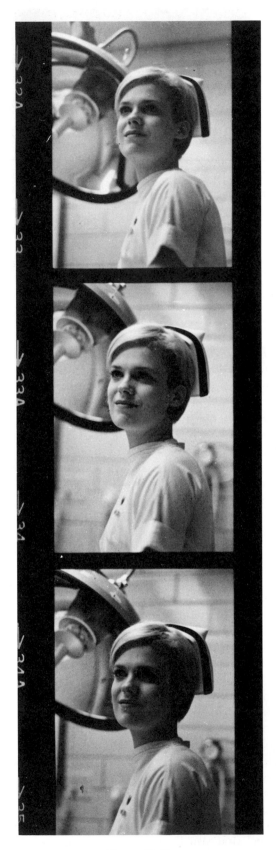

Figure 15-13

The Selection for the Cover

Frame 32A of Figure 15-13 is requested as an enlargement to be considered for the cover. It is used, but with a modification (Figure 15-14). You could have ignored the cluttered background; you could have ignored your concern with the operating room light because the entire background is airbrushed out. This is the art director's decision. The overall thinking is to get nurses and they did not want any indication that a certain type of nurse is featured, for example, operating room nurse as opposed to maternity or floor nurse.

The Teaching Pictures

After lunch, you and the account executive return to the personnel office. You are hastily brought upstairs to a private room in which you find three nurses and an orderly awaiting you. They have donated their services as models to illustrate the "teaching program" and "patient care" aspects.

In the room there is a piece of apparatus that looks like a portable swing. It isn't; it's called a patient harness. You ask a few questions and discover that this harness is employed in lifting an incapacitated patient out of bed. The head nurse will be instructing the other two nurses in its application. As usual, they all turn to you and ask you what you want them to do.

You give clear, concise directions. You instruct them to take the equipment out of the room into the corridor. They are to wheel the equipment in and to proceed as though you are not in the room. This is to give you a chance to see just what will take place. Your cameras are readied. Although you tell them that you are not contemplating any pictures, you are. This is a gambit you often employ. The purpose in telling them this is to relax them. Since you won't be exploding flashbulbs in their faces, they may not be aware that you are taking pictures.

At your signal, the patient harness is wheeled in and you begin taking pictures. You have stationed yourself at a spot where you can include the patient in the bed and a nurse (Figure 15-15). You have time for just 2 frames when the equipment is bedside. To get a large depth of field, you use the wide-angle (35 mm) lens. Unfortunately, the light direction is frontal, but there is nothing you can do about it from this point of view.

As soon as the equipment has reached the patient's side, you change the point of view. The only time you stop taking pictures is when you feel that you have enough of a particular action.

THE RICH REWARDS OF NURSING AT BETH ISRAEL HOSPITAL BOSTON

Figure 15-14

pher is available to take pictures? While you were working on the patient lift pictures, passing personnel would peek in to see what was going on, and they disseminated the information. One of the pictures that had been discussed at the agency was that of the "shock team" in action. As you and the art director had visualized this picture, it would consist of the personnel of the team (simulated, if necessary) wheeling a pacemaker (which starts a heart electrically) through the corridor. You would seek an image that conveyed a feeling of urgency. Now you are presented with an opportunity to photograph a doctor and his nursing aides working on a patient who is in shock.

You Don't Give Directions

An irregular, hoarse, gasping breathing dominates the otherwise still room as you enter cautiously. The

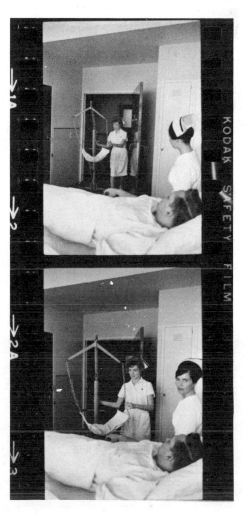

Figure 15-15

You record each and every nuance of their activity. You have no sketch to guide you. The art department is depending on you. As the simulated patient is turned one way (Figure 15-16) and then the other, you expose film as fast as you can. Every position that presents itself to you is captured on film. The patient is finally placed in the device (Figure 15-17) and you are ready to have them repeat the entire sequence, when a doctor enters the room and asks you if you'd like to take some pictures of an actual patient across the corridor. You temporarily abandon the action you've been working on to look at the scene that has been suggested. The account executive scurries about getting releases signed before the personnel leave the area.

A Sidelight

How is it, you might ask, that a doctor working on a very seriously injured patient knows that a photogra-

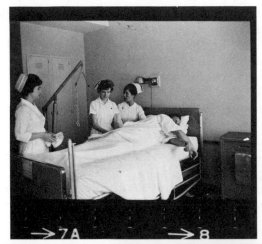

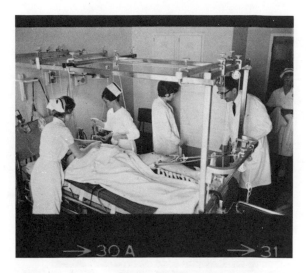

Figure 15-18

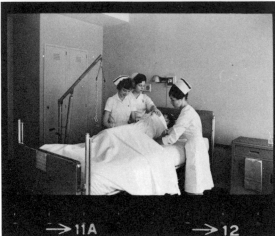

Figure 15-16

two nurses who accompany you into the room, position themselves around the apparatus that surrounds the inert figure from whom the labored breathing emanates (Figure 15-18). No one has to tell you that the patient is seriously ill. A fast survey of the medical equipment serving him and the exposed, injured,

bruised, swollen leg that is visible, accentuates the severity of his injuries.

You decide rapidly to stay out of everyone's way and ascend the window sill in a corner of the room. From this vantage point your mind tries to blot out the human drama in front of you as you attempt to approach the busy scene dispassionately.

The physician administers to the patient, giving instructions to the nurses. From the photographic point of view, you are disturbed by the position of one of the nurses (Figure 15-19) but you make no attempt to ask her to shift. The personnel director is with you and she cautions you not to include the patient's face. The nurse in the upper right-hand corner of frame 34A, Figure 15-19 does not approve of your taking pictures, but since you have the approval of the attending and responsible physician she doesn't bother you. The personnel director informs her why you are taking pictures and mollifies her attitude about an unathorized individual (you) being present.

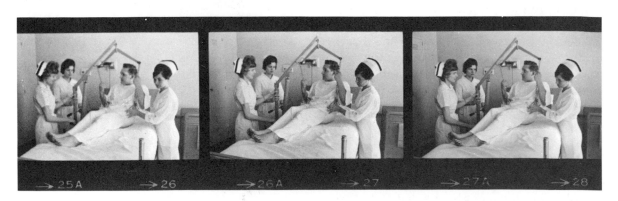

Figure 15-17

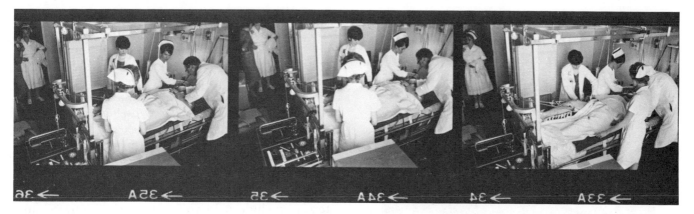

Figure 15-19

You shift to another point of view trying to get a more dramatic light direction—side lighting (Figure 15-20). No one asks you what you want them to do; each person knows just what to do. The room is small and all available space is occupied by medical apparatus. Some is being used and more is on hand should it be needed. In your mind you associate the "shock team" with equipment. You wriggle into a corner of the room behind part of the medical paraphernalia and, keeping this in the foreground, make a series of exposures (Figure 15-21). Your viewfinder tells you that you aren't getting as much of the scene as you would like: you would like to have the doctor in the picture as well. You turn the camera to give a horizontal format. This includes him (Figure 15-22) but excludes the medical apparatus in the foreground. You could have used a 28 mm or 21 mm focal length lens in this situation, but you don't have it. When the

hospital personnel have administered all the aid they can, the doctor turns to you and asks if you have enough pictures. You say, "Yes." You are really eager to leave the vicinity. You have picked up the information that the young fellow's injuries in a motorcycle accident are extremely serious. You are not yet conditioned to operate your camera (which you love to do) under such sorrowful circumstances. Very subdued by the drama you have witnessed, you return to the room across the hall to continue the assignment. Everyone is dispersed.

The Selection

Frame 35A, Figure 15-19 was selected for publication (see Figure 15-23). The deciding factor for its selection over the others is the pose of the nurse in the backgound. Her head is turned in the opposite

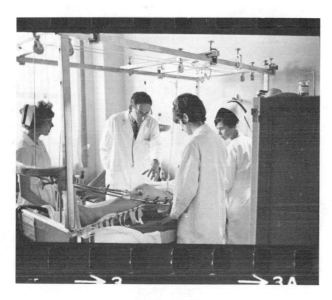

Figure 15-20

Figure 15-21

Figure 15-22

direction from her body. This imparts action to the figure. It is a good point to remember whenever you are able to pose your subjects. This position is assumed naturally by people when they are active: the nurse did. The turn of her head is the only differing element in frames 34A and 35A illustrated in Figure 15-19.

Getting a Retake

You take it "from the beginning" when you commence exposing film for a "research" illustration. The procedure is similar to that sequence you were working on (the patient harness) before the shock team opportunity arose. The nurse will wheel in the equipment, accompanied by the doctor (Figure 15-24).

Why do you begin with the identical sequence?

If you don't take the "wheeling-in" pictures of the pacemaker equipment, because you feel that you have a wheeling-in sequence with the harness equipment, luck will have it that the wheeling in of the pacemaker equipment is needed for the brochure while it is not needed for the harness equipment. How will you explain this situation? You take the pictures so that you won't have to explain anything.

There is another reason for beginning the sequence in this manner. This is the way it would actually occur. You want your models to "get with it." This action aids them in losing their self-consciousness. If they hesitate in their performance it will be up to you to get them back in stride with your conversation and direction. These are not professional models and are not familiar with the saturation method of camera operation. Once you have taken 2

pictures they tend to stop whatever they are doing. You tell them, when this happens, that what they just did was great, but that you need the same action from a different angle. Usually there will be no trouble in their giving you the repeat. But if there is, then you fall back on the statement that "something was wrong with my camera and we'll *have* to do it all over again."

Neither of these situations arises and your subjects continue to function smoothly. From force of habit you move in closer to record the action (frames 10 to 12, Figure 15-25) before you realize that you are not getting the apparatus in the scene. You back off a few steps to include it in your viewfinder, refocus, and pick up recording the scene (Figure 15-26).

An examination of the 3 frames in Figure 15-26 will lead you to conclude that the selection of frame 18 for publication is the best. There is more action denoted by the position of the nurse at the left. In frame 16, the nurse's shoulders are square to the camera. In frame 17 her head is turned in the same direction as the body, but in frame 18 her head is turned in the opposite direction from her body. This is the same principle demonstrated in the selection of the shock team picture (Figure 15-19).

Figure 15-23

A City of Life, Excitement, Friends, and Fun!

There are just 90 minutes left to get pictures that will illustrate what the city has to offer for relaxation. A reference to the copy that will appear in the brochure brings forth phrases which give you ideas: "dining in gourmet restaurants . . . where Broadway plays open before Broadway sees them . . . sailing on the Charles River . . . culture . . . Boston POPS."

From your files two pictures will be used: one long shot showing the interior of Symphony Hall during a POPS concert and a medium close-up of Erich Leinsdorf and the Boston Symphony Orchestra, but you need pictures with a nurse in them. One of the nurses has the afternoon off—it's about 1 p.m.

You are lucky that the nurse, who has the time off, played an important part in the pictures you have already made. The young lady who was the model did not participate in any nursing function. You are happy that a bona fide nurse, already used in the pictures, will be available for this sequence. It helps the credibility of the illustrations. Since there is a variety of assignments that recipients of this brochure may prefer, it is certainly acceptable to have more than one nurse represented. It would not be an honest presentation of a hospital of this size to have the same nurse in the medical, surgical, operating room, maternity, outpatient, X-ray, gastrointestinal and physiotherapy depictions. Any one of the above specialty nurses can be and should be used for the recreation pictures.

You and the account executive confer about possible graphic representations. The suggestion that she be photographed in the theatre district is vetoed because your visualization of this is to photograph her at night. She would need evening clothes. The preparation and photography would take up more time than she has. The preparations and coordination needed to have her at a cozy table in one of the city's picturesque restaurants would take too long. "Sailing on the Charles" offers the best bet. The nurse is in sport clothes and the Community Boat House is but a 15-minute drive from where you are.

The three of you get into the account executive's car and drive off. Approaching an "Emergency Only Parking" cut-off, you ask the driver to pull in—you have an idea. The boy and girl riding in the front seat gave it to you. Romance is always an appealing element. After all, the great talent in advertising on TV tries to sell the idea that "if you smoke a certain cigarette, the girls will go for you." They also try to infer that using a hair bleach will result in a girl getting her mate. Put a male in the picture and let the viewer's

Figure 15-24

imagination supply the rest. You shoot some pictures with the couple (Figure 15-27) and some with the nurse alone. You want an easily recognizable Boston landmark in the skyline, but this view doesn't give it to you.

Back into the car and across the river to the other side. On the bridge you ask him to stop. You try an-

other interpretation (Figure 15-28). The view from this bridge doesn't contain an easily recognizable landmark either, but since you have inconvenienced all, you justify the stop by making a few frames. On one side of the bridge you have backlighting (frame 14, Figure 15-28). It does not delineate the nurse's features, which is not serious in itself, but there is no

Figure 15-25

Figure 15-26

Figure 15-27

Figure 15-28

easily recognizable landmark. You cross the road and photograph her with a front light, but again no landmark that instantly says "Boston."

The Other Side of the River

Back in the car and you are on the other side of the river. At least one recognizable landmark appears on the horizon. As soon as you feel that it will show up in your pictures, you ask to have the car stopped. The nurse is positioned. You are always talking, suggesting where she should look, what she should think, and how she should feel. You are so busy watching the position of the 8 oared shell and motorboat (Figure 15-29) that you neglect to see that the nurse is not walking. She is too posy. Back into the car until you spot the John Hancock building and the Prudential Tower in the background. Out of the car again, and sequences are shot of the nurse alone and with the "boy." In frame 24 (Figure 15-30) you think you

have the shot: the girl, the boats, the landmark, and the boy. What is more, he is so positioned that if the editors want to cut him out, they can do so without disturbing the picture. (It was not used: frame 21, Figure 15-29, was used: the first exposure of the medium sequence.) Back into the car again, and this time no further stops are made until you reach the Community Boat House.

She's No Sailor

Introducing yourselves to those in authority at the Boat House, you politely explain your mission. You get the necessary permission to use a sailboat, but you can't take pictures of her sailing on the Charles: she can't sail. But you must have her doing something so you suggest that she unrig the boat. Since sunset is close and the intensity of illumination is low, you have to use a slower shutter speed than you like: 1/125 sec. You set the infinity mark on your lens mount at one

Figure 15-29

Figure 15-30

end of your depth of field scale—opposite *f*/5.6, your aperture. You want the Boston landmark in the negative, and in focus. You kneel down on the dock and ask her to get aboard. She gingerly steps aboard, and it is quickly evident to you, even through the viewfinder, that she is very unhappy on board. Now you are very pleased that you had the foresight to make the stops along the way. You aren't going to get any pictures here. As she is getting off, the boat starts to give way at its mooring and it looks as if the nurse will wind up in the river. You hesitate for a fraction of a second: you are torn between assisting the young lady and getting an unexpected picture. You will take the picture, but the moment of indecision leads to camera movement (frame 33, Figure 15-31). And this was the one selected for the brochure. It's action—and it's believable.

Some Afterthoughts

You are of the opinion that more thought and groundwork should have gone into this part of the assignment. The original thinking was to use just the pictures of the two orchestras from your file. This sequence was not on the budget. It was your idea to try and get the nurse into the scene. She was a volunteer, so how much could you impose on her good nature? You have given your own services, spontaneously to be sure, and how much can you impose upon yourself?

You Donate a Half Day

During your interview with the hospital representative you had been shown some bad examples of photography. The subject matter dealt with the maternity and operating room departments. You didn't want these pictures in "your" brochure. The reason these areas were not assigned to you was exactly the same

Figure 15-31

reason that "recreation" pictures were omitted: the budget. You are going to add this brochure to your portfolio and, when you display it, you don't want to explain that "this one" is not yours and that "you didn't do that one either."

You telephone the art director in charge of the project and tell him that you will donate your services to make just the maternity and operating room pictures. He is very pleased at this news, because he doesn't want the other photos in the brochure either. He is only too aware of how miserably they will reproduce, and it will reflect poorly on his agency if they are to be printed.

He has to do a lot of arranging and coordinating. The public relations department of the hospital has to be informed. Permission from the mother of the child who will be photographed must be obtained. It takes a day to get the two sequences coordinated. You are informed when and where to report. At the appointed hour you show up and are briefed. You must get into a cap, mask, gown, and nonconductive shoes. You've been through this procedure before (Chapter 9). You tell your contact this, to allay her fears about your knowing how to conduct yourself in and about an operating room.

The Cry Babies

Appropriately clad, you are permitted to enter the vestry of the nursery. Rules and regulations forbid your entering the nursery proper. This time you use the normal or 50 mm lens on the camera, employing it as a medium telephoto. You focus on the bassinet, take meter readings, and select the proper shutter speed and aperture, so that when the nurse approaches the crib, you can take pictures before she is aware of what you are doing. Frame 22, Figure 15-32, is with the 50 mm; frames 23 and 24 are taken with the 90 mm, same camera-to-subject distance.

When the nurse feels that you are going to take pictures, she asks you what she should do. Even if you have never been a father, you certainly know enough to say, "Change the diaper." During the exchange of words, you decide to work with the 90 mm lens (frames 23 and 24, Figure 15-32). After the diaper is changed, the nurse picks up the baby and you continue to take pictures.

The nurse asks you if you have enough. You have 18 frames and that is enough. Part of the hospital's thinking is to include the mother in the sequence: not every picture has to be clinical. This time the illumination is not as intense as in the nursery so you shift to the 35 mm lens to make your exposures. After you

Figure 15-32

have made a few medium shots (frame 11A, Figure 15-33), you move in closer. You don't change the lens because you want the two advantages that a wide-angle lens can give you: a greater depth of field and less camera shake.

The light direction is not the one you want. You have a fast decision to make. Should you disturb the naturalness of the action by requesting that the equipment and subjects be turned so that the light direction will be more frontal and hope that the mood will not be disturbed?

Your decision is to use what you have. When you feel that you have enough of this situation, you request a shift. It doesn't take more than 3 frames to see that the original mood you had is destroyed (see Figure 15-34).

Figure 15-33 **Figure 15-34**

Operating Rooms

Several operations are taking place at the same time—of course, in different rooms. You learned the last time you photographed an operation that it is permissible to enter and leave the room during the operation (see Chapter 9). Naturally, you judge the propitious moment for either your entrance or exit. Peering through the glass windows into the operating rooms, you decide to enter the one that displays the least tension. You don't want to walk into an area in which the surgeon might be disturbed by your presence. True, most surgeons are used to having one or more interns watching over their shoulders, but you aren't certain about their reaction when a camera is pointed in their direction. At any rate, you enter one of the operating rooms, having found the place where you know you'll be out of the way. Your objective is a nurse. There are three in the room you have entered (Figure 15-35). True to your format, you shoot a few long shots (frame 4, Figure 15-35), then some medium shots using the 90 mm lens (frame 6, Figure 35-35). There is a minor problem in exposure involved. The nurse is just on the fringe of the operating room light. You have to open up 2 stops to record her. This means that the surgeons will be overexposed. If the surgeons will be needed in the final print, you can "burn them in" during the printing. You make a series of medium shots of the nurse performing her duties (Figure 15-36), and then you start to look for a different point of view. You tread easily—there is an operation in progress.

From the new point of view you take one frame (Figure 15-37), when a thought occurs to you. Your eye has taken in the collection of surgical hardware at the nurse's right hand. You think that if this were included the picture would be improved. The nurse's activity slows down, you can't get the shot of her that you thought you could, so you abandon this point of view and go in search of another.

You have the long and the medium shots but you need the close-ups. You edge in a bit closer to the operating table and keeping the gleaming surgical instruments in the foreground, take 2 rapid shots (frames 17A and 18A, Figure 15-38). You continue walking around the table to find another point of view. You wait until the nurse is framed by the 2 surgeons in the foreground (frame 19A, Figure 15-38), and you make 2 more. You think you have the shot you want and you leave the operating room.

Across the hall more surgery is taking place. No one takes notice of you as you enter. The nurse is completely engrossed in her duties. This emboldens you to make your close-ups first. You rapidly make 4 frames.

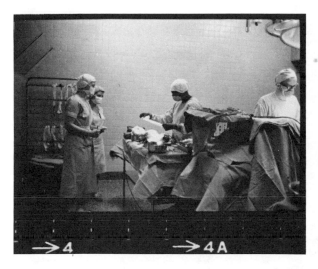 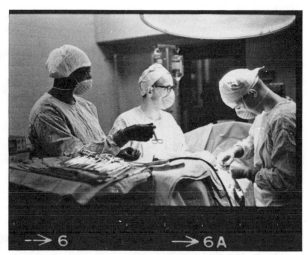

Figure 15-35

You are particularly pleased with these sequences for you notice that her image falls completely within the dark screen in the background. She is very intent in frame 22, Figure 15-39, and even though you can't control the direction of light, you notice that there is a highlight on the short side of her face. Her cap is illuminated as if you had placed a spotlight over her head. You like the concentration in frame 25A, Figure 15-40, and wish that she had been busy passing an instrument to the surgeon. But you aren't about to tell her to do so.

You have your close-ups and you retreat a few steps, replacing the 90 mm lens with the 35 mm. You kneel to get a different point of view, and to your annoyance the nurse starts passing clamps or scalpels to the doctor. Why didn't she do it before? You wish that you had waited a few more minutes before backing off (Figure 15-41).

The only thing you can do is retake the close-ups. Switching lenses (your other camera is loaded with color), you again make her your prime target. This time one of the surgeons has shifted his position, and you can't get the uncluttered background that you had during your first close-ups. You can't get as close to the table as you were the first time and still get an untrammeled view of the nurse. You don't think it wise to get too close to the back of the surgeon.[1] You

[1]Working in an operating room without having the surgeon notified beforehand bothered me. I didn't know just how far I could extend myself without annoying him. That was a human being on the table and I didn't want to be the cause of any mishap. My previous experience in an operating room (Chapter 9) caused me no such concern. I had met the doctor beforehand and he had told me he had worked with cameras trained on him many times. I have worked in operating rooms many times since, but have always met the surgeon first, to remove my doubts about "points of view," and how close I could position myself.

do the best you can (Figure 15-42) and at the end of this roll of film, you exit quietly. Frame 35 in Figure 15-42 was used in the brochure.

The Wrap-Up

With the shooting completed, you have the processing of the film, simple editing and contacting to perform. Within 24 hours of receiving the new contacts, the agency calls you and requests that you send them 8 × 10 enlargements of 6 frames. You are given two of each sequence: the nurse and baby in the nursery, in the mother's room, and two from the operating room coverage. To facilitate the art department's job in layout, you print the full negative of each selected frame: they will crop the picture to fit with their layout.

Sometimes by messenger (if time is pressing) and sometimes by mail you receive a "lucy." This is a pen or pencil outline on tracing paper of the exact size of enlargement that the art department wants. With this as a guide, you make two prints of slightly differing contrast for submission. The ultimate responsibility is theirs: you let them select the best print for their needs.

About one month later you receive several copies of the brochure. As you leaf through the pages with a bit of pride, you reflect on this assignment. What actually went into it?

Salient Points

1. Calling on agencies to let them know that you exist.

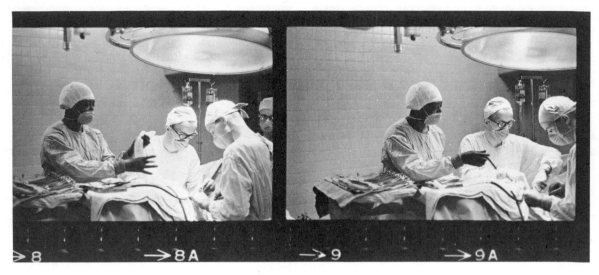

Figure 15-36

2. The ability to convince the art director that you are in agreement with their thinking about the job.
3. The knack of giving the job more than you contracted for: the nurse (model) walking out of the dormitory; the recreation sequence; the nursery and operating room coverages.
4. The ability to estimate an assignment in terms of time and expense: this comes from experience.
5. Complete familiarity and confidence in your equipment.
6. Knowledge of darkroom techniques.
7. The necessity of communication between you and the personnel you will contact. Add all this to your growing experience.

Extra hint. When working in mental hospitals, make certain that the patients in a photograph are unidentifiable. The 21 mm lens was used for Figure 15-43 to illustrate one of the recreational facilities available for patients.

DO	DON'T
. . . direct by concrete suggestion.	. . . expect assignments to seek you out.
. . . give more, not less.	. . . undertake challenges beyond your ability and equipment.
. . . listen to suggestions.	
. . . be careful before you criticize.	. . . forget model release forms.

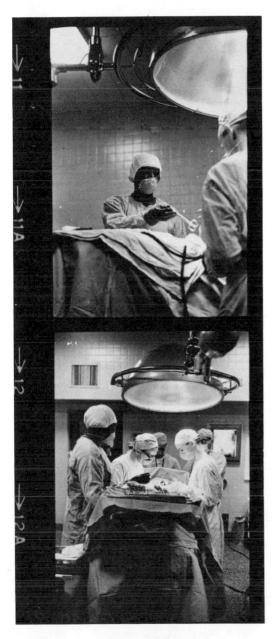

Figure 15-37

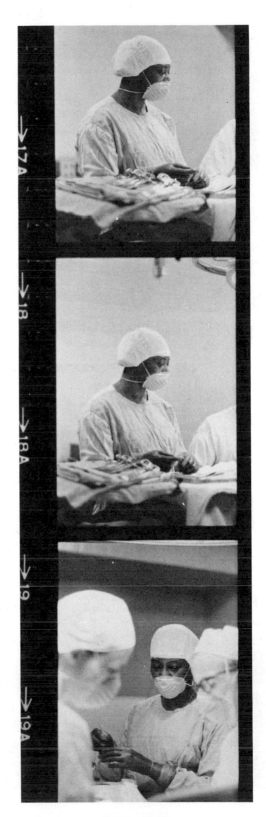

Figure 15-38

227

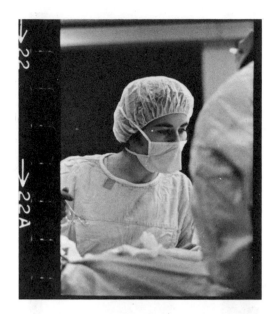

Figure 15-39

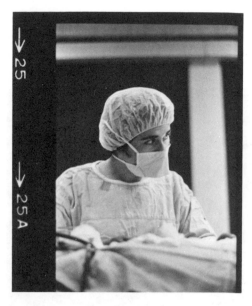

Figure 15-40

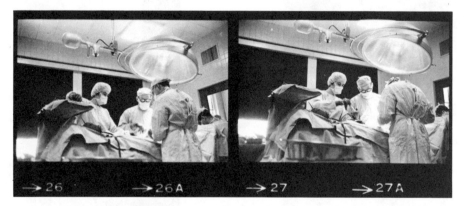

Figure 15-41

Figure 15-42

228

Figure 15-43 When working in mental hospitals, make certain the patients in a photograph are unidentifiable.

Chapter 16

Corporate Publications: Annual Report

Industry has a perpetual need for a wide variety of publications with which they communicate to the public. In the previous chapter you applied photo-journalistic techniques to a recruitment brochure for nurses. Other published material which large corporations deem necessary are facility brochures, instruction manuals, the house organ, and the annual report.

The responsibility for an annual report falls, basically, on three men. A company executive represents company thinking; the photographer represents the conversion of the thinking into visual commentary. The link between the two of you is the public relations man.

Regardless of the size of the corporation or the number of pages in the report, the annual report centers about three areas. The first is capital outlay — where and how much money is spent. The second is the area of management. Each year there are many new stockholders. The only way that they, and previous stockholders learn anything about those responsible for expenditure of their money, is through the material in the annual report. The third area to be considered pertains to the company's products and services, and plans for the future.

The assignment for making photographs to illustrate an annual report will come your way through an advertising agency, the public relations department, or a company executive.

Deciding on a Photographic Theme

It is easy to decide on a theme about which you will center your photography, no matter how complex the corporation's operations, or what their product. Your photographs will illustrate the three areas mentioned. Management should be pictured as realistic, hardworking members within the complex. Once again you find that you will be dealing with busy people and photographing them in an informal manner, using the basic principles stressed in earlier chapters.

To be prepared for your participation in the discussions which will precede the actual photography, you should acquaint yourself with the annual reports of previous years. From your appraisal of the photographs that appeared in earlier issues, you can partic-

ipate intelligently in the discussions. Some of the suggestions you offer will be vetoed as too time-consuming, emphasizing the wrong point or repetitious. Eventually, a photographic approach will be agreed upon. But don't leave the discussion until you determine what management would like emphasized. Your problem is how to do it.

The viewing audience of an annual report is universal: some stockholders are rich and some are poor. The selection of what appears finally in these reports is not your responsibility. But you must give the person who has this responsibility a wide choice, so he can meet his responsibility. This is another reason for saturation shooting (Chapter 8).

Your Payment

Since management must account for all expenditures, you will be asked your fees and what they will get for the fees. Depending upon the prevailing rates in your community, your reputation, your fee and what the company will receive for this fee is negotiable. A minimum of $150 per 5-hour shooting day plus expenses is fair if the coverage is to be in black and white. It is wise to set a minimum amount of black and white, 8 × 10 prints, to which the company is entitled, per shooting day. If 10 are included, the company will be paying you $15 per 8 × 10 selected. A scaled price schedule should be agreed upon for any additional enlargements requested after these 10. A clear understanding should exist between you and management that this price schedule holds just for publication in the annual report. If any pictures are to be used in advertising, you should state that you expect additional compensation.

Your minimum charge should be $200 if you are shooting in color. The cost of film should be included as one of the expense items for a psychological reason as well as a monetary consideration. If you are being reimbursed for the film, you won't stint on its expenditure. Film, particularly color film, can be quite an expense when it is being exposed in the saturation method.

A roll of 36-exposure 35 mm film costs $3 to $3.75 a roll, unprocessed. Processing adds $3.40 to your costs. It is not uncommon to expose 10 rolls of film

per 5-hour day—$70. If the cost is coming out of your pocket, you might be stingy in your exposures—and this you *must not* be.

The Basic Principles

The principles used in the photography of an individual are exactly the same principles used for the photographic coverage for an annual report.

Unless you are an in-plant photographer, you will be accompanied by the public relations director or one of his assistants. Never underrate the importance of a knowledgeable public relations man. There are many advantages in having him accompany you. He knows his way around the complex you will be photographing; he is acquainted with the managers and foremen of the various departments and he can make your job much easier, by helping you make up shooting schedules.

After he has brought you to an area in which you are going to work, you begin with a visual survey of what is before you. When you are satisfied that you have the best point of view, make at least 3 exposures of the long shot. With the experience you now have, you feel confident in your equipment and don't have to bracket your exposures when recording a scene as illustrated in Figure 16-1. If you are using color film, no matter how confident you are in your equipment, you should bracket, by half stops for varying degrees in the saturation of colors. You would be extremely wise, if this assignment is in color, to purchase a large quantity of film of the same emulsion number and run a series of tests with color-compensating filters on one roll before tackling the assignment. Although there could be many filter combinations—depending

Figure 16-1

upon the type of fluorescent used—a practical approach is to use either a 10 or 20 point density, magenta color-compensating filter with film balanced for daylight, if cool or white fluorescents are the source of illumination.

Always the Format

Following the long shot that sets the scene, you go after the medium shot. At first glance it looks like a long shot, but when referred to the small figure in the center of Figure 16-1 you can see that Figure 16-2 is a medium view.

In frames 20 and 21 of Figure 16-2 you select a point of view at eye level. You use the principle of framing by including the edges of the two ladders. Another reason for the saturation method is the activity of the individual depicted. Would the editor prefer him looking up or looking down? You don't know, so you make a variety of frames (at least 6). After this you change your point of view by climbing one of the ladders and frame 22 of Figure 16-2 is the result.

Still staying with the format you move in closer and closer (Figure 16-3).

The Visual Comment

What are the visual comments that Figures 16-1 through 16-3 are making? Money is being spent to increase and improve the service the telephone company gives you.

This view in frame 24, Figure 16-4 comments on the physical layout of the room, showing the supervisor's desk in relation to the aisles of distribution frames. Frame 22 comments upon the aisle itself. If the editor should decide to comment on the man servicing or installing a new component relay system to better service the public, he may select frame 20.

Direction of Light Always Important

An emphasis on light, with special attention to how it falls on the human face is stressed in this book. While you can do nothing about the direction of light in the long and medium shots, you can do something about the employment of light direction in your close-ups.

Since you are unable to move any of the available-light sources, you move. As you move about the aisles, with close-ups in mind, you discover that if you are in the aisle with the installer, you would have to use a frontal, overhead source of illumination. But, frontal

 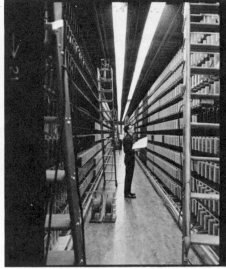 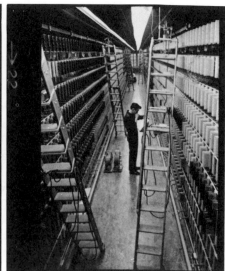

Figure 16-2

lighting is to be avoided. A long walk (you have visual proof of the length of the aisles) around, into an adjoining aisle, gives you the back-lit direction. This gives impact to the figure and texture to the components (Figure 16-5). The necessity of a person in the photograph is very evident. Without the individual in the picture the viewer has no idea of size relationship. There is nothing the viewer can identify with, and the photograph is "dehumanized."

Good Photography Is Work

As you move from department to department, you may feel that repeating the format in each situation is just extra work. It is not "extra work," but necessary coverage. Unless you and the company representative reevaluate the pictorial possibilities, you must cover each department as though that section is the one to be featured.

Such is your fate when you are finished in the central office where you have photographed the company's "bettering the service" aspect and arrive at the dial installation room. Here again, you will be photographing the service aspect.

First from one angle and then from another (Figure 16-6) you begin your coverage in your conditioned format, with the long shot.

In Figure 16-7 your eye catches men at work in-

Figure 16-3

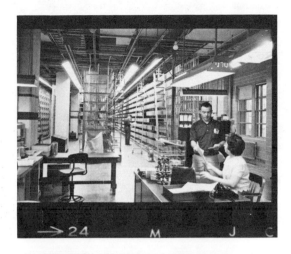

Figure 16-5

Figure 16-4

stalling the dial system for those communities that don't have it.

Another Advantage of the PR Man

You need a ladder to get elevation for your pictures of an installer at work. Public relations is right there with the help and clearances to get you where you want to be. For this sequence you have to use the light direction as is. It's not what you would like to have, but it's all you've got.

This time, to give impact to your picture, you frame the installer within the scaffolding. By framing the subject, you have a better photograph than one made without framing (Figure 16-8).

Information Please or 411

Whenever you dial 411, your call goes to the department pictured in Figure 16-9. It is here, where a lovely, young lady has a wide variety of ways to get

Figure 16-6

Figure 16-7

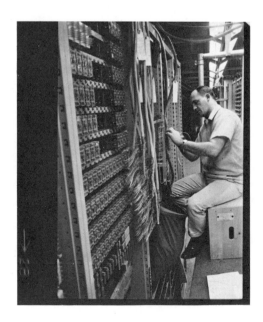
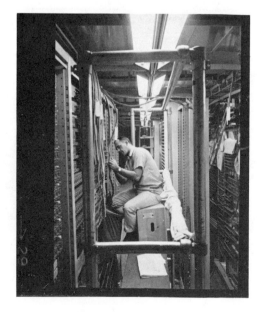

Figure 16-8

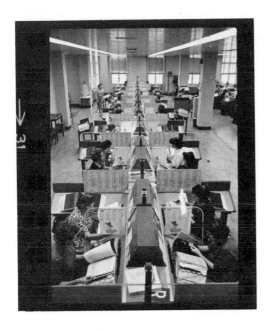

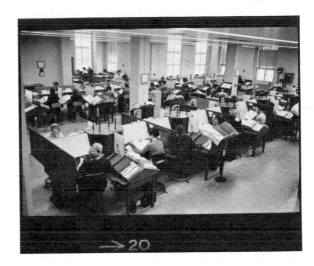

Figure 16-9

you a number, with the misinformation or lack of information you give her.

Time: an Element in the Depth of Coverage

Time is an important factor in the depth of coverage you can provide in any area. You are not so proficient that photographs with impact will continually roll through your camera. It takes a while for you to become involved in the action and for compositions to evolve. You don't want the additional pressure of having an individual waiting for you to finish your photography in one area so he can take you to another.

The man with you is a professional. He asks you how much time you think you'll need. You estimate about 45 minutes. He gives you an extension number where you can reach him if needed. He leaves, after ascertaining that you'll have no difficulty with supervisors. He will only give you full responsibility if you have previously demonstrated your ability to him.

You don't notice his departure because you are busily engaged in capturing a series of frames which depict the telephone operator scurrying from one index to another, digging out the number for the person at the other end of the connection (Figure 16-10).

Figure 16-10

It is a good idea to get a few frames where the person in the picture is unidentifiable or doesn't show at all. You want to cover yourself in case it may be difficult to obtain the person's release. You try a few frames without the operator in the picture (see Figure 16-11).

You do not forget the close-ups (Figure 16-12).

As you move about the large room, you observe various aids for the operator's use. You record one of them, by sitting on the floor.

Which format shall you use? This question arises when you see the size of the index. If there is a question about the format, shoot it in the horizontal as well as the vertical. The vent in the ceiling (Figure 16-13) annoys you. It can be retouched if it annoys the art director.

All day long and into the next few days you pile up mileage and exposed film in the various departments of this complex organization.

The Selection

After you have submitted the contact sheets and several enlargements for consideration, the following are finally agreed upon by the company executive and the advertising agency responsible for publishing the annual report.

Figure 16-14 is a long shot of a section of the "information please" room, made with the 35 mm wide-angle lens, and a close-up of one operator, captured with the 90 mm lens.

Figure 16-15 is a backlit view and a medium view depicting expansion of the company. Both were made with the 35 mm lens. The semi-silhouetted shot is a grab shot, and the other is an unposed posed view.

DO	DON'T
. . . find out what is to be stressed pictorially.	. . . ignore previously published reports.
. . . make some pictures where people are unidentifiable.	. . . be stingy with film.
. . . give complete coverage to every area.	

Figure 16-11

Figure 16-12

Figure 16-13

Figure 16-14

Figure 16-15

Chapter 17

House Organ: Working With a Writer

An assignment that might come your way via the photo agency is one for a company that is worldwide. The house organ may have a circulation of more than 25,000 copies. In most cases articles cover a wide geographic range. One issue contained articles, all illustrated, from Hawaii, California, Tennessee, and Massachusetts. It is impractical for one photographer to cover all of these locations for one issue. The company turns to a photo agency which has "stringers" all over the world. The reputation of the agency depends on you; you must be qualified before you are listed by the agency.

Since you have climbed the ladder in your agency by satisfactorily completing several of the informal portrait assignments and have progressed through the specified picture assignments (Chapter 10), you are ready to demonstrate your talents on a picture story. This time you are going to be on your own— almost. The company is sending down a writer to interview the subject.

Basic Information

The first you hear of the forthcoming assignment is the telephone call from your agency checking on your availability for a specific day. You're available. A fast rundown on the assignment is provided. You will spend a day at a gasoline service station about 15 miles from your home. There, you will meet a writer who will brief you on the subject matter of interest to him. Where you are to go, when you are to be there, whom you will contact, the telephone number of the location, the address, and the expected remuneration are rapidly related. A confirming letter is on its way. You reserve two days in your appointment book for the assignment—one day for shooting and the following day for processing, identifying, and contacting. It isn't necessary for you to process or to contact, but you want one set of contacts for your file and you want to see the results immediately. It is more important to evaluate the density and contrast of the negative than to view a print. You can add the processing charges, along with costs for mileage and phone calls, to your expense sheet.

On the evening before the assignment, you wait for the weather report before retiring. A great deal of your shooting will be done outside and you'd like to have good weather: hazy and bright is what you prefer; clear and sunny is your second choice. You don't dare think about what you'll do if it rains.

Meeting the Writer

Upon arising on the appointed day, you look out the window and you have your second choice—clear and sunny. You are supposed to be at the station between 9:30 and 10 A.M. The reason for this late start is that the writer will need the subject for interview purposes for about one hour. At 9:30 A.M. you pull into the station. You are easy to spot with two cameras dangling from your neck. The writer greets you, and general introductions follow. He still needs about 15 minutes with the manager. You busy yourself reconnoitering and taking meter readings.

Finally, you get your chance to talk with the writer.[1] You have some questions for him: What is the article about? Are there any specified pictures desired? Is there any phase that he (the writer) would like accentuated? You hope you'll be able to evolve an approach to this assignment from his answers. As yet, you don't know where you'll begin. You want a theme.

Before the writer left his headquarters he had a discussion with his editor. Let him tell you what transpired in his own words:

"I talked generally about the assignment with the editor of S_____P_____. Since I'd done several dealer stories, details were brief. He did note: (a) B.'s funny sign on the back of his truck; (b) B.'s spiraling gallonage figures (subject not eminently photographable). After that, it was my assignment . . . My instructions were to get plenty of shots of the overall operation. We shouldn't have to pose many shots. Just make it a day in the dealer's and the station's life."

[1]This was not the first time that you worked with this writer. His observations about your method of operation on the previous assignments are worth keeping in mind. What do they (the writer, the editor, the layout man, and your agency) want from the photographer? The writer says, "I'd already noted that you possess the two key ingredients: (a) a sense of saturation shooting, adroitly handled and well photographed, and (b) imagination."

A fast rundown by the reporter tells you that this particular manager has boosted gasoline sales by 70% in the two years that he has been in charge of this station. For two years he has won the district first prize for "cleanliness" and that he believes in *service*. Your agency didn't give you this information, you've got to dig it out.

Now you have the key points in mind; now you know just what action you will record—cleanliness and service. You are anxious to start photographing. You ask the writer one other question: does the publication he represents have any policy as to points of view? The interpretation is all in your hands and eyes: it's all yours from this point on.

You Begin Photography

One picture they will certainly want (you think) is a shot of the manager and his station. It's December and the station has tasteful decorations for the approaching holiday: in the window is Santa Claus with a company hat on his head. You have an idea. Why not have the manager depicted as he arrives at work? You'll shoot the sequence from inside the station and keep Santa in the foreground. There is a brief discussion with the subject and he walks off. To obtain the greatest depth of field, you use the camera with the wide-angle lens. Before he is literally out of the picture, you manage to record 3 frames (Figure 17-1, frames 1 to 3). To get at least 6 as a total, you ask him to start from the same place and repeat the action. He does and you make 3 more frames (Figure 17-2). This will not be the only time that you make a picture using this particular point of view. Later on in the assignment you will find yourself in the office, when you catch a view of your main subject, very busy. You won't be able to get 6 shots, but you take what you can and that will be honest (Figure 17-3). Even though you have covered a specific sequence more than once, you will be ready to shoot anything that you see which pertains to the same idea. It will be different: there will always be some variable present even though you have previously made what seems a similar shot.

A Staple Picture

Since this is a company periodical, you know that another "must" is an overall view of one of their in-

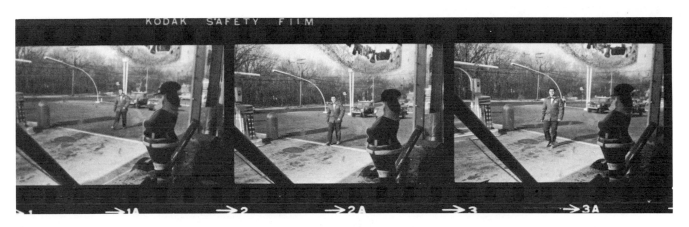

Figure 17-1

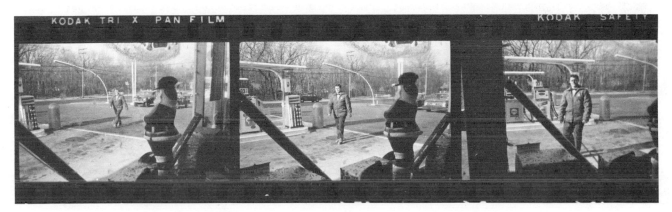

Figure 17-2

Figure 17-3

stallations. You also know that at different times of the day there will be different light directions. Which will be best? Since you don't know, you decide to make a few of the long shots showing the overall view of the station immediately. Your general plan is some coverage now, again at noon, and once more just before you call it a day: this will capture the scene with different light directions.

Once on the other side of the road, you make a long shot (Figure 17-4, frame 28). A thought crosses your mind: should you include other vehicles on the road? Would this make a better picture? You don't know what the editor's thinking is, and you are in a position to make the picture, so you make them (frames 29 and 30), including parts of and full representations of vehicles on the highway. This implements the station shot without traffic.

Later on in the morning, you go after the same shot again, knowing that there will be a different light directional source. You also decide to go after a new point of view. You look and find a beautiful framing device: the night-light fixture. The format to which you are conditioned haunts you so you make a real long shot (Figure 17-5, frame 28) before moving in a bit (Figure 17-5, frames 29 and 30). A comparison of the pylon (chimney) in Figure 17-4 and Figure 17-5 clearly shows the differing directional sources of light. In Figure 17-5 the front of the pylon is hit by the rays of sunlight; in Figure 17-4 the front and side of the pylon are of the same tonality.

Just as you planned, before finishing, sometime

Figure 17-4

Figure 17-5

after lunch, you cover this one more time. Again the traveling sun gives slightly different illumination. This is easily seen if you look at the small pipe jutting out of the roof at the left of the pylon. In Figure 17-6 the sun has hit it, while in Figure 17-4 it is still in shade. Was one of these frames selected? Were any considered?

In the course of the day 15 exposures of the type illustrated were made. Frame 30, Figure 17-5 was ordered as an enlargement for consideration; it was not used.

Cleanliness and Service

From the writer's comments, you have filed two words in you head: cleanliness and service. Throughout the day at the service station, there is plenty of opportunity for a service picture, but what about the cleanliness aspect? This company, incidentally, does not have any printed suggestions to offer the photographer. A new photographer to the agency never gets this type of assignment as a proving ground. The

company knows that a proven cameraman will be assigned to their project: no need for the list, it's part of the man.

Before you use the "unposed posing" you try to get what you need in the course of the day. And in the course of the day, opportunities present themselves.

Around the corner of the island near the gas pumps, your subject appears lugging a "blower-cleaner" (Figure 17-7, frame 23). As yet you don't know what the contraption is, but you don't have a picture of him with it, so you make a shot (frame 23). He pushes this contraption up and down in front of the island, and you make additional pictures.

When he starts the machine, you go to your other camera and make a medium shot (Figure 17-8); then back to the first camera you are using. You need a long shot of this action so you put a bit of distance between you and the area. While you are walking, a truck drives up to the pumps. The owner shuts off the cleaner and prepares to service the vehicle (frame 25, Figure 17-7).

Having finished servicing the truck, the subject

Figure 17-6

Figure 17-7

Figure 17-8

continued to work with the blower-cleaner. You are there with your camera to record it (Figure 17-9).

The Selection

In all, you make 8 frames pertaining to the blower. Figure 17-10 shows the 3 considered for publication:

frame 25, Figure 17-7; frame 27 in Figure 17-9, and frame 13A in Figure 17-8. Frame 25, Figure 17-7 was selected for publication, cropped as in Figure 17-43.

Three individuals rule on the final selection: the editor, the layout man, and the writer. The writer says:

"First of all, on any job, I work from contact sheets sent on from the photographer or photographic agency. I try to be very selective at this point, limiting myself to 10 to 20 shots on which I'll order prints. In other words, much of the selection process must be done at this point, trying to avoid duplication and to choose shots that will best tell our story. So I order the glossies. By this time, I've usually written the story and am, therefore, guided in the type of shots I want, depending on the aspects of the totality that I've focused on. When I receive the glossies, I try to sort them out somewhat, anticipating the kind of layout that the artist might choose. Then, with 6 or 8 photos (I'm thinking in terms of a 3-page magazine story now), and the story in galley form, I'll sit down with the artist. Here we'll be ruled, naturally, by space, pic-

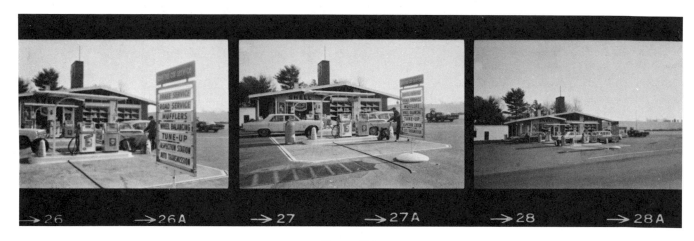

Figure 17-9

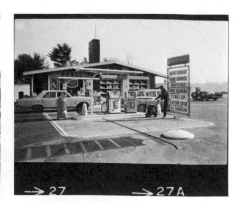

Figure 17-10

torial excellence, and the kind of story we're trying to tell.

"I selected about 20 shots—a few simply because they were good pictures (well-defined, interesting shadows, good portraiture, etc.), and others (also good shots) because they dealt with points brought up specifically in the article. When we (writer, editor, and layout man) came to select the 7 shots that would be used in the publication, we had to eliminate some of the best, simply because of our audience or because we could tell the story more directly with another picture. Maybe at this point I should identify my audience—we're writing for 25,000 Shell dealers, and when we do a dealer story, it's because a man is a model, usually having one special recommendation and a good overall operation. In this case, I chose to concentrate on service."

Why did he select the picture of the man with the blower?

"The shot of B. and his portable blower served two purposes—one of showing the station's appearance; and the other, of picturing an unusual aspect of his business, the blower itself."

You didn't take the picture for the same reason that it was selected and neither was it selected for the reason that you took it. It's just a question of your being alert, having an eye, and using the saturation method. You were on the right track in making the pictures that showed the general view of the location. You were just lucky that B. decided to do a bit of cleaning when you were around.

To dispense 70,000 gallons of gasoline a month, means that the station is busy every moment of the day. This also indicates a lot of tire pressure checks, oil checks, and cash or charge transactions (Figure 17-11). Nearly every time a car appears you are busy taking pictures. The question of releases is discussed with the writer. You are told that he will take care of these. Nevertheless, experience has taught you that if others are included, try to make them as unrecognizable as possible. You are happy with the fact that the driver is obscured in Figure 17-12, frame 26A, but to make certain, you change your point of view (frame

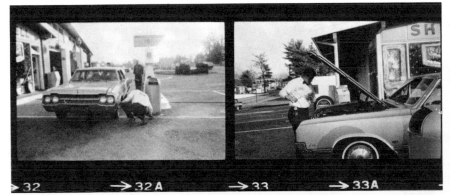

Figure 17-11

Figure 17-12

27A). Maybe they need a vertical format of this picture? Make a few this way (frame 28A). They might not need them, but *make* them. Because cars have been driving up rather frequently, you decide to wait at the spot. Between car servicings, you keep you eyes open and suddenly a juxtaposition claims your attention. There's a man in the ladies' room (Figure 17-13). Here is a real candid; you want this. You don't have time to take the readings for light intensity in the ladies' room. Your experience comes in handy. Cut down on your shutter speed 1 step, and open the diaphragm 2 stops. This is equivalent to increasing the exposure 3 times, when compared with the combination you were working with outdoors. How do you arrive at this conclusion? Either from testing, experience, or following directions that are enclosed with each roll of film. You know that if you have the correct exposure for sunlight, open shaded areas require about 3 stops more. In this case the door to the restroom was open, and you made an educated guess. You were slightly underexposed but the latitude of the film and the photo technician who made the final print took care of the slight error.

Figure 17-13

What was your thinking on the picture? It was the incongruity of the situation: a man in the ladies' room. What was the writer's thinking on the picture? It was selected because "the picture . . . shows the station's cleanliness, a recurrent theme of the magazine. It also got one of B.'s men into a picture."

The picture could be staged if you have insight. Would you have thought of staging it if it hadn't actually occurred?

More on Cleanliness

You are unaware that you have already made the 2 pictures that will be chosen to illustrate "cleanliness." So, whenever you notice anything that has to do with cleanliness, you operate your cameras.

Quite unexpectedly, you come upon a scene where the owner is having a discussion with a customer. He was hosing down a bay when interrupted. You are pleased that he is engrossed in his discussion and ignores you, because you want the naturalness of the situation. You have time for only 3 exposures before she leaves. He continues hosing down the bay. Since you feel the sequence is better with the woman in the picture, you make only one shot of him alone (Figure 17-14). (The editors and writer selected the one of him alone for consideration but did not use it.)

More Service Pictures

The pump island offers many opportunities for service pictures. You resume your service coverage after the cleanliness interlude. Each time a car approaches you record the customary services. These are all shot as sequences; never just one, if you can help it (Figure 17-15).

Though you concentrate on the main subject, you remember a casual comment of the writer. It pertained to getting some of B.'s men in the pictures. When one of his men is performing a service, you record his movements. You shoot this in sequence and saturation, although not as extensively as you do for the owner (Figure 17-16).

The Selection

In all, you make 54 frames that pertain to the service just related. Three were ordered as enlargements for a final decision: frame 27A, Figure 17-11; frame 26A, Figure 17-12; and frame 35A, Figure 17-15. Frame 26A, Figure 17-12 was selected (see Figure 17-17). Why? Let the writer tell you in his own words.

Figure 17-14

"I chose to concentrate on service. Therefore, the lead shot of him cleaning a windshield seemed our best bet. He was clearly defined, another car was also being serviced, and the customer wasn't so distinct that we had to worry about her asking for modeling fees."

Inside Servicing

Other types of services are performed in the bay. When tires have to be changed (Figure 17-18), you are there with your camera. You are happy when there is an assistant in the picture. When there are three people in the picture and there is action depicted (frame 6, Figure 17-18), you are happier.

Raising a car to change the tires provides an opportunity to get another point of view (Figure 17-19). Figure 17-20 is the trouble-under-the-hood picture.

There is a lull in the mechanical activity and the owner sits down to enjoy a smoke while he chats with one of his customers. You first see him framed between a toolchest and the raised hood of a car. The whiteness of his shirt catches your eye. You raise your camera and shoot (Figure 17-21). Realizing that you are shooting with the wide-angle lens, you change to the camera with the 90 mm lens. Still keeping the same framing devices and the same distance, for you don't want to disturb the naturalness of the situation, you resume taking pictures (Figure 17-22). In the first frame (29A) he is attentively listening to his customer. The Santa head in the background disturbs you but you like the expression on the owner. You make it because you know that you will be making others. If the others are not as good, you'll have this one. If the others turn out better, you have lost nothing. In frame 30A, he has shifted slightly so that the Santa head is not disturbing, and he is partially obscured by the toolchest, and you've lost the customer. In frame 31A, he sits down in another car, is animated, unposed, and happy. He is well framed and the customer is in the picture, but again unidentifiable. That's saturation.

Selection

The last picture in the publication is frame 31A, Figure 17-22. The writer says:

"The picture of him talking to a customer is labeled 'friendliness' and is a good shot of B. It's candid. You've gotten him in an unguarded moment. And, though we are forced to run a lot of nuts-and-bolts stuff, with shots of cars being greased and the like, we

Figure 17-15

Figure 17-16

It's getting close to lunch time and you are grateful for the break. The owner says that he knows the place to take us but that he has to go home for a few minutes first. Would we rather wait at the station until he returns or accompany him to the house? You welcome a change in location and here is an opportunity to show another facet of your subject.

Another Side of Your Subject

Arriving at your subject's home, you jump out of the car and ask him to delay going in until you are ready. You quickly focus on his house and place this distance at one end of your depth of field scale. A glance at the scale shows that you have 12 ft. to infinity in focus at the shutter speed and aperture you are using. You ask him not to go into the house until you are there. You don't know what or who will be inside the house, but you want to be there before he is, so that in case there is something to shoot, you'll be ready. With an energetic stride he starts for his house. He is moving so fast that you have time to get just one frame exposed (Figure 17-23) before his

are interested in good pictures of real people. It's hard enough to get any different shots when we have to keep returning to the one subject—service stations—so our general rule is to look for unusual aspects of a business and to hope that each shot is clear, candid, and somewhat interesting."

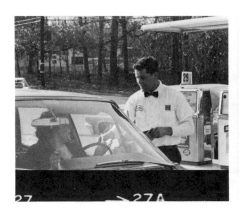

Figure 17-17

Figure 17-18

Figure 17-19

Figure 17-20

Figure 17-21

figure is ineffective for your needs (frame 5, Figure 17-23).

In the Kitchen

Before he can open the door, you yell, "Don't go in yet!" While calling out to him, you are racing to the back of the house to be inside before he is. You quickly take a meter reading in the kitchen, where there are 6 children grouped around a table curiously looking at you. You set your focus on 12 ft. and the rest of your dials according to your meter. His wife opens the front door and the father of these children bounds into the kitchen. The nearest one to him leaves her lunch and hugs him (frame 6, Figure 17-24). You keep exposing as fast as you can and as long as the action continues (Figures 17-24 and 17-25).

After the excitement quiets down, you are shown another room in the house. Against one of the walls is a display case containing an impressive array of rifles. You feel that you must have a few pictures of your subject with the firearms. You suggest that he clean one of them to get action in the sequence. This is vetoed because of the amount of time needed. The writer doesn't demonstrate any enthusiasm for this sequence.

You settle for his taking a few rifles out of the case (Figure 17-26), and then he offers to show you his backyard. While he finishes putting the arms away, you go outside to look around for points of view.

A man and a dog. (One of the three "B's" of publicity pictures stands for "beast," the other two are babies and beauties.) The writer again does not demonstrate much enthusiasm for this, but the dog is out of his kennel and playfully bounding about his master. Even though interest is not displayed for this sequence, you are there, you have film in your camera, and you make several frames (Figure 17-27).

It really is time to get going, so everyone says good-bye, (frame 35, Figure 17-28). Your subject had nearly forgotten why he had to return to the house in the first place. It was a private household matter. You tag along with him. By this time he has come to accept the fact that you are going to be his steady companion. You make 2 shots, finishing the roll of film in one camera (Figure 17-28) and decide to give him and his wife a little privacy. You join the writer outside and wait for the manager, so you all can finally have lunch.

Figure 17-22

Figure 17-23

Figure 17-24

Figure 17-25 Expose as fast as you can and as long as the action continues.

Figure 17-26

The Selection

Concerning the pictures taken at the dealer's home, the writer states.

"The visit to B.'s home was part inspiration, part proximity. He lived nearby, had kids galore, and was glad to have some shots taken in the house. This, inci-

dentally, compares with one of the editor's original photo points: 'Try to get the dealer out of the station, preferably at one of his community functions.'"

Three frames were selected for consideration: frame 6, Figure 17-24; frame 12, Figure 17-25, and frame 27, Figure 17-27. (See Figure 17-29.) Of the one decided on for publication (frame 6, Figure 17-25), the writer gives the following reason: "The shot of the subject and his children provides candid emotion for the magazine."

Resumption of Coverage

On returning to the station, you feel that you have enough of the standard service pictures required: such as windshield wiping, checking oil, and changing tires, and look around for something different. You are not as energetic as you were in the morning, for you have worked off some of the energy and devoted another part of it to digesting your lunch. You are in the station office waiting for something to happen when a telephone call comes in from a motorist in trouble. You overhear the manager tell the caller that he'll be on his way immediately. As he puts on his coat, you begin taking pictures (Figure 17-30). He heads for his service car (Figure 17-31) and you operate the camera. You have only a few frames of this sequence and want additional ones. The action you want is that of him getting into the pickup. He obliges by leaving the cab and getting in once again (Figure 17-32). You have your long shots on this sequence but you want some material that is taken closer.

To cover the way someone else (the writer or the layout man) might see the situation, you make 3 frames of him as he begins to back the truck into the garage to load the necessary materials to take care of the stranded motorist (Figure 17-33). You are using your other camera, the one with the 50 mm lens for these medium shots. As he loads the wrench and jack into the truck, you are back with the other camera, recording the action (Figure 17-34).

You hurry into the garage bay in order to get the sign on the back of the truck from a different point of view. First, you make it from one side (frame 14A, Figure 17-35) and then you make it from the other. Frame 15 is better composition. For another point of view you hop intò the cab of his pickup and get him loading the pickup (Figure 17-36). Of course, you have asked him to reload the truck again. By this time he is anxious to get to the motorist stranded on the highway. But you have just one more request: you want some close-ups. First from one side which has

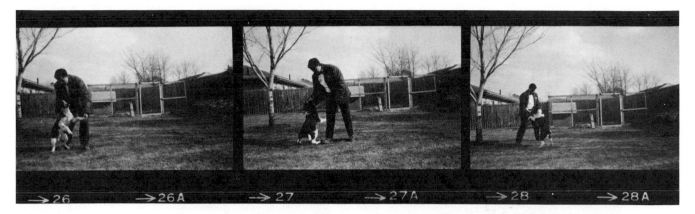

Figure 17-27

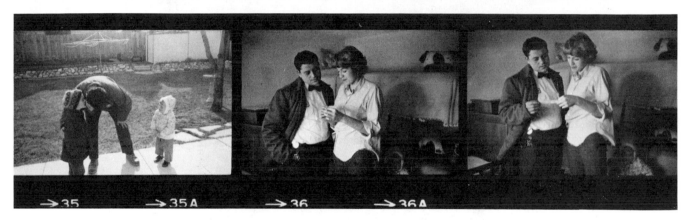

Figure 17-28

frontal lighting (Figure 17-37, frames 15A and 16A), and then from the other side (Figure 17-37, frames 18A and 19A) which has backlighting, you make your close-ups. You ask him to talk into his radio, which is in the pickup, as though he were on the road talking to his service station. After this sequence he drives off to aid the motorist.

The Selection

Two frames were considered for publication: frame 4, Figure 17-31 and frame 8A, Figure 17-33. Frame 4 was selected. Earlier in the day the writer had mentioned that he would like a shot of the sign on the back of B.'s truck. You want to wait until the truck would actually be put to use—the realism factor—before you have to pose it. The magazine editor had briefed the writer about getting the "funny sign on the back of the truck." The writer's comments on this shot were: "The shot of his truck is playing up a special feature of B.'s business, the 'invitation to a blow-out.'"

Incidental Coverages

Through the course of the day, your camera turns to other aspects of the service station business. When the company salesman visits the station (Figure 17-38) you record the meeting. None of this sequence is considered for use.

It is a treat for you whenever there is any activity other than servicing. When one of B.'s men is busy with the miscellaneous items that the station stocks, the camera with the wide-angle lens records the activity (Figure 17-39). In fact, whenever there is a scene or moment that you feel you haven't already recorded, you do so. Even though you have taken a sequence of frames with the owner at the cash register, you don't have the sequence with him and one of his men there: so you shoot it (Figure 17-40). Frame 35 is one of the views considered, but rejected. Other pictures tell *their* story better.

You feel that you must have a picture of the manager at the entrance to his shop and, of course, the company name must be displayed. It's fairly easy by this time to obtain a pleasant smile on your subject

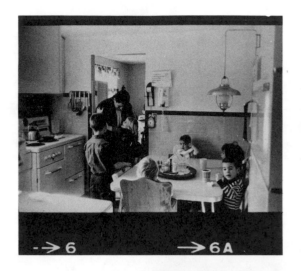
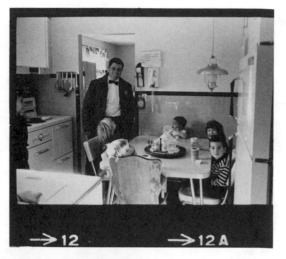

Figure 17-29

Figure 17-30

Figure 17-31

Figure 17-32

Figure 17-33

Figure 17-34

Figure 17-35

Figure 17-36 Get as many points of view as you can.

Figure 17-37

Figure 17-38

Figure 17-39

Figure 17-40

Figure 17-41

(Figure 17-41). You merely state, "This is the last of the pictures," but it isn't, because the writer approaches you and remarks that this particular proprietor has boosted tire sales as well as gasoline sales. Back to work!

Want To Buy a Tire?

As incidents occur which prompt you to take pictures, so with the writer. While the bulk of the discussion concerning the article took place at the writer's home base with the editor of the magazine, impromptu conversation with the subject gives the writer additional material to include in his article. As the writer states, "He (the subject) told me the tire business was good, so we arranged for him to be 'selling' me a tire."

Now the responsibility is yours. You become a director. Your eye views the various backgrounds that will appear in your pictures—with the tires as the focal point—and you note the direction of the light source, which pleases you, for it is from a back direction. Since you are working for a company periodical, you select a background that shows the brand name of the tire this station sells. You need someone to whom a tire can be sold and you ask the writer to be the customer. You give the salesman the approach:

you tell him that the customer has never bought a tire at a service station, but always buys them at places where tires are the main item. Now you say, "Convince him that he should purchase his tires from you." He starts selling; you start taking pictures. Eight frames in all are exposed of which 3 are illustrated in Figure 17-42.

The Selection

Frame 32A, Figure 17-42 was selected for publication. The writer gives the following reason for selection: "The tire-selling shot is kind of staple—personal service equals salesmanship." The published material appeared as in Figure 17-43.

Additional Comments on Selection

The writer's comments: "As I noted, the selection was tripartite. If I had not been present, we might not have used a shot like frame 31A, Figure 17-22, or even B, at home (frame 6, Figure 17-29). (See Figure 17-44.) But generally the editor and layout man had reasonable taste, so it was a matter of telling the story."

In all, 273 exposures were submitted from which 20 were enlarged to be considered. The final selection was narrowed down to 7 that were published. This job was not overshot, nor was it undershot. It was good enough to have you requested as the photographer for additional assignments for the same company.

After the Assignment

You offer to drive the writer to the airport, but since his plane won't be leaving for two hours, you decide to have a beer. You would like a bit of time to unwind and so would he. You both adjourn to a pub where the writer remembers: "A very jovial chat, a feeling that we'd done a good job. You know, it's great to be finished; let's drink." We had two.

Back to the Studio

Because there is no rush for delivery, the processing can wait until the next day. It is finished in the morning, edited, and contacted in the afternoon, and one set of contacts with the negatives are mailed to your agency, along with your expense sheet. Two months later the agency sends you a copy of the periodical containing your pictures. It goes into your portfolio.

DO	DON'T
. . . ask for key points to be featured.	. . . pose if you can get it candidly.
. . . determine the publication's policy and viewing audience.	. . . be stingy with film.
. . . make the same photographs under differing light conditions.	
. . . be alert for unusual situations.	

Figure 17-42

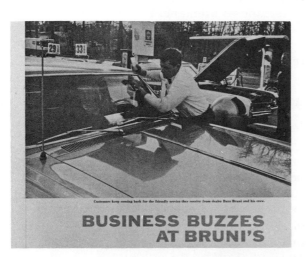

Customers keep coming back for the friendly service they receive from dealer Buzz Bruni and his crew.

BUSINESS BUZZES AT BRUNI'S

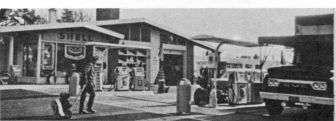

Buzz helps to keep his driveway area clear of litter by using a portable power blower.

Every member of Buzz' crew—including number two man Jim Counihan—chips in on cleaning duties. Special treatment is given to the sparkling restrooms.

A warm welcome awaits Buzz at his home, which is located in a development just a short distance from the station.

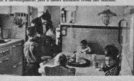

Buzz interrupts a job for friendly words of advice.

Despite heavy competition, Buzz boosts his tire business by applying the personal touch.

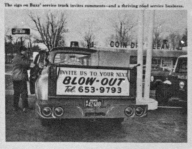

The sign on Buzz' service truck invites comments—and a thriving road service business.

building. And for both men and women customers, Buzz stresses the "personal touch."

Buzz has known many of his customers since 1961, when he became one of the members of the original crew at Natick Shell. The station, one of the area's first ranch-style units, became available when the existing dealer announced his intention to quit. "He felt the station had passed its peak," Buzz recalls. "But I didn't agree. After all, it's at an ideal location, in a growing community."

Recalling his opportunity to take over the station, Buzz says, "It couldn't have come at a better time. I was right at the point where I was going to ask Shell for my own station. I liked the way Shell treated its dealers, and I thought I was ready for my own station after seven years' experience in the service station business."

Buzz was one of some 15 applicants for the station. "Shell chose me, I feel, because I knew the station and the customers. And I'd already proven that I was willing to work."

When he took over the station in February, 1964, Buzz started putting his experience to immediate use. He'd also learned quite a bit by talking with other Shell dealers. And he found that he could keep an accurate check of his finances by using the E. K. Williams bookkeeping system.

"We went right to work, cleaning the place up and really pushing service," Buzz recalls. "My biggest problem was getting good help. But I offered fair wages, plus an incentive system, and fortunately the right men started showing up." Buzz' crew of four full-time and three part-time men includes two ex-dealers and a mechanic who "can fix any car blindfolded." Talking about his crew, Buzz remarks, "I have confidence in my boys; I can leave things to them when necessary. What's more, every one of us does every job—including the cleaning."

Service, cleanliness, and reliability soon brought Buzz an increased list of satisfied customers. "Almost 100 percent of our business is from regular customers," he says. And regular customers mean more sales of tires, batteries, accessories, and specialties, and more repair work, as well. (Repair work has increased about 75 percent in the last two years, and TBA sales have risen to approximately $4000 a month. "And we do up to 40 lube jobs a day," Buzz adds.)

"We do a rounded selling job here," Buzz explains. "Nothing is left to collect dust on the shelf." But he's quick to add: "We don't try to oversell anybody. We make recommendations after we've had a car on the lift. And at the pump island we try to sell items of a seasonal or special nature, depending on our customer's needs." Buzz' customers make many impulse purchases of merchandise contained in a large drum which is placed next to the pump island. And the attractive window displays, which are changed every two to three weeks, help to "let people know we're interested in their cars."

Another sales boost is provided twice a year when all cars must pass a state inspection. Buzz' station is licensed by the state, and he and his crew handle about 6000 cars during the two inspections. "We get to do a lot of selling then," says Buzz. "More important, we gain many new customers. Originally they come for inspection. But if they like the way we do business, they're sure to come back."

Running a state inspection station requires extra help and longer hours for Buzz' entire crew. "But the boys pitch right in."

At inspection time, Buzz attracts business by station displays and a series of newspaper ads. "But then—as at any time of year—the best advertising is word of mouth," he says.

Lately Buzz has been getting free newspaper "advertising" as a result of his success in contests run by the Massachusetts Petroleum Council and by Shell's Boston District. Buzz won a savings bond for his third-place showing in the statewide "service station of the year" contest. "For weeks before they named the winners," he notes, "my customers kept asking, 'did you win yet?' They were never disappointed that we didn't take first. But there's always next time." And, for the past two years, Buzz has won 1000 gallons of gasoline—first prize in "Operation Shipshape," a cleanliness contest involving all District stations.

Buzz and his crew made special efforts to prepare for the contests; but they make a point of keeping the station "shipshape" at all times. There's a regular cleaning schedule for bays, salesroom, driveway, and pump islands—and special treatment for the restrooms. Buzz has learned that "even when you're doing 70,000 gallons a month, it's easy to keep a station clean—as long as you don't let it get out of hand."

Buzz grins as he recalls how a Shell sales trainee helped to wash the white pump island on a rainy day last summer. (Now, mats are placed there, ensuring that the men never dirty the pump islands by stepping on them directly.)

"With the amount of inside work we do," Buzz adds, "it's doubly important to keep things clean. That way, the station looks good, and we don't get grease all over the job."

Because of this thriving business in the service bays, Buzz has installed an appointment system. "We try to schedule our inside work so we don't get hit by a sudden influx that we can't handle," Buzz explains. "This way, we can do a good thorough job and still have a car out in a hurry, no matter how big the job." In warm weather, lube-bay traffic is relieved, since George Celdrier, Buzz' mechanic, can do repair jobs out in back of the station.

The Allstate Emergency Road Service program, which is new in this area, should help to attract new business, Buzz feels. He already gets a number of comments from a sign on the back of one of his road service trucks which says: "Invite Us to Your Next Blowout." Number-two-man Jim Counihan says, "We've even been invited to parties by people who've seen it." And, Jim adds, "both of those service trucks are real money makers. Since they're equipped with two-way radios, those trucks will often stay out in the cold weather from night in the morning to five at night, taking care of stalled cars."

Since he runs a "neighborhood station," Buzz feels that credit cards are especially important to his business. When he first took over the station, he handed out an application to each motorist who drove in. Since then, credit card business has risen steadily to its present 75-percent, and he would like it eventually to reach 90 percent of all business.

Buzz gives Shell credit for being "years ahead of industry" in developing the ranch-style unit. "In a nice town like Natick, it's especially important to have a good looking station. After all, we rely on the acceptance of the community."

You get a good idea of how Natick feels about Buzz Bruni when he says: "When Sears opened right up the street with its 40-bay service complex, some people became concerned. But I'm competitive in price with Sears, and—above all—I can offer that personal touch which a mass-produced operation can't match. As a result, I haven't lost a single customer to Sears."

In fact, competition is the least of Bruni's worries. Says Buzz: "I'd love to have a competitive station across the way. Then there'd be more prospective customers for me."

Figure 17-43

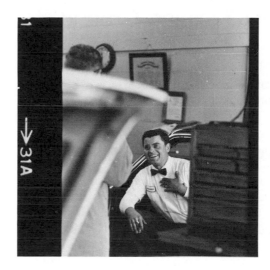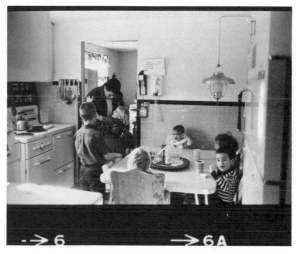

Figure 17-44 The writer insisted on these photographs being included.

Chapter 18

Function Photography: The Perfect Training Ground

There isn't a single problem you will encounter while satisfactorily fulfilling a photojournalistic assignment, which will not occur in covering a function.[1] This applies to the amateur photographer as well. The established, professional function-photographer has certain obvious advantages over the amateur. Nevertheless, the function-photographer has certain disadvantages that will be apparent.

The practicing of photojournalistic techniques is what you should be concerned with. How does a function provide the opportunities for the necessary experiences?

The professional function-photographer needs a portfolio—or wedding album—to show his prospective client. How does he get it? Each has his own answer. Some begin as assistants in established studios; others go to school and photograph their friends' nuptials. The neophyte photojournalist builds his portfolio in the manner indicated in the previous chapters.

Both the novice photojournalist and the studio owner have to contact prospective clients and have to "sell." They have to sell their ability and they have to sell themselves. The bride's father allots a budget for photography, just as the advertising agency does. Before your business obtains a good percentage of its work through referrals, you are going to do a lot of telephoning and knocking on doors. You will be meeting large numbers of people with a variety of emotional makeups and budgets in both the function and journalistic fields.

Advantages Professional Function-Photographer Possesses

Within your grasp and with a minimum of effort, you have the background and the basic knowledge to transfer this knowledge to become an excellent photojournalist. If you are in photography every day of your life, you experience the majority of problems that you will encounter in photojournalism. And as you know, there is much more to any function assignment than just the photography.

[1]"Function" is used in the sense that the photographer's greatest source of income is derived from the photography of weddings, anniversaries, college and high school yearbooks, and studio portraiture.

The highly emotional mother, father, and the bride herself have given you experience to handle the temperamental subjects you will encounter in photojournalism.

Police lines or secret service agents? Did you ever try to get into a room where the bride and bridesmaids are dressing? Have you ever had any problems with the maitre d', who has to have his soup served hot and doesn't care about your problems in getting photographs?

Uncooperative individuals? What about the 5-year-old flower girl who trundles down the aisle on the heels of the bridesmaid who precedes her? Or the clergyman who has no idea of the unobtrusiveness of available-light techniques during the religious service. You've run into this problem. This varies with the various religious sects and the particular clergyman himself, within faiths.

If you are a good candid man, you are making the majority of your function photographs candid. In other situations, you have to pose groups. As a result, you have surveyed the areas available to you for photographs, taking into consideration the backgrounds and foregrounds, and then decided on the best point of view. This has given you practice in composition. In other cases, you have made many photographs, with just a few seconds to evaluate the physical surroundings, which will often occur in photo reportage.

You certainly have coordinated the many aspects of a function with the other professional people (orchestra leader, master of ceremonies, and individuals who bear responsibilities for the smoothness and successful running of the particular function). Thus, you have some experience to coordinate and work with people such as art directors, models, and writers.

There are many occasions when "glossies" have to be rushed to meet the social page deadlines. This is similar to working with public relations departments who also have to meet deadlines.

And who is the severest critic of the work you perform? In function-photography you are dealing with vanity as well as photo reportage. All studio operators have to give re-sittings because of the "expression." "You just haven't caught me, my daughter, my son." It is much easier to satisfy an art director or a photo editor than a parent or the subject himself.

The majority of function candids are made with

flash. But a flash picture, as illustrated in Figure 18-1 is not wanted by any publication of note.

If you have done any studio portraiture, you should be well acquainted with the lighting problems as discussed in Chapters 2 and 3. A studio portrait, Figure 18-2, is an improvement over the flash. To obtain this picture, you should have made 6-12[2] exposures. Although the pose illustrated was a natural one, it lacks the realism which can be captured by the available light technique.

Many writers, photo editors, or art directors do not know just what they want in a picture that will best illustrate the text that the photography is to accompany. The photojournalist's approach, illustrated in Figure 18-3, gives the editor a variety of poses, points of view and expressions from which he can make a selection to suit his needs. This is the approach that gives realism. This is the treatment that publications of today and tomorrow are demanding.

The Miniature Camera at a Wedding

You are probably familiar with a miniature camera, since many a function is covered via the color transparencies. But here again, you employ the flash technique with the possible exception of the "time exposures" during the wedding ceremony. And you undoubtedly use the normal lens exclusively. (Chapters 4,5,6, and 8 will probably be all you will refer to.) Once you have mastered the material in these chapters, you will be able to supply your func-

[2]This is a form of saturation shooting.

Figure 18-1

Figure 18-2

tion client with an "unusual" candid, and you will also be qualified as a photojournalist.

Getting Paid for Practicing

One of the staple pictures in function photography is a close-up of the bride with her bridal bouquet (frame 10, Figure 18-4). If the bride has not had the "formal" sitting in the studio, you will need at least a $\frac{3}{4}$ shot, or close-up of her, to submit to the society editor of the local newspaper.

The next time you are on a wedding assignment, bring along your 35 mm camera with the 90 mm lens and, telling her that you are going to give her something "different"[3] or "extra," position her near a window and make a few close-ups by available light: use the saturation technique.

In the beginning, you will be wise to have an assistant along to cover you by making the close-up in your standard fashion (see Figure 18-4, frame 11A). Let him employ the $2\frac{1}{4} \times 2\frac{3}{4}$ with flash, while you back off to make a few medium shots (frame 11).

Now you can get some practice in being a photo editor yourself, by examining the contacts you have made and enlarging these to the same size you use to submit the rest of your proofs. Submit the picture your assistant made as well. To really impress your client, try making an 8 × 10 out of it. She might feel that it is different, buy it, and you will be paid for practicing.

[3]These pictures are "unusual" or "different" only because they were taken by the available-light technique. Very few function-photographers do this.

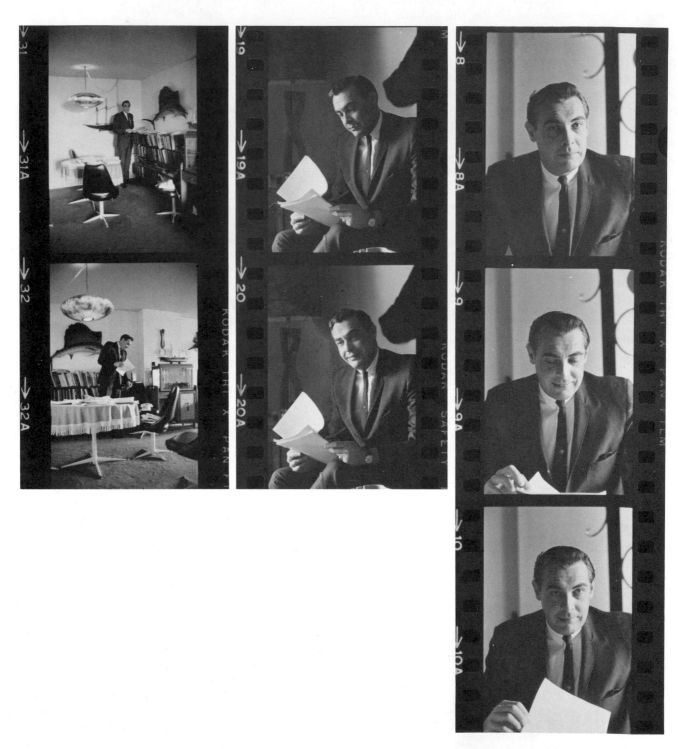

Figure 18-3 Always use the format: long shot, medium shot and closeup.

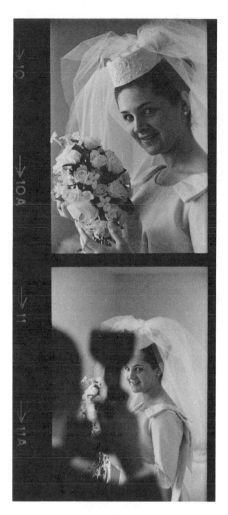

Figure 18-4

You can continue practicing the format by making your long shots (Figure 18-5). If you notice the frame numbers, you will see that the long shots are made first. The bride was busily engaged in viewing one of her bridal gifts (frame 3), then she notices you (frame

4), and you observe that you hadn't included her entire bridal train. You now make a series of vertical pictures of which frame 5 is one. In the wedding business, if you are going to show the bridal train, better show all of it, at least in one of the proofs.

More Opportunities for Practicing with Daylight

The function candidman has at least three opportunities to practice "zone-focused shooting" with the miniature camera when covering a wedding (see Chapters 9 and 12). The first of these is when the bride leaves her home on the way to the church.

In Figure 18 6 you have the opportunity to practice zone-focus shooting and the saturation technique as well. Normally, the candidman operating with the 4 × 5 camera (now on its way to extinction for function coverage) will rarely make even 2 exposures; and these will usually be posed — or lack action.

This particular bride requested coverage in black-and-white as well as color. (My assistant made just one shot of this incident in color, while I made 5 with the 35 mm). Frames 7A and 8A (Figure 18-6) were enlarged to 4 × 5 and included in the set of proofs along with the color.

With the 35 mm lens attached to the body of the camera, a shutter speed of 1/250 sec, the lens focused at 12 ft., your depth of field will vary upon your aperture. The aperture and shutter speed you will select depends upon the light intensity available. If is is bright and sunny, and the aperture is set at $f/16$, you will have a depth of field from 4 ft. to infinity. If overcast and you have to stop your lens down to $f/5.6$, your zone of sharpness will be from 7 to 25 ft. Under these conditions you don't have to focus your camera: you can concentrate on taking pictures in the saturation method, changing your points of view and getting realism into your bridal candid.

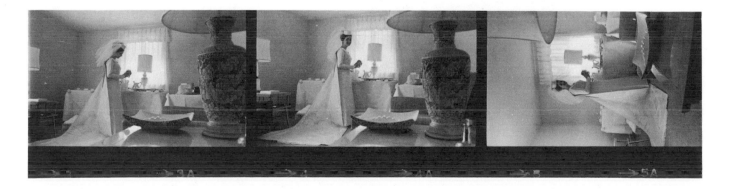

Figure 18-5

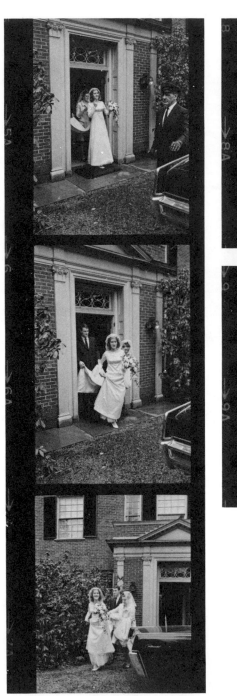

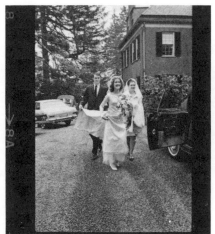

Figure 18-6 Saturation exposing.

The Other Two Opportunities

Two other opportunities to practice zone-focus saturation shooting are the arrival of the participants at the church and the arrival of the individuals at the reception, if this is different from the location of the ceremony. The former is illustrated in Figure 18-7a and the latter in Figure 18-7b. And now a word to the "friend of the family" who is taking pictures. The three opportunities discussed are ideal for you.

Figure 18-7a **Figure 18-7b**

Working with the Professional

Introduce yourself to the professional who has been hired to cover the assignment. Note his position and when the action starts, start operating your camera. If you are using color, use the reversal type—the kind that gives you transparencies. After you have received this film from your processor, select the best and have your enlargements made directly from these.

If you want better results, you can have internegatives made from the best transparency and have a custom color print made. The cost will vary with the quality you desire. The internegative (orange in appearance) will range from 40c to $7.50, depending upon the size and quality desired. The custom print (8 × 10) will range from $3 to $15 depending upon the quality desired.

Inside the Church (Procession)

As mentioned before, there are some temples and churches that do not permit the photographer to enter the sanctuary. In these cases you will be limited to working in the foyer. You can start taking your photographs whenever you see one. Here the 35 mm wide-angle lens is indispensable. For the greater depth of field and the minimum of camera shake it's better than the normal 50 mm lens. The sequence illustrated (Figure 18-8) speaks for itself.

If there is one place where you can give maximum saturation coverage and gain practice using a variety of lenses, it is at a Catholic Nuptial Mass. Since there will be no bright flashes of light to disturb the solemnity of the service, you can work at your leisure and provide the client with a different type of candid than your colleague whose only available-light approach is making a time exposure from the choir loft. If the church you are working in has a balcony, look at what you can do.

With a superwide (21 mm) lens, just about the entire setting can be recorded. And this includes the harpsichordist on the balcony who supplied the music in place of the traditional organist (see Figure 18-9A).

The 35 mm lens will give this much coverage (Figure 18-9B). With bayonet-type interchangeable lenses, the change is accomplished in a few seconds. The 50 mm lens will give coverage as in Figure 18-9C. The 90 mm moves you in closer (Figure 18-9D). The 135 mm moves you in still closer (Figure 18-9E), and all of these pictures can be made without a single distraction.

If you are covering this function in color, load your camera with the high-speed, Type B film, and be cer-

tain to bracket your exposures. Now you can have the best transparencies made into 3× prints by any photofinisher, and include these along with your other proofs. Should any be selected, have an internegative made and the final print made from this.

If there is no balcony ringing the interior of the location of the religious ceremony, there is always the door that leads onto the altar in Catholic churches. From this vantage point you can use various lenses once the services have begun.

With the indispensable 35 mm lens you can make your long shot, setting the scene (Figure 18-10). With a slight change in position (naturally you have obtained the clergyman's permission first), and shifting to the 50 mm lens, you make the medium shot. Of

Figure 18-8

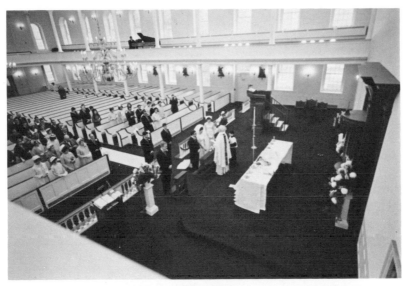

Figure 18-9a

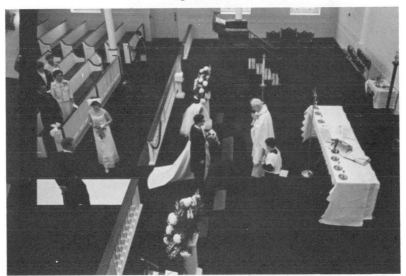

Figure 18-9b

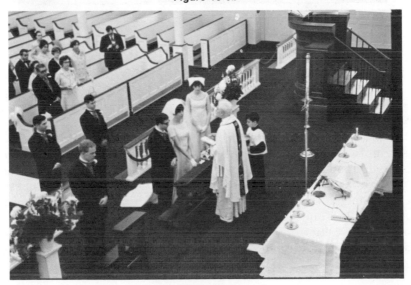

Figure 18-9c

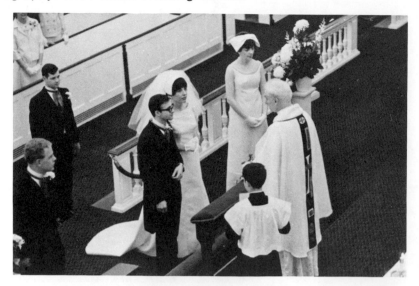

Figure 18-9*d*

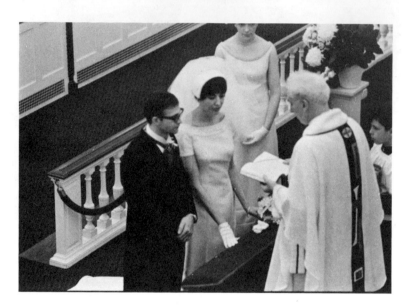

Figure 18-9*e*

course these are shot with a minimum of 3 exposures (Figure 18-11).

Then the close-ups. Changing to the 90 mm lens, you make as many exposures as you want, until you know that you have the picture that best represents what you want to show (Figure 18-12). In frame 8 the choirboy intrudes too much upon the scene and obscures the hands of the couple. The bride's face is turned too far from the camera. In frame 14 you almost have what you want. In frame 15 you feel "That's the one." Can you get a better one that this? You continue to make a few more frames until your intuition says, "Enough."

Operating When You are Really Restricted

There will be many times when you must stay out of the area where the guests are located, and flash photographs are either prohibited or impractical because of the distance involved. Using the basic lenses suggested in Chapter 4, the wide-angle (35 mm) lens hand-held, with the chest tripod and cable release providing steadiness, you again can present to the clients scenes they never would see, unless you make them. In Figure 18-13 you show them the splendor of the setting. By merely changing to the other lens suggested as a basic part of your equip-

ment, the 90 mm, you can move in for a closer look without leaving your position. Figure 18-14 was made with a 90 mm lens employing the aids mentioned. If you aren't certain of your exposure, bracket.

The Recessional

The flash photograph does not give the viewer a true representation of the scene. What would you see if you were there? You would see the background and all the nuances of light and shade (Figure 18-15)—which the flash destroys. The flash in Figure 18-16 destroys the beautiful, delicate lace pattern of the bride's gown.

Wherever you have an opportunity to employ available-light technique, do it. As a professional you will be making a "different" picture for the bride. It will not only give you practice for photojournalism but "one-upsmanship" on your competition. If you are an amateur who wants experience, it's another chance to practice your technique and to get better acquainted with the variables involved in exposure, shutter speed, aperture, depth of field, subject movement, and choice of film.

Both proofs were submitted to the bride. The available light (Figure 18-15) was selected for inclusion in the album over the flash counterpart. They have good taste.

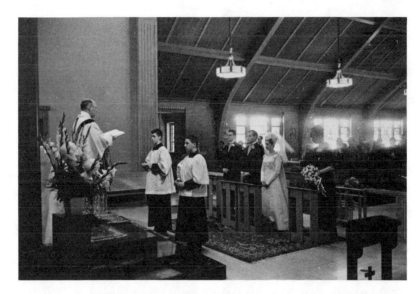

Figure 18-10

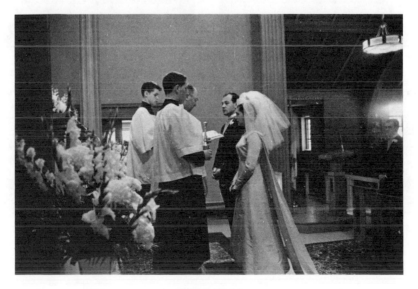

Figure 18-11

Figure 18-12

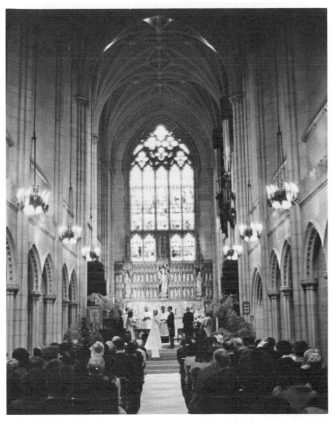

Figure 18-13

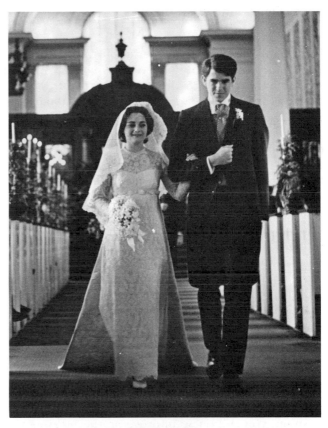

Figure 18-15

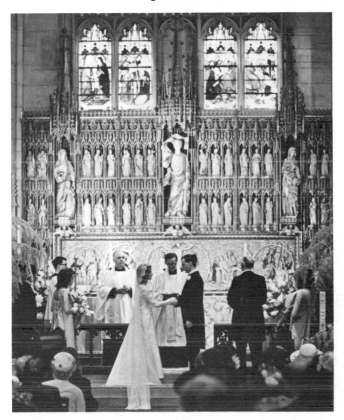

Figure 18-14

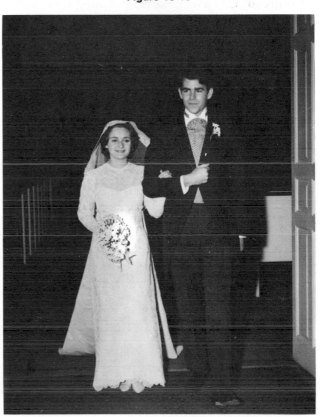

Figure 18-16

Other Opportunities to Practice

At afternoon weddings where daylight enters the building, there are many other opportunities. In Figure 18-17 you see the flash candidman making the bridal dance (frame 15A). In the other two frames on the same strip you see what can be done by the photojournalistic techniques.

Another advantage of this technique is that the camera operator doesn't have to be on the floor intruding upon the action. To an ever increasing number of prospective clients, this intrusion is quite objectionable. This group of clients doesn't want the camera operator evident: these people don't want the photographer "running" the affair. This can be one solution to the problem and an additional "selling" point as to why you should be selected as the photographer for their function, rather than your competitors.

By giving plenty of space around the dancing figures, there can be no doubt that *this* is the bridal dance. It tells the story much better than the standard 12 ft. shot. In frame 15A, Figure 18-17, the bride and groom can't help but appear to be posed, missing a prime requisite in photojournalism—have the picture unposed and with action. If you have a sense of composition, you will try to improve on the pictures you have already taken by rapidly estimating what is available for you to use and using it (Figure 18-18).

Use of Large Tripod

Your basic equipment should include a large tripod. There will be times when you may want to copy items, or will need the tripod because the level of illumination is extremely low, necessitating exposures of several seconds.

A candlelight ceremony provides very little illumination. This demands a long exposure when you

Figure 18-18

must have a great depth of field. You are using a small aperture—$f/11$ or $f/16$. With the camera firmly mounted on a tripod, you bracket your exposures. If your basic exposure is 2 seconds, you can make one at this time duration, another at 1 second, and a third at 4 seconds. The use of the wide-angle (35 mm) lens provides the coverage in Figure 18-19. A word of caution: it is very easy to give a false representation of the brightness level by overexposing a situation of this type. In the making of the final print care should be taken that the print conveys a true representation of the actual level of illumination present.

Switching to the 90 mm lens, you follow the same procedure (Figure 18-20). Your client is now provided with maximum coverage without any disturbance. If you have a 135 mm or better, there is nothing that says you can't employ it.

Putting It All Together

Functions give you the opportunity to gain experience in one of the most important areas a photojournalist needs: the ability to view a situation and

Figure 18-17

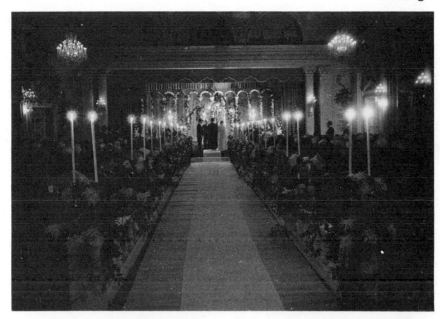

Figure 18-19

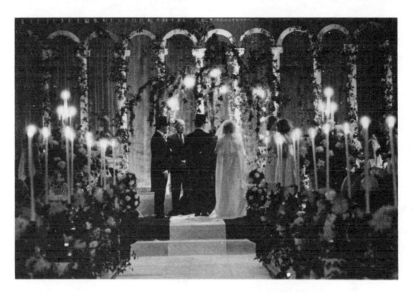

Figure 18-20

evaluate all the pictorial possibilities with computer-like speed.

With your assistant covering the affair with flash, you see an opportunity to really make a "different" picture. In the dim, candle-illuminated room, the startling finger of a spotlight appears that singles out the bridesmaids during the processional (Figure 18-21). Rapidly cutting the aperture to *f*/5.6 and shutter speed to 1/125 sec (from experience), you quickly focus on the first bridesmaid and shoot. The second bridesmaid is better framed because you are all set.

The third? Too bad. You waited too long to get the expression. The spotlight didn't follow the subject.

You missed; you should have used the saturation method of shooting. By using this method you would have had at least one picture of the bridesmaid before she was out of the range of the spotlight.

There are many other opportunities to use (or practice) the available-light technique at functions, which parallel the various conditions you will encounter in a career of photojournalism. I leave their discovery and application to you.

Figure 18-21

Function Photo and Photojournalistic Counterpart

Figure 18-22 is a photograph of an internationally known individual. The problems involved in taking this picture were discussed in detail in Chapter 13. Where can you gain the experience to make this picture?

As with your earlier practice, you begin in an area where there is a high light intensity level, such as an outdoor reception (Figure 18-23). At every wedding

Figure 18-22

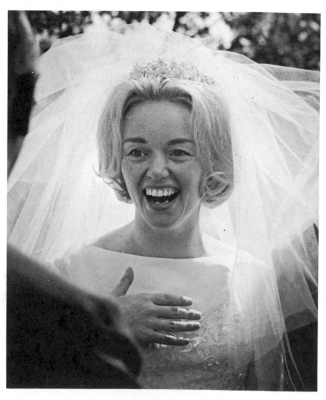

Figure 18-23

there is a receiving line. With patience and the use of the saturation method (Chapter 8), you have ample opportunity to practice the techniques necessary to obtain the photojournalistic counterpart. The variety of expressions you can capture is legion. You will have to anticipate both the moment when the bride is not obscured by a well-wisher and the emotion she will display at the comments of her guests.

In Figure 18-24 you have a shot that you have made many times. Its photojournalistic counterpart (Figure 18-25) demands the same techniques you employed — with a slight variation. You want a large image of your subject. You know enough to use a telephoto lens to get it. You have confidence in your determination of the camera settings, because you have confirmed your guide number (Chapter 14) by testing and by evaluating the results from the function photograph.

For practice at low light intensity levels, there is the Bar Mitzvah. At the rehearsal you can make close-ups of the 13-year-old boy's hand and the pointer he uses as he reads from the scrolls. The techniques practiced in obtaining the picture in Figure 18-27 are no different from the techniques you need to obtain the picture in Figure 18-26 which was used in a brochure pertaining to a new method in abrasive science.

You will never know when your experience at functions will pay off. In 1967 at least four nuptials were covered by national and foreign press: Rockefeller-Percy, Johnson-Nugent, Rusk-Smith and Johnson-Robb.

The photo editors of three prestige pictorial magazines and the managing editors of two photo agencies with foreign stringers are unanimous in their comment: "Before we would entrust a new man with even the simplest identification assignment, we must feel that he's capable of covering a political convention or a rocket launch."

Practice!

DO	DON'T
. . . employ zone focusing.	. . . use flash.
. . . use the saturation method.	. . . interfere with a professional.
. . . seek constructive critique.	
. . . practice.	
. . . coordinate your photographic responsibilities with those who have other responsibilities.	

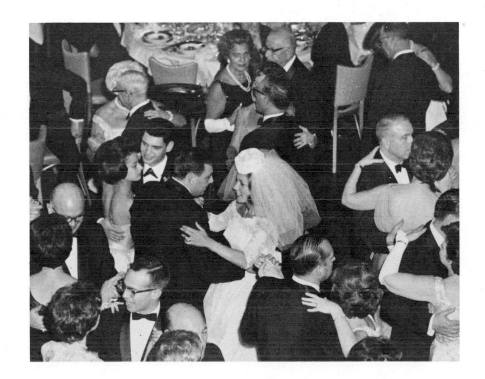

Figure 18-24

Figure 18-25

Figure 18-26

Figure 18-27

The techniques used in the function photograph (Figure 18-27) are exactly the same as those used in the illustration for industry (Figure 18-26).

Index